Drawing WORDS & WRITING Pictures

Making comics: manga, graphic novels, and beyond

Jessica Abel & Matt Madden

First Second

NEW YORK & LONDON

First Second

New York & London

Copyright © 2008 by Matt Madden and Jessica Abel

Published by First Second
First Second is an imprint of Roaring Brook Press, a division of Holtzbrinck Publishing Holdings Limited Partnership
175 Fifth Avenue, New York, NY 10010

Distributed in Canada by H. B. Fenn and Company Ltd.
Distributed in the United Kingdom by Macmillan Children's Books, a division of Pan Macmillan.

Design by Tanja Geis and Danica Novgorodoff

Library of Congress Cataloging-in-Publication Data

Abel, Jessica.
Drawing words, writing pictures : making comics from manga to graphic novels / Jessica Abel, Matt Madden. -- 1st ed.
p. cm.
ISBN-13: 978-1-59643-131-7
ISBN-10: 1-59643-131-8
1. Comic books, strips, etc.--Technique. 2. Cartooning--Technique. I. Madden, Matt. II. Title.
NC1764.A24 2008
741.5'1--dc22
2007044125

First Second books are available for special promotions and premiums.
For details, contact: Director of Special Markets, Holtzbrinck Publishers.

First Edition June 2008
Printed in China

3 5 7 9 10 8 6 4 2

PERMISSIONS

All uncredited illustrations and comics are by Jessica Abel and/or Matt Madden and are copyright © 2008 by the respective author(s).

We have made every effort to track down and contact rights holders for all other comics and illustrations. If you feel an accreditation was made incorrectly, or know of another problem with credits or rights, please get in touch with us so we may correct the error.

Chapter 1

9 Copyright © 2008 Matt Feazell
9 *Long Shot* by Shane Simmons copyright © 1997 by Shane Simmons
9 John Porcellino Image copyright © by John A. Porcellino. Used with permission.
9 *My New Fighting Technique is Unstoppable* by David Rees copyright © by David Rees
9 Copyright © 2000 by Martha Keavney

Chapter 2

17 Wallace Morgan cartoon courtesy of Fantagraphics Books
17 Copyright © Kalo, from the collection of Seth. All rights reserved.
18 Sam Henderson Image copyright © by Sam Henderson
18 David Mazzucchelli Image copyright © by David Mazzucchelli
19 Renée Magritte Image copyright © 2008 by C. Herscovici, Brussels/Artists Rights Society (ARS), New York
19 *No Title (The World Was)* by Raymond Pettibon copyright © 1987. Courtesy Regen Projects, Los Angeles.

Chapter 3

28 *Mutt and Jeff* strip by Bud Fisher copyright © by H.C. Fisher
29 *Wash Tubbs* by Roy Crane copyright © Distributed by Newspaper Enterprises Association, Inc.
30 *Maakies* by Tony Millionaire copyright © by Tony Millionaire
31 *The wrong planet* Activity copyright © by Paul Hluchan. Used with permission.
33 Tom Hart Image copyright © by Tom Hart
33 Brian Biggs Image copyright © by Brian Biggs
35 *Nancy* by Ernie Bushmiller copyright © by United Features Syndicate, Inc.

Chapter 4

48 *Nancy* by Ernie Bushmiller copyright © by United Features Syndicate, Inc.

Chapter 5

57 Charles Burns Images copyright © by Charles Burns

Chapter 6

68 *Popeye* by E.C. Segar copyright © by King Features Syndicate, Inc.
72 *Hellboy*™ copyright © 2008 by Mike Mignola. Published by Dark Horse Comics, Inc.
73 *Epileptic* by David B. copyright © by David B. and L'Association
73 *Blankets* by Craig Thompson copyright © by Craig Thompson
74 *Ode to Kirhito* by Osamu Tezuka. Image used with permission from Vertical, Inc., and Tezuka Productions.
74 Paul Pope Image copyright © by Paul Pope

Chapter 7

100 Brian Biggs Image copyright © by Brian Biggs

Chapter 8

104 Phoebe Gloeckner Image copyright © by Phoebe Gloeckner
105 Jaime Hernandez Image copyright © 2008 by Jaime Hernandez
105 Franco Matticchio Image copyright © 2008 by Franco Matticchio
111 Lorenzo Mattotti Image copyright © by Lorenzo Mattotti
112 Barry Windsor-Smith Image copyright © 2008 by Marvel Characters, Inc. Used with permission.
115 *Blade of the Immortal* by Hiroaki Samura copyright © 2008 by Hiroaki Samura. All rights reserved.
 New and adapted artwork and text copyright © 2008 by Dark Horse Comics, Inc. Published by Dark Horse Comics, Inc.
120 Guy Davis, *B.P.R.D.* ™ copyright © 2007 by Mike Mignola. Published by Dark Horse Comics, Inc.
121 R. Crumb Image copyright © 2008 by R. Crumb
122 Joe Sacco Image copyright © by Joe Sacco

Chapter 10

147 Jon Sperry Images copyright © by Jon Sperry. http://www.jonsperry.com

Chapter 11

156 *Sin City* by Frank Miller copyright © 2008 by Frank Miller, Inc. All rights reserved. *Sin City* and the *Sin City* logo are registered trademarks of Frank Miller, Inc. Published by Dark Horse Comics, Inc.
157 Jaime Hernandez Image copyright © 2008 by Jaime Hernandez
157 *Louis Riel* by Chester Brown copyright © 2000 by Chester Brown
157 *Below the Shade of Night* by Jordan Crane © Jordan Crane
158 Gilbert Hernandez Image copyright © by Gilbert Hernandez
158 Anders Brekhus Nilsen Image copyright © by Anders Nilsen
159 *Laika* by Nick Abadzis copyright © 2007 by Nick Abadzis. Used with permission of First Second Books.
159 From *FUN HOME, a Family Tragicomic* by Alison Bechdel. Copyright © 2006 by Alison Bechdel. Reprinted by permission of Houghton Mifflin Company. All rights reserved.
 For United Kingdom: From *FUN HOME, a Family Tragicomic* by Alison Bechdel, published by Jonathan Cape. Reprinted by permission of The Random House Group Ltd.
159 *Blade of the Immortal* by Hiroaki Samura copyright © 2008 by Hiroaki Samura. All rights reserved.
 New and adapted artwork and text copyright © 2008 by Dark Horse Comics, Inc. Published by Dark Horse Comics, Inc.

Chapter 12

171 *My New York Diary* by Julie Doucet copyright © Julie Doucet
171 Jack Kirby Image copyright © 2008 by Marvel Characters, Inc. Used with permission.
171 *Purity Plotte* by Julie Doucet copyright © Julie Doucet. Published by Drawn & Quarterly, 1996.
171 *Kampung Boy* by Lat copyright © 1979 by Lat. Used with permission of First Second Books.
171 Kim Deitch Image copyright © by Kim Deitch
171 Kaz Image copyright © by Kaz
173 Copyright © by Les Humanoïdes Associés SAS and Dupuy & Berberian
173 *American Born Chinese* by Gene Yang copyright © 2006 by Gene Yang. Used with permission of First Second Books.
173 *Missouri Boy* by Leland Myrick copyright © 2006 by Leland Myrick. Used with permission of First Second Books.
174 Dylan Horrocks Image copyright © 1998 by Dylan Horrocks
174 David Mazzucchelli Image copyright © by David Mazzucchelli
174 James Kochalka Image copyright © 1999, 2005 by James Kochalka
174 *From Hell* copyright © Alan Moore & Eddie Campbell. Used with permission.
176 Osamu Tezuka Image used with permission from Vertical, Inc. and Tezuka Productions.
176 Joe Sacco Image copyright © Joe Sacco
176 *Le Tueur de Cafards* by Jacques Tardi copyright © by Casterman. Used with permission from the author and Editions Casterman.
176 *American Born Chinese* by Gene Yang copyright © 2006 by Gene Yang. Used with permission of First Second Books.
176 R. Kikuo Johnson Image copyright © 2007 by R. Kikuo Johnson

Contents

A focus on creating a believable comics world, plus a brief look at drawing heads and hands.

A lesson in inking with the brush, including techniques for softening blacks.

Preface

THE TSUNAMI OF COMICS: COMING TO A TOWN NEAR YOU

Things have changed in the world of comics. Once they were understood to be escapist fluff aimed primarily at children (though, even then, there were lots of sophisticated exceptions). Today, comics are being produced all over the world at a startling rate, and their range runs the gamut from traditional escapism, to original or adapted works of literature in graphic novel form, to adults-only eroticism and ultraviolence, to topical or political comics, to religious comics from all possible spiritual points of view, to alternative comics coming from offbeat perspectives, and beyond. In short, the word "comics" now encompasses as broad a range of subjects, perspectives, and innovations as music, literature, painting, sculpture, or any other art form.

Comics is a medium on the cusp: With a somewhat checkered history behind us, we are beginning to see a critical mass of young, ambitious artists interested in pushing the medium in all kinds of new directions, to truly explore what's possible in comics.

We are now living in a world full of great comics, and fewer and fewer people are inclined to treat them with condescension. Comics are winning major awards and recognitions (a Pulitzer Prize for Art Spiegelman's *Maus*, a *Guardian* First Novel Prize for Chris Ware's *Jimmy Corrigan*, a Guggenheim Fellowship for Joe Sacco, the author of *Safe Area Goražde*, among other works). Manga and comics aimed at adults are flying off the shelves faster than bookstores can stock them. A never-ending stream of comics is being adapted for the screen—it seems that just about every superhero comic ever created has been filmed; such idiosyncratic works as *Ghost World* and *Persepolis* have also been made into films; and even the lives of influential comics artists have become cinematic subject matter (*Crumb*, *American Splendor*). College literature courses and textbooks are increasingly making a concerted effort to bring comics into the fold alongside contemporary works of fiction, poetry, and drama.

In short, the territory of comics is wide open for any artist bold enough to take it on. Unlike in film, an even younger art form, there has never been much of a comics avant-garde. There is still very little work in the literary or high-art area. While there is great genre fiction, by no means have all the stories been told, nor all the methods for telling those tales exhausted. And while journalism and memoir have proven in recent years to be rich veins for comics to mine, there remain plenty of underexplored areas. Poetry in comics form? Almost nonexistent. Comics essays? There have been a few, but not many.

The outer limits of the medium have yet to be discovered; there is a vast terra incognita waiting for pioneering cartoonist-explorers.

COMICS EDUCATION: THE TIME IS NOW

Now that there is a growing number of people interested in entering the comics field in either an artistic or commercial capacity (or both), how do they get started? Unfortunately, what hasn't kept pace with the rather spectacular change in fortunes for cartoonists is education. Currently more and more high schools, colleges, universities, art schools, and adult education programs are offering courses on how to create comics. We teach these courses ourselves, and have done so for a number of years.

However, while the few books on the market that provide instruction on creating comics all contain nuggets of good information, none of them can really be considered textbooks on the subject—they don't follow a pedagogical approach that engages students and guides them from the basic to advanced stages of writing and drawing comics. And instructors, often asked to teach a comics course on very short notice, have felt at a loss as to where to begin and how to present such multifaceted subject matter in a way that will not collapse under the weight of its own complexity. Comics is a brutally difficult medium to master. It requires expertise in a wide and not necessarily compatible set of skills: drawing, of course, but also graphic design, writing, and strategic thinking. It also requires the practitioner to be patient, and very hardworking.

ENTER *DRAWING WORDS & WRITING PICTURES*

For all the above reasons, we have written *Drawing Words & Writing Pictures*. Although our book is designed both for the classroom and for independent individual or group use, we approach the material in textbook form. That is, the book you are now holding in your hands presents the same kind of cumulative, systematic, pedagogically thorough instruction you might find in a first-year history, chemistry, or sociology textbook (although we've kept it as unstereotypically "textbooky" as possible—no endless pages of unbroken prose or dry, academic writing).

We have designed this book to follow a typical 15-week college semester format (which can be adjusted for longer or shorter courses), and we have tried to maintain a friendly, coaching tone and step-by-step methodology throughout. In addition, pedagogical materials (including class-tested exercises and activities), special features (such as the sidebars), and a companion website, www.dw-wp.com (featuring a variety of extras not found in the book), go beyond basic instruction to provide a complete learning environment.

We will not undersell the difficulty of the subject matter—as we said, comics is a very complex and difficult art form—but we hope that over the course of this book we will prepare students to tell the stories they want to tell, whatever those stories may be. And we hope that instructors will find the task of teaching this course a much simpler, more straightforward experience.

A NOTE ON THE TITLE

Drawing words means to think of the letterforms as a part of the visual language of the comic. *Writing pictures* means to think of the images as carrying meaning much as language does. Comics has been compared to calligraphy in the blending of word and image, and to music notation in the visual translation of time passing and emotion written in ink.

Making comics requires creators to think fluidly of words and images, to smudge the boundaries, and to artfully blend the two usually distinct forms of communication into a synchronized whole.

ACKNOWLEDGMENTS

We can't imagine how this book would have ever happened without the help and encouragement of an enormous team of people. We want to thank most especially Marina Corral, our dedicated studio assistant, and, later, permissions czar. Having her there to keep track of all the bits of paper and make sure we stayed on track was really a luxury.

We can't say enough about the major contributions of the rest of the large and wonderfully competent team who worked on the book directly. The initial elegant design concepts from Danica Novgorodoff were passed seamlessly to her colleague Tanja Geis, who had the unenviable job of drawing a hundred little orange arrows, and then moving them around when we changed our minds. Tanja did a spectacular job, and never lost her cool, no matter how many changes we gave her. Bruce Cantley, our editor, was a font of invaluable knowledge about how this wacky textbook thing we dared to attempt was supposed to work. His expertise and patience helped us enormously through many a confusing crisis. Kat Kopit handled the administrative details of, among many other things, our beta tester groups, with aplomb, and could always be counted on for a straight answer. We thank them all for their tireless work.

We also want particularly to thank Mark Siegel for his vision and support through this very first try at a textbook for comics. It wouldn't have happened without him. Nor would it have been possible without Bob Mecoy, our agent, who put this project together and helped us shepherd it though to the end.

Finally, we'd like to thank our "beta testers," a small group of volunteers around the country who worked through the rough cut of the book and shared with us their insight into how to improve it. They are pioneers, and we are glad to have worked with them. Susanne Shaver was the star student of this group, and deserves special thanks for her careful notes on our work.

In addition to all the people who played a concrete role in putting this book together, there are many who inspired us and gave us ideas for the material herein. Most especially, we want to mention Scott McCloud, who threw down the gauntlet as far as serious thinking about comics with *Understanding Comics*, and has been such a source of energy and ideas ever since. We also owe a special thanks to Ivan Brunetti, from whom we borrowed the idea for the cumulative structure of the book. Our fellow faculty at the School of Visual Arts, most especially Tom Hart, Keith Mayerson, David Mazzucchelli, Klaus Janson, Nick Bertozzi, Gary Panter, and Joey Cavalieri have encouraged us and traded teaching ideas with us over the years, while Tom Woodruff, our intrepid department head, is responsible for bringing us all together and developing an excellent comics curriculum.

Over time we have had many student interns pass through our studio, all of whom have helped our lives immeasurably. In particular, Nate Doyle, Rob Dewing, and Jodi Tong made significant contributions to this book, from cutting paper to scanning to coloring on the computer.

The artists who allowed us to reproduce their art have lent a richness and complexity to our book, not to mention the world, that deserves all our thanks. We owe particular thanks to Charles Burns and Chris Ware for their generosity. In addition we would like to thank all the editors, publishers, and rights managers who helped us navigate the complex straits of copyrights and credits. Two people we would like to single out are Chris Oliveros, who patiently answered a large number of questions and requests, and Diana Schutz, who not only helped us secure rights but also provided us with art and generally encouraged us.

Above all, we'd like to extend our gratitude to all our students, particularly at SVA but also at the various other schools and workshops where we have taught over the years. There is absolutely nothing like the inspiration and energy we get from them. We would never have embarked on this ambitious project if not for that incredibly rich, interesting, and productive relationship. ∎

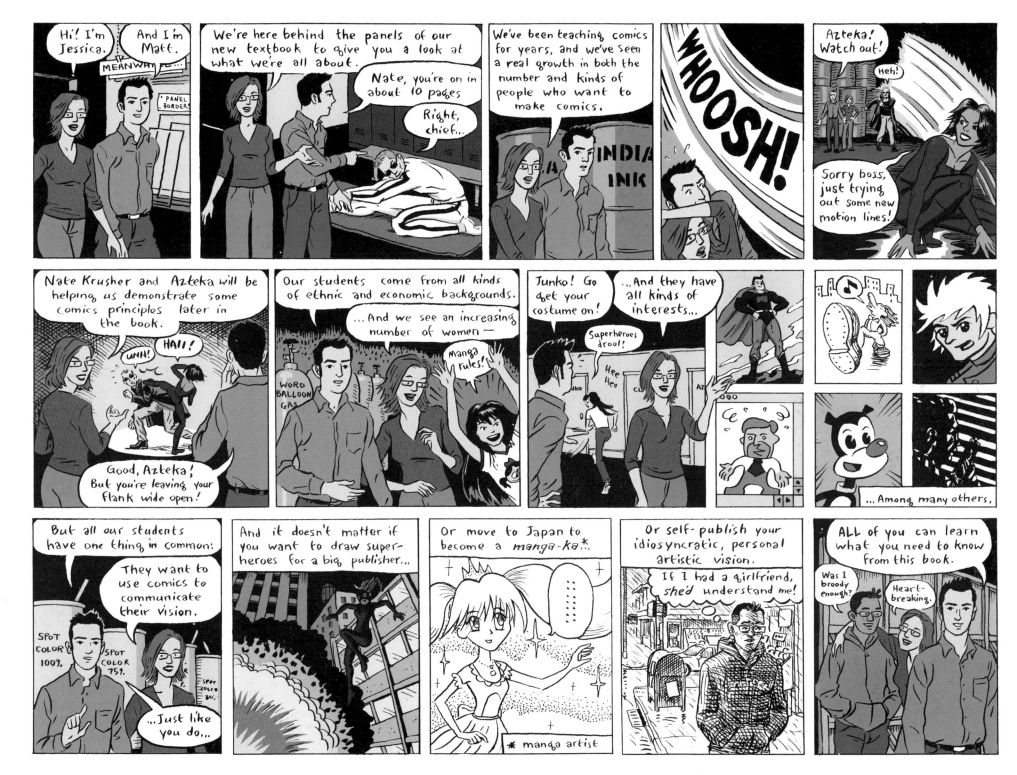

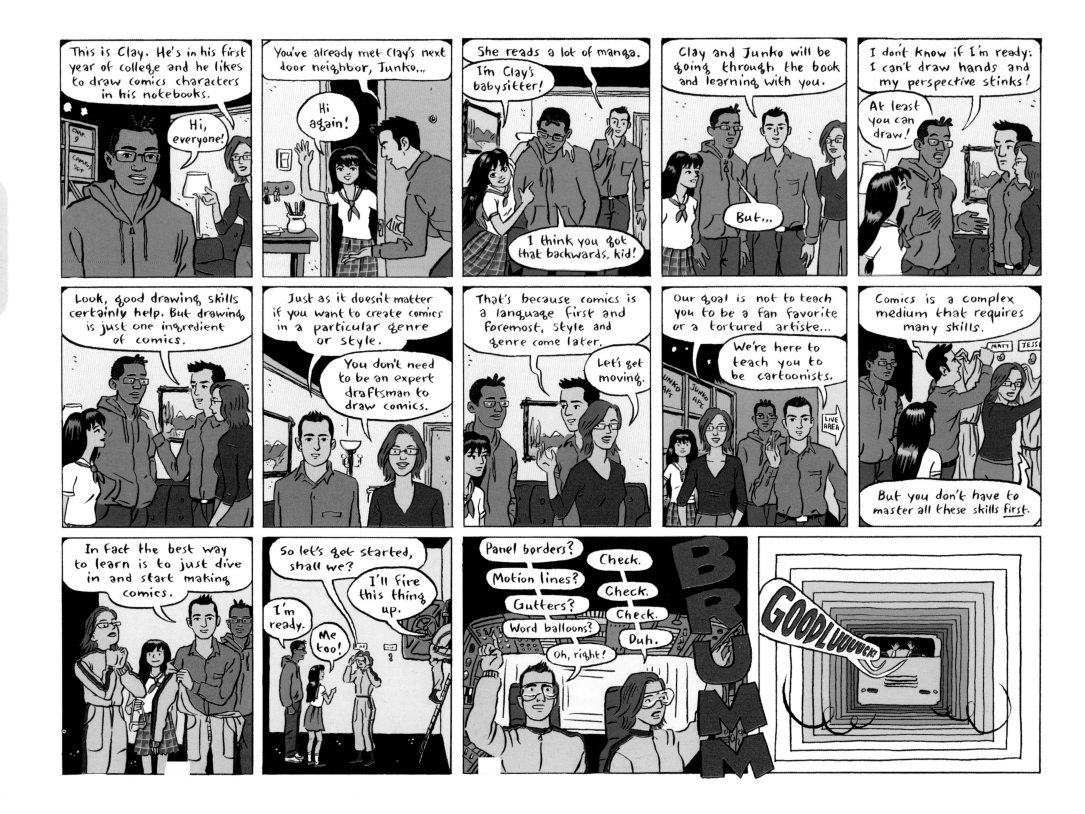

Introduction

How to use *Drawing Words & Writing Pictures*

WHO IS THIS BOOK FOR?

If you're interested in the art of making comics—whether that means you plan to create comic strips, longer comics, graphic novels, or massive space operas spanning 20 volumes—*Drawing Words & Writing Pictures* is for you. We have structured this book following the model of a 15-week college semester in a studio classroom setting (typically a three- to six-hour session once a week). We have invested it with all the rigor and seriousness that we bring to our own classroom.

However, we know that it's possible that you won't be studying comics in a classroom with the benefit of an experienced teacher, so we've built in features and methods by which individual, independent learners (we'll call you *Ronin*, after the masterless samurai who roamed feudal Japan) can easily use the book as well.

But because we do believe that there is a great inherent value to learning in a group situation, we have also built in resources for those of you who want to create your own independent groups, either in person or online, and share your insights and experiences with others (we'll call you the *Nomads*).

Classroom students

If you're using this book in a classroom situation, whether in a high school, college/university, art school, or adult education program, your approach is straightforward: You can rely on your teacher to guide you. The chapters are cumulative, so academic courses should follow them sequentially. For shorter or longer courses, we've provided alternate syllabi on the book's companion website, www.dw-wp.com, to help instructors adjust the book to their course needs. Teachers will also find tips and teaching ideas on the site.

Ronin

If you are a Ronin, you can work through the book at your own pace and as you see fit. However, because the chapter topics and skills described in each chapter build in a cumulative manner, you should, as a rule, work through the chapters in order, like other users of this book. Throughout the book we provide special tips for you where applicable on how to adjust exercises and activities to an individual-learner context. Ronin should also pay particular attention to the book's companion website, www.dw-wp.com, where we'll provide samples of other students' work and additional commentary so that you'll have models with which to compare your own work.

Nomads

We really want to encourage independent learners to come in from the cold and form Nomad groups to work through the book together. The extra effort required to create and maintain a group (and it is indeed extra work) will be amply repaid by the extra richness you'll be able to get out of the exercises and critiques by drawing on the perspectives of other people. The encouragement you can lend each other will also help you to finish the course, and then continue to make comics long after you're done working through this book. We've included a few tips on forming groups on the following page, and there are more on our website, www.dw-wp.com.

Forming a Nomad group

There are several ways to go about forming a group:

- Get together with friends who share your interest in becoming cartoonists.
- Put up a flyer in your local comic book store, café, or school.
- Post an announcement on comics-oriented message boards saying you want to start a group. Alternately, if there isn't a critical mass of interested parties in your area, you can start an online group.

We recommend gathering a minimum of five people to start, and ideally more like eight to ten. There is always attrition, even among the most dedicated groups, and the final core group will almost always be smaller than what you started with.

Choosing a place to meet

You should look for a place to meet that is convenient for everyone and which is also reliably available, like a café, campus student center, or even a bar. Some comics stores have space where people can meet, so don't be shy about asking the manager of your local comic book store or non-comics bookstore. Of course, you can also meet at someone's house or apartment if they have space and agreeable roommates or family members, or even rotate meeting-hosting among members. If you meet in cyberspace, there are a number of ways you can set up your meetings using image sharing and message boards, chatrooms, or private online groups.

Choose a schedule and stick to it

It is very important to commit to a regular meeting schedule and to do your best as a group to keep up the momentum. We recommend meeting every two weeks, but if you want a more intensive pace, you could meet every week. Try not to let more than a month go by between meetings.

Readings and activities

In a given chapter, you should plan to do all of the readings before your meeting. This includes explanations and demonstrations, activities, and also sidebars. Read through all the materials lists and make sure to bring to your meeting all supplies the activities call for. You should do activities with your group, though there are a few you might want to prepare ahead of time, especially if your meeting space isn't set up well for drawing.

Homework

You thought you were done with homework when you graduated from school, didn't you? There's a homework section in each chapter, and the assignments in those sections are meant to be completed independently, between meetings. Always bring your completed work to meetings, so you can participate in group critiques.

For more assistance and ideas

Our website, www.dw-wp.com, has more information and resources about starting and running a Nomad group, including prep guides to help you get ready for each meeting. ■

ORGANIZATION OF THE BOOK

We have designed this book to be a complete beginning course in comics. If you take this course seriously and work through all of the chapters, activities, and homework assignments, in 15 sessions you will have a strong basis in the fundamentals of making comics. We start with the basics, such as understanding comics terminology and creating a single-panel comic. We then interweave chapters that cover technical skills (such as penciling, lettering, inking, and scanning) with chapters dealing with narrative considerations (such as panel transitions, story structure, character, and setting). Finally, we conclude with writing and drawing a six-page comic of your own. Please take a look at the table of contents for brief descriptions of each chapter.

In volume two of this book, we will cover more advanced skills, such as structuring a graphic novel, and will spend some time discussing the professional world of comics: production, publishing, and distribution.

SPECIAL FEATURES

Following is a list of special features we have included in the book and what each feature is designed to accomplish:

Further reading boxes

The essays and tutorials that anchor each chapter cover concepts in as much detail as space allows, but there is always more to learn. In particular, historical context is an important area of study that does not fit within the scope of this book. For this reason, "Further reading" boxes are provided wherever appropriate, offering a selection of titles for those of you who are interested in exploring certain topics in more detail. These selections are not definitive or comprehensive; they are simply intended to point you in the right direction.

Activities

Our teaching method depends on the student's complete involvement in every stage of the learning process. Activities, which we designed to be completed while in the classroom or with your group, are included in every chapter, and are broken into "materials," "instructions," and "talking points" for ease of use. We've also included special instructions and additional web support for Ronin.

Homework

Every chapter ends with one homework assignment. As with the activities, each homework assignment includes "materials" and "instructions" subsections for ease of use. These are projects that are meant to be completed alone, on your own time outside of class or group meetings. Homework assignments are the core of the curriculum as it builds from chapter to chapter, and so it's essential that you complete them in the order given and on the same schedule as your group.

Homework critiques

Critique talking points for each homework assignment are located in Appendix B. These are designed to help you evaluate your own work and that of other students. You should always take time to critique your work before beginning the next chapter, whether you're in a classroom or working on your own. As with the activities, the homework critiques are often written with a focus on collaborative work, so we've included special notes to help Ronin adapt the critiques for their own use.

Sidebars

You should read all of the sidebars in addition to the regular text. The sidebars are set apart from the regular text, not because the information is less relevant, but because it runs parallel to the main essays. The sidebars serve a variety of functions. First, we've put all the detailed information about art supplies into sidebars. Second, a number of the sidebars include helpful context that, although important, would otherwise interrupt the flow of the chapter's basic instruction, for instance: definitions of key terms directly relevant to the chapter topic, or historical background. Finally, a selection of the sidebars provides helpful tips, such as reassurance for students who are worried about their drawing skills (Chapter 1), tips on posture when drawing (Chapter 8), and methods for making corrections (Chapter 8), among others.

Extra credit

We are aware that your class, group, and individual time is limited. For that reason, we streamlined activities and homework into what we feel is achievable in a standard one-semester course. However, we know that there will be times when you'll have a bit of extra energy, or a strong interest in a particular topic, and you might want to go above and beyond. We created the extra credit assignments for those occasions.

Appendices

We have provided a number of appendices to help both students and instructors get more out of the book:

A. Supplies. Because the variety and number of supplies discussed in the various sidebars may be daunting to some (not to mention hard to use as a shopping guide), we've provided a list of the essentials here, along with a few optional but still highly recommended items.

B. Homework critiques. As discussed earlier, we have collected all of the homework critiques in an appendix. We encourage everyone who uses this book not only to complete the homework assignments but also to assess the results closely via these critiques.

C. Story cards. This appendix contains a list of character and story elements and instructions for making your own flash cards for use in a variety of storytelling activities. Chapter 10 introduces these cards, and you may find they come in handy over and over again.

D. Comic book book report. One of the key elements to learning about comics is learning through reading and analyzing other comics. Though the book doesn't cover this in depth, we have included this appendix in order to facilitate your reading and further study.

E. Making minicomics. A great way to learn about printing and publishing comics, which form the final link between your initial idea and your reader, is by making your own photocopied minicomics. However, given the time constraints on a one-semester course, we didn't have room to include activities on making minicomics within the text. Nonetheless, this is such an important activity that we created this appendix to help you learn how to make them on your own.

Bibliography

Many books consulted in the writing of this book, along with additional resources mentioned in the "Further reading" boxes, are included here for those interested in further independent research.

COMPANION WEBSITE FOR STUDENTS AND INSTRUCTORS, WWW.DW-WP.COM

One of the most important supplements to this textbook is its companion website, www.dw-wp.com, particularly for Ronin, but also for classroom students, Nomads, and instructors.

Student resources

For students, we offer a number of helpful features to enhance the instruction and features already included in the book. We think you'll find the examples of student work particularly helpful. The work itself is posted on the website, www.dw-wp.com, along with commentary on what students did well, and what could have been improved. These examples will be helpful to all students as models of good student work, and they will be especially useful for Ronin, who will not have the advantage of viewing the work of classmates or other members of a Nomad group.

Instructor resources

For instructors using the book in a traditional course, we offer a variety of helpful features. For those not using the book in a typical 15-week course (for instance, teaching a ten-week course, or a very brief summer course) we offer sample syllabi suggesting subsets of the material in this book that will cover as many of the essentials as possible. In addition, we've provided teaching tips on leading group discussions, getting students involved with the homework critiques, and more. ■

START YOUR ENGINES

When you sit down to plunge into this book, whether in a classroom, in a Nomad group, or as a Ronin, here's all you'll need to have on hand:

- a pencil
- an eraser
- a few sheets of blank looseleaf paper (office paper, see page 21)

Prep guides for each chapter—telling you what you need to have read and done as well as which supplies you'll need—are available on the website, www.dw-wp.com. ■

Building Blocks

1.1

Know 'em when you see 'em

DEFINING "COMICS"

Some of you are into manga, others are into the underground comix of the 1960s, and still others are into film or video games, but you are all here to learn how to make this thing we call comics. This probably seems straightforward enough, but let's take a step back for a moment and ask ourselves what comics is, exactly. You may well ask why; comics has long been one of those "I know 'em when I see 'em" media, and as long as that works, who cares, right?

Well, right and wrong. We have no interest in pinning down a specific, bulletproof definition. We are not academics examining the nuances of production and reproduction methods along with economic, cultural, and historical factors to produce a paragraph-long definition that covers every contingency. However, the purpose of this book is to teach you how to make "comics," so it seems only fair to put out a working definition up front.

First, we want to make it clear that when we talk about "comics" we are referring to it as a medium, just like "film" or "painting." You don't think that film necessarily means movies about gangsters or cowboys, do you? Or that painting always depicts realistic landscapes? Film, painting, and other media are ways to express ideas—any you like. Comics is like that too. It's a container for ideas.

At that basic level, we can find pretty universal agreement among theorists and would-be definers. However, when we try to get more specific about what exactly sets comics apart from other media, what its essential characteristics are, that's when we run into more debate. With that in mind, let's take a look at some of the existing definitions out there.

Will Eisner

"Sequential art"

Will Eisner is a cartoonist known for his work on the comic *The Spirit*, from the 40s on, and, more to the point here, for his pioneering long-form comics (he may have been the first to use the term "graphic novel"), as well as two analytical books on the art form. His two-word definition, "sequential art," is a straightforward attempt to define comics by its formal properties (stories told by putting art in sequence) and to escape the content-related connotations of words like "comics" (implying something funny) or "comic book" (mainly associated with superheroes).

Scott McCloud

"Images juxtaposed in deliberate sequence in order to convey an idea and/or an aesthetic response"

Scott McCloud is a cartoonist/theorist who wrote a book (in comics form) called *Understanding Comics*, examining how comics works. Upping the ante on Eisner, McCloud expanded Eisner's two-word definition to pinpoint more precisely what makes something a comic. Notice that neither Eisner's nor McCloud's definition mentions text—in fact, most people think comics don't need to include words to be comics, but we include text in our working definition because the vast majority of comics do use it.

David Kunzle
"The four prerequisites of the 'comic strip'"

The scholar David Kunzle wrote *History of the Comic Strip*, a two-volume history of comics created before the 20th century (unfortunately now out of print). In order to distinguish between comics and comicslike art, such as the Bayeux tapestry and Mayan codices, he invented a definition that was more narrowly construed than Eisner's or McCloud's definition. To elaborate, he proposed four prerequisites to make a comic a comic.

1. There must be a sequence of separate images.
2. There must be a preponderance of image over text.
3. The medium in which the strip appears and for which it is originally intended must be reproductive; that is, in printed form, a mass medium.
4. The sequence must tell a story that is both moral and topical.

The first prerequisite is an echo of what we have already seen. The second continues in a formal vein, suggesting the mixture of word and image (notice that unlike McCloud and Eisner, Kunzle includes text). The third prerequisite is perhaps the most interesting, because it introduces technology and, more generally, historical context into the discussion. Think about it: Can you imagine a comic as something separate from the way it is published, whether as a newsprint comic book or on a web page? This rule challenges you to think about questions such as: If you have a series of drawings on a wall, or even an original page of drawn comics hung in a gallery, is that a comic? Or is it something more like a manuscript? The fourth and final prerequisite is the most problematic given the way comics has changed as a medium in the last fifty years, but it certainly offers food for thought. Keep in mind that, by "moral," Kunzle doesn't mean that a comic needs to "have a moral," rather that a comic has to deal with the way people live in contemporary society. One reason Kunzle made this distinction was to disqualify works that are educational or instructional, such as illustrated airline safety manuals. This isn't an exclusion we necessarily agree with.

What we talk about when we talk about comics

Now, keeping all those other definitions in mind, here are some criteria that we use when deciding if what we're looking at is a comic.

1. Are there multiple images that are intended to be read in a certain order?
2. If there's only a single image, does it have a kind of narrative to it?
3. Is there a combination of both text and images?

There are other indicators as well. Comics also often feature such things as…

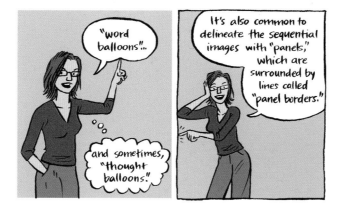

These techniques aren't essential for making comics, but they are quite common.

Let's end with a few questions to discuss and ponder:

1. How is a newspaper strip similar to or different from, say, a superhero comic book or a manga?
2. Can an instruction manual be a comic?
3. Can you have a comic with no words?
4. Can you have a comic with no images?
5. How is a movie like a comic?
6. Does a comic have to be something reproduced (in print or on the Web)?
7. Is a single-panel humorous cartoon (think *The Far Side* or the cartoons in *The New Yorker*) a comic? ◼

FURTHER READING

Will Eisner, *Comics and Sequential Art*

———, *Graphic Storytelling and Visual Narrative*

David Kunzle, *History of the Comic Strip. Vol. 1, The Early Comic Strip: Narrative Strips and Picture Stories in the European Broadsheet from c.1450 to 1825*

———, *History of the Comic Strip. Vol. 2, The Nineteenth Century*

Scott McCloud, *Making Comics: Storytelling Secrets of Comics, Manga and Graphic Novels*

———, *Understanding Comics: The Invisible Art*

 ## What's in a name?

My name's Jessica. Why did my parents choose this name? They thought it was nice and, at the time, somewhat unusual. Well, it's a nice name, I guess, but it turned out not to be all that unusual, to say the least. But even if my parents were half-wrong, they put a lot more thought into naming me than whoever came up with the brilliant name "comics" did for what we do.

OK, so comics are not necessarily, even not usually, funny, as the word implies. But many arts media are named just as randomly. "Movies"? Think about it. Move-ey. Weird, right, to be named after the fact that movies move? "Novels"? Novel=new. New? What? Why? But, that said, we're not going to change the word "novel" to "extended prose fictional composition" any day soon.

So why are we tying ourselves into knots over the name "comics"? At least it sounds better than "images juxtaposed in a deliberate sequence" (see McCloud, page 4). In an attempt to come up with an alternative to the word "comics," others have proposed "graphic novel," which has since gained popularity largely due to marketing departments' efforts to make comics more palatable to the general public. Still, we use the term ourselves because it's the only one the non-comics-savvy world out there is recognizing these days.

Which is just sad. Sure, the historical prejudice against comics as a serious medium for artistic expression continues to be strong. We've heard serious painters and writers say that it's actually not possible to create art using the medium of comics, which is simply ludicrous, not to mention insulting when said to our faces. Let's just look at the facts: You've got words, the medium used by novelists, poets, essayists, and playwrights, and you've got pictures, the medium used by painters, illustrators, and photographers. On top of that, you've got the additional meaning made possible by juxtaposing the words and the pictures. Where's the limit? We just don't see it. Granted, this antique prejudice is finally fading a little. But one price we are paying is the name of the medium. Now, you hear otherwise intelligent people claiming that "comics" are juvenile and simplistic, while "graphic novels" are intelligent and serious. Use "graphic novel," "graphic narrative," "sequential art," or "manga" as much as you want, but what we do is all comics! Be proud of it!

In other countries, people have come up with names for comics that are both better and worse. In French, they're "*bandes dessinées*," drawn strips. As a description of the medium, that's not bad. In Spanish, they're "*historietas*," little stories, which is OK in that it acknowledges the storytelling aspect of comics, but it also implies that the stories are "little" or minor. In Italian, they're "*fumetti*," little puffs of smoke, referring to word balloons. That's fine, but the word balloons are only one aspect of comics and again the "little" rears its head. In Portuguese, they're "*quadrinhos*," little boxes, which poses the same problems as the Italian term. In Japanese, they're "*manga*," which translates roughly as "nonsensical pictures." Not much better than "comics," when you think about it.

In English, we've also used the name "cartoon," which has an honorable history: Originally, "cartoon" was the term for preliminary drawings that were used to plan wall frescoes as far back as the Renaissance. Thus "cartoon" refers not to humor, but to the often sketchy quality of the art. But the generally understood meaning of "cartoon" has changed over time. These days it means either a single-panel drawing, often accompanied by a humorous caption, or a work of animation. And just to muddy the waters thoroughly, an artist who makes comics is a "cartoonist," but an artist who makes cartoons is an "animator." And let's not forget that a person who tells jokes is ... a "comic."

1.2

Comics terminology

FREQUENTLY USED TERMS

As we have just seen, the word "comics" has a few slippery sides to it, but we hope that we've come up with a genuinely useful working understanding. Most other terminology is less problematic. Here, you'll find definitions of the majority of the terms we'll use in this book.

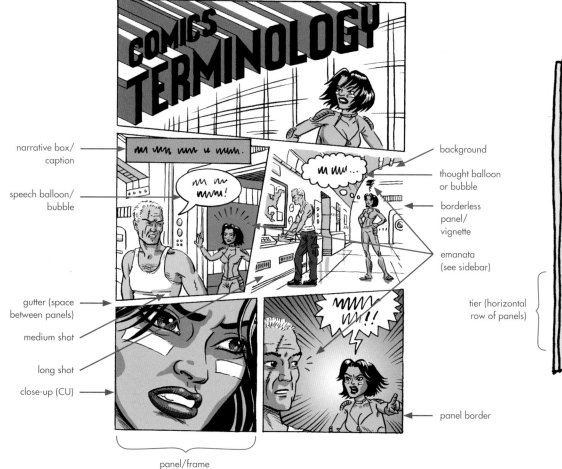

narrative box/
caption

speech balloon/
bubble

gutter (space
between panels)

medium shot

long shot

close-up (CU)

background

thought balloon
or bubble

borderless
panel/
vignette

emanata
(see sidebar)

tier (horizontal
row of panels)

panel border

panel/frame

motion lines

bleed (image runs off page). Also, full bleed: image
runs off page on all sides (as in this case)

splash page (full-page image, not
necessarily a bleed)

(two-page) spread

inset panel

Emanata

"Emanata"?! What kind of word is that? Don't be alarmed if you aced your SATs and you still don't recognize it: That's because it doesn't exist. Or at least it didn't exist until cartoonist Mort Walker (of *Beetle Bailey* fame) made up the term to refer to the various sweat beads, motion lines, curlicues, and stars that emanate (the root of the word) from comics characters and are such a distinctive feature of comics. Walker made up the word as a joke—and then he went on to give silly individual names to every emanata he could think of, using outlandish terminology like "grawlix," "briffits," and "agitrons."

Well, it may have started out as a joke, but over time some cartoonists have come to use the word "emanata" to refer to the whole class of these marks that efficiently and often humorously express movement and emotion. When we talk about emanata, then, we are using it as a catchall term to refer to drawn elements that express information not normally visible in real life: motion, impact, emotions, and so on. But don't worry, we won't ask you to start calling flying sweat beads "plewds"! ■

FURTHER READING

Mort Walker, *The Lexicon of Comicana*

 Can't draw? Read this

If you have little or no drawing experience, you may be unsure how to approach this chapter's activities and homework assignment. You're probably feeling pretty self-conscious about your lack of drawing skills, especially if you find yourself in a classroom full of prodigies who seem able to conjure up imposing barbarians and Transformers while blindfolded. We salute you for plunging into this book without a drawing background. It's intimidating and difficult, we know, but you're obviously a hardy soul who can take the heat. Here are a few things you should keep in mind:

- First of all: You're probably not nearly as bad as you think you are, and you will get better with time, no matter what your current skill level.
- In comics, the realism or flashiness of a drawing is nowhere near as important as its ability to convey information.
- Comics is a language, and, as in writing, it's good to have neat handwriting, but you don't need to know calligraphy.
- There are many successful artists out there who are not in fact "good" artists—just look in any newspaper comics section! Many artists overcome their lack of drawing skills with any number of strategies: Some choose a very simple style (stick figures and even dots can be expressive), some wear their bad drawing as a badge of honor, some get around drawing by using collage or clip art, and some hire other artists to handle the drawing. All of them, if they are any good, understand that ultimately a comic is greater than the sum of its parts—individual drawings are not as important as their combination with other drawings and with text to tell a story.

In case you think we're putting you on, here are a few examples of strategies different artists use to make good comics without relying on fancy, elaborate artwork:

Matt Feazell draws using stick figures so that he can concentrate on telling simple, fun stories.

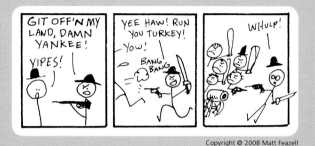

Copyright © 2008 Matt Feazell

Shane Simmons took drawing to the minimalist extreme: He drew dots speaking lines of dialogue!

Long Shot copyright © 1997 Shane Simmons

John Porcellino embraces a simple, quickly-drawn style to evoke daily life.

Copyright © John A. Porcellino. Used with permission.

David Rees uses "clip art"—free art that you can reproduce for any use you want.

My new fighting technique is unstoppable copyright © by David Rees

Martha Keavney tries to preempt criticism by calling her book *Badly Drawn Comics*…however, she's been drawing long enough that she's gotten quite good!

Copyright © 2000 Martha Keavney

And, by the way, neither of us had a lick of formal training when we started drawing comics, so we feel your pain. Don't let it stop you!

As a starter, if you can't draw people realistically, simply draw a stick figure. If you can fill it out a bit, do so, but keep it basic. If you don't know how to draw a realistic Porsche, just draw a rectangular shape with a few circles under it: instant car! ■

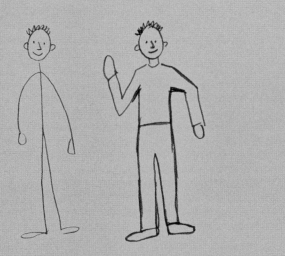

 Drawing time

Action within a drawing

One of the primary things we look for in a comic is some kind of story: a narrative. That narrative can take many forms, but one of its central functions is that it gives the impression of time passing, or of actions happening. It's a kind of magic, really; you read a comic about a baseball game, and you can mentally "see" the ball getting hit, the runners circling the bases, and the shortstop throwing the ball home.

At the most basic level, comics tell stories by creating a sense of movement and of time passing within each drawing. Let's look at how this works. In this activity, you will learn how to portray different kinds of motion within a single drawing. The challenge is obvious: Your drawing doesn't literally move. How can you bring it to life?

Materials

- some office paper or a sketchbook
- pencil
- eraser

Instructions

Following is a list of five moving objects. Sketch them in five separate drawings, each one a single image (not in sequence). Don't draw a panel border around the image.

1. a person running
2. a car speeding
3. a ball falling
4. a person staggering
5. a newspaper page blowing in the wind

Talking points

Post your work up on the wall. Look carefully at all of the drawings. Compare different versions of each object drawn by your colleagues. Which drawings are most successful at depicting movement? Which are not working? Why? Make a list of all the techniques people used to imply motion.

Ronin

Look at the website, www.dw-wp.com. You will find examples of other students' solutions, and more specific guidelines for looking at your own work.

Action within a panel

People "read" drawings in comics much like words: Although drawings are aesthetic objects, their primary purpose in comics is not to look pretty but to carry information about what's happening in the story. And, just as with readers of text, readers of comics tend to start each panel at the top left and read across to the right, then down, back to the left and across to the right again.

Let's look at how to incorporate multiple actions within a single drawing. Also pay attention to how putting a panel border around that drawing affects the reader's understanding and the rhythm of the image.

Materials

- some office paper or a sketchbook
- pencil
- eraser

Instructions

Draw boxes on three separate sheets of paper, each one about four inches high and six inches wide. Then draw each of the following three scenarios:

Scenario 1: A ball crashes through a window into a kitchen and rips through the newspaper of a person sitting in the room. The person reacts to the window breaking. Optional: A dog catches the ball in midair after it comes through the newspaper.

Scenario 2: Person 1 trips person 2. Person 1 is laughing, person 2 is trying to catch him or herself and is knocking over a lamp.

Scenario 3: Two guys are fighting. Guy 1 throws a rock at guy 2. Guy 2 is hit by the rock, which makes him accidentally shoot his gun into the air. The bullet hits and breaks a chain holding up a heavy lamp over guy 1's head.

Talking points

Post your work on a wall, and look at it carefully, and at other students' work. For each panel you can ask some or all of the following questions:

- Does the panel read correctly? In other words, does the reader's eye easily follow the sequence of events in the order you intended? Have a colleague use a finger to follow the path he or she perceives.
- What are alternate ways of arranging elements?
- Does effect clearly follow cause?
- Do actions themselves follow left-to-right reading order? (Into the future? Or into the past?)
- If movement is generally against reading order, i.e., from right to left, is it forceful enough to make the reader follow it? Other things you might look at include body language and facial expression, motion lines, and emanata.
- For Scenario 3, look for compositional solutions that cause a reader's eye to follow the action in a clear trajectory, possibly circular, and not necessarily in standard reading order.

Ronin

Look at the website, www.dw-wp.com. You will find examples of other students' solutions, and more specific guidelines for looking at your own work. ■

Homework
Drawing in action

In this chapter's activities, you have practiced drawing situations that were scripted for you. Now you have an opportunity to reinforce what you have learned by drawing an original single-panel drawing depicting a number of actions happening either in sequence or simultaneously.

Materials
- sheet of office paper
- pencil
- eraser

Instructions
Draw a 5" x 7" panel border, and create a drawing (in pencil) that contains the following elements:
- two characters
- one or more props (objects)
- an action and its result
- the reaction of one or both characters shown in facial expressions or bodily gestures

Do not include any text. ■

Extra credit
Directed jam comic

A great way to dive right into the world of comics is to make a "jam comic" with your colleagues or a group of friends. A jam comic is an improvised collaborative comic wherein one person draws a single panel and then passes it on to the next person, whose job it is to draw a new panel that continues the story. In addition to being a relaxed introduction to creating comics, jam comics are a great warm-up activity and icebreaker!

Jam comics are often more fun to create than to read since they tend to become a little chaotic. However, one way to create more interesting comics is to assign yourselves a rule that will give all the participants a common guiding principle or constraint. For example, you could make a jam comic where every panel has to include a circle, a triangle, and a square.

Materials
- office paper laid out with a nine-panel grid (one per participant). A PDF of the nine-panel grid is available on the website, www.dw-wp.com, or you can make your own.
- pencils and/or pens

Instructions
Every participant gets a sheet of paper with a nine-panel grid on it. Before you start drawing, everyone must choose a rule for their jam comic to follow and must write that rule (along with an explanation if necessary) at the top of the page. Here are a few suggestions (this list is based on one put together by cartoonist Tom Motley), but feel free to come up with your own rules:

1. **Backward.** Start with the last panel. In each previous panel, show what happened before.
2. **Pay it forward.** The first contributor draws a panel, leaving space at the top for a caption, and adds a caption to the second panel. The next contributor illustrates the captioned second panel, and adds a caption for the third panel, and so on. (The last contributor must add a caption for the first panel.)
3. **Carryovers.** Each new panel must contain an image from the previous panel.
4. **Zoom out (or in).** Each panel should zoom out (or in) from the previous panel.
5. **Panorama.** The backgrounds on the entire page must depict a continuous landscape, while the comic still tells a story.
6. **Monosyllables.** Write using only one-syllable words.
7. **Monotext.** Use only one word in every panel.
8. **Monotext/Monosyllable.** Every panel can include only one one-syllable word.
9. **Icons.** Word/thought balloons can only contain images or icons, no words.
10. **Allusions.** Make a comic which alludes to other comics or cultural works.
11. **Snowball.** Each new panel has one more object/character than the previous one. This can apply to text as well.
12. **Melting snowball.** Same as previous, only one fewer.
13. **Imageless.** You can use words, sound effects, etc., but no representational images.

Once you have chosen a rule and written it at the top of the page, draw your first panel. Don't worry about making polished, perfect drawings, just sketch your ideas in and have fun with them. Work in pencil or pen, whichever you prefer, keeping in mind that the final comic will look better if everyone uses the same thing. Every time you finish a panel, find someone to trade with (if there are nine or more of you, try not to draw on the same comic more than once). Keep the jam moving along at a steady clip. At the end of the jam the group will have a pile of one-page comics.

Talking points
Pass your finished jam comics around or hang them on the wall. You will all get a good laugh out of the unexpected twists, funny gags, and general goofiness of your comics. Taking it a step further, focus on some individual comics and discuss why they work (or why they make no sense at all). Remember to use the right terminology when discussing the comics: panels, tiers, word balloons, and so on.

EXTRA EXTRA CREDIT A: EDITING
This exercise will help you think about editing comics: What kinds of changes can you make to an existing comic that will make its ideas clearer, its gags funnier, its suspense more acute? Take one of the jam comics and redraw it on a new sheet of office paper (feel free to trace parts of it). Clarify unclear drawings, change text, reframe panels, replace panels completely if they don't work—whatever needs to happen to make the comic more successful. Sometimes it's a matter of clarifying a sequence of events that is difficult to follow in the original, while elsewhere you might find a great opportunity for a gag or insight that someone didn't notice.

Bring your jam and your edit back to the group, and compare the two. Is your edit an improvement? In what ways is it more successful? Are there ways in which the original one is better?

EXTRA EXTRA CREDIT B: PHOENIX COMIC
As a creative exercise, try creating a new comic that will rise, phoenix-like, from the ashes of a jam comic: Take one of the jam comics and choose any three panels you want—you can choose three that appeal to you or you can choose them at random. Make a new nine-panel grid on a sheet of office paper and create a new comic incorporating those three panels. You can either cut and paste the three panels in or redraw them. You do not need to use them in the same order or position as they appeared in the original jam comic. Let the three panels act as catalysts for your comic: What situations, conflicts, and settings do they suggest to you? Can you take three panels from a silly comic and make a new one that is contemplative and poetic? ■

Every Picture Tells a Story

You've already seen how movement, action, and the passage of time—in short, a story—can be embedded in a single drawing. Now let's try adding words to the mix and see how that makes things more complicated and interesting.

When you think of a single image accompanied by text, the first thing that will probably come to your mind is the "gag" cartoon as seen in *The New Yorker* magazine or newspaper features such as *The Far Side* or *Bizarro*. If you think about it, a lot of the humor in these strips is generated by an unlikely combination or juxtaposition of image and text. But humor isn't the only thing that can arise from these juxtapositions. The combination of words and images is an extremely rich and flexible source of meaning. In this chapter we will look at techniques for telling stories in one panel using word and image.

2.1
Word and image

Homework critique for Chapter 1 on page 239

THE JUXTAPOSITION OF WORD AND IMAGE

What happens when you add words to an image? If you draw an apple and then write the word "apple" under it, you are simply labeling the drawing. No additional information comes from the text, except perhaps for small children (or English-language learners) who are seeing the relationship between the word and the image for the first time. ⟶

apple

If you take the same drawing of an apple and write the word "New York" underneath, you'll likely think of the expression "The Big Apple"—New York City's famous nickname. Here we start to move in a direction that will be useful for creating comics: The word and the image do not, on the surface, mean the same thing, and so the reader is required to compare the two elements and create meaning based on his or her experience. ⟶

New York

Now let's put a different word under our apple: "temptation." Most readers are going to instantly think of Adam and Eve and the snake in the Garden of Eden: The word-image combination here suggests a well-known story from the Bible. ⟶

temptation

If you write "doctor repellent" under it, the apple might suddenly seem mildly funny to you. Why is that? It's always dangerous to analyze humor, but we can agree that part of the humor arises from the surprising juxtaposition of text and image: We expect to see "apple," but instead we find an unexpected phrase that causes us to rethink our assumptions and look at the apple in a new, unlikely way. ⟶

doctor repellent

This little apple has shown us how an image can take on a variety of meanings when combined with different words. Now let's see what happens when we introduce the elements of motion and time into the equation.

Here's a drawing of a falling apple. Note how the use of a tilted angle, motion lines, and a shadow introduces a sense of motion and time passing and creates an expectation of cause and effect: The apple is falling; therefore, it will land somewhere. ⟶

past :00

:01

:02

present :03

future :04

Let's put the falling apple into a context.

And now let's see what happens when we juxtapose words with the image.

THE SINGLE-PANEL COMIC

"I don't think you understand the gravity of the situation."

The addition of text results in a complete single-panel comic (or cartoon). In this case the sense of movement and of time passing, combined with the relationship between image and text, work together in the reader's mind to create humor. We now understand that the apple is falling toward Sir Isaac Newton's head and he is—rather ridiculously—about to invent the theory of gravity just because he happens to be simultaneously using the word "gravity" in a different context.

A CLOSER LOOK: CARTOONS AND BEYOND

Let's look at a few more examples of cartoons and see how they combine image and text to create effect, humorous or not. Many cartoons are in fact funny written gags accompanied by drawings that simply illustrate a humorous situation.

One way to test how much text and image are interdependent in a given single-panel comic is to ask yourself if the text makes sense without the image. In this cartoon, you can read the two lines of dialogue and it's easy to understand the situation and get the joke. The drawing is not essential in this case. That said, it is a charming drawing and it does add a certain amount of detail to the situation: The young man is dressed in a tuxedo, but his stiff posture and awkwardly crossed feet reveal him to be barely more than a child, while the flapper looks composed and carefree. The juxtaposition of word and image here enhances the humor rather than creating it.

If you read the caption of this next cartoon on its own, it's a bit confusing, or at least not very funny. But when it's juxtaposed with a drawing of a child talking to his mother, it suddenly makes sense. Here the juxtaposition of word and image *creates* the humor.

Breaking It Gently
HE: *I thought we were engaged?*
SHE: *We were.*

"No, I don't want privacy,
just leave me alone."

In this next cartoon, a common expression implying, on its own, a complaint against greedy and selfish people is combined with a highly unlikely drawing, resulting in a completely new and unexpected reading. Notice that in this case the cartoonist has used a word balloon rather than the more traditional typeset caption beneath the drawing. This doesn't change the meaning of the cartoon, but it does affect the rhythm and order of reading. ──────

This next cartoon—or is it an anti-cartoon?—exploits the ambiguity that can be created by pushing the text and image apart from each other. The situation almost makes sense and, largely because of the format we associate with humor magazines, we expect there to be a punch line. But the neutral statement in the word balloon doesn't match up with the intensity of the drawing. And the drawing itself is ambiguous: Is the couple in a passionate embrace, or is the man assaulting the woman? ──────

While we have talked mainly about gag cartoons thus far, it's important to realize that the principle we are discussing here—the combination of word and image—has applications beyond humor. In the world of fine arts, for example, numerous artists and artistic movements have made use of the possibilities of combining text and image. Dada and Surrealist artists in the early 20th century made deliberately absurd combinations of words and images to comment on the fragility of the relationship between the two. The translation of the French text in this painting by René Magritte is "This is not an apple"—but a painting of an apple appears below it, causing us to question the relationship between objects, representations of those objects, and their names.

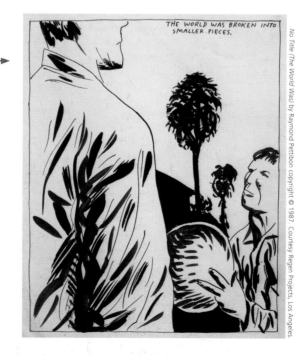

Contemporary artist Raymond Pettibon draws from the visual lexicon of comics, juxtaposing images with terse texts that seem torn from pulp comics and novels. The resulting drawings suggest narrative, yet they remain beguilingly out of reach.

The juxtaposition of text and image is an endlessly rich source of meaning for you as a cartoonist, whether your goal is to generate dramatic tension, make readers laugh, or cause them to question their assumptions about the stability of language and representation. ■

FURTHER READING

Any of the dozens of collections of *New Yorker* cartoons

Charles Addams, *Chas Addams Happily Ever After: A Collection of Cartoons to Chill the Heart of Your Loved One*

Peter Arno, *Peter Arno*

B. Kliban, *Never Eat Anything Bigger Than Your Head and Other Drawings*

Gary Larson, *The Complete Far Side*

Joel Smith, *Steinberg at the New Yorker*

Robert Storr, *Raymond Pettibon*

 Gag reflex

Now that you've spent some time looking at single-panel comics and your own uncaptioned drawings, it's time to start putting words and pictures together.

Materials
- your homework
- pencil
- eraser

Instructions
The goal here is to make funny gag cartoons out of your previous homework drawings. Your job is to come up with captions that are as silly and unlikely as possible for the images you've already created. Think in terms of contrasts or ironic commentary. You can do this exercise in one of several ways:

1. Add captions to your own images.
2. Post the drawings one at a time on the wall. Look at them as a group and brainstorm possible punch lines. Vote for the best one.
3. Pass the group's drawings around. Each person should make up captions for each of the drawings.

Repetition is key. It's important that you flex your writing muscles repeatedly so that you can get comfortable with thinking through how words and images work together. With this in mind it might be a good idea to try each of the methods above. Start with the group effort if you are feeling stumped.

Talking points
Here are a few ways to approach discussing this activity:
- Try to define the ways in which the cartoons work: misunderstanding, slapstick, pun … what makes them funny? Yes, we realize discussing the joke will suck all the life out of it. Sorry.
- Is there any way to define what has gone wrong with the cartoons that don't work? Do these cartoons have anything in common?
- When you come up with a good caption, reexamine the art, and think about whether the text or the image could be tweaked to be even funnier.

- Think about the "stories" that the cartoons tell. Can you tell them in a beginning-middle-end format? What are the stated or implied conflicts? Is there both a cause and an effect, or an action and a reaction?

Ronin
Look at your own work and try to come up with a variety of captions. On the website, www.dw-wp.com, you will find a number of un-captioned cartoons for you to play around with. ■

 Putting pen to paper

If you have never drawn comics before starting this course, you may be wondering what instruments to use for these first activities and homework assignments. Very soon we will get into the materials and methods generally used by professionals, but, for now, don't worry about it. Just use whatever you usually write or doodle with: pencil, marker, or ballpoint pen would all be fine.

If you want to jump into using a tool that's more geared toward art-making, get yourself a disposable drawing pen with pigmented ink, such as the ones made by Micron, Faber-Castell, or Uni-ball. We'll call them "pigment pens" from here on. These pens are easy to use and are great for sketching and for creating panel borders and lettering. The key is to look carefully at the label before buying the pen. "Pigmented" ink is made with very finely ground particles of pigment, and will sometimes be labeled as "waterproof," "fade-proof," or "archival." This is in contrast to "permanent markers" such as Sharpies, as well as similar markers made by other companies like Avery and Bic, which are filled with dye-based ink, and thus are not at all lightfast. After a few months—even in a drawer—Sharpie drawings will fade to a dull brown. Beware the "permanent marker!"

If you want to get just slightly fancier, try out a technical pen, such as Rapidographs, made by Koh-I-Noor, or Rotring. These pens are designed to make lines of reliable thicknesses, but are filled (and refilled) with regular india ink. You don't need a whole set; just get one that's around .50 or .60 mm in thickness. Even once you start to use more flexible materials to draw, having a technical pen can be really useful for lettering, panel borders, and small corrections. One note of caution: Count on completely disassembling and cleaning your technical pen after you refill it two or three times, or after three months, whichever comes first. If you don't, it might get clogged. See more on technical pens in Chapter 7's sidebar, "Ruling a straight line."

As for paper, the best item to buy when you're going to be making ink drawings is a spiral-bound sketchbook or drawing pad that you can tear pages out of to show to the group. Barring that, you can use regular copy or printer paper (that is, standard white 8.5" x 11" copy or printer paper). We will ask you to use this paper for all sketches and thumbnails, and we'll call it "office paper" from here on. It won't stand up to a lot of erasing or inking, but it's perfectly usable for sketches and studies.

One other tip to get you off on the right foot: Start your drawings with a light pencil sketch so that you can make adjustments before you finish the drawings in a darker pencil line or in ink. This technique of building up pencil sketches under ink helps, no matter what level you are at in your drawing skills. ∎

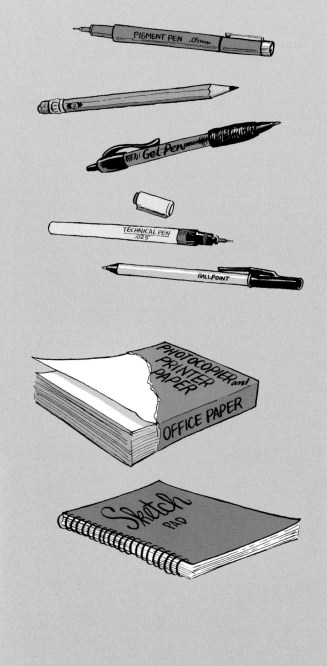

 Wondering about these bubble shapes? We'll cover this in Chapter 5, "Figuring out the figure."

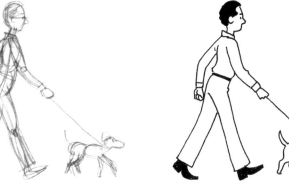

pencil sketch inked version, pencil erased

Homework
Gag me

Using the newly powerful and flexible gag muscles you've developed, write and draw your own gag comic.

Materials
- a sheet of office paper or sketchbook paper
- pencils and pens
- eraser

Instructions
Draw a 5" x 7" panel border in either horizontal or vertical orientation, and create a captioned gag comic.

- It's a good idea to start out with rough sketches at a smaller size before you commit to the full-size drawing.
- If you are having trouble coming up with ideas, do what the pros do: Explore the classic gag scenarios! A desert island, a psychiatrist's couch, a CEO's office, a drunk at a bar, etc.
- When drawing the image, think about creating a sense of action, time passing within the panel, paying attention to reading order and image composition. Write at least three captions, and choose the funniest one.
- Try inking over your penciled drawing with whatever pen feels comfortable to you (see the sidebar, "Putting pen to paper"). ■

Extra credit
Sum of its parts

The interaction of word and image has often been used in interesting ways in fine arts—sometimes provocatively, sometimes mysteriously, sometimes even humorously (look at the works of Marcel Duchamp, Joan Miró, and Jean-Michel Basquiat, among many others). But comics also cover a vast range of subjects, moods, and approaches, and the juxtaposition of words and images is one of the most powerful tools you have as a cartoonist to convey information, create suspense, and deepen meaning.

Select a photo from a newspaper, magazine, or the Internet. Make three copies of it, either on a photocopier or with a scanner. Now try to think of three single words that give the image three different surprising, contradictory, or mysterious meanings. Avoid words that directly describe the image. Write one of the words under each copy of the photo and share all three word-image combinations with your group.

Talking points
Discuss the meanings that may be suggested by the combinations (especially those that are not suggested specifically by the image alone or the word alone, but only by the two together) and the changes to the feelings and information conveyed by each otherwise-identical image when paired up with the different words. ■

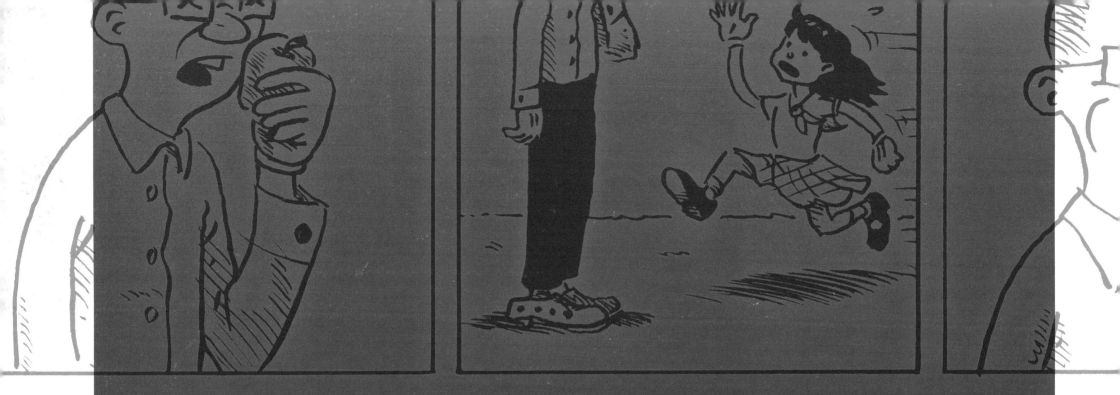

Chapter 3
The Strip Club

The single-panel comic or cartoon is a rich and varied form,
but one thing cartoons can't do is tell extended stories. In
this chapter we'll add a few more panels to the first, and
see what that allows us to do. Then we'll explain the whys
and hows of creating thumbnails, an important part of the
comics-making process.

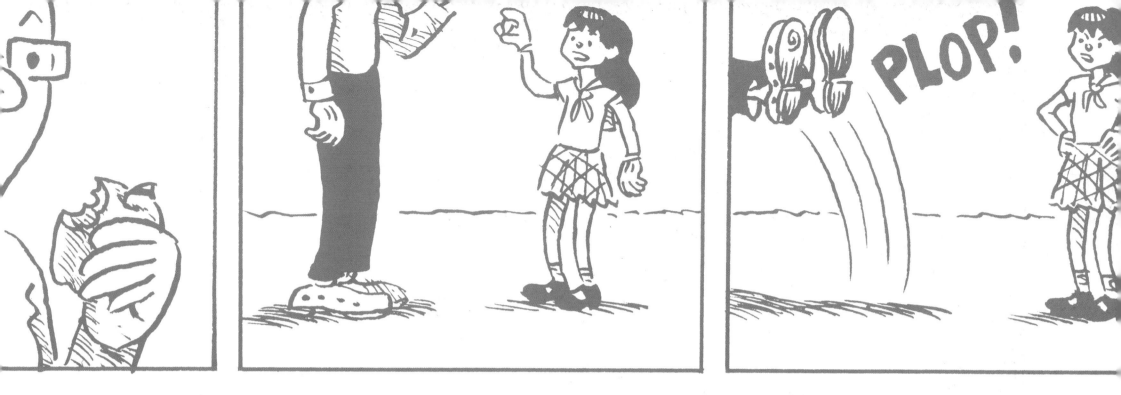

3.1

A comic a day

CREATING A COMIC STRIP

We've seen some of the things you can do with a single drawing with or without text. Now let's look at how you can create meaning by putting more than one picture in a row. Start with a simple image:

The above panel stands on its own, but the only story it tells is "Clay is about to eat an apple." By itself, the image doesn't make us wonder, "What happens next?" Eating an apple is a normal thing to do. It doesn't cause us to wonder, "Why's he eating? Why an apple?" You could call this panel "static." It doesn't carry any inherent drama. But what if we add a second panel?

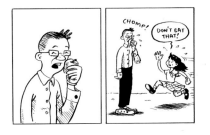

Now we have the makings of a story: two characters, a prop, an unexpected warning. . . . We immediately ask the question "Why?", which leads us to expect and want at least one more panel in this comic, one that will answer that question. These two panels together start to form a "dramatic" scene. We are not simply told that Junko sees danger in the apple, we are also shown via Junko's actions and expression (not to mention all those emanata) that something more is going to happen. So we really want to know what happens next.

Homework critique for Chapter 2 on page 239

Incidentally, notice that we can be very economical in both the art and the writing: The setting isn't important, so we just draw a ground line (with a few blades of grass to show we're outside). Also, Junko doesn't need to say, "Don't eat that apple!" because we can see what Clay is doing—in fact, we could even just have her saying, "Don't!"

Continuing the story can be as straightforward as showing Clay's logical response:

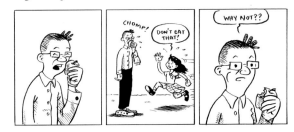

While this may not make for an exciting panel in and of itself, it helps to build tension and sets us up for an answer from Junko:

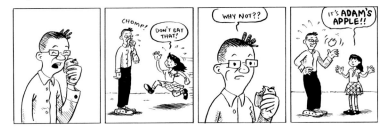

There, now we have a comic strip. It's as easy as that. Notice, however, that creating a comic strip is not simply a matter of stretching out a single-panel cartoon over a series of panels—this joke has too much information to fit into one panel. More precisely, this joke is a story, if a very simple one, and it requires a sequence of panels for it to unfold in a clear way.

VARIATIONS IN RHYTHM AND PACING

There is no one correct way to tell a story; in fact, there are limit-
less ways to make even a simple strip like the one we just created.
For instance, we could fold the second and third panels into one
horizontal panel:

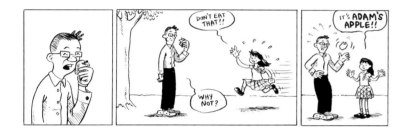

Notice how this speeds up the dialogue ("Don't eat that!!"—the
"chomp" was eliminated) while at the same time creating a long
beat of suspenseful pause in the middle of the strip leading up to
the punch line.

We can also add or change panels:

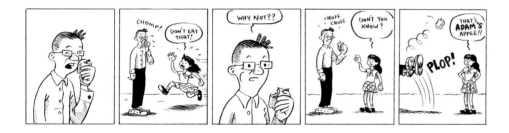

Here we've extended the suspense in a different way. Rather than
creating a longer beat in the middle of the strip, we've added an
extra beat. Just as a musician might choose either to prolong a note
or to add an extra one prior to the satisfying completion of a musical
phrase, comics artists make similar choices. Here the choice to add
an extra panel showing Clay taking another bite of the apple and
Junko asking, "Don't you know?" heightens the impact of the final
panel—the classic reaction shot to groaner punch lines—a "plop."

You can't just do anything with your panels and expect comic
coherency, though:

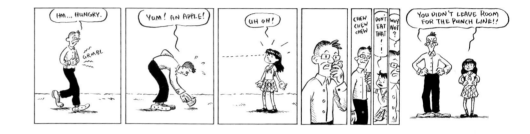

And it doesn't help to rush either:

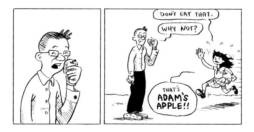

There isn't any pause that builds up to the punch line. Part of the
enjoyment of any art that involves timing, whether it's comics, music,
or film, is the pleasure of anticipating what's going to happen next.

A CLOSER LOOK: THREE STRIPS IN ACTION

Let's take a look at a few strips and see how they work.

Bud Fisher's *Mutt and Jeff*

First up, let's examine a *Mutt and Jeff* strip from 1932, by Bud Fisher. Just look at how that first illustrated panel is bursting with comics language and drama! A man angrily marches into Mutt's office—sweat beads trail behind him, as do his coattails and even his hat—clutching a newspaper showing the headline "Mutt's Column." Mutt sits poised at his typewriter, fingers extended and at the ready; his head is turned back expectantly, a question mark appearing above him behind the squiggles and flecks of ashy cigar smoke. Although there is a lead-in panel with narration filling in the context, it's basically unnecessary: Everything you need to know is communicated in the first illustrated panel.

So we open with a confrontation: A restaurant owner threatens legal action over what Mutt wrote in his gossip column. In panel two, Mutt defends himself with a good offense: He puts his arm around his "good man" and suggests they discuss the matter over lunch. Notice how Mutt leans into the man, stopping him in his tracks.

In the third panel the pair set off together and now it's the restaurant owner's turn to sprout a question mark as Mutt suggests they go to his restaurant.

When we talk about gag structure in a comic strip, we often describe the punch line as a reversal that upsets our expectations of what will happen next. Well, Bud Fisher gives us a literal reversal here as the restaurant owner wheels the pair away from his own establishment toward a "better" restaurant. The reversal (which happens right at the edge of the last panel—just follow those frantic "U-turn" emanata) is reinforced visually by the leftward lean of the two figures, now heading in opposition to the determined rightward gait of the first and third panels. This change in the poses of the characters visually underscores the sudden about-face of the restaurant owner.

The art in this strip is cartoony—exaggerated and stylized—in the extreme. *Mutt and Jeff* is about as classic a newspaper strip as you can find. The drawing is simple (although more detailed and competent than in many contemporary strips), the main characters are emphasized and exaggerated (they are almost always drawn full figure, as if on a stage, and have distinctive features and clothing), background detail is kept to a minimum (interiors are indicated by a baseboard and the occasional chair, city streets are indicated by a fire hydrant and some impressionistic buildings emerging from a haze in the distance), and solid black is used to identify characters and guide the eye clearly through the strip.

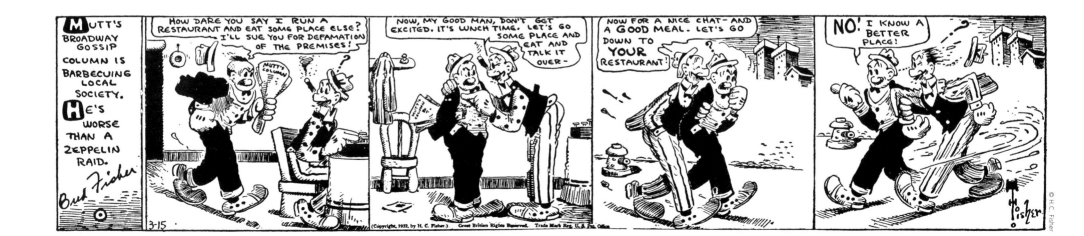

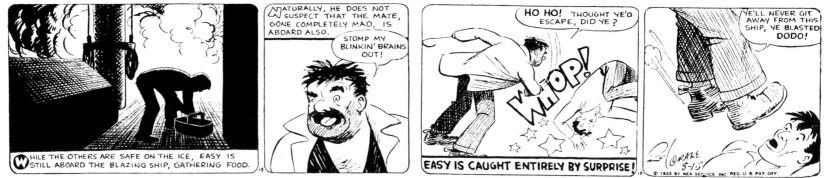

Roy Crane's *Wash Tubbs*

The majority of comic strips are humorous, but the strip form can be used for other modes of storytelling as well, such as adventure, mystery, and romance. Roy Crane was one of the first artists to introduce serialized adventure stories to the daily newspaper. Although the basic storytelling grammar is the same as in a humorous strip, adventure or other non-humorous strips don't have to end with a gag. On the other hand, you can't tell a whole romance story in five panels (well, you can, but not every day for thirty years!), so the challenge becomes, how do you hook your readers in and make them want to come back day after day?

In this *Wash Tubbs* strip from 1933, Crane utilizes a variety of comics techniques to tell this installment of a sea adventure: He varies his illustrative approach panel to panel, from the photo-realistic shadow play of the first panel to the emanata-filled attack in the third panel—against an empty background.

Crane makes judicious use of narration to set the scene, while not letting it dominate, and uses dialogue more for color than for communication.

The particulars of the scene are left to the reader's imagination—how exactly did the mate sneak up on Captain Easy?—but Crane sets a breakneck pace, jumping in time from one panel to the next: The crazed mate hits Easy over the head in panel three; then, in panel four, we catch the mate in mid-jump, just moments away from inevitable impact. This is the classic cliffhanger ending that continuity comics (that is, comics with stories that continue from one day to the next) borrowed from the movie serials of the time: Instead of a gag that definitively ends the strip, we have an unresolved, highly dramatic situation that makes readers eager to know what happens next.

As you can see, Crane's choices as an artist are very different from those of Bud Fisher. Yet both strips are told in basic panels.

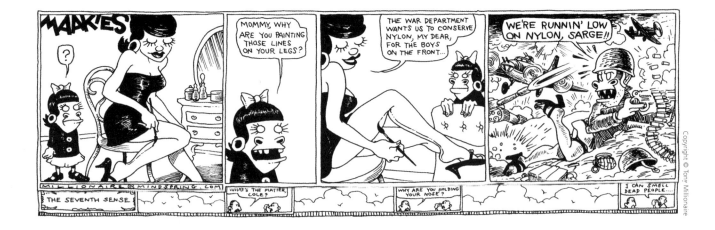

Tony Millionaire's *Maakies*

In this *Maakies* gag strip from the late 90s, Tony Millionaire balances narrative economy with detailed and evocative art.

The first panel sets the scene and introduces a question (literally) in the form of a question mark above the young…monkey-girl's head. The reader's eye is led from the title at the top-left corner down to the question mark; the tail of the balloon sends us on a quick glance down to see who's confused, then we move to the full figure shot of a seated woman, whose right forearm leads the eye straight to the focal point of the panel: The woman is painting stocking seam lines onto her legs. Notice that this easy-to-miss detail is reinforced by the composition: The woman's glance, both her legs, even the hem of her slip direct the eye to the hand holding the brush.

Perhaps because the question is so implicit in the first panel, the second panel is a simple head shot, framed vertically, with no background.

The third panel offers a seemingly straightforward answer to the monkey-girl's question, referring to the austerity measures of life during wartime. The little monkey-girl's head, framed between the word balloon and the mother's extended leg (notice she is expertly continuing the line she was drawing in the first panel), acts as a maudlin addition to the clichéd scene—a mother explaining the harsh realities of the world to her innocent, bow-wearing daughter—but it also serves to create a pause in the strip—both a narrative one, as the blankly gazing young ingenue considers her mother's answer, and a visual one, as the girl's gaze is reversed in direction, causing the reader's eye to pause on her face momentarily before moving on to the sublimely absurd final panel.

It's worth paying attention to Millionaire's artistic choices. The artwork strikes a successful balance between simplicity and detail, featuring solid blacks and strong lines in the first three panels and extensive detail, emanata, and movement in the final panel, thus heightening the impact of the final gag.

As a side note: Notice too that the whole strip is subtly framed with a thin line decorated with little hatch marks along the bottom. This is not typical of comic strips, but a decorative border can help hold a strip together visually, especially if it needs to compete with other information on a newspaper or web page. Another atypical feature of this strip is the little "ministrip" that runs along the bottom of the main strip. This is a separate gag strip which, while rare, has a precedent dating back to the beginning of newspaper comics (in fact, George Herriman's *Krazy Kat* began life in a supporting "ministrip" underneath another feature of his, *The Family Upstairs*). ■

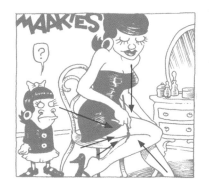

FURTHER READING

Bill Blackbeard, ed., *Smithsonian Collection of Newspaper Comics*

Robert C. Harvey, *The Art of the Funnies: An Aesthetic History*

———, *Children of the Yellow Kid: The Evolution of the American Comic Strip*

Jerry Robinson, *The Comics: An Illustrated History of Comic Strip Art*

 The wrong planet

When you go from a single panel to a sequence of panels, the choices you have to make increase exponentially. This activity will get you thinking about how to approach those choices. Plus, it's fun!

Materials
- several pads of 3" x 3" Post-it adhesive notes in white or another light color
- drawing implements of your choice

Instructions
Divide up into groups of five people. Read the story below, and assign one line of the story to each person in the group.

Story
1. An astronaut launches his rocket…
2. lands on the moon…
3. and plants a flag.
4. He returns home to much fanfare…
5. but then realizes he has gone to the wrong planet.

Step 1
Each person draws his or her line of the story in four or five panels, one panel per Post-it note, without consulting with other group members or looking at their panels. Work on your panels for about 20 minutes.

If you have fewer than five people in a given group, combine parts of the story so that you have the appropriate number of sections (i.e., in a group of three, person one will draw parts 1 and 2, person two will draw 3 and 4, and person three will draw 5).

Step 2
Each group sticks their notes on the wall in order, re-creating the full story. Take a look at your own group's story, as well as the stories the other groups have generated. (Ignore differences in spaceship design or the astronaut's outfit from section to section. Use your imagination.) Go back to your story, and, in consultation with the other group members, create five or six new panels to insert into your story in order to stretch the action or smooth it out and create bridges between sections.

Think about pacing here—is there a really fast bit at the beginning of the story or a slow point somewhere in the middle? How can you control how the reader experiences the story by lengthening sequences? Take about 15 minutes for this part.

Step 3
Take a look at the extended comic. As a group, think about how you might change the sense of time passing by adding, subtracting, or rearranging panels. It might feel a little bloated in spots now. Discuss this with your group and decide how to trim those down to size. Does the astronaut need a long, contemplative space walk to set the scene? How does he figure out that he's on the wrong planet, and is it a positive or negative realization? Are there funny bits in the story? How can you make them funnier? Assign members of your group to draw at least four new panels and as a group remove at least two at this stage. Take 10 to 15 minutes.

Step 4
How many panels can you remove and still tell the whole story? How much will readers be able to understand by implication? What is the story you want to tell? Read the story again as a group and figure out just how much you can remove. Take those panels out, then assess it again. Can you take more out? How low can you go? At this point, the story may have changed quite a bit from its original version. If, for example, you have some funny business, how many panels can you subtract and have the joke still work? If the joke isn't part of the basic storyline, can you stand to cut it? The standing record for this step is three panels, by the way….

Ronin
You can do "The wrong planet" by yourself. You simply need to run through the same set of steps looking at your own panels. There are also some sets of panels on the website, www.dw-wp.com, that you can download and use along with your own. ■

3.2

Thumbnails

WRITING PICTURES

Now that we've gotten to the point of creating full strips, let's talk a little more about the drawing and writing process. One of the most common questions asked of comics professionals is: "Which is more important, the writing or the art?" It's an interesting question, and hard to answer. Here's why: The questioners usually draw a strict line between "writing" and "art." To the casual viewer, that line seems obvious. The writing is the words and the art is the pictures, right? But in comics, the meaning is carried in the images as well as in the words. So part of "writing" comics is planning how you're going to utilize the images to tell concrete elements of the story. At the same time (and we will get into this more in Chapter 7), the words utilized in comics are part of the "art." That means drawing is a part of the writing process and writing is a part of the drawing process, which is why questioners often get a much more complicated and confusing answer than they expected.

CREATING THUMBNAILS

Because the interaction between drawing and writing is somewhat complicated, the best way to start any comic is to plan ahead and think it through before setting pen to paper. Which brings us to the thumbnail.

You've probably heard the term "thumbnail sketch." In common parlance, the term means a quick, rough drawing. It means the same thing in comics, but thumbnails are much more important in comics than the general usage of the term implies. (In traditional superhero-type comics, thumbnails are often called "layouts.")

Drawing thumbnails is an essential part of making comics. You've already been drawing thumbs without knowing it if you've followed our suggestion to make rough sketches of your cartoon panels before committing to the final drawing. You've been utilizing the thumbnail process *well* if you've drawn not only one quick sketch, but two or three, in order to figure out how to solve a storytelling problem that we set for you.

Thumbnailing can take many forms. Some people draw them small but neat, then blow them up on a photocopier or scanner in order to use the thumbnails as a guide for pencils. Some people's thumbnails are crazy messy. Some people do all of their writing during the thumbnail stage, working and reworking the layout and dialogue (Matt does that). Some people write a script in just words first, and then make rough thumbs as they go along (Jessica does that).

It's a good idea to develop thumbnails to the point where they are complete and cohesive rough drafts for your final pages. You want the characters to be identifiable in a basic way, and their positions relative to each other to be clear. You should include all of your dialogue in the thumbs and make them big enough for other people to read. In our classroom, we ask our students to use standard 8.5" x 11" office paper for their thumbs, using the whole page to sketch one page of comics.

However, do not get carried away with the details of your drawings! If you start lovingly slaving over the hairstyles and facial expressions of your characters, how are you going to feel when you discover that you need to rework an entire page because it makes no sense? You're going to feel annoyed and reluctant to redo the drawings you spent so much time on. In short, do not get too precious in your thumbnail stage. It is a *huge* mistake. Make the action and dialogue clear, and that's all. Then when you find you need to make changes or start all over again, you won't have lost a work of art.

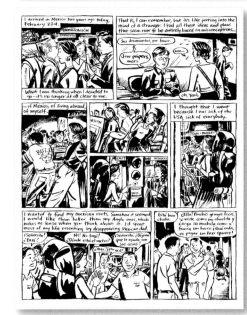

A thumbnail and the final version of a page from Jessica's book *La Perdida*.

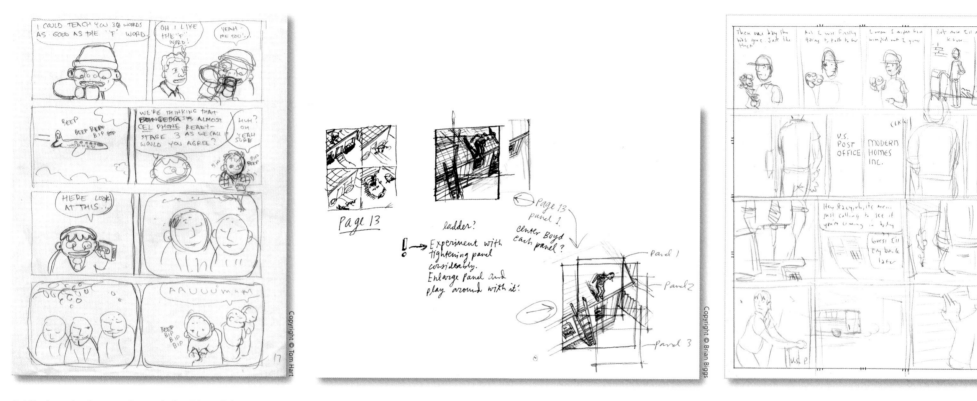

Quickly drawn thumbs are easily reworked and discarded, as Tom Hart did with this page.

Brian Biggs's thumbnails are small and diagrammatic. He also does numerous sketches to work out compositional problems for individual panels.

This is one of Matt's thumbs. Note that he uses a preprinted box to lay out his thumbs. The tick marks along the edges make it easy to plan various standard panel breakdowns. ■

Homework
Strip it down

"Brevity is the soul of wit": this is a necessary maxim of the daily comic strip. Even in the "good old days" (when you didn't need a magnifying glass to read comics in the newspaper), the limited space available to them forced daily-strip cartoonists to set up their panels efficiently, so that the storytelling would be clear and the gag would appear at just the right moment. In this assignment you'll try your hand at this challenging format. We are going to stick to humor, because dramatic continuity strips are not as self-contained as humorous ones.

Materials
- a few sheets of office paper
- pencil
- eraser

Instructions
First, brainstorm alone or with friends and create a list of characters and situations you might find in a humorous daily newspaper strip. Characters might include a married couple, a group of children, talking animals, and so on, while situations might include the introduction of a new character, an argument, or a holiday. A prop such as a hundred dollar bill or a bomb with the fuse lit can generate a conflict the characters need to resolve, and that's always a good way to start a story, even one as short as five panels long.

Next, brainstorm visual or verbal gags that might be produced by that situation. Write down every idea you have, no matter how dumb or irrelevant it seems—you can always cross it out! Although it is nearly impossible to explain what constitutes a good (i.e., funny) gag or punch line, one general principle to keep in mind is that an effective punch line will resolve the problem you set for your characters, but in an unexpected, sometimes ludicrous way, as in the *Maakies* strip earlier in the chapter.

Sketch a few characters you want to work with—they should be of your own design, although they can be inspired by existing ones.

Now fold a fresh piece of office paper in half lengthwise, unfold it, and draw a line along the crease: You now have two "strips" on which to create the thumbnail of your daily comic. You may only need one of them, but you'll have a backup.

Think about how many panels your comic will need, and divide your strip accordingly. Remember that most daily strips consist of 3 to 5 panels. Using stick figures or very simple drawings, sketch in your strip, deciding how many characters should appear in each panel and where they should appear. You might want to place your dialogue balloons even before you draw the characters to make sure that all of the words will fit. Read the strip a few times through, checking for clarity and rhythm. Think about what adjustments you can make to improve the strip. Erase and resketch figures, words, or panels if you need to. The whole point of a thumbnail is to work quickly and make as many changes as you need—remember, don't overwork your drawings!

When you are happy with the rhythm, composition, and pacing of the strip, pencil in a (little) bit more detail on your characters, props, and setting and make sure your lettering is legible, but don't worry about getting it perfect. Keep your drawings simple, providing only enough detail to make your comic readily understandable by another person.

And now you've got a finished thumbnail! ∎

Extra credit
How to read *Nancy*

Mark Newgarden and Paul Karasik's article "How to Read *Nancy*" is a concise and funny analysis of the basic grammar of comics strips. You can find the essay here: http://www.laffpix.com/howtoreadnancy.pdf

Newgarden and Karasik break it all down for you, and will give you a jump on further understanding what your comics toolbox contains. Read and enjoy! ■

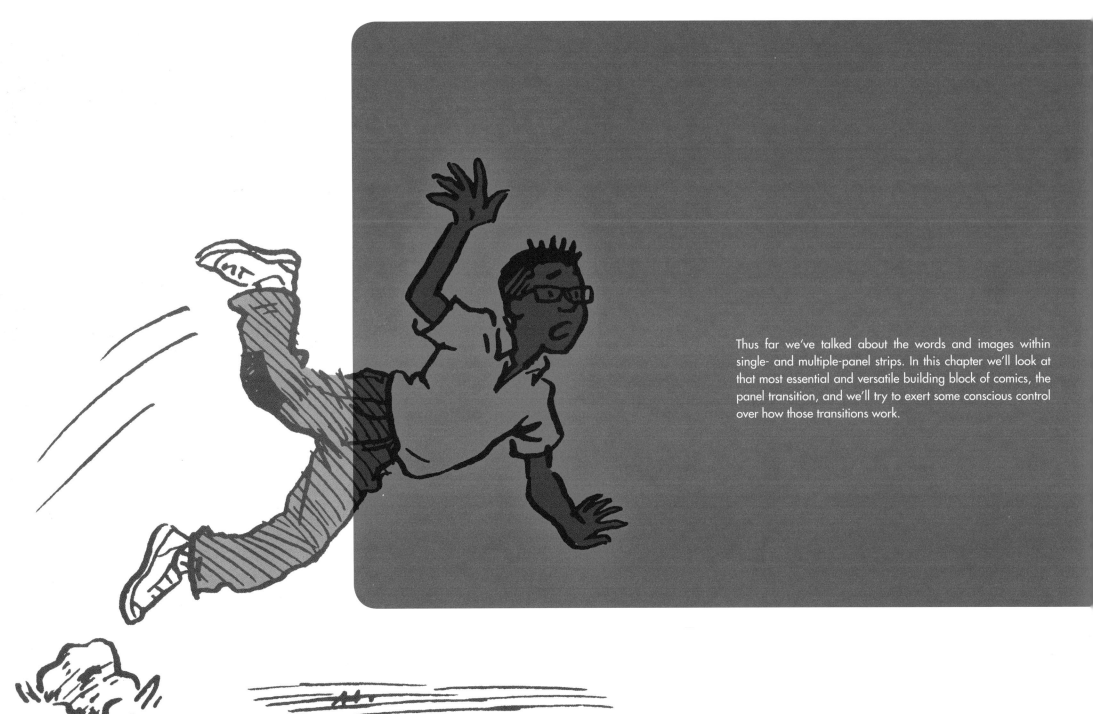

Thus far we've talked about the words and images within single- and multiple-panel strips. In this chapter we'll look at that most essential and versatile building block of comics, the panel transition, and we'll try to exert some conscious control over how those transitions work.

Bridging the Gap

4.1

Reading between the lines

Homework critique for Chapter 3 on page 240

TRANSITIONS AND CLOSURE

One of the things we human beings are particularly good at is making connections and drawing conclusions based on available evidence. This is what a detective does when she uses a smoking cigarette butt, a rumpled carpet, and a torn sleeve to reconstruct a crime scene. This is what a professor does when he looks at a few fragments of manuscript and makes the case that the fragments are from a lost work by a literary master. We all possess the ability to construct a whole when presented with the parts.

This isn't merely a useful ability; it's also a basic human drive. We must constantly struggle to make sense of the world around us, and the information available to us is necessarily going to be incomplete. Making sense of the world and negotiating our way through it is a survival skill, but it can also be fun.

When confronted with a series of items—oh, let's just say a bunch of individual comics panels—we instinctively connect them by making logical leaps between each panel. We'll make herculean efforts to find the connections, even in the most unpromising of circumstances. For example, what does the combination of the two panels below suggest to you?

Is the sleeping man waiting for the plane? Has he missed it? Is he on it? Maybe he's dreaming about it. We can't say for sure, but we feel compelled to make a connection.

Scott McCloud, in his indispensable book *Understanding Comics*, proposes a term for what happens when a reader connects two or more comics panels into a continuous story: he calls it "closure." McCloud theorizes that the reader actively participates in the telling of a comics story; he or she makes decisions and fills in the blanks between the moments and points of view that the author has chosen to depict. Further, McCloud proposes, this act of reader participation takes place in the gutter—that is, in the empty space between panels. As a model for how the mind actually understands comics, McCloud's theory has its detractors and critics, but the idea of closure remains a useful model for artists to visualize how comics function.

Naturally, the artist plays a pivotal role in the closure process. In order for a reader to make sense of a comic, the artist must decide how much information to expect the reader to fill in, and what kinds of jumps the reader will need to make between panels. These jumps are called "panel transitions," or simply "transitions."

To clarify what we mean by "transitions," hark back to last chapter's activity, "The wrong planet." In the first stage of that game, you were asked to draw a scene from a story in four to five panels. Every time you started a new panel, you had at least three decisions to make:

1. **When** should that new panel be taking place? A moment later? A day later? In the past?
2. **Where** should the new panel be set? In the same location as the previous panel? Somewhere else?
3. **What** should the panel focus on? The same character or object? Something new?

The answers to these questions will tell you what kinds of transitions you'll want to use. And the types of transitions you choose will dictate the amount of closure your reader will need to perform in order to understand the story.

SEVEN TYPES OF PANEL TRANSITIONS

In *Understanding Comics,* McCloud identifies six types of transitions, and we've added one of our own. Note that as you progress down the list of transition types, you require the reader to perform more and more closure. The seventh transition type on this list goes so far as to defy the reader to be able to perform closure.

A ***moment-to-moment*** transition represents the least amount of closure a reader must make. The goal is to show time passing incrementally. The result can be similar to slow motion in film or video.

An ***action-to-action*** transition encompasses only a bit more time and space than a moment-to-moment. An action-to-action transition tends to show the beginning and end of an action rather than showing every step. However, the difference between an action-to-action and moment-to-moment transition can be fuzzy, a matter of personal opinion, since moment-to-moment depicts an action also, just one of very short duration. When that duration qualifies as a full "action" and not just a "moment" can be debatable.

A *subject-to-subject* transition takes place in one scene, but moves from one character or object to another within that scene in order to move the narrative ahead. This transition is commonly used for dialogue, among other things.

A *scene-to-scene* transition moves from one place or time to another. Here, we should define the term "scene": A scene is a sequence that takes place in one continuous time period, and in one place. If the story moves from one place to another or one time period to another, a new scene has begun.

An *aspect-to-aspect* transition shows multiple views of the same scene without providing any linear narrative direction. This type of transition can appear similar to a subject-to-subject transition. However, whereas the purpose of a subject-to-subject is to move the narrative forward, an aspect-to-aspect transition is a way to deepen the mood or feeling of a sequence, and specifically to avoid narrative progress. It is commonly silent.

A **symbolic** transition is our addition to McCloud's list. This type of transition occurs when a panel that takes place within the storyline is preceded or followed by a panel that depicts something non-literal, in order to make a point about a character's state of mind or a situation via a visual metaphor.

Finally, a **non-sequitur** transition, the last of the six types defined by Scott McCloud, is a transition that defies closure. A non-sequitur is a transition that you simply cannot shoehorn into a storyline. As such, it's mostly of theoretical interest. However, given our basic human desire to make sense of a series of panels, you'll find it's surprisingly difficult to create a true non-sequitur transition. Your readers will perform all kinds of contortions to make sense of it, and before you know it, they'll turn it into a symbolic transition!

This list is not necessarily definitive; there may be other types of transitions, and the ones we have listed often overlap—meaning that in some cases, more than one transition type may seem to apply. For example, one transition we have had a hard time fitting into the categories is one that happens during a conversation scene, in which a panel of a character speaking is followed by another panel of that same character speaking. This transition is sort of action-to-action, but the continuity of the action argues against that. This transition is sort of moment-to-moment, but the "moments" can last several seconds. We've yet to pin this type down. If you think of and define any new transitions, be sure to let us know!

One final note: With a system like this that can feel so complete, it's tempting to try to define all storytelling through its terms. However, there are many levels on which storytelling takes place in comics, including within a panel, between a long series of panels, and at the page and page-spread levels, that aren't covered when we talk about transitions. Don't let your new understanding of transitions blind you to the other interesting levels of structure and narrative in comics.

To review:
Transitions are what you, the author, create.
Closure is what the reader does.

You'll see as you go along how using transitions thoughtfully can work to your advantage in creating an effective comic. There will be times when you want to make sure your reader understands down to the smallest detail what's going on, in which case you might use moment-to-moment transitions. And then there will be times when you want to leave a lot of room for the reader's imagination to run wild, and you might choose to employ a challenging aspect-to-aspect, subject-to-subject, or metaphorical transition.

Transitions have many purposes. The most basic one is to create the impression of time passing and movement. But more subtle functions might be to subtly create a point of view or to nonverbally raise questions about the reliability of a narrator by your choice of panel juxtapositions. The possibilities are endless. ■

Comic jumble

Most of the time, transitions are not something you're consciously aware of when you're making comics. When you need to jump the story ahead, you may use a scene-to-scene transition, without thinking about it. However, there are benefits to understanding how to deploy these tools intentionally, and it's a good idea to get familiar with the different things transitions can do.

Materials
- a copy of the daily paper's comics page (one for each participant)
- scissors
- scrap paper
- tape

Instructions
Using only one day's comics page, cut out comics panels from various different strips and rearrange them on a sheet of scrap paper to make up a new story that employs at least one instance each of the following transitions, in any order:

moment-to-moment
action-to-action
subject-to-subject
scene-to-scene
aspect-to-aspect
symbolic (no more than two)
non-sequitur (no more than one)

Make sure the comic tells a story!

When you have decided on your story, tape the panels in place. Ignore small differences in character design (e.g., say your character is a cat. It doesn't matter if your cat appears one moment to be Garfield and the next to be Mooch from *Mutts*, or Bucky from *Get Fuzzy.*).

Talking points
When you're done, post your comics on a wall and compare them. Point out the transitions and make sure everyone's got at least one of each. Some of you might disagree on the nature of a given transition. If someone disagrees with one of your

transition types, make your case and see if you can convince your colleagues. Take note of the differences in feel produced by strips that are heavy on certain types of transitions, for instance action-to-action, or scene-to-scene. Also note if there is overlap between the various strips. Did one panel or one strip from the newspaper get used frequently? If so, why? Talk about the stories as well. Make suggestions for cuts, replacements, and rearrangements. Make these the best comics they can be!

Ronin

Because of considerations related to reproducing copyrighted material on the Web (and jumbling them up), we can't place sample comics jumbles on the website. However, when you complete you own comic jumble, ask yourself the same questions classmates might ask. Are any of your transition types debatable? Why? Could any of your transitions be considered more than one transition type? Which ones? How might you cut or rearrange your comic? ∎

Homework
Closure comics

Now's the time to flex your new understanding of transitions and how they affect closure. You're going to thumbnail a two-page comic of the old Jack and Jill nursery rhyme using all seven types of transitions. Here's what to keep in mind: Every time you use a transition type, you are saying something about the amount of time passing, the point of view of the reader and of the characters, and the mood of the story, among many other things. For example, Jack and Jill is a story that, as written, takes place in one continuous scene. You'll have to figure out how to break it into at least two scenes in order to create a scene-to-scene transition. Where and how you do that will affect your story deeply. Also, neither Jack nor Jill has any "interiority"—as depicted in the rhyme, Jack and Jill have no opinions or moods. You can decide what kinds of personalities they will have, and how they react to the situation they're in. Your use of transitions will tell your readers a huge amount about who these characters are, and what and how you want your readers to feel about them.

Materials
- a few sheets of office paper
- pencils
- erasers

Instructions
Draw a thumbnail for a two-page comic. You can add dialogue and narration. Important: Use only *one* side of each sheet of paper so that when you do your homework critique, you can post your work on the wall and readers won't have to flip the pages over.

Your story
Jack and Jill went up the hill to fetch a pail of water. Jack fell down and broke his crown, and Jill came tumbling after.

Use all seven kinds of transitions
moment-to-moment
action-to-action
subject-to-subject
aspect-to-aspect
scene-to-scene
symbolic
non-sequitur ∎

Extra credit
Five-card Nancy

Five-card Nancy is a game invented by cartoonist Scott McCloud, who was inspired by Ernie Bushmiller's comic strip *Nancy*. Although it was created as a game—and it is indeed a lot of fun to play—it is also a surprisingly useful tool for gaining an understanding of the ways two comics panels, when juxtaposed, create meaning... or don't! We've souped up McCloud's game by adding an extra rule, inspired by his own work in *Understanding Comics*.

Materials
- a table
- a standard six-faced die
- Nancy cards (a bunch—as many as you like)

Nancy cards are simply individual panels from Ernie Bushmiller's classic strip *Nancy*.

Here's how to make your own set of Nancy cards
First, buy a few books of *Nancy* reprints and read and enjoy them. There are none currently in print, but you can find used copies pretty easily online. Then, photocopy at least 50 pages of strips onto card stock. Most copy centers can provide card stock. If you are copying from different books, make sure to copy panels at the same height. Using an X-acto knife and a metal ruler, cut out the strips and then the individual panels until you have a big, scrambled pile of individual *Nancy* panels. You can also play this game with cards made from other very simple, straightforward strips, like *Hagar the Horrible* or *Dilbert*, though it won't be quite so stylish. Avoid strips that have too many different characters and settings.

Instructions
- Depending on the size of your group, either play individually or form small teams (two or three people). You will want to have two to four players or teams.
- Shuffle the deck of Nancy cards and deal five cards to each player or team, then put a single card down on the table. Put the remaining cards face down in a pile off to the side.
- Each player or team rolls the die. High roll plays first.
- The first player or team rolls the die again.
- Each number on the die corresponds to a type of panel transition:

1. wild card—your choice
2. action-to-action
3. scene-to-scene
4. subject-to-subject
5. aspect-to-aspect
6. non-sequitur or symbolic

(We don't use moment-to-moment transitions, since the randomness of the cards makes it practically impossible to create a true moment-to-moment transition.)

- The player/team then must choose one of their five cards to put down next to the starter panel on the table. The panel transition the player creates must not only make sense, but it also must correspond to the type of panel transition dictated by the die. If the player doesn't have a card that fulfills this type of transition, he or she must select new cards from the pile without discarding until an appropriate panel is selected.
- Whenever a player puts down a panel, the opposing players or teams must vote on whether or not the panel a) fulfills the indicated transition and b) makes some kind

of sense. It is very important to be ruthless as a judge, because if you let even a few nonsensical panels into the sequence, you will lose any hope of creating the interesting, funny, weird, surprising strips this game can produce! On the other hand, try to be fair and not toss out proposed panels just because Nancy has a different dress on or something. You have to make some allowances for the fact that the cards come from different strips.
- If the proposed panel is accepted by the group, the player/team who put it down may roll again and try to place more panels. If the panel is rejected, the next player/team takes a turn.

The first player/team to get rid of all their panels is the winner, although a more collective approach is to keep playing until the group has found a satisfactory ending for the strip.

Ronin
Make your own set of Nancy cards and play the game with your friends. It doesn't require a comics expert to get the hang of transitions, and this can be a great way to get friends of yours excited about comics. ∎

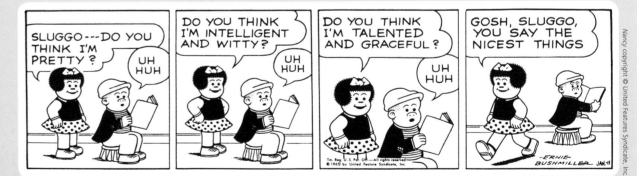

Penciling

In Chapters 1 through 4, we've talked primarily about what comics are and how they work. In this chapter we'll start working on the technical skills that are a part of creating finished comics. Penciling is the crucial stage of artwork where you elaborate on your thumbnails and build up the linework that will be the basis for inking. We'll also talk a little about drawing the human figure.

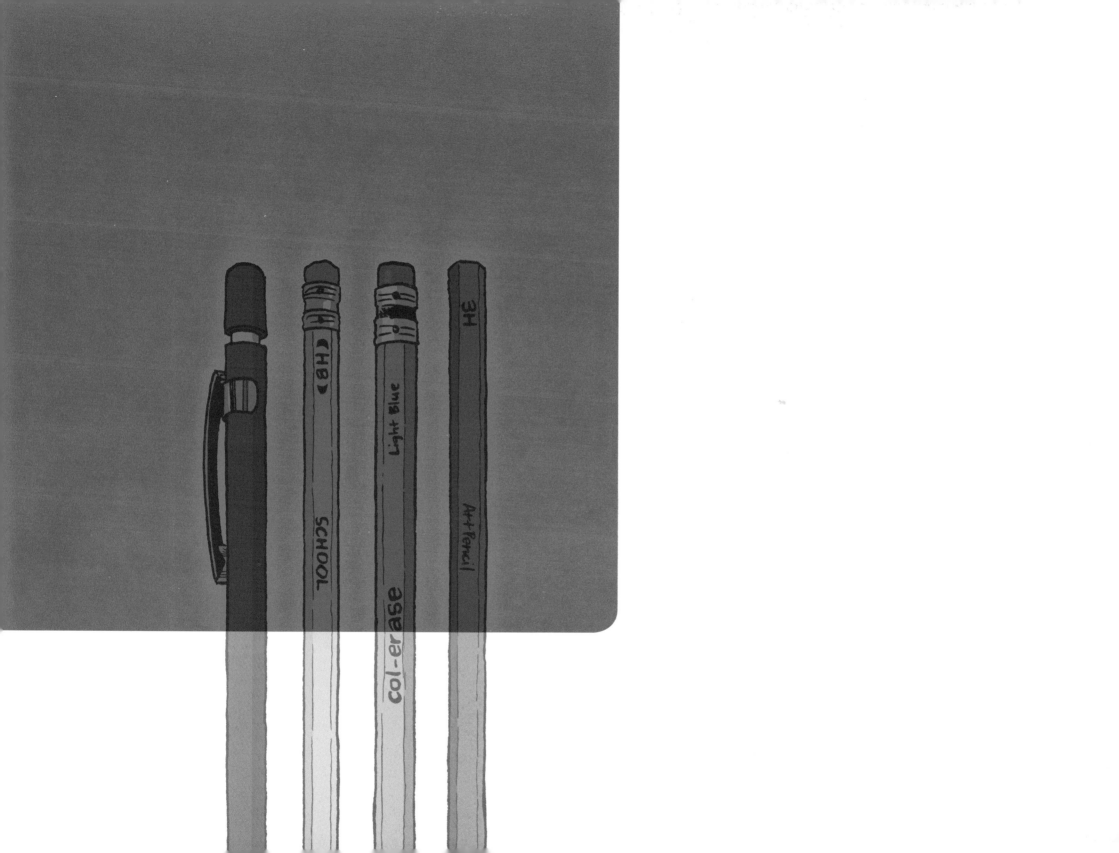

5.1
Penciling comics

LADIES AND GENTLEMEN, SHARPEN YOUR PENCILS!

Once you have your thumbnail ready, you've done the essential work as far as composition goes, but your drawings may be beyond basic. How do you translate that sketch to an image that you can use as a basis for your final inking? The answer is penciling.

Some parts of this section may seem overly obvious to you, since drawing with a pencil is on the surface pretty basic. Some parts may seem new and utterly mysterious. Have patience. We'll be covering some of the more technical aspects of layout and lettering in the upcoming chapters. But the main point we want to make here is that there are lots of ways you can get your drawings on the page. Don't let yourself get stymied. See the "Penciling toolbox" sidebar later in this chapter for more information on the materials we mention in the next few pages, and have a look at the thumbnail (*right*) that Clay's trying to pencil in this chapter.

Clay's thumbnail

Clay nailed that expression the first time!

Keep thumbs simple.

PENCILING PITFALLS

The simplest penciling method is to lay out your final page directly on bristol board. Use the same panel layout as in your thumbs at about twice the size of your thumbs (we'll get into exact sizes in Chapter 6). Then rough in the image lightly in pencil and tighten up the drawings with bolder lines once you are happy with them. The main problem with this method is that most of us don't have total control over our drawing. We talk about some of the things that may go wrong, at the right.

Homework critique for Chapter 4 on page 240

Clay's first try at penciling his thumbnails

The spontaneity of your thumbs has been killed by the work of penciling.

Don't pencil in all the blacks; it's a waste of energy and makes your page messier.

The underdrawing is so dark and/or chaotic that you can't find the right final lines.

The drawing is penciled very darkly and won't erase sufficiently for reproduction.

The final drawing is so worked over and heavily erased that the paper surface gets messed up, making it hard to ink.

The background is so complex that you can't tell which pencil line corresponds to what drawn object.

The composition comes out wonky, off-balance when you try to reproduce your small thumbnail sketch on a large piece of paper.

"Drawing through," that is, drawing complete shapes—as you can see here, where Nate's back is drawn as if his coat were transparent—can help you get your poses right.

PENCILING STRATEGIES

There are many penciling techniques that are designed to get you around the pitfalls.

Blue pencil

Try doing your rough pencils in light blue pencil (make sure to use a Col-Erase or other erasable colored pencil, or you'll have problems when you get to inking), and do your final pencils in regular gray pencil—HB or 2B. You'll have no trouble distinguishing your final pencil lines from the rough ones. (Obviously, we are using orange as a stand-in for blue in the illustration.)

Colored pencil

Sometimes one of your panels may involve a complex scene, with elaborate perspective in the background, foreground figures, and something going on in the middle ground too. This is when it's handy to have a number of different colored pencils around. You can draw the horizon line and perspective lines with one color, the buildings with another, the background figures with another, and the foreground with yet another. With all that stuff going on, this is a good time to work up your pencil on a separate sheet of paper and trace it onto the final page, as well!

Map it

Make a map of the location where your scene takes place, whether it's a forest grove or a New York apartment. With a map in hand, you can figure out how the characters will move around relative to each other, and what will be in the background no matter which point of view you use. Some artists (like Seth and Gerhard) even build small paper models of their locations to use for reference.

3. Tighten and polish traced drawing with darker pencil.

If you're not fully satisfied with your thumbnail or initial pencil of a given panel, sketch out a bunch of variations until you find one you are happy with.

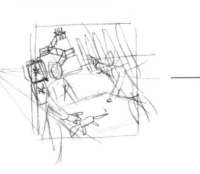

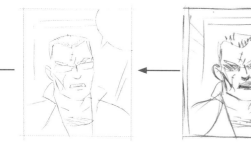

2. Thumbnail blow-up traced lightly or in blue pencil onto final page.

1. The original thumbnail panel blown up to final size with a photocopier or scanner.

Photocopying or scanning up thumbs

You should draw your thumbnails at print size or smaller, in part because it will force you to simplify your compositions and will let you see how each panel balances with the rest of the page. If you draw your pencils freehand using your thumbs only as general reference you will find that it can be difficult to reproduce the exact proportions on your bristol board. Also, even though you're trying not to be precious about your drawings when you're working on them, sometimes your thumbs may come out beautifully, and you will want to reproduce them faithfully in your pencils. In either case, simply enlarge your thumbs up to your working size and trace them onto your final page. You can either use a photocopier, or scan and size your thumbs on the computer and then print them out. Some artists use this method for every page, so they make sure that their thumbs are the same proportion as their final pages (see Chapter 14 for more on scanning and enlarging).

Drawing outside the box

If you can't figure out the anatomy of a cropped figure or object, try drawing it out beyond the panel border. You can also draw the figure on a separate sheet and trace the portion you need onto the final page.

Preparatory drawings

Sometimes a pose is just too difficult to draw off the top of your head, even if you have a lot of experience. Try doing preparatory drawings in a sketchbook. You may want to have a friend pose for you to help you with your sketch. Or keep a mirror on your desk so you can pose for yourself.

Tracing

Tracing is an essential part of penciling. If you've erased so much that you've screwed up your paper's surface, or your art is impossibly dirty, or you've spilled coffee on it, trace it onto a new piece of bristol and you have a fresh start. If you've lost the spontaneity of an earlier version of a drawing, sometimes tracing is a way to gain that back. If you've really nailed a perfect drawing, but you realize it's in the wrong spot, trace. Many penciling methods depend on tracing. Some people will sketch very loosely on cheap paper, trace that, draw some more, trace again, and so on until they slowly develop the drawing to a high finish. More on tracing in Chapter 8. There are two effective methods of tracing—using a light box, or using good old-fashioned tracing paper.

Tracing with the light box

If you're fortunate enough to have access to a light box, use it. Although light can't shine through all papers, most lightboxes will enable you to trace onto two- and even three-ply bristol board.

If you don't have a light box, but do have a glass coffee table, put a lamp, preferably one with a florescent bulb, under the table for a makeshift light box. You can also tape your work to a window and use that. This technique works only during the day, of course!

Tracing and transferring with tracing paper

Using tracing vellum (i.e., tracing paper), trace the bits you want to transfer. Then, either you can trace your drawing down to your bristol using actual carbon paper (not erasable, thus not recommended) or you can make your own carbon paper by thickly covering a clean sheet of tracing vellum with graphite. Use a graphite stick or a 4B or 6B pencil. If you want, you can moisten a bit of paper towel with mineral spirits (a kind of thinner available in art supply or hardware stores) and smudge the graphite around with it, to make a consistent film.

You can also scribble graphite directly on the back of your tracing. This technique is best if you're only going to trace it down once.

Now use a sharp ballpoint pen (you'll get a cleaner traced line with that than with a pencil) to trace your drawing onto the bristol. You can modify the drawing at this stage: reposition it, flip it, change the position of one or more elements in the image. This process is especially valuable when you're making moment-to-moment transitions: You can use the same tracing for multiple panels, changing small portions of the drawing where you need to.

Bristol board

Bristol board is a type of heavyweight paper that's been treated with a "hard size" (a kind of glue impregnated into the paper), so that it will accept ink well. You can choose either smooth surface (also known as hot press) or vellum/regular surface (also known as cold press) bristol board. You can also choose different weights—the most common is two-ply, but you can find four-ply or higher weights. Bristol is also available mounted on stiff cardboard, sold as "illustration board." Although you can also get one-ply bristol, it isn't great for comics work because it's so fragile. However, one-ply bristol can be handy for making corrections. In addition, most manufacturers grade their paper into "professional" and "student" grades (and sometimes several other grades in between). These grades refer to the amount of cotton fibers in the paper, as opposed to wood pulp. The more cotton, the better, and the pricier. High-end paper is nicer to draw on, but as long as the paper's acid-free (archival), lower-grade paper is fine to use.

For now, you should buy student-grade two-ply bristol board. It often comes in 14" x 17" pads, and that is a good size to use. Be careful, though: All bristol isn't created equal. Strathmore paper is consistently high quality, and there are many other brands that are also quite good. However, some bristols, when you ink on them, particularly with a nib pen, will bleed like crazy (the ink will spread out on either side of the line), and there's nothing more annoying. If you are not familiar with a brand, see if your art store has samples that you can do test-inking on. Two good ways to test bristol are to scribble on it with a relatively sharp nib pen, like a Hunt 102, to see if the ink bleeds, or to brush on some diluted ink to see if this produces a nice, smooth tone, not a mottled or streaky one.

In general, it's a good idea to avoid the "professional blue-line" comics paper—even though certain brands are in fact used by professionals. This type of paper may seem easier to use, since the layout lines are on there for you (and that is why some publishers require their artists to use it), but it tends to be lower-quality paper, and will withstand very little erasing or pen-inking without bleeding.

Tracing vellum

The other tool you'll want always at hand for penciling is tracing vellum. The word "vellum" used to mean thin, translucent parchment made from sheepskin, but these days vellum is made of cotton and wood pulp. It's basically tracing paper, but a bit thicker and sturdier than regular tracing paper, which is a very good thing when you're reusing it several times. Get the heaviest weight you can find. 50- or 60-pound paper is good.

Pencils

You'll want to have several types of pencils:

1. *A variety of gray pencils*. You should have plenty of HB (#2) pencils, as well as B pencils, which are soft, and H pencils, which are hard and are useful for detailed drawings. The higher the pencil number the more pronounced its hardness or softness, so a 2B is relatively soft while a 6B is very soft, almost like charcoal. A 4H will be very hard.

2. *Mechanical pencil*. This type of pencil is useful for layout, lettering, and drawing small details. Mechanical pencils have replaceable leads that come in a variety of sizes as well as in the full range of hardness. The two most common lead sizes for mechanical pencils are 0.5 mm and 0.7 mm. 0.5 mm leads are useful for drafting purposes, but the 0.7 mm leads are more pleasant to use for drawing, and are fine for general use.

3. *Sanford Col-Erase or other erasable "light blue" pencils*. These are for underdrawing and less-reproducible penciling. We recommend erasable pencils, because non-erasable pencils are too waxy to ink over, and they are difficult to erase. Although they may seem appropriate, we do not recommend "non-photo blue" pencils, because they are very waxy, causing ink to bead up on the pencil lines when you go over them.

4. *Other erasable colored pencils*. Red, orange, green, purple, and other colored pencils are useful for complicated perspective and establishing-shot panels.

Erasers/erasing tools

The most all-purpose eraser is medium-soft white plastic. It has a good damage-to-paper/effective-erasing ratio. You may also want to purchase a kneaded eraser, which is more gentle. An erasing shield may also be useful. It is a thin metal stencil that allows you to block out parts of the drawing that are OK, while selectively erasing small details. ■

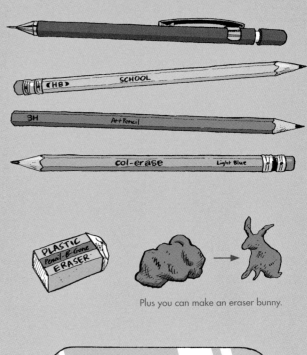

Plus you can make an eraser bunny.

 A closer look: a master cartoonist's penciling method

Here are several of the stages Charles Burns goes through to develop his pencils. As with most artists, his process varies slightly from page to page, but you get the basic idea. Notice how carefully he plans his final lines before inking. They get even tighter in that final stage, the one that gets inked over. Keep in mind that what we're seeing here is just one tier from a full page. In his own words:

> After I've worked out the flow of my story and written the basic narrative and dialogue, I usually begin by creating a rough thumbnail of my page so I can plan the size and configuration of my panels and where I want the lettering to be placed. Based on my thumbnails, I rule out the borders on what will eventually be my final board and then I tape down a sheet of tracing paper and start a rough, generalized drawing of the entire page using a soft pencil. Some of my drawings at this stage look almost abstract—I'm not interested in details; I just want to define the basic shapes and work out the design of the page. At this early stage I can also cut out portions of the drawing and reposition them or even resize them. I continue by laying down new sheets of tracing paper and refining the drawing. At some point I usually flip the tracing paper over and do another drawing in reverse so I can look at it with "fresh eyes" (try looking at your drawings in a mirror and you'll understand what I'm talking about). The final stage is transferring the tracing paper drawings to my bristol board by using a light box and a pencil with hard lead (I don't have an image for this stage ... it's been inked over).

1. First rough pencil on tracing paper.

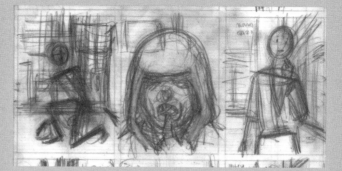

2. Another round of penciling on a second piece of tracing paper.

3. A third, refined drawing traced from the *back* of the second sheet of tracing paper.

4. The final page on bristol board, inked directly over the last round of penciling.

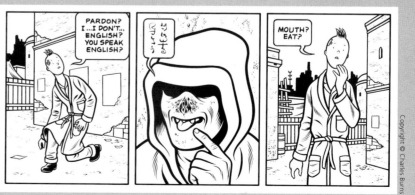

Pencil one panel three different ways

Now you'll try drawing three different "tight pencil" versions of the same panel.

Materials
- HB pencil
- colored pencils
- mechanical pencil
- eraser
- office paper
- tracing paper
- bristol board
- ruler

Instructions

Choose a panel from your Jack and Jill story, one that has interesting action in it: Jack or Jill falling or fetching the pail of water, for example. On a clean sheet of office paper develop three distinct versions of the panel in sketchy, thumbnail form. Think about how many different ways you can show the same scene or action: You can view the scene from a distance or close up; you can view the scene from an unusual angle (tilted or from above); you can focus on a detail (a hand, the pail, etc.); you can vary your style from realistic to cartoony; you can use motion lines and emanata or take a more "photographic" approach to action—you will quickly realize that the possibilities are endless. Choose three variations that are significantly different from one another.

Take a sheet of 14" x 17" bristol board and draw, in pencil, three panel borders of the same size. Make the panel height five inches and choose the width that best suits your panel design. Loosely sketch in your figures and word balloons (if there are any), using your HB pencil or a light-colored erasable pencil. Review the section on penciling tips and try out some of the approaches suggested there for solving problems: Draw outside the panel borders, make a map, draw sketches of expressions or gestures using yourself as a model, looking in a mirror—whatever your drawing calls for. As you tighten up your sketch, go in and sharpen the final lines using an HB or 2B pencil. You can erase and redraw lines or entire figures if you need to.

Talking points

Post your panels on a wall alongside your thumbnail and take a look at them together. Use the nonjudgmental "I notice" approach to try to understand what differences your choices make in mood, information conveyed, and creating pleasing images. (Check Appendix B, "Homework critiques," for instructions on "I notice" and other critique techniques.) Look back at the comic and imagine this panel in context. Decide which of the three panel choices would work best in the context of the story. Try to articulate why.

Ronin

If you take a little time away from your panels, you'll be able to objectively perform the same critique on yourself. You'll be amazed by how much difference compositional and stylistic choices can make. ■

5.2
Figuring out the figure 1: sticking to the basics

USING "FIGURETTES"

In general, this book is not designed to teach you how to draw, but to teach you how to tell stories in comics form. As we discussed in Chapter 1, you don't need fancy drawing skills (or any drawing skills at all, if you use photos, clip art, or collage) to make comics. That said, we realize that one of the most frustrating things for most students of comics is learning the skills necessary to realize their visions in drawings. So we're going to devote a little time to drawing basics, starting with this section on figure drawing principles. We'll also discuss drawing heads and hands in Chapter 12.

Learning to draw a realistic human figure is a skill that takes years of practice. A solid understanding of human anatomy will not only help artists who want to draw realistic poses and musculature; it will also help give weight and dynamism to even the most simple cartoon figures. In fact, many art schools' animation departments require extensive practice in drawing the human figure from real life.

If you are just embarking on drawing, you should look into finding figure drawing offerings in your area. In addition to classes at colleges, art schools, art centers, and adult education programs, you should be able to find open drawing sessions in your area where participants pitch in for the model's fee and draw a variety of poses for a few hours.

If you're looking for really intensive training, however, you should seek out a class specifically in figure drawing, anatomy, perspective, or wherever your interests and needs lie.

For now, though, let's stick to what's right in front of us and look at one of the basic ways of building a figure. ——————

Yes, it's a stick figure! Pretty simple, huh? But in fact it's a perfectly good starting point for drawing a more realistic human form: We can get a basic idea of the pose, and the relation in size and position of the head and limbs is in place. One problem with stick figures is that they're a little on the skinny side, so how can we make this drawing look a little more "fleshed out"?

If you think about a skeleton, you will realize that the main masses are the rib cage and the hips. ——————

Now, leaving the details aside for a second, what if we were to add rough, roundish shapes corresponding to those two areas of our stick figure? This "fleshed out" stick figure (we'll call it a "figurette," after Jack Hamm) can be used as the basis for almost any kind of human figure illustration, from cartoony to realistic. ——————

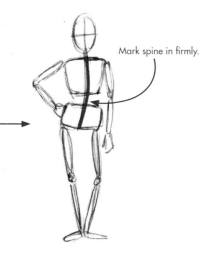

Mark spine in firmly.

Now that we've transformed a stick figure into a figurette by fleshing out the hip and rib-cage areas, here are a few things to keep in mind about anatomical proportion:

- As a general rule, you can draw male figures by making the chest slightly larger than the hips; female figures by making the hips bigger and the chest smaller.

- The vertical center of the body isn't the waist; it's the groin, where legs hinge.

- Elbows fall roughly at the top of the hips.

- Hands fall about mid-thigh.

- Upper and lower arms are the same length as each other, as are the upper and lower legs.

- The standard height of an adult figure is usually called "seven heads high." This means that the height of the head, multiplied by seven, is a good ballpark length for the full figure. Of course, depending on the age of the character and level of exaggeration, this number may vary somewhat (e.g., a "heroic" muscle man may be eight to 11 heads high, while a cute manga figure may be six.)

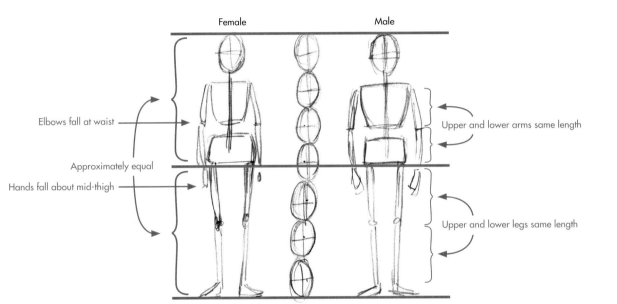

Female Male

Elbows fall at waist

Approximately equal

Hands fall about mid-thigh

Upper and lower arms same length

Upper and lower legs same length

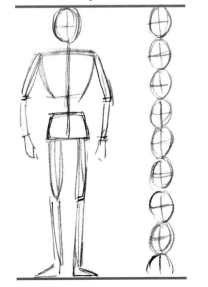

"Heroic" figure (8.5 heads)

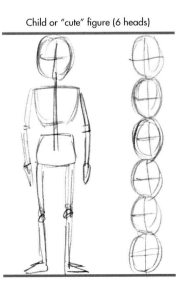

Child or "cute" figure (6 heads)

Finally, you won't want your figurettes simply standing around. Here are some things to keep in mind when showing them in action:

- Unless your figurette is falling over, his or her body mass will be more or less equally distributed on both sides of a center line.

- The chest and hips are somewhat pillow shaped, so if a figure turns in profile, you need to draw the ovals flatter.

- Remember to maintain proportion. If your figurette is walking, jumping, sitting, etc., hands and elbows may shift position, but upper and lower arms and upper and lower legs still need to be of equal length. ∎

Body mass more or less equally distributed on either side of a center line

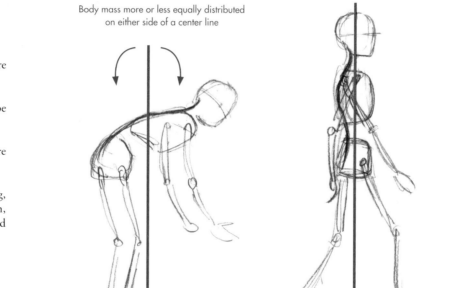

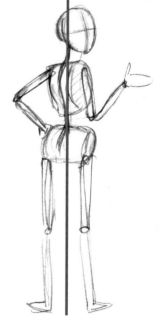

FURTHER READING

Jack Hamm, *Drawing the Head and Figure*

Homework
Penciling

Here's an opportunity to put your new penciling skills into action. Be sure to try as many of the techniques from this chapter as you can. This is also a chance to try out building figures with figurettes.

Materials
- HB pencil
- colored pencils
- mechanical pencil
- eraser
- office paper
- tracing paper
- bristol board
- ruler

Instructions
Draw a one-panel scene that suggests something is happening. The panel should have three planes: foreground, midground, and background (i.e., objects or figures that are close up, at a medium distance, and relatively far away). There must be at least two figures in the panel who are interacting.

When you think of what you want to draw, start with a thumbnail. Do at least three thumbnail versions of the panel before you start penciling. Pick your favorite thumbnail.

Draw a panel border that's at least six inches high and eight wide. Using the penciling techniques described in this chapter, draw the scene you developed in your favorite thumbnails. Draw the panel completely: get the figures as correct as you are able, and fully develop the space. Draw the props that belong there and the background details that make us believe in it. ■

Extra credit
Practice drawing figurettes

Materials
- office paper or a sketchbook
- pencil
- eraser

Instructions
Fill a few pages with figurettes in various positions. Start with standing figures, then make them walk, run, jump, kneel, and so on. ■

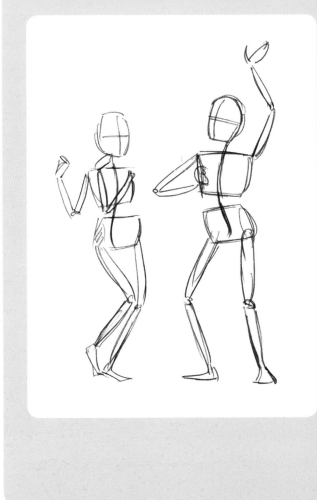

Extra credit
Drawing figurettes by tracing photos

Tracing can be an enlightening way to study the human figure by working backwards. You will trace photos of real people to discover the figurette structures that underlie them.

Materials
- vellum tracing paper
- various magazines, newspapers, or photo books
- pencil
- eraser

Instructions
Look through magazines, newspapers, or photo books for full-figure photos of people. Place vellum over a photo and pencil in an oval over the head, another over the area of the chest, and a third over the hips. Draw elongated bubbles over the limbs and simple circles or even blobs for the hands and feet. (Don't trace outlines: This is not about detail, this is about getting a sense of the proportion and weight of the figure.)

Do this on at least four drawings of people, then try it on other kinds of figures: animals, robots, trees—you will see that you can learn a lot by reducing objects to lines and ovals.

Now put away your magazines and use your figurettes to draw finished figures. Draw characteristics for your figures different from those in the original photos. ■

FURTHER READING

Eadweard Muybridge, *Muybridge's "Complete Human and Animal Locomotion."* Muybridge is a great resource for understanding bodies in motion. There are also mountains of photographic manga pose books that can come in handy.

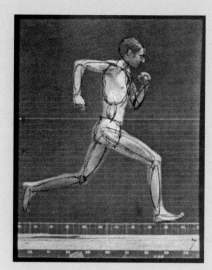

Don't just trace the photo directly—abstract the pose by making a figurette and using that as the underpinning of your character.

You'd probably want to do this messy workup in blue pencil or on a separate sheet, to be traced onto the final.

With a few adjustments, the same figurette can underpin all kinds of figures.

Note that we've "drawn through" the outlines of Krusher's nude form to help place his clothing.

Krusher is more thickly muscled than the man in the photo, but the figurette still gives him structure.

Here we used the same figurette to draw Azteka. Notice that we tailored the figurette to Azteka's physique's smaller rib cage, bigger hips, thinner arms.

Getting on the Same Page

The four-panel comic strip we discussed in Chapter 3 is the medium's haiku. Most artists, however, prefer to work on a broader canvas and tell longer stories. The next step up the formal ladder of comics is the full-page comic. We'll start by discussing the elements of one-page comics and then get down to the nitty-gritty of laying out a page, its tiers, and its panels.

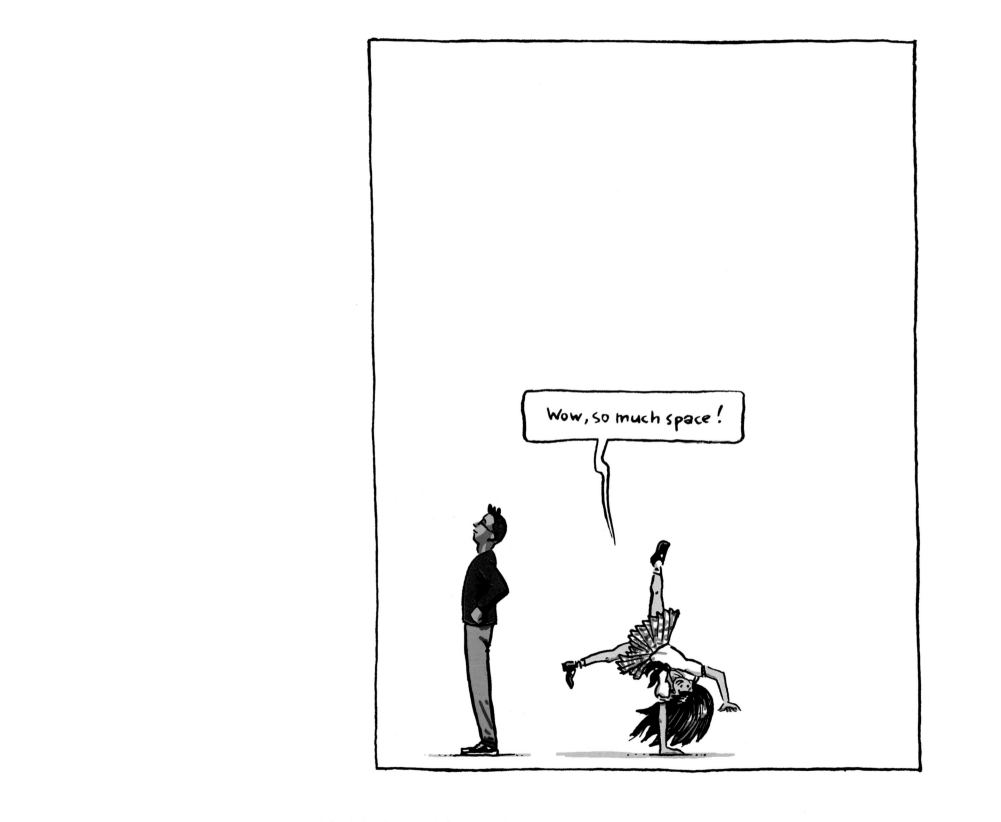

6.1
Elbow room

THE ONE-PAGER

We are aware that you are probably eager to embark immediately on a superhero odyssey, a space opera, or a graphic novel about tragic young love. But bear with us as we limit ourselves to the single page.

Like the comic strip, the comics page has an illustrious history in its own right. It's a staple of the Sunday pages of yore, where our art form had its first creative flowering, and it remains a regular feature in anthology comics, humor publications, and even mainstream magazines like *The New Yorker* and *Spin*. When one-page comics first appeared, their content was almost exclusively limited to humor. However, the form quickly expanded to include serialized adventure stories, and, later, reportage, slice-of-life, variations on a theme, and experimental comics, among other subjects. If you're able to master the single-page format, you'll find yourself with lots of publication possibilities that aren't open to those working in longer formats. But just because they're short, don't think making one-page comics is an opportunity to slack off: in fact, making single-page comics is almost as difficult a process in its own distinct way as making a graphic novel.

After the individual panel, the page is the most elemental unit of a comic. Once we fill a page with panels, the page becomes the main organizing structure, and individual panels become subordinate structures.

One of the great advantages of working in the one-page format is that, since the reader sees the whole work all at once, you have an opportunity to control the visual rhythm and design in ways unavailable to cartoonists working in longer formats. Among other techniques, in a one-page story you can use panels in tiers arranged to control the pacing and punctuation of the work. You can also lay out panels in meaningful or decorative designs.

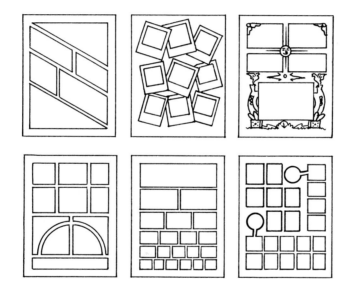

So set your epics aside a while longer and let's have a look at what kinds of stories you can tell in a single page.

Homework critique for
Chapter 5 on page 241

Thimble Theatre

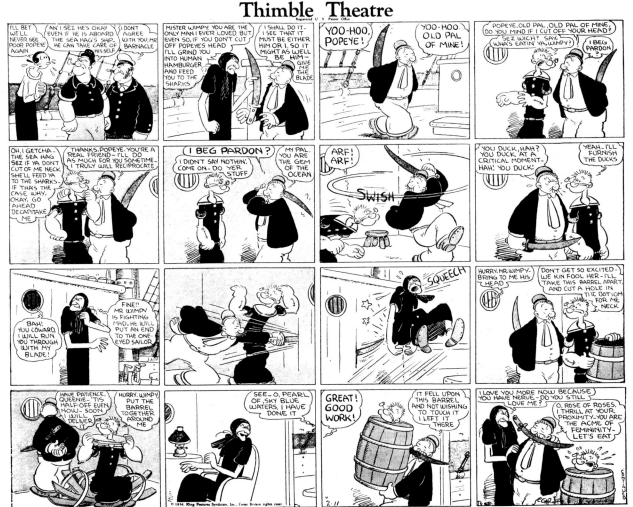

Popeye copyright © King Features Syndicate, Inc.

A CLOSER LOOK: TWO MASTERS OF THE SUNDAY PAGE
Segar: the page as story

E.C. Segar's *Thimble Theatre* (the original title of the strip that eventually became *Popeye*) is a great example of a less-is-more approach to page design. During 13 years of Sunday pages, Segar rarely strayed from a rigid 16-panel four-tier grid. Using regularly shaped panels gives a metronome-like rhythm that underpins the multiple plotlines and antic adventures that unfold each week. Segar's panel composition is similarly restrained, typically featuring two or three characters in a medium shot with the barest of background details: a kerosene lamp on a table, a ship's rigging against an ocean horizon, etc. This simple storytelling setup gives Segar a lot of flexibility to fill scenes with action and cut from one scene to another, all the while confidently drawing the reader along.

Unlike a daily strip, which is limited to a single gag or one step forward in a longer narrative, the Sunday page allows Segar to tell a whole minidrama that doesn't depend on the larger narrative arc.

In this episode of *Thimble Theatre,* Segar presents Wimpy with a clear conundrum to solve: He must kill Popeye or be fed to the sharks himself. Notice how Segar sets the scene—one episode out of a longer story—without the use of narration; within the first two panels we are up to speed on the situation. Wimpy halfheartedly asks Popeye's permission to behead him, and Popeye blithely accedes, only to duck Wimpy's blow with a salty "Arf! Arf!" Segar uses repetition as a rich source of humor and characterization. J. Wellington Wimpy is the epitome of this technique (even the *W*s in his name sound funnier with repetition) and seems unable to say anything just once: "You duck, hah? You duck at a critical moment—hah! You duck!" (Read more *Thimble Theatre* and you'll get the joke of Popeye's sarcastic response here.) He also repeats "pal" and "I beg pardon" to express his growing anxiety. Popeye hits on an absurd solution to Wimpy's dilemma, which the Sea Hag amazingly buys. The story ends happily, with everyone feeling temporarily victorious—even if we can tell the adventure is far from over.

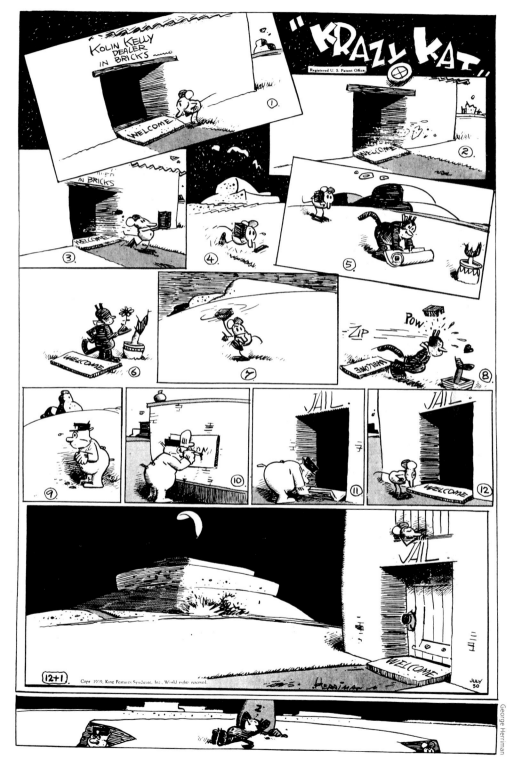

Herriman: the page as design

George Herriman's *Krazy Kat* is inarguably one of the greatest achievements yet in our youngish medium, and this achievement is nowhere clearer than in Herriman's consistently inventive and enchanting Sunday pages. Over the years Herriman played to varying degrees with layout, making his pages look at times as much like decorative art as comics.

In this example from 1939, Herriman uses both tilted and borderless panels to create a visually engaging page that nonetheless tells a clear story. The first panel is tilted backward and appears to be floating over a night sky. The next two are straightforward, establishing the action, but in the fourth panel we seem to be peering through the surrounding panels at Ignatz Mouse as he runs across a desert landscape at night (you can see that Herriman numbered his panels, as was the convention of the time; however, his pages rarely rely on that shortcut). In this fourth panel the sky extends up to the top of the page. In fact, it's the same sky that frames the opening panel and also serves as an inky backdrop to the title lettering. The second tilted panel (the fifth consecutive panel) introduces Krazy to the scene, unfurling a welcome mat, this episode's leitmotif. The sixth and eighth panels are borderless, creating an emphasis on the central (seventh) panel, in which Ignatz winds up his brick.

By the way, if you're not familiar with *Krazy Kat*, the scenario of Ignatz Mouse's frenzied attempts to bean Krazy with a brick, which Krazy interprets as a sign of Ignatz's love, is recurring. Offissa Pupp, who really does love Krazy, is on a mission to catch Ignatz and put him in jail. Of course, if this is all news to you, you should take it as a sign that you need to read more *Krazy Kat*.

Back to our analysis: At panel nine we have a change of scene and rhythm. After the varied, action-filled opening, we cut to a calmer sequence, almost like a comic strip embedded within the larger narrative: Offissa Pupp figures out his own use for the welcome mat. The culmination of the "ministrip" is the classic image of Ignatz spending the night in jail. This last panel is in an enlarged horizontal one emphasizing the calm, strange beauty of the desert at night.

Note that, as much variety as there is in this strip, it still has a solid grid structure underlying it: The panels are tilted and overlapping, but if straightened out they would follow a clear course. The reader can easily understand the page, despite its alterations, because that underlying structure is there. We wouldn't guess that Herriman actually drew everything normally first and then tilted the panels, but he certainly thought of the layout in traditional left-to-right, top-to-bottom reading order, and probably planned the story in that manner before canting (that is, tilting) the panels.

While many of Herriman's devices serve the story—the different-sized panels, borderless panels, and so on tip off readers as to what to focus on—other devices comment in a playful way on the conventions of page design, calling reader attention to the fact that we are looking at lines on paper, and mixing up the notion that comics pages must consist of continuous atemporal space. For instance, the backgrounds change from panel to panel, even if a character is standing in the same space (see panels five and seven); the title logo includes a strange decorative element that appears to be resting on top of the page, like a button or thumbtack; and there is that wide, squat image at the bottom of the page, which has nothing to do with the events and time line of the story, instead visually restating the relationships of the main characters: vigilant cop, sneaky mouse, sweetly oblivious Kat.

ELEMENTS OF PAGE DESIGN

Now that we've taken a look at a couple of famous one-page comics and the ways those comics' artists work within the one-page format, let's take a closer look at some of the elements of page design, starting with the grid.

The grid

The concept of organizing elements using a grid can be useful for any artist. In graphic design, the grid is the underlying structure that helps ensure a readable, integrated composition for a newspaper, a poster, or a web page. In drawing and painting, the grid can help an artist organize visual material in an effective way—and fine artists like Piet Mondrian and Chuck Close have even made the grid the basis of their entire body of work. Right now we're going to talk about how the grid can be useful when approaching page design in comics.

A typical comics page is made up of three or four tiers of panels. The panels themselves can be different sizes or shapes depending on the effect you want, but, using the grid system, plan to start with a basic grid of equal-sized panels.

Creating panels of uniform shape and size will give your comic a steady rhythm that you can punctuate and accentuate through repetitions and variations from one panel to the next. This approach is certainly well-suited to low-key, everyday drama, but it's equally effective for comedy (e.g. *Thimble Theatre*) and even action (take a look at Alan Moore's work for excellent examples).

A lot of instructional books oriented toward superhero comics on the one hand and manga on the other are disdainful of the grid, claiming it lacks "visual interest" and makes for dull storytelling. However, a quick read through the wide variety of comics that use panel grids will show you that this is not at all the case. Using a grid foregrounds the story and action as the comic moves from one panel into the next. When you do break up the strict uniformity of the grid by introducing a tilted panel, to name one variation, the effect is much more powerful because the tilted panel jumps out at the reader to emphasize a mood, plot point, or dynamic motion. If every panel is tilted and shaped differently, it's much harder for the reader to find the rhythm of the page. If you go back and look at comics that you remember having wild layouts, you'll be surprised at how many of them use a regular grid layout the majority of the time.

Even if you plan to go crazy with lots of diagonal lines, bleeds, splashes, and inset panels, you still want to have an underlying grid because the grid is what gives the page a scaffolding for you to build on and adds visual rhythm and continuity to multiple-page stories.

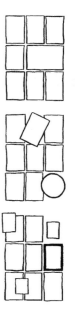

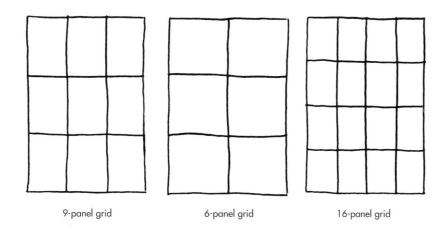

9-panel grid 6-panel grid 16-panel grid

More approaches to page design

Using a grid is one way of jump-starting your page design. In this section, we present five comics pages to demonstrate a variety of story-telling and page-design techniques that move beyond uniform grids. These pages, along with the Segar and Herriman and pages preceding, are just the tip of the iceberg: When it comes to page design, your choices are legion. We will return to the subject of design in Chapter 11, when we look in detail at the composition of individual panels.

We are only skimming the surface in this section, and this is a crucial topic. We strongly suggest that you do the extra credit in this chapter, the *Comic book book report*, reading closely both old Sunday pages and individual pages of your favorite comics, and looking at them from a design standpoint.

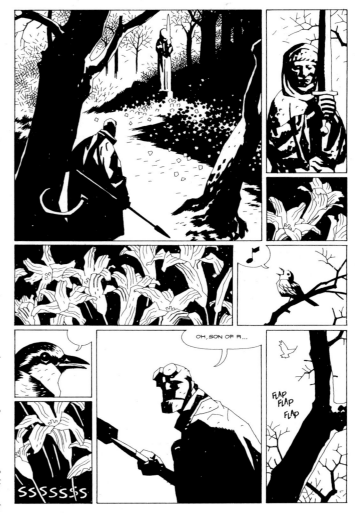

This page from the story "The Nature of the Beast," in *Hellboy*, by **Mike Mignola**, is a beautiful example of creating rhythm and mood through the use of panel size and aspect-to-aspect transitions. Mignola starts with a large panel establishing the scene, an "establishing shot," which he then breaks down into smaller bits. The repeated smaller panels of lilies (white on black) create a pattern in contrast to the dominant effect of black on white, and punctuate a tense scene in which the enemy is about to strike. The overall effect of the page is of several long moments. On another level, Mignola is a master of black spotting and organizing abstract geometric shapes and silhouettes to guide your eye through the page. The stark black branches in panels five and nine lead the way to the next scene, a dramatic moment of action. The stillness in this page amps up the impact of the action in the next.

In this page from **David B.**'s *Epileptic*, the shape and orientation of the panels guide and reinforce the storytelling. First, a horizontal panel brings the protagonist into a wooded scene. The panel is drawn so that the "camera angle" is canted, which makes for a feeling of anxiety, one that is reinforced by the deep black of the woods, and, when our eyes reach the end of the panel, the sinister skull- and cat-headed figures among the trees. Despite the heavy blacks of the panel, you would never fail to notice the figures in the woods because the gleaming white path points straight at them.

The next three panels seem to take the first panel and flip it 90 degrees. As the first panel referred to and reinforced the idea of the path, so now, these three panels frame and highlight the verticality of the tree. With three panels of this kind in a row, the page itself becomes an enchanted forest. Our eye mounts from panel to panel as the protagonist climbs, followed by his floating ghostly companions. Their bodies form a continuous rising shape, a virtual path. The word balloons follow suit until the last panel, where a long tail leads us to the bottom of the panel, edging us toward the next page. The use of black is striking, and very appropriate for the mood. Instead of black spotting leading our eye through the page, as in the Mignola example, here, we essentially have "white spotting." Squint at the page, and you can follow a simple, clear path made up of flowing white marks and small areas of solid white.

In his graphic novel *Blankets*, **Craig Thompson** constantly looks for new ways to tell his story through dramatic and unexpected page layouts. This page starts out conventionally enough with an establishing shot, a horizontal panel showing two brothers in a winter landscape. The second panel uses an extreme close-up to create a tense pause accompanied by a small sound effect, one that would be easy to miss if it weren't so well framed by the child's torso and arm. The "crack" leads us with its tail straight down (against the usual reading path) via the negative space created by the child's body below and through the surface of the ice. (Negative space is what it sounds like: the space around the drawn objects.) Only then do we pull back and read/hear the sound effect, which itself breaks through the lower panel border and guides us into the vertiginous, half-page final panel. The narration floats near the top left, then we drift down to find the child, surrounded by oppressive negative space—the white visually represents a blanket of snow, yet it also suggests the isolation and alienation felt by the young protagonist. Note the asymmetrical placement of the figures on the page. We'll talk more about that in Chapter 11.

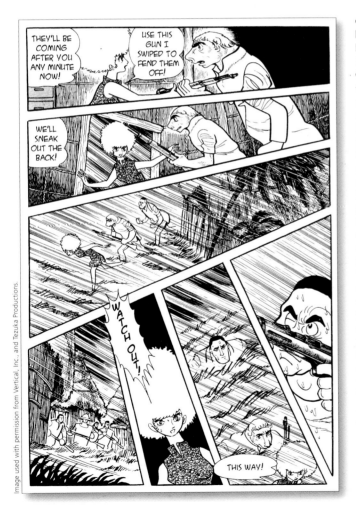

Osamu Tezuka laid the building blocks for much of the storytelling language of manga, and his influence is growing in the West. One of his many innovations was to break up the traditional grid into diagonal sections that often reflect the heightened emotions of the characters as well as the mood, pace, and direction of the action. In this page from *Ode to Kirihito*, a group of three increasingly distorted panels leads us down and into a row of vertically oriented panels. In the first three panels, the female character seems to be dragging the panels downward with the force of her will as she tries to guide her friends to safety. The "pivot" panel at the bottom left shows a group of angry villagers with guns—as the protagonists' fortune changes, so does the direction of the panels. The panels now mount in thin columns as the tension mounts, leading to a tight close-up of a villager getting ready to fire. Notice that the "wind" lines, appearing in all but three panels, visually unite the page and scene. Also note the judicious use of blacks: For instance, the black at the end of the first panel registers Kirihito's shock as he accepts the gun—a premonition of terrible deeds to come.

Paul Pope's pages seamlessly fuse influences from American, European, and Japanese comics. You can see the influence of manga in his use of wildly differing sizes of panels and his extensive use of bleeds to create a sense of dynamic action that is constantly spilling out of the page. This page flips symmetrically between two scenes showing characters in crisis: The big splash panels express the drama of their particular problems while the smaller, horizontal panels show us the specifics: we zoom in on the face of the unconscious man, then we see alternate angles of a young woman as she struggles to retrieve a very important ball. Pope creates busy panels full of texture and motion, yet his pages are always clear and legible, in large part due to his bold use of blacks and negative space, both of which guide the eye through his complex scenes.

Reading order

Here's a simple element of page design that we don't need a lot of space to discuss, but it's a critical one. In the West, we read from left to right first, and then top down. You need to follow this direction when laying out your panels. If you don't, you run the risk of confusing your readers ... with potentially disastrous results.

Why did these guys get blown up? Didn't the guy with the hair understand the code? Well, did you? Let's see.

Maybe the code is 5JQ9:

But wait, what if it's 5QJ9:

Note how without arrows, there's no way to know for sure what the correct reading order of the two middle panels is. Should the reader start left to right, as usual (but then counterintuitively read right to left) or break reading order intuition and start by reading top down? It's impossible to decide from the information available here. You should avoid pointlessly presenting your reader with such an ambiguous situation.

Title design

Before we move on, let's look at one more design aspect of the one-page comic. One of the first things that will jump out at you if you read an old Sunday page is its carefully designed eye-grabbing title. Sometimes these titles are typeset and appear at the top of the strip. Other times they are hand-drawn and appear in the same form every week. In rarer cases—dramatically in *Krazy Kat*—the artist draws a new title logo every week, incorporating it into the layout of the comic. Title design is an important part of creating an identity for a comic—not just for Sunday pages but for all comics, especially short ones. The title and the way it's presented can play a crucial role in attracting readers and setting the tone of the story. The type of letters you use, the size you draw them, where and how you place them on the page—all of these decisions will affect the way a reader receives your work. We'll talk more about this idea in Chapters 7 and 11. ∎

FURTHER READING

Please see "Further reading" in Chapter 3, and:

George Herriman, *Krazy and Ignatz*

Dan Nadel, *Art Out of Time: Unknown Comics Visionaries 1900–1969*

E.C. Segar, *Popeye*

Brian Walker, *The Comics before 1945*

6.2

Laying out pages, tiers, and panels

LAYING OUT A PAGE

Now that you have a good idea of the elements of a one-page comic, let's start work on a standard, printable comics page. When you first sit down to draw a "real" page of comics, a bunch of brand-new questions are bound to occur to you, such as, "How big should my page be?" or "How much space should I leave between panels?" The stage where you figure out the answers to these questions is called "laying out" the page.

There is no set rule as to what a comics page needs to look like, but there are general principles and approaches you'll need to keep in mind. First of all, you can't just make your page any old shape; you need to have some idea of where your comic is going to be reproduced and choose your dimensions accordingly. As an obvious example, if you're working for the computer screen, your work should probably be in a horizontal format. If it's for a book, probably vertical.

This doesn't mean you have to draw to the exact size your comic will be reproduced. On the contrary, very few cartoonists draw their comics at print size. Typically, cartoonists draw their original pages one and half times to double their actual print size. As long as the ratio of the dimensions (the shape) is the same, the page can be reduced to fit in the final format.

Once you realize you should draw your art bigger than it will be reproduced, you still have to figure out exactly what size it should be. There are a few ways to do that, which we'll discuss in a moment. But first, you need to learn about a new concept: the "live area."

Live area
The first thing you need to do when you start a comics page is to draw a rectangle defining the area you will fill with your art. What is this rectangle? It's the "live area" (or "active area" or even "safety zone") of the printed page. "Live area" corresponds to the outline of all of a comics page's panels taken together, but not including the margin—the (usually) white border between the art itself and the edge of the page.

Of course not all comics have white margins. If you look at a lot of recent manga and superhero comics, you'll notice that the art runs off the page. This is called a "bleed," because the art "bleeds" off the edge of the page. However, there's still a live area in there; all the

necessary action and dialogue continue to take place at least one half-inch from the edge of the page to avoid essential action getting cut off during printing. Printers make mistakes: If you draw some dialogue or important part of the action too close to the edge of the page, it could get cut off by a sloppy printer (meaning the inky guy who is printing your book at the shop, not the little machine next to your computer). Bleeds can look good, but as much as you might want to use bleeds right away—and if you're a manga fan, we know you're champing at the bit—they're pretty complicated technically, so we're going to avoid using them for now.

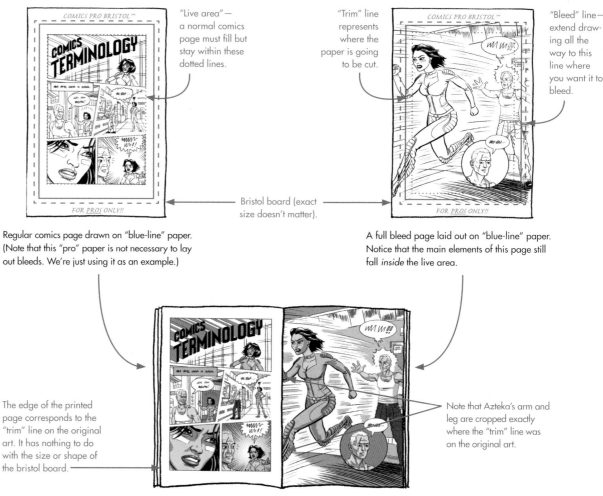

"Live area"— a normal comics page must fill but stay within these dotted lines.

"Trim" line represents where the paper is going to be cut.

"Bleed" line— extend drawing all the way to this line where you want it to bleed.

Bristol board (exact size doesn't matter).

Regular comics page drawn on "blue-line" paper. (Note that this "pro" paper is not necessary to lay out bleeds. We're just using it as an example.)

A full bleed page laid out on "blue-line" paper. Notice that the main elements of this page still fall *inside* the live area.

The edge of the printed page corresponds to the "trim" line on the original art. It has nothing to do with the size or shape of the bristol board.

Note that Azteka's arm and leg are cropped exactly where the "trim" line was on the original art.

Printed comic book.

Inside the live area

It's important to understand that your comic will fill the live area. That means your outer panel borders should rest on the live area border. You should not treat the live area like an imaginary page from a book and add a margin so that it "looks right." The margin is what is *outside* the live area. This may seem obvious but it is a very common mistake made by beginners.

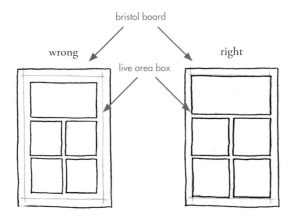

bristol board

wrong right

live area box

Don't mistake your live area box for a "page" that needs a margin …

…the outer edges of your panels should be along the live area box.

Original art size

OK, now that you understand the concept of live area, let's return to the point we made at the beginning of this section, and this is an important point to keep in mind when laying out your page: *Original art for comics is drawn larger than reproduction size.* The reason for this is simple: If you draw something big and then reproduce it at half the size, all the little flaws and mistakes will be less obvious. In other words: Drawing your art larger than print size makes it look better. Just how much larger you draw is ultimately up to you, but be consistent, and use the same proportion throughout a story or book.

Although it isn't a hard and fast rule, the vast majority of cartoonists choose to work at 150 percent of reproduction size. That means that if the printed size of the live area is 6" x 9" (which is close to standard American comic-book size) you would multiply that by 1.5 to determine the size to draw your original artwork, which would be a live area of 9" x 13.5". Once you've drawn a number of comics pages, you'll be in a better position to decide at what size you're most comfortable drawing. Until then, let's go with the standard 150 percent.

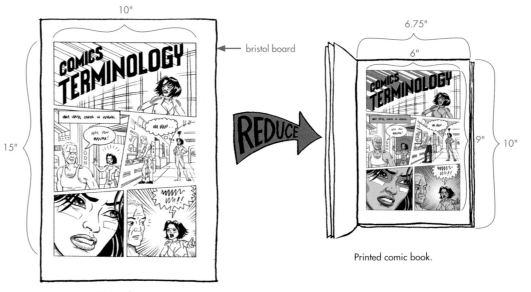

10"

bristol board

15"

REDUCE

6.75"

6"

9" 10"

Original art.

Printed comic book.

Page ratio

If you don't know how or where you are going to print your work, use a standard page-size ratio.

A common scenario when you're getting started drawing comics is that you don't have a final destination for your work in mind; chances are, you're just making comics and figure you'll worry later about where they'll be reproduced. However, you can cause yourself trouble if you disregard standard printing formats. If you decide to draw a comic that is square, skinny, or veeeery tall, or, for that matter, triangular, it may turn out quite cool but you will probably find it hard to find a publisher who will print it for you. If getting published is your goal, it's best to use one of the two most common ratios for page size.

2:3

- Standard American-style comics have basically a 2:3 ratio. That means that, whatever size you draw, you should make the width of the original a multiple of 2 and the height a multiple of 3.
- The most common original size for American comics is 10" x 15", which is a 2:3 ratio. This is close to the live area size you will find on preprinted blue-line paper.
- Manga also typically use a roughly 2:3 ratio. There are a few standard sizes for professional manga art, but, for example, one common size is 10" x 14" paper with a live area of 9" x 13". That's an approximation of the actual size used in Japan, since, of course, they're on the metric system.

3:4

- Magazine-size comics, European comics, and many graphic novels are more commonly in a ratio of 3:4.
- The most standard size for your original, if you want to use the 3:4 ratio, is 12" x 16".

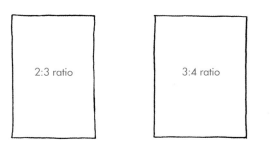

You can also size your pages according to the size of the printed book they are destined for.

If you know where or how you're going to publish your pages (for example, in a minicomic of your own design or in a publication that already has an established format) you can tailor your originals to the final print size. The best way you do this is by using a proportion wheel. We'll explain how to use the proportion wheel in Chapter 14.

This is why page ratio is important. If you draw your comic 2:3, it will look best in a book that's also close to 2:3.

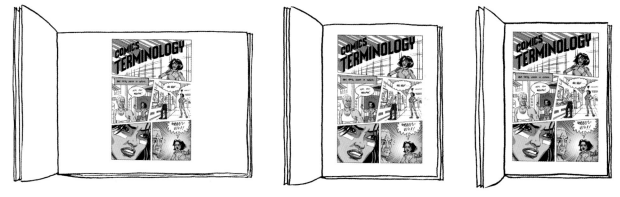

3:2: Way too wide. 3:4: Better, but still too wide. 2:3: Juuust right!

Resist the impulse to use bleeds or black gutters for now.

At the end of this book, we will recommend that you print your own minicomic. It's crucial to remember that most photocopiers and computer printers don't print to the edge of the paper, so bleeds and black borders don't work. For now, restrict your art to inside the magic live-area rectangle.

Gutters

Remember, your art will be reduced in size when it's reproduced. That means all parts of it will be reduced, including the gutters—the space between panels. You should figure out how wide you want your gutters to be in the final printed work. Then you have to multiply that by 1.5 to come up with the width you want to use on your original art. Don't go too wide with gutters, because the panels will tend to visually fall apart from one another and not look like a unified page. Don't go too small either, or panels will tend to run together and be hard to read.

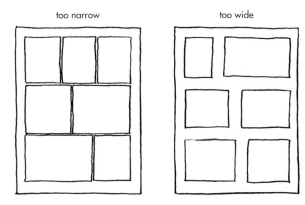

too narrow too wide

A good gutter size to use on your original art is 3/8" to 1/4".

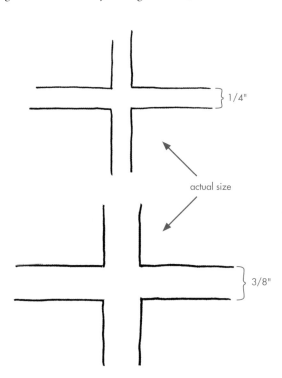

} 1/4"

actual size

} 3/8"

Tiers

Once you have decided on a gutter size, you are ready to lay out your tiers. Remember that the word "tier" refers to a horizontal row of panels. In general, a comics page is made up of three or four tiers, each of which typically has from two to four panels on it. ■

Lay out your live area

Materials

- a sheet of bristol board (at least 14" x 17" in size)
- a clear plastic 18" ruler marked in 1/8" increments
- drafting or Scotch tape
- a pencil—a mechanical pencil is handy for this

Optional but recommended
- a T-square
- a triangle
- a rectangular table or a drawing board

(You can lay out your pages on any flat surface with only a ruler, but these optional tools will make it a *lot* easier.)

Instructions

In this chapter's homework, you are going to start working on a one-page newspaper comic that you are going to thumbnail, pencil, and ink over the course of the next few chapters. Before penciling, you're going to need to lay out your live area on a sheet of bristol board, so let's go ahead and do that now.

In order to emulate the old-time Sunday comics page as closely as possible, we're going to lay out a 12" x 16" live area (that's a 3:4 ratio), since it's about the largest page you can fit on a standard pad of bristol board, which is 14" x 17". Real Sunday pages in the classic era were drawn even bigger, as big as 18" x 24", but this will have to do for now!

Lay out your live area using a T-square

1. Tape your bristol board to a drawing board or rectangular table. Align the bristol board square to the edge of the drawing board or table. If you have a T-square, you can align the paper more exactly than without one. Make sure it's vertical; i.e., that its shorter dimension is parallel to the front edge of the table.

Make paper parallel to the table by lining up the edge of the paper with the edge of the T-square.

2. Hook your T-square on one side of your table and draw a horizontal line about 1/2" from the bottom, all the way across the paper.

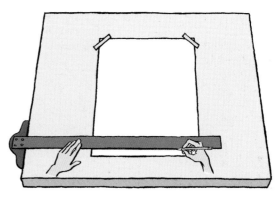

3. Using your ruler, measure 1" from the left edge of your paper and make a tick mark on the horizontal line you've just drawn. Then measure 12" from the tick mark (i.e., at the 13" point on your ruler; see illustration below), and make another tick mark on the line.

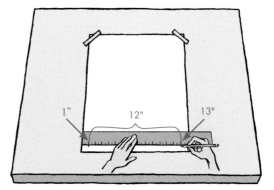

4. Hook your T-square over the top of your table, and draw vertical lines through each of the tick marks you've just made, all the way to the top of the page. (Or you can leave your T-square hooked to the left side of your table and set a triangle on top of it to make your vertical lines.)

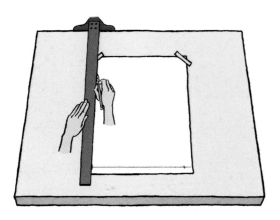

5. Using your ruler, measure from the horizontal bottom to line up the vertical lines 16", and make tick marks at the 16" points. (If your bottom horizontal line is at exactly 1/2", then you'll make a tick mark at the 16 1/2" point on your ruler, as illustrated below.)

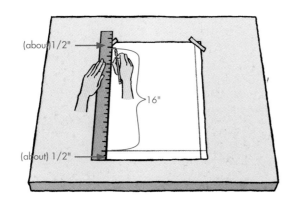

6. Hook your T-square over the side of your table again, and draw a horizontal line through the two tick marks you just made.

7. You should end up with a rectangular live area with 90-degree corners that is 16" high and 12" wide! It's a good idea to verify that the corners of your rectangle are square by lining up a triangle in each corner. Also, verify with your ruler that your live area ended up 12" x 16", and not some other size.

If you don't have a T-square and a rectangular table, you can also simply use a ruler, but it's a lot harder to make sure the rectangle has 90-degree corners. You can use the edges of the paper for reference (i.e., draw your vertical line exactly 1" from the edge of the paper and then measure 12" across…), but pads of bristol aren't always cut exactly square, and you may end up with a wonky angle in there.

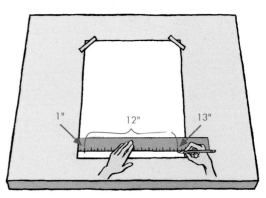

Make sure that no edge of your live area rectangle is sitting on the edge of the paper. You want to have at least 1/2" between the edge of the paper and the edge of your art on all sides.

Lay out your gutters and tiers

In the early part of the last century, at the height of newspaper comics' powers, a standard Sunday page used to have four tiers, so we're going to divide our page that way. The page you've laid out is 16" high, so obviously, each tier is going to be 4" high, right?

But wait, what about the gutters?! You're going to have three horizontal gutters in there that you have to account for. The first solution that might occur to you is to rely on basic math: If the gutters are 1/4" each, and you have three of them, that makes a total of 3/4" of horizontal gutter space within your live area.

Subtract that 3/4" from your 16" live area height, and you're left with a total of 15 1/4" for your tiers. Since there will be four tiers, divide 15 1/4" by four, and you're left with … 3 3/16" for each tier??

"13/16"? Is that even on here?!"

You're thinking, "There's got to be a better way!" Well, there are a few other methods you can use. The less accurate but faster method is simply to put tick marks on one of the vertical borders of your live area at 4", 8", and 12", and then mark 1/8" on either side of those tick marks, making 1/4" gutters (if that's what you want) on the 4", 8", and 12" centers. Use your T-square or ruler to run the gutters all the way across. The drawback of this method is that the interior tiers are just slightly smaller than the outer tiers, because they have gutter eating into their space on both top and bottom.

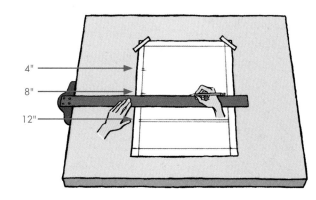

4"

8"

12"

Don't divide your tiers up into panels—yet. If you had a thumbnail ready for this page, you'd divide up the page vertically into panels at this point. However, since you're just starting your first comic let's hold off until you have done a thumbnail before moving to the next stage. Put the page away for now—you'll come back to it in the next chapter's homework assignment. ∎

Homework
"A month of Sundays" thumbnails

For this assignment, which will continue over the course of the next several chapters (hence the "A month of Sundays" title), we've given you the story for a one-page comic in order to let you focus your time on composition at the panel and page level. You should also come up with interesting character designs, and have fun with the dialogue. You'll be surprised how different your interpretation of the story can be from others'.

Materials
• office paper
• pencils
• erasers
• the story description, below

Instructions
Using the script scenario below, develop a thumbnail for a one-page, four-tier comic strip. Words in **bold** represent dialogue —you should rephrase to suit your taste and sense of humor but stick closely to the dialogue and action as it's written.

Start by dividing up the action into "beats" and assigning each beat a certain chunk of real estate on the page. This will help you make sure you have room to fit the whole story in, and that you emphasize the parts that need it.

Finally, pencil in the dialogue you've written clearly enough that it can be read by the group. Don't forget to leave space for your title!

Chip and the Cookie Jar
Many classic Sunday strips revolve around a character's single-minded pursuit of something: Jiggs trying to go out and play cards in *Bringing Up Father*, Ignatz Mouse trying to bean Krazy with a brick in *Krazy Kat*, Garfield eating a pan of lasagna, etc.

What follows is a script for an imaginary Sunday comic strip called *Chip and the Cookie Jar*. Each week, Chip, a little boy of about six, schemes to get at a cookie jar that sits prominently on top of the refrigerator in the kitchen. His parents don't want him eating so many cookies. His mother keeps a close eye on him and is hard to fool, while his dad is a bit absent-minded and gullible.

Setting: a kitchen
Chip: **Dad, can I have a cookie?**
Dad: **Chip, you'll spoil your dinner.**
Chip has a tantrum. He wants a cookie.
Dad: *(trying to distract Chip)* **How about a piggy-back ride?**
Chip has a lightbulb moment as he thinks about it.
Chip: **Ride me on your shoulders!**
Dad: **You're getting a bit big for this!**
Dad lifts Chip up. On his way up, Chip grabs the cookie jar.
Dad: **How's the view?**
Chip stuffs his mouth with cookies.
Chip: **Great. Take me around the houf!**
(His voice is muffled by the cookies in his mouth.)
Dad: *(puzzled)* **You sure you're all right, son? You sound funny. Let me get you down …**
Chip: **Noooo! Waaaah!**
(Chip throws a new tantrum, but is clearly faking it.)
Dad: **OK, OK, around the world we go.**
They enter the living room, where Mom is reading.
Mom: **Don, you're going to get a hernia carrying that boy. He eats too many cookies!**
Chip hides the jar behind something (artist's choice) as they pass.
Chip: **Mmmph.**
Dad: **Oh, ha ha, Sally, don't you worry.**
Chip and Dad pass through the front hall.
Chip: **Mmh hhmm!**
(Crunching sounds)
Dad: **Sounds like we've got that squirrel in the attic again!**
Dad and Chip return to the kitchen.
Dad: **All right, that's enough. I'm getting tired!**
Chip shakes out the jar and slides it onto the fridge on his way down. Dad feels the crumbs hit his head.
Dad: **Oh boy, the plaster is crumbling—I'll have to call the contractor about that …**
Dad: **If you don't tell your mother, I'll give you a cookie.**
Chip: **That's OK, Dad. I don't want one anymore.**

The reason we are giving you a prewritten story and script is that we want you to concentrate purely on visual storytelling and page design at this point. A further advantage is that you will learn a lot by comparing your version of the story to those of your colleagues. If you already have experience with writing you may decide to write your own Sunday page. That's fine; just make sure your teacher or fellow Nomads are in agreement. ∎

Extra credit
Comic book book report: Sunday page

One of the things that will help you grow quickly as a comics artist is to become an attentive comics reader.

Pick out a Sunday comics page from a collection of pre-1950 comics. Pick it simply because it appeals to you, or pick one that seems complicated or challenging. Either of those criteria is equally valid as a basis for your choice. (See "Further reading" in this chapter for some ideas.)

Once you've chosen the page you'd like to study, go to the "Comic book book report" Appendix D and respond to the questions there. ■

Chapter 7

Lettering

In Chapter 6, we introduced the importance of lettering briefly by discussing titles—how eye-catching title design can attract readers and set the tone for the comic as a whole. Now let's delve deeper by talking about lettering within comics. We'll also take a look at using the photocopier, a tool you'll find yourself using more than you might think.

7.1

Hand lettering

7 Lettering (side tab)

DRAWING WORDS

Not every comic uses words, but most of them do. And as soon as you use words, you'll need to find a method to get them on your art. That's when you need to know how to letter.

Lettering is not handwriting

Most importantly, although it's often made by hand, lettering is not handwriting. Lettering requires thinking of the letterforms as small drawings. Each letter needs your full attention as you draw it. You should think about the direction of the strokes, the size and shape of the parts of the letter, and the space between letters and words. We, Matt and Jessica, still struggle mightily with our lettering and are far from accomplished lettering stylists, but each of us has developed at least one style that functions well with our drawing styles.

Let us show you what we're talking about:

This is Jessica's handwriting.

This is Jessica's lettering.

WHAT'S WITH THE ANTIQUE TECHNOLOGY?

It's not unlikely that you're sitting there reading this and thinking to yourself, "What's with these people? They're talking like they've never heard of computers!" Believe me, we've heard of 'em. But we're of the opinion that hand lettering not only looks better than computer lettering, but it also works better. Also, we think that computer lettering can only be done well by someone who already knows how to hand letter, because those well-versed in hand lettering are better able to make strong aesthetic decisions about placement of lettering and choice of fonts, word balloons, and effects lettering. Finally, our mission here is to give you all the tools you need to make comics, and that includes lettering.

But let's get back to our first, most important, assertion above, that hand lettering works better than computer lettering. You may not have thought about this, but you've probably seen comics where

the lettering seems to be in a very separate physical space from the art. This happens especially often, though not exclusively, with painted or highly rendered art—the art depicts deep space and realistic characters, and the dialogue just sits there on top, like a Post-it note stuck on an oil painting:

In this situation, we tend to read the words, then look at the pictures, or the other way around, but we don't absorb the meaning from words and pictures almost simultaneously, as should happen in the best comics. The "reading" experience is choppy and unnatural.

Even with cartoonier art, the clash between computer lettering and the drawing style can make for a choppy, unclear reading experience.

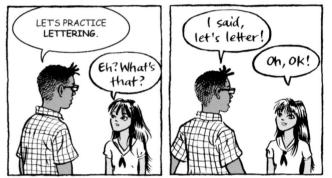

This is one of the effects of pasting computer lettering into your comics. Lettering, as we've already said, is not simply words, and while its purpose is, like words, communication, some of that communication is aesthetic, about the world the words "live in." Letterforms are drawn, not written, and when they're drawn by the same hand that draws the art, the two elements fit together seamlessly. The reader is able to "hear" the dialogue as if it's spoken by the characters.

Homework critique for Chapter 6 on page 241

Once you understand what works in hand lettering, and where problems may pop up, you may be able to work through those things when they come up in computer lettering. You may also have a computer font made from your own lettering, which can help you with the problem of clashing art and dialogue, though even fonts of your own lettering can still sometimes come out mechanical and stiff. In any case, you can't have a computer font made of your own lettering if you don't know how to letter! ⟶

In short, give hand lettering a chance. You will see what we mean if you go with the program for a while.

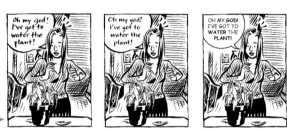

Original Font based on lettering Computer lettering

A case for upper- and lower-case lettering

Before you go the default comics lettering route—the all upper-case "comic book" style lettering—take a few moments to consider the arguments for upper- and lower-case lettering. The human brain processes written language in several ways at once. For example, you probably aren't sounding out each word in this paragraph as you read. Instead you grab words, and even phrases, in chunks. One way you do that is by perceiving the exterior shape of the words, and the shape of the spaces between words. Therefore your choices regarding the case of the lettering have an impact on the reader's experience.

Strings of words written in ALL CAPITAL LETTERS have a uniform shape, which makes blocks of text denser, less differentiated, and thus harder to read.

THINK ABOUT IT. IT'S A LOT HARDER TO READ E-MAIL, FOR EXAMPLE, WHEN PEOPLE WRITE IN ALL CAPS.

Traditional comic books were originally lettered in all capitals only because editors realized they could fit more text on the page that way. It's up to you if you want to follow this comics tradition, but we encourage you to keep an open mind and consider other options.

Lower-case letters are easier for the eye to differentiate:

the shape of words

the shape
of the space
between words

Capital letters are boxy and tend to run together:

THE SHAPE OF WORDS

THE SHAPE
OF THE SPACE
BETWEEN WORDS

Lettering styles

In addition to deciding when and how to use upper- and lower-case lettering, you can choose to employ all kinds of different lettering styles for emphasis, characterization, or aesthetic reasons.

Try out both upper- and lower-case lettering and see which works better with your art. You could think about developing both styles for use with different projects. You can also use **bold** and *italic* letters, *script fonts,* Deliberately sloppy (but still legible) lettering, hand-lettered adaptations of mechanical fonts, (typewriter, decorative fonts, computer fonts for robots, etc.). There are endless possibilities. While you're at it, you may want to check out the lettering styles of cartoonists you like and consciously emulate what they do. That is, unless they use computer lettering, in which case, ignore it!

Other lettering concerns

One of the biggest problems inexperienced cartoonists have with lettering, whether it's done by hand or on the computer, is bad placement of lettering and word balloons and uneven spacing between letters and words. You must, absolutely must, place your word balloons in the right spot so that words are read when you want them to be read. And you must make sure that the space between letters and between words is sufficient. Lastly, and this is the trickiest part, you must leave adequate space between the edge of the panel or word balloon and the words.

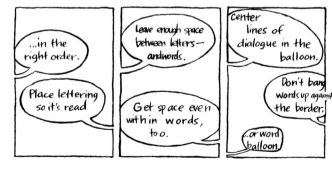

THIS ALL GOES
FOR COMPUTER
LETTERING, TOO!

WELCOME TO AMES

Hand lettering benefits enormously from ruled guidelines. These can be made with a ruler, of course, but the process is laborious. Luckily, there is a cheap and handy tool that will make creating lettering guidelines almost effortless: the Ames Lettering Guide.

There are a lot of things the Ames guide can do for you. For our purposes, we'll simply talk about how the guide makes it easy to draw sets of parallel lines that we can use to keep our lettering straight and even.

First of all, orient the guide so that the name "Ames Lettering Guide" is right-reading and the angled edge is at the right. You should see a disk-shaped part in the middle of the guide with three rows of holes through the center. One row is labeled "3/5." Orient the disk so that the "3/5" is at about one o'clock, and that row of holes extends downwards to the left, as in the illustration at right. The center row consists of evenly spaced holes, and the row on the right is labeled "2/3."

At the bottom of the disk, you'll notice a row of numbers, and directly below the disk is a tick mark. Line up the "5" on the disk with the tick mark. Now you're ready to use the guide, making letter guidelines that are size 5.

If you rotate the disk so that higher numbers line up with the tick mark, you can make wider lettering guidelines, thus larger lettering. If you rotate the disc the other way, your lettering will be smaller. We are going to start with 5, because it's a nice average size. You can decide for yourself later if you are comfortable with this size or if you would rather use wider or narrower lettering guidelines. If you want to letter in classic superhero style, set the wheel at 3 1/2, as most comic book letterers do. ■

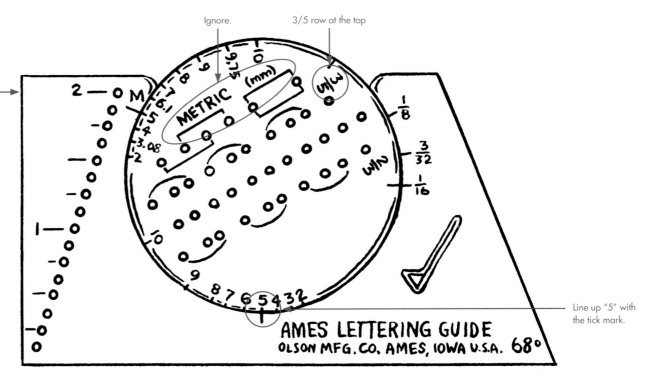

FURTHER READING

Mark Chiarello and Todd Klein, *The DC Comics Guide to Coloring and Lettering Comics*

J. C. Fink, Maura Cooper, Janet Hoffberg, and Judy Kastin, *Speedball Textbook for Pen and Brush Lettering*

Ross F. George, *Elementary Alphabets*

Bill Gray and Paul Shaw, *Lettering Tips: For Artists, Graphic Designers, and Calligraphers*

Martha Sutherland, *Lettering for Architects and Designers*

 Make lettering guidelines and practice lettering

Materials

- Ames Lettering Guide
- mechanical pencil
- T-square or ruler
- bristol board
- pens

Instructions

Let's start by trying out the "2/3" row on the Ames guide:

1. Make sure your Ames guide is set to size "5."

2. Locate the 2/3 row, the bottom row of the three rows.

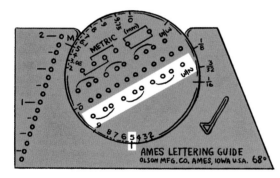

3. Look carefully at the holes. You'll notice that some of them are linked together with a parenthesis. These will tell you which sets of lines go together. More on this later.

Top hole doesn't have a parenthesis, but you still need to use it!

4. Tape a piece of bristol board to your worktable, and lay your T-square or ruler across it horizontally. Hold the T-square or ruler down so it can't move.

5. Put your Ames guide on the top edge of the T-square or ruler toward the left side of the paper, and insert your mechanical pencil in the very top hole of the 2/3 row—the one that isn't connected by a parenthesis.

6. Drag the Ames guide across the paper, along the top of the T-square or ruler, with your pencil.

7. When you get to the other side of the paper, put your pencil in the next hole down the row, and drag the Ames guide back to where it started. *Do not move the T-square or ruler.*

8. Continue down the row of holes, using each and every hole in the 2/3 row. You will end up with a lovely set of ten parallel lines.

9. Pick up the Ames guide and find the parentheses. Draw the parentheses on your paper, linking the lines they correspond to (once you get used to the guide, you can skip this step, but it's very easy to get confused at first, so use this trick until you get comfortable).

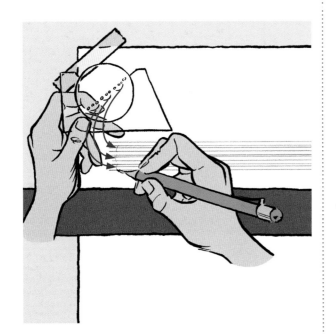

10. Take a good look at the lines you've made. You'll note that the sets of lines within the parentheses may be parallel, but they are not all the same distance apart. That's because when you're lettering upper- and lower-case, you want the height of your lower-case letters (officially called the "x-height") to be more than half the size of your upper-case letters. In this case, you might notice that the x-height is 2/3 of the total height … and you might go ahead and make an educated guess that the 3/5 row of holes will produce an x-height that is 3/5 of the total letter height …

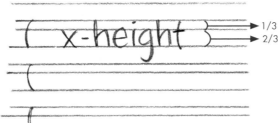

By the way, the middle row of equally-spaced holes on the Ames guide works fine for all caps but is not well suited to lower-case letters—you will end up with really tall caps and really small lower-case characters.

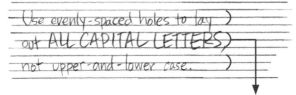

Use two, leave one blank.

11. Practice lettering. Practice with pencil first, then with nib pens, such as a bowl-pointed nib (see Chapter 8 for more on these) and/or technical pens. Use the illustration below as a guide to how the letters should fit on the lines.

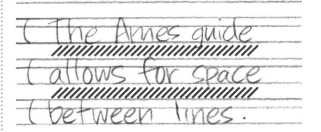

Note how the Ames guide is designed to make inter-spaces between lines of lettering. This space is also used for letters with descenders like p, g, or q. If your lettering takes up all the available space, you're not using the guidelines correctly. Double-check your parentheses against the Ames guide.

Making more lines

Sometimes you just have a lot to say. Three lines of lettering, which is what the Ames guide can lay out for you in one go, may not be enough for you. So, how do you lay out more lettering?

Notice that you've drawn ten lines with your Ames guide, but only nine of them are connected by parentheses. The remaining line is there so that you can continue making more lettering lines.

1. With your paper still taped in place, reposition your T-square just below where it was the first time. (If you're using a ruler, not a T-square, this is where your life gets more complicated. You have to make sure the ruler stays parallel to the guidelines you've already drawn. The lesson? Get a T-square.)

2. Position the Ames guide over the lines that are already there so that the lonely hole at the top of the 2/3 row is centered on the bottom line of the set you've already drawn.

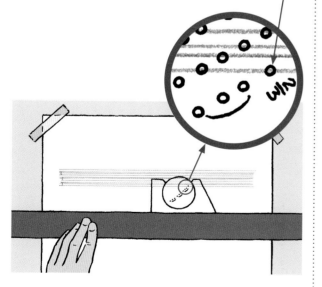

3. Hold down the T-square in this position, and run another set of lines, using the same diagonal row of holes you used before.

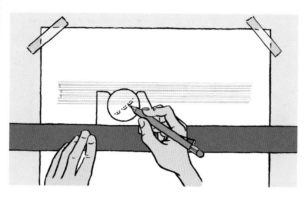

4. You can also position the Ames guide so that the bottom hole is over the top line, and continue your guidelines upward.

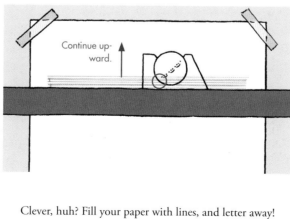

Clever, huh? Fill your paper with lines, and letter away!

Guidelines for all upper-case lettering

These same guidelines can be used when you want to create all upper-case lettering by simply ignoring the x-height line—this is how classic comic book letterers do it. You can also use the center row of holes, which are evenly spaced. Simply use two lines for your row of lettering, and then leave one line blank between rows. ■

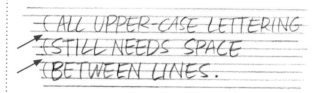

Making word balloons

One of the trickiest aspects of hand lettering is making the word balloons. They often look so perfect that people assume the balloon shapes are made with templates—and they can be, certainly. But with almost every phrase you letter, the width of the panel and/or the number of lines of text will change. You'd have to have a massive collection of templates to cover all eventualities. Not to mention the fact that your hand-lettering style may not look that great with a mechanically perfect oval balloon. For these reasons, perhaps surprisingly, those smooth ovals are mostly just sketched by hand.

Ink your lettering first, then quickly sketch in an oval around the lettering, leaving plenty of air around the words.

Once you work at it a bit, you can find a nice smooth shape within your sketch. Ink the balloon carefully, not in a single go but in short, overlapping strokes.

If you want to use an ellipse word balloon template, you should still letter first and hand sketch the balloon. Then move the template around your hand-sketched balloon until you find an ellipse that fits. You may have to try multiple templates to find the right one. Ink the whole ellipse using a technical or pigment pen, and then add the tail (use graphic white, which we explain later in this chapter, to connect the tail to the balloon afterwards).

You can even use the ellipse template to make neat, mechanical tails.

And don't forget: Oval isn't the only shape you can use for word balloons. ■

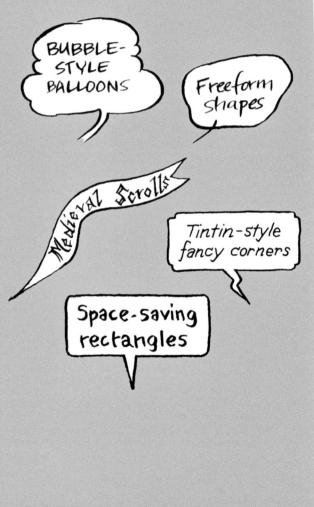

A comic with no pictures

Now you are going to draw a comic with a twist: You can't draw any pictures! This activity serves two purposes. One is to practice laying out a page as described in Chapter 6: measuring out your live area and laying out your tiers and gutters, as well as learning about inking panel borders, deciding on panel sizes, inking lettering and sound effects, and so on. The other is to challenge you to see what kind of story you can tell using only empty panels and lettering.

Materials
- minimum 14" x 17" sheet of bristol board
- pencil and eraser
- beveled ruler
- triangle
- T-square
- Ames Lettering Guide
- pens (technical pen, ruling pen, pigment pen, and/or nib pen. Do not use gels or ballpoints, or other ordinary writing pens.)
- waterproof india ink
- graphic white or white acrylic or gouache for corrections
- brushes for applying blacks and graphic white

See the sidebar, "Ruling a straight line," in this chapter for more details, and, if you'd like to try them, information on nib pens, brushes, and india ink in Chapter 8.

Instructions
Lay out, pencil, and ink a one-page comic that tells a story without using any drawings.
1. Come up with a story that can be told using no images—let the very idea of no images be a starting point: What is a situation in which something might happen in a field of white or black? Classic examples would be a scene with two characters caught in a snowstorm or having a conversation in total darkness. But you can be more creative than that!
2. Make a thumbnail. You can use as many panels as you want, and you can include lettering, thought balloons, speech balloons, narration boxes, emanata, and sound effects. You can leave the panels white or you can fill them in with black (use a brush for this!), but you can't draw any shapes; the panel has to be either white or solid black (not gray).

Again, the comic should still tell a story despite the lack of images. Think about how you can tell a story entirely through the placement, size, and rhythm of panels, use of text (dialogue, sound effects, narration), and emanata.
3. Choose your page size: It's a good idea to stick to either a 2:3 or a 3:4 ratio, which translates to a 10" x 15" or a 12" x 16" live area.
4. Lay out your page carefully, setting up your panels, tiers, and gutters. Refer back to Chapter 6 if you need to.
5. Lightly mark in pencil where your lettering and effects will go.
6. Use the Ames guide to lay out lettering lines, then pencil your lettering. If your lettering isn't fitting right on the lines, or if it's hitting the side of the panel … ERASE, and do it again. Don't put up with sloppiness.
7. Pencil any emanata and sound effects you are using.
8. Ink your page. Start with the panel borders. Use a ruler, and either a technical pen, a ruling pen, or a pigment pen to ink straight lines.
9. Next, ink your lettering. You can use a pigment pen or technical pen. If you know how to use a nib pen, feel free to use it. If not, don't worry about it: We'll get into that next chapter.
10. Ink word balloons and narration boxes, double-checking first that they frame your lettering effectively.
11. Ink the emanata and sound effects, then fill any black areas with a brush.
12. CORRECTIONS. Don't start correcting before you finish inking—you never know when your ink blot will turn out to be invisible under the other ink you lay down. But once you're done inking, don't think you're done until you correct all your mistakes with graphic white! If a panel goes too awry, use a new piece of bristol, and draw a replacement panel. See Chapter 8 for more on corrections.

Finish this page for homework, along with the homework assignment later in this chapter. When you finish, make a photocopy of your page so that it fits on an 8.5" x 11" piece of office paper. Sometimes that's easier said than done, so read on. ∎

7.2
The photocopier

THE GOOD, THE BAD, AND THE UGLY

At the outset of your comics career you'll find you need to make photocopies frequently, and even if you have your studio set up with a printer and scanner, there still will be times you need them. Knowing your way around one of these sophisticated yet clunky and old-fashioned machines is incredibly important for any cartoonist. If you don't learn photocopies now, one day you'll find yourself up against deadline facing a cranky copy shop machine, and you'll wish you'd figured it out earlier!

First of all, try to get access to a "classic" copier and not one of the new-fangled digital copiers—the new ones make better copies in a lot of ways, but the nondigital copiers make crisper copies of line art because they have no fancy "photo" settings (which make line art look fuzzy).

The key to effective photocopier use for cartoonists is knowing how to override the automatic settings on the menu. When you need something to come out on letter-size paper (i.e., for this chapter's activity), don't let the machine spit out an oversized sheet that you'll have to cut down messily. Set the paper size to "manual," and select letter size. If you are using a digital copier, don't let the "photo" setting take over. Find the "text" setting if there is one—remember, you want clean black and white and no grays or fuzzy lines, and that is what the "text" setting will give you. Manipulate the contrast. Get down to the various levels of choice the machine offers you. Mostly, bring extra money for messed-up copies!

If the original page is too big to fit on the glass of the copier, make one reduced copy of the bottom half, and one reduced copy of the top half. Carefully trim the overlapping section off one of the copies, tape the two copies together, and then make a final copy, reducing as necessary to fit the comic all on one page.

It's really important that this final copy is good quality, and the right size. All of your pencils should be erased, and any smudges that appear on the copy should be cleaned up. Don't get lazy and make an oversized copy, or a correctly sized copy on oversized paper that you trim down. This may be the first time that you're assigned a format for your final work, but you hope it won't be your last—professionals have to grapple with required formats all the time.

Get comfortable with the machine now, and you'll have a relatively easy time of it later. ∎

Ruling a straight line:
some tools that will help

Technical pens ⸺

The best tool to start out with when you're inking panel borders and lettering is a technical pen, as we mentioned back in Chapter 2, in the "Putting pen to paper" sidebar. This is a type of pen that was designed for architects and mapmakers, back when they didn't use computers for everything. The most common brands are Rapidograph and Rotring. They cost about $15 each, and you should start with a .50 or .60 mm version, since that's nice and medium-sized. These pens have lots of moving parts and are filled with lovely thick black india ink, but that means they can easily clog if not used for a while, so keep yours flowing by using them regularly, and cleaning them. A technical pen will come with full instructions on cleaning, and that's one owner's manual you might want to read.

Ruling pens ⸺

A ruling pen is a simple and very useful tool for inking straight lines. It looks like a pair of tweezers and the ink is held between the two blades. You can adjust the width of the line by turning the little wheel. To use the pen, use an eyedropper to ease a bead of ink between the blades or simply dip it in ink and wipe off the excess ink on the side of the jar. Hold the pen perpendicular to the paper as you run the bottom blade along a beveled ruler or T-square.

how to hold a ruling pen

Beveled ruler ⸺

If you're using a technical, ruling, or nib pen to rule your lines, you'll immediately find that it's not as easy as it looks. Often the ink wants to spread out under the ruler. Here's the key to preventing this: the inking bevel. On most rulers, if you look closely, you'll notice an edge that's either cut away (plastic rulers) or raised by a strip of rubber or cork (metal rulers).

metal ruler

plastic ruler

This isn't accidental. The cut or raised portion of the ruler is known as the inking bevel, and it is designed to keep liquid ink from contact with the ruler edge. Lay the ruler down on the paper with this inking bevel on the underside. You can improvise a bevel on a flat ruler by taping a few coins to the underside. Keep your pen upright, so that the tip doesn't angle into the bevel. The bead of ink that you lay down, seen in profile, will look like this:

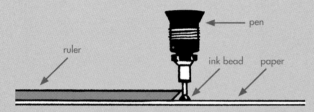

If you allow the bead of ink to touch the ruler edge, the surface tension of the ink will grab on to the ruler and flow along its surface, creating a giant blob on your ruler and your paper!

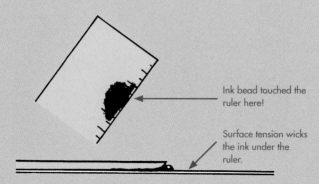

Ink bead touched the ruler here!

Surface tension wicks the ink under the ruler.

Brush for spotting blacks

We will talk more about brushes in Chapter 13, but for the time being you should buy a round watercolor brush for filling in black areas, also known as "spotting blacks." We have seen far too many cartoonists—sometimes even pros—wasting their time, arm muscles, and eyesight laboriously filling in large areas of black by scribbling with a pigment marker. A brush makes spotting blacks much easier—and the final result even looks better. Your spotting brush can be synthetic or natural hair and should be of a decent size, #3 or #4. Keep the brush in good shape by not plunging it all the way into your ink jar (keep the metal part dry) and by washing it out with water and mild soap when you're done with it. For difficult shapes like letters (a big "BLAM!" sound effect, for example), ink the outline in pen and then fill in the rest of the form with your brush. With a bit of practice you'll find you can quickly and accurately fill in even very complicated areas.

Graphic white

Graphic white is white paint that you use to correct mistakes. It is not, however, a correction fluid like Wite-Out.

Get something like this.

Not this.

Although some cartoonists do use it, correction fluid is blobby and hard to draw over, and it often isn't archival. It's also hard to apply accurately. We strongly recommend using an opaque white ink or a tube of gouache or watercolor that has good brushing qualities and good coverage. You may have to try several brands. Some reliable ones are Winsor & Newton, Pro-White, and Deleter (numbers 1 or 2). Be prepared: This stuff is thick and gooey; it has to be to cover anything. Stir when you open it and again every once in a while. Apply it with a brush (see note below). Our method of dealing with graphic white is to use the lid of the jar as a palette, mixing a little white and a little water (from an eyedropper) until we have the right consistency. As the lid is used repeatedly, a ring of dried white tends to build up, which serves as a handy little bowl. We call it the "volcano." Graphic white dries out quickly, so keep the jar closed when you're not using it.

Some people use white acrylic paint or gouache right out of the tube, but it may or may not be opaque enough. If you want to experiment with it, try titanium white, as it's more opaque than other white pigments. For more on making corrections, see Chapter 8.

Brush for applying graphic white

You'll want a small and relatively stiff round watercolor brush to use with your graphic white. ■

Homework
"A month of Sundays" penciling and lettering

Materials

- 14" x 17" sheet of bristol board with 12" x 16" live area and four tiers laid out (this is the one you laid out in Chapter 6)
- your revised thumbnail from "A month of Sundays"
- penciling tools
- eraser
- ruler
- Ames Lettering Guide
- mechanical pencil
- T-square
- inking tools

Instructions

1. **Title design**. Think of a title for your "A month of Sundays" one-page comic and decide where you want it to appear on the page. You might want the title to run across the top of the whole page, or you might want to make it take up the space of the first panel. Make ruled or freehand guidelines in pencil where you want your title to appear, and roughly sketch your title using a light blue erasable pencil, aiming first to fit all the letters in without crowding. After you have the title roughly laid out, go back in with an HB pencil and develop your lettering in an interesting style, using a ruler and ellipse or circle templates if appropriate. You might use simple block lettering, imitate a font you like, or try a looser, hand-made style—imagination and legibility are your only limits! Look at examples in your own comics collection for inspiration. We'll discuss this topic more fully in Chapter 11. Jump ahead and take a peek if you like.

2. **Lay out panels**. On your bristol board, lay out your tiers and panels according to the plan you made in your "A month of Sundays" thumbs. Use your T-square and ruler, and make sure the vertical gutters are the same width as your horizontal gutters. Refer back to Chapter 6 to review this idea, if you need to.

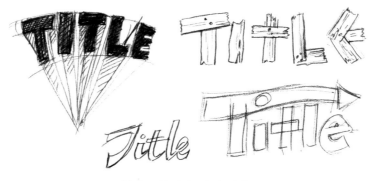

Work on title designs in sketch form.

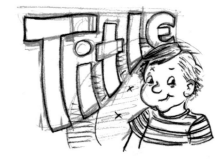

The rough version is in red—we've tightened it up in gray.

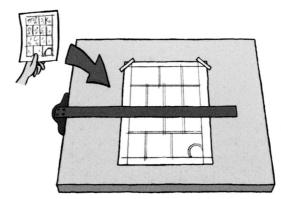

3. **Rough Pencils**. Take your revised "A month of Sundays" thumbs and lightly block in those images in pencil on the bristol board you have just laid out. Start by blocking in simple shapes (this is one stage where you might want to use an erasable blue pencil). Using a light hand, block in your dialogue lines where they belong. Pencil the words freehand so that you get a sense of how much space they'll take up. If you've overwritten, you will start to figure that out now.

4. **Pencil lettering**. First use your Ames guide and mechanical pencil to create lettering guidelines right over the lightly blocked-in rough lettering. Then pencil your lettering carefully, making sure your letters and words are evenly spaced. Erase and start over if you have to; it's better to get the lettering right in the pencil stage than to wing it while you're inking.

Freehand guidelines can help you center your lettering.

5. **Ink lettering, balloons, and panel borders**. Once you're satisfied with your lettering, ink it, and then ink your word balloons. Make sure the lettering still fits comfortably in the balloon. Make any adjustments to the size and shape of the balloon before you ink it. Finally, ink the panel borders.

6. **Refine your blocked-in drawings using an HB pencil**. Don't forget about the penciling tips in Chapter 5. Review them if you're getting stuck.

The order of work in this homework assignment is very important. Mark this page and keep it handy until you get used to working this way. ■

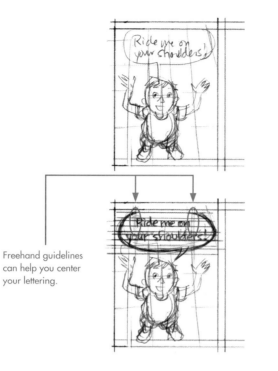
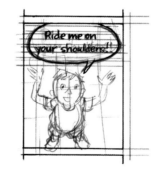

Extra credit
Lettering that speaks for itself

There is a strong tradition in comics of using hand-lettering styles to reflect and enhance characterization. Walt Kelly, the creator of the long-running newspaper strip *Pogo*, most famously used this technique. Will Eisner and Dave Sim have also used it frequently. Now you've got a chance to try it out.

Materials
- inking tools
- lettering tools

Instructions
Create lettering styles for each of the following three characters. The style should reflect the personality and characteristics of each. You should also develop a word balloon style that goes along with the lettering style.

- a robot
- a knight
- a child

Below, you'll find a practice sentence and three statements. Draw guidelines using the Ames guide, and warm up by lettering the practice sentence in various styles. Then rewrite three statements in the voice of each character (i.e., rewrite the dialogue as a knight would phrase it). Once you know what words you want to letter, develop lettering styles that match or enhance your concept of each character, and letter the dialogue. Make appropriate word balloons to hold the lettering—remember that word balloons can express character too. Do not draw the character! Let the lettering stand on its own.

Here is your practice sentence:
The five boxing wizards jumped quickly.

This is a *pangram*, that is, a sentence that contains all the letters of the alphabet (another pangram is "the quick brown fox jumps over a lazy dog"—which you can use instead if you prefer).

And here are three statements that you should rewrite to reflect the personalities of each character. Think hard about voice here!

Statement 1: **I am in charge.**
Statement 2: **Your [technological item] can't stop me.**
Statement 3: **Give me [nourishment].**

Talking points
Show your lettering samples to one or two friends not familiar with the exercise, and see what they understand about the characters just from the lettering. Can they guess what types of characters are supposed to be speaking? Talk about what clues they are picking up on. How could you make the lettering correspond more closely to the characters? ■

FURTHER READING

Brian Biggs, *Dear Julia*

Walt Kelly, *Pogo: The Complete Daily & Sunday Comic Strips*

Dave Sim, *Cerebus*

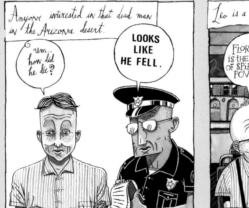

Copyright © Brian Biggs

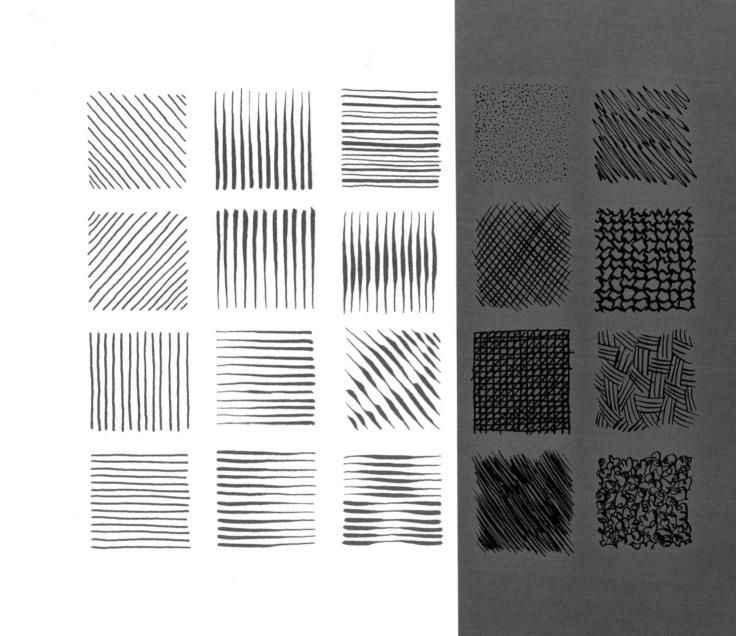

Inking the Deal

Technically, comics can be drawn with just about anything. But around the world, the vast majority of comics are drawn with ink. In this chapter, we'll talk about why, and get you started learning how to ink.

8.1

Inking with a nib pen

WHAT IS INKING FOR?

You don't have to ink to make comics—some artists print their pencils; others "ink" on the computer; still others work in different media, like scratchboard or collage. However, inking is a technique that is deeply intertwined with what we think of when we think "comics." There's a good reason for this: Comics is a medium that is defined partly by the fact that readers don't typically read the original drawn page. Instead they see the art in some reproduced form, whether the form is olde-styley offset printing or newey-styley web reproduction. And reproduction entails a reduction in fidelity, meaning that the reproduction of a thing will never have exactly the same qualities as the thing itself. In comics, reproduction is actually several long steps away from the original work—we reproduce comics on cheap newsprint paper or low-resolution screens, and in a size up to 50 percent smaller than the original, to boot.

What does this mean? It means that bold, sharp pen or brush-and-ink lines are very well suited to comics. They lose relatively little when made smaller and copied, even several generations of copies later. Good cartoonists are constantly aware of the fact that the images they draw and the words they letter will go through some rough handling before their readers get hold of them, and they work with the reproduced comic in mind.

WHAT'S A NIB PEN?

One of the most important inking tools is known as the nib pen. A nib is a tiny piece of cut and rolled steel designed to fit into a plastic or wood "nib holder," forming an old-fashioned dip pen. A nib pen has no ink cartridge; you have to dip the nib into a jar of ink every so often to keep working.

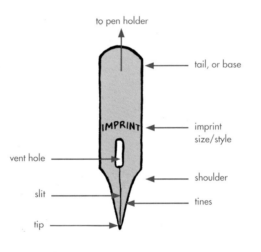

At first, beginning cartoonists may find this antique technology frightening. But let us remind you: This is the exact kind of pen your ancestors had to use when learning to write—at the age of five. It is not rocket science. You can master the nib!

Phoebe Gloeckner is a master of creating textures and moods through varied ink line and cross-hatching techniques. She is also particularly good at conveying personality and expression in people's faces with a minimum of marks.

Copyright © 2008 Jaime Hernandez

Jaime Hernandez's line is so fluid and sensual that you might think he inks with a brush. In fact, he inks his lines with a Hunt 22 nib, which is stiff enough to give him great control but also flexible enough to create varied lines.

Copyright © 2008 Franco Matticchio

Franco Matticchio is an Italian cartoonist and illustrator whose effortless-looking pen drawings are full of charm and sophistication. His cross-hatching, which evokes classic book illustrations, creates a palpable, animated environment that drives his stories forward.

WHY NIB PENS?

Why are we making you put down your beloved markers and rollerball pens and draw like a primitive human from the ancient 20th century?

The number-one answer to this question is simple: expression. Nib pens are immensely expressive, or can be, once you get the hang of them. They are flexible and sharp, and they can make a vast number of beautiful marks, each different from the next. Your work will be enriched and improved by what you can do with these tools.

There's also the fact that india ink, which is what you use with nib pens, is a beautiful deep black (as long as you have good ink). It is completely archival, so your artwork will last longer than you will.

Most of you will have been using markers for your art up until now (we hope at least you were using pigment pens and not "permanent markers"). Markers create fuzzy and imprecise lines, which might be exactly what you want in terms of your personal style. But to limit yourself to just that kind of mark is a mistake. On the other hand, nib pen lines (and brush lines, which we'll discuss in Chapter 13), reproduce beautifully. In the end, that's what choosing a tool to create your comics is all about.

It's hard for a lot of young cartoonists to wean themselves from markers, and of course, you can use whatever you want. You don't have to ink at all, or even draw on paper. But it's important to try out new tools and techniques and see what ideas they inspire. Even being bad at something for a while can be a productive experience.

8 Inking the Deal

Homework critique for Chapter 7 on pages 241 and 242

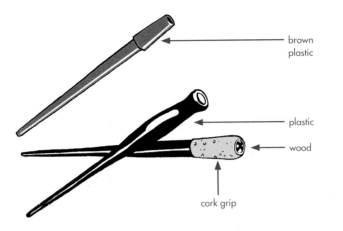

brown
plastic

plastic

wood

cork grip

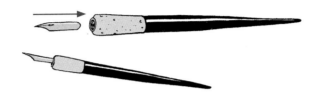

SELECTING A NIB

Steel drawing nibs are available from several producers, and each offers a bewildering variety. And there's no easy way to figure out how one nib is different from another—the identification numbers etched on the nibs are often more confusing than helpful. There are, however, several things to keep in mind that will help you decide which nibs you want to buy.

Two basic kinds of nibs
The first thing to know is that there are essentially two kinds of nibs: lettering nibs and drawing nibs.

Generally speaking, a lettering nib has a flat tip that may be square or round, and it usually has a brass plate attached to retain ink. Lettering nibs are designed not to be flexible, but to make even lines of a specific size and shape. Thus, in comics, they're mainly used for lettering and for inking panel borders.

Drawing nibs are pointed and don't have brass plates. They come in two basic shapes. One type, known as a crow quill, is small and tubular and fits into a small brown Hunt nib holder; the other type, which is much more common, is crescent-shaped and fits into larger nib holders made by various manufacturers including Speedball and Koh-I-Noor.

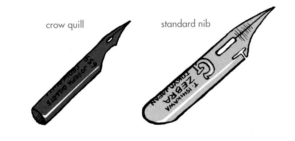

crow quill standard nib

Bowl-pointed nibs
"Bowl-pointed" nibs (Hunt and Deleter make them) fall somewhere between lettering and drawing nibs. They have a stiff, blunt tip, and a slightly bowl-shaped body, which holds a bit more ink than the usual nib. They won't give you the level of expressiveness you can get from other nibs, but they are excellent for drawing straight lines and for lettering.

The thumbnail test
A good way to find out if one of the many types of nibs is right for your purposes is to press the point of the nib against your thumbnail. This will give you an idea of how stiff, pointy, or flexible the nib is.

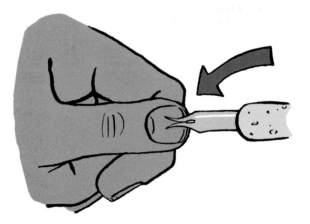

Nib characteristics

Nibs have two main characteristics: flexibility and fineness of point. Therefore you can say nibs are either stiff or flexible on the one hand, and either coarse or fine on the other. These two measures don't necessarily correspond—that is, a stiff nib can be either coarse or fine. The chart to the right will give you an idea of the flexibility and fineness of a variety of nibs commonly available today.

Buying nib sets

A good way to start learning about nibs is to buy one of the prepackaged nib sets offered by various pen-makers:

1. ***Rexel Drawing Pens Set***. This contains eight Gillott nibs of various levels of flexibility and fineness.
2. ***Speedball (Hunt) Sketching Pen Set***. The "sketching" set is the best choice. It's more versatile than the "artist's" or—despite the name—"cartooning" sets.
3. ***Deleter Trial Pen Set.*** This is an assortment of nibs used by some manga professionals.

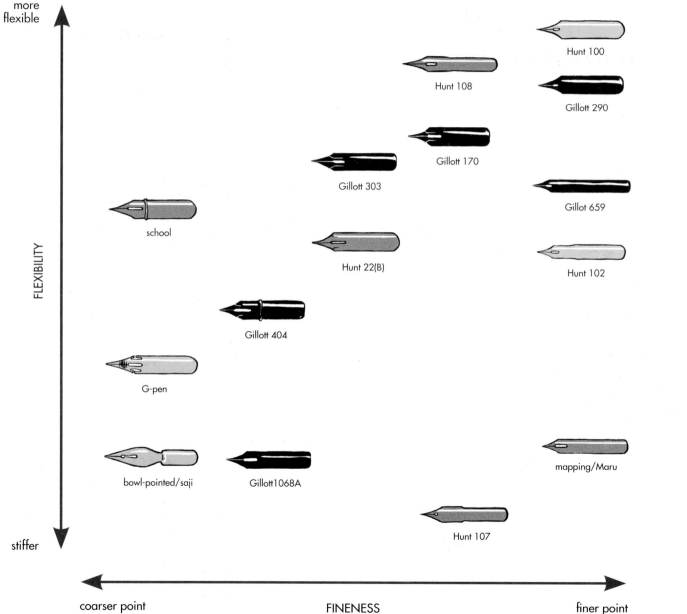

HANDLING A NIB PEN

Some nibs—those made by Gillott, for example—come with a factory coating that you need to remove before using the nib for the first time (it's to keep the nib in good shape before sale). Drop your nibs in boiling water for about 30 seconds or hold them over a lighter before using them. Some artists suck on the nibs, but we don't recommend that!

Hold the nib pen as you would a regular pen, with the top of the nib—the convex side with the imprint—facing up.

Before you dip your pen into the ink, press on the underside of the nib and observe what happens to the tip of the pen. The two tines of the pen spread apart from each other. This spreading due to pressure is what will allow you to control the width of the lines when you draw.

Dip your nib in your ink bottle (don't use a palette dish; it's too shallow), immersing the point about halfway. Ideally you'll want to fill the vent hole of the nib, but not get ink up in the pen holder, where it'll start making a huge mess of your fingers (india ink washes off skin fairly easily, but not out of clothes). The ink's surface tension allows a small amount of ink to cling to the nib so that you can draw for a while before having to dip again.

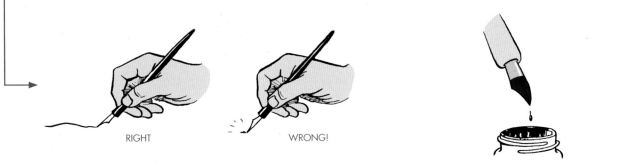

RIGHT WRONG!

Drawing with the nib pen is fairly intuitive, but be aware that you can't maneuver as freely with most nibs as you can with, say, a ballpoint pen. Drawing the nib pen toward you is always a good idea, whereas pushing it away from you, against the tip of the nib, is a recipe for splattering ink and breaking the nib. For certain lines, especially long horizontal lines and very thin ones, you might try holding the pen sideways.

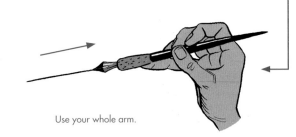

YES YES NO!!

Use your whole arm.

DRAWING WITH A NIB PEN

Once you have a good ink flow from your nib, practice making marks on a piece of scrap paper or in a sketchbook. Keep your hand relaxed and draw by moving your whole arm across the page, not just your wrist.

Try holding the pen in different positions and observe the way applying varying degrees of pressure changes the thickness of the lines. If you apply too much pressure, the two points of the pen will spread too far apart to hold ink. You might even accidentally bend or snap your nib.

Practice some basic strokes to get a feeling for what a nib can do. Take a sheet of bristol board and draw, in pencil, a grid of small squares 1 or 2 inches wide and tall. Now, fill each box with different sets of parallel lines: vertical and horizontal lines, diagonal lines in both directions, lines of equal weight, lines of varying weight, and so on. Don't change your position or move the paper at this point: You want to practice making lines in all directions from the same position.

When you are drawing in pen you can draw outlines but also create tones of various sorts. Try filling up the squares with some different patterns: cross-hatching, stippling, scribbling, and any other patterns you can think of. As with linework, you can get different effects by varying pressure on the nib and the speed of your pen strokes.

You can learn a lot by replicating the same practice sheet three or four times, using different nibs. It's a great way to demonstrate for yourself how nibs are similar or different.

Draw a grid of 1-inch squares like this one (actual size):

1"

1"

Practice drawing lines.

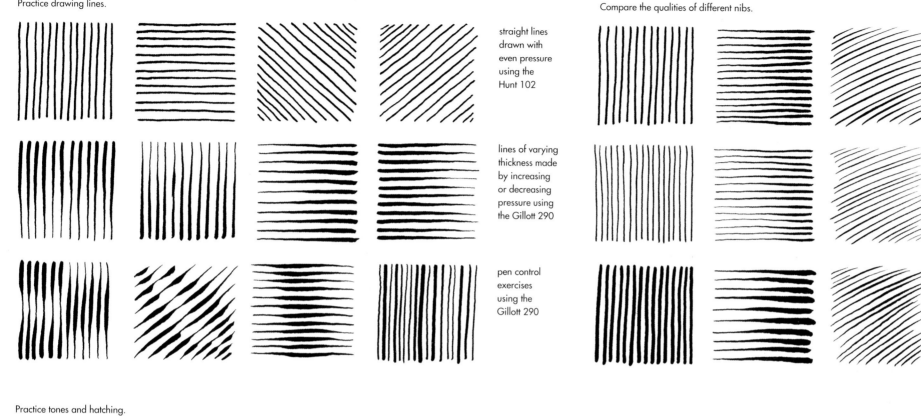

straight lines drawn with even pressure using the Hunt 102

lines of varying thickness made by increasing or decreasing pressure using the Gillott 290

pen control exercises using the Gillott 290

Compare the qualities of different nibs.

Hunt 102

Tachikawa mapping quill

Gillott 290 (I had to draw these lines very carefully because this nib is so delicate)

Practice tones and hatching.

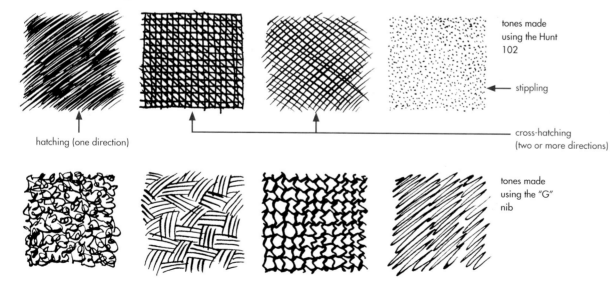

tones made using the Hunt 102

stippling

cross-hatching (two or more directions)

hatching (one direction)

tones made using the "G" nib

Next, try drawing curving lines of varying lengths and eventually try drawing circles. You will find that only by using the coarsest, stiffest nibs can you easily draw a complete circle. Most nibs will catch, skip, or stab the paper, so practice making circles in two strokes drawn toward you.

Turn paper for larger circles.

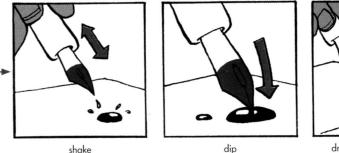

shake dip draw (repeat as needed)

TROUBLESHOOTING NIBS

First experiences with nibs can be frustrating because there are lots of little things that can go wrong. With a bit of practice, though, anyone can get a handle on using nib pens. Here are a few problems you might encounter:

- **No ink comes out of the pen.** New nibs take some patience to wear in, especially some of the finer ones. Make sure you have removed the factory coating. Make sure you are holding the pen with the convex side facing up. Try sanding down the point a bit on some very fine wet/dry sandpaper. (Put a drop of water on the sandpaper and carefully draw on it in your usual drawing direction or in small circles.) If there's still no ink flowing, carefully shake a little bead of ink onto your scrap paper and dip the nib in it for a quick charge. Make sure your nib is fairly clean as dirty nibs can clog easily. After all this, it might be that you just have a bum nib. It happens. Luckily for you, nibs are relatively cheap, so just chuck it and use a new one!

- **The lines I draw are bleeding.** Because nibs are sharp, they tend to tear paper fibers. On lightweight paper or paper that is improperly manufactured for drawing with ink, these tears will cause the ink to spread out from the line you've drawn in feathery marks. Bristol board is specifically manufactured to accept ink without bleeding. However, sometimes the manufacturers do a bad job—this is why you should test the paper out before buying. In general, the heavier-weight, better-quality paper you use, the better results you will get. If you are still getting bleeding lines, the environment you are working in may be too humid. Or you could be creating that environment with your own damp hands. Try wearing a cotton photographic glove or a sock with finger holes cut out.

- **My nib won't fit into the holder.** First, make sure you are using the right nib holder for the nib you are using. If, on the other hand, the nib falls out too easily, try sticking a layer of tape over the base of the nib before inserting it in the holder.

- **I dropped my pen and now it won't work.** Nibs are delicate things. If you bend the tip the slightest amount, ink will not flow and there is no way to fix it. Sorry. But again, nibs are fairly cheap, so just use a new one.

- **I'm smearing my ink all over the page.** Ink takes a long time to dry. When you lay down a line with a nib pen, particularly if it's a nice fat line, the line can take minutes to dry. If it's a humid day, drying will take even longer. Remember to start inking at the upper left of your page, work across, then down (or start on the upper right if you're left-handed). Make a complete pass inking the page, and then leave the paper aside to dry before inking further details. If you're working on more than one page at a time, you can set one aside to dry while you work on another. Don't get impatient! It will only lead to tears.

- **I've only just started and my page is already all messed up.** What, you dripped ink on your page? Your nib caught and spattered? Join the club. That's what graphic white is for! Seriously, don't worry about it. Just keep inking, and when you're done, you can either correct the mistake, or sometimes, it will just blend in. ∎

FURTHER READING

Arthur Guptill and Susan Meyer, *Rendering in Pen and Ink: The Classic Book on Pen and Ink Techniques for Artists, Illustrators, Architects, and Designers*

Klaus Janson, *The DC Comics Guide to Inking Comics*

Gary Martin, *The Art Of Comic-Book Inking*

Joseph A. Smith, *The Pen & Ink Book: Materials and Techniques for Today's Artist*

8 Inking the Deal

Lorenzo Mattotti is best known for his pastel work in graphic novels and in magazines like *The New Yorker*, but he is in many ways even more impressive as a pen artist. Using a variety of nibs, Mattotti attacks the page with a bewildering variety of painterly marks. He must break several nibs a page drawing like this—let's all be glad nibs are so cheap!

👉 Inking tools

Nibs are covered in great detail in this chapter; we discussed technical pens and ruling pens in Chapter 7, and we'll cover brushes in Chapter 13. But what about other inking tools?

Inking setup
This arrangement is for a right-hander; reverse it if you're left-handed.

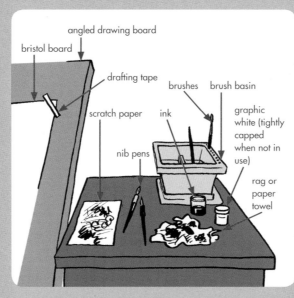

Ink
How basic is that? But not just any kind of ink will do. First of all, make sure that you use india ink. India ink is finely ground solid carbon suspended in water and mixed with a binder, a kind of glue that sticks it to the paper. It comes in waterproof and non-waterproof varieties. You may encounter "calligraphy" or fountain pen ink, but it's thin and not waterproof, so you should avoid it. Another ink you may encounter is sumi ink. It's a good choice, black and thick, but it's usually not waterproof, which can be a problem when you're making corrections. It's also a bit too thick for nibs. Lastly, you may run across acrylic inks, which are basically fine, but they can wreak havoc on your brushes if you don't clean them carefully.

Even when you buy india ink, you may find that the ink is gray and washed-out looking. We have found that the quality of many inks has gone down noticeably over the years. Brands once reliable for a consistent jet-black sheen are now instead watery and gray. If you end up with bad ink, leave it open to evaporate for as long as necessary (days, or weeks, even), and/or pour a very small amount at a time (a teaspoonful, maybe) into a small palette with round indentations (round so the ink evaporates evenly). It should evaporate fast enough for you to use in a half hour or so.

Good brands to try include Koh-I-Noor Universal 3080-4, (which is sold in a squirt bottle, so you'll need a small jar with a tight lid to decant it into); Winsor & Newton Black Indian Ink (with the spider on it. It's extremely black and glossy, so you may need to mix in a little water); and Dr. Ph. Martin's Black Star India Ink, "matte" or "hi-carb" (that's carbon, not carbohydrates!). We're not sure what's in Deleter's "black inks," but they seem to work well and they have six different number- and color-coded varieties whose uses are explained on the Deleter website.

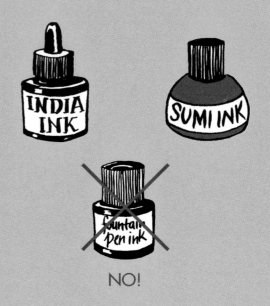

NO!

Brush basin

This is a tool that is used primarily when inking with a brush, but even when you're just spotting blacks or using your correction brush, it's great. A brush basin can be square or round, but it's always divided down the middle into two compartments. Fill the compartments with water, and you're ready to go. One side of the basin contains ridges against which you swish your brush to loosen the ink or graphic white. The other side contains small indentations that will hold your brush suspended in the water so that it neither dries out (bad) nor stands on its tip (worse). We have found that the square-shaped basins generally hold brushes in place better than the round ones, but each manufacturer makes them differently, and we've also found that there are some basins with brush-holding slots that are too wide for the small brushes we use. Try out the basin you're considering buying, using a brush, while you're in the store. Does the brush sit in the slot without the tip touching the bottom? If the slot's too big, the brush will slip down and sit on its tip, and that's no good.

A few other ideas

To prevent your ink bottle from tipping over or sliding down your drafting table, tape the bottle down with masking tape or cut a bottle-sized hole in a sponge or small cardboard box, put the bottle in it, and tape the sponge or box to your desk. Some people keep a small brass brush face up on their desk to jab their pen into to clean their nib pens. A small eyedropper bottle filled with purified water for thinning ink or graphic white is also always handy when inking. ■

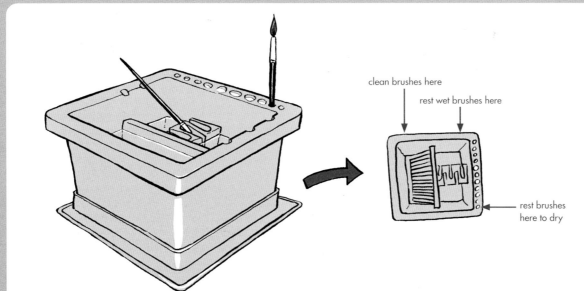

clean brushes here

rest wet brushes here

rest brushes here to dry

Barry Windsor-Smith's elaborate, elegant pen inking shows the influence of Alex Raymond (*Flash Gordon*), but also turn-of-the-twentieth-century illustrators in the Art Nouveau movement. His long strokes and low-angle hatching lend movement and roundness to his forms.

 A word on posture

OK, perhaps you're still young, and you don't end up with an aching neck after a day of cartooning. Believe me, brother (or sister), you will. Drawing comics requires untold hours of solitary attention to very small drawings, and the tendency for most artists is to hunch right down there and get close. And then they end up spending thousands of dollars on chiropractors and massage therapists (let's not even talk about surgeons) later in life. Don't let that be your fate.

The drafting table and drawing board are designed to tilt so that the art can come up toward your face and you don't have to get down there with it. If possible, learn to draw with your board set at a 60-degree angle, and keep a small table (aka taboret) next to you with your supplies on it. Get yourself a good ergonomic chair (that means a chair that's specially designed to support your body properly). Make yourself take breaks every half hour to walk around the room and stretch your hands, arms, and back (a few ideas for stretches are on the next page). Your future self thanks you.

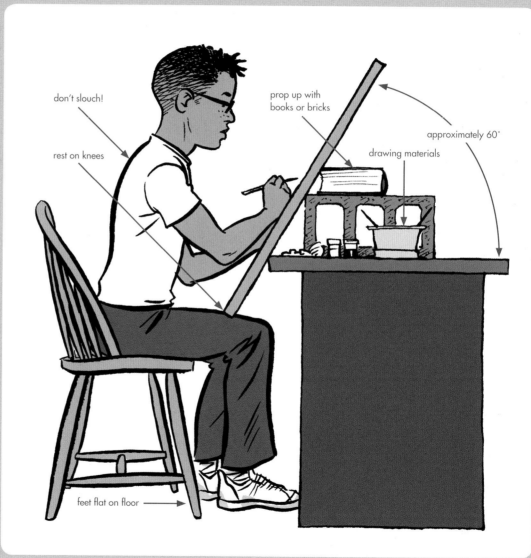

don't slouch!

rest on knees

prop up with books or bricks

approximately 60°

drawing materials

feet flat on floor

Some stretches for your breaks:

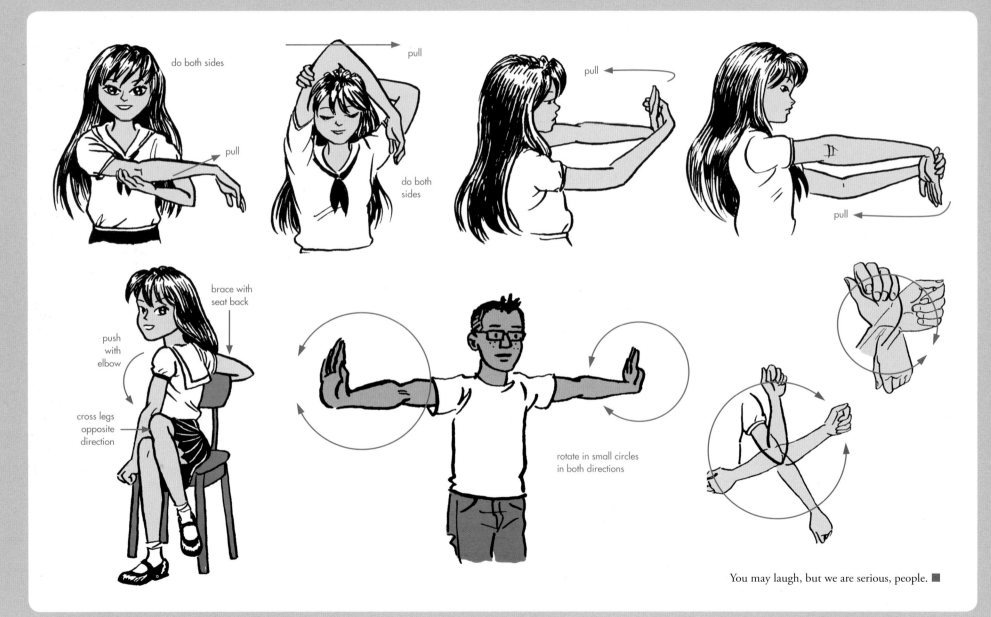

do both sides

pull

pull

pull

do both sides

pull

pull

brace with seat back

push with elbow

cross legs opposite direction

rotate in small circles in both directions

You may laugh, but we are serious, people. ■

 Ink your own drawings with a nib

Drawing little boxes full of parallel lines as we did earlier in this chapter is great practice, but to get a real sense of how nibs work, there's nothing like inking your own drawings with a nib pen.

Materials
- bristol board
- your penciled "A month of Sundays" strip
- penciling tools
- assortment of nibs and nib holders
- india ink

Instructions
Choose a panel that you like from your penciled "A month of Sundays" comic and trace or copy it onto a new piece of bristol board. (Refer to Chapter 5 and the "Making corrections" section on the follwing page for tips on tracing.) Ink the principal linework in your panel using a nib pen. Try different nibs for different areas of the drawing, or even within the same figure or object to see how they change the effect of your panel. Don't forget to wait for the ink to dry! After you have drawn the main lines, try some hatching patterns to create effects of light or texture. Keep in mind that you do not need to fill the entire panel with inked lines. Quite the contrary: White space is as important as black in an effective drawing.

Copy the same panel two more times, and try inking it differently. If you used a lot of texture the first time, lighten up. If you were very spare, use more hatching. Try different kinds of textures. Try using all your nibs. Working on more than one panel at a time, if the panels are on separate sheets of paper, is a good idea here—you'll be able to leave one aside to dry while you work on another.

One note of caution: Your first instinct may be to use your pen as you would a pencil, sketching shapes in and shading them with tiny marks. But pens are very different tools from pencils, and the kinds of effects you'll get are not going to be what you're used to. Try to remember what nib pens are good at—clean, bold lines; areas of white and black; simple, bold hatching; and tones—and think about how you can apply those strengths to your drawing.

You might be tempted to try other tools on this assignment, but stick to the nib pen and see what you can make it do for you. Do not use any ink wash (watery ink) for this project.

Talking points
Post everyone's three versions on a wall. Stand well back from the work to see which panels work best from a distance. Some will be crisp and clear, while others will look a bit like mud. Some will have subtle modulated grays, and some will be pure black and white.

1. Pick out a few favorites and compare and contrast them. What makes them work? What is it that makes them legible and attractive from a distance?
2. Compile a list of techniques people used. Think about how you might be able to utilize those ideas in the future.
3. Pick out some examples that don't work so well. Try to figure out why not, and what might be done to salvage them.
4. Move closer to the work and discuss "mistakes." What did you have difficulty with? Try to use the group experience to glean tips on how to approach problem areas.
5. Look for instances in which successful inking isn't tied to flashy drawing. Someone with minimal drawing background may have hit on a simple yet effective way to use the nib that brings their comics to life.

Note: To start to understand how your inked comics will reproduce, try photocopying these panels at 60 percent, and assessing the inks at that size. You can also photocopy your pencils (at full size) and test out inking ideas on the copies before committing to the bristol.

Ronin
You can find some examples of other students' work on the website, www.dw-wp.com; compare and contrast these examples to your own. ■

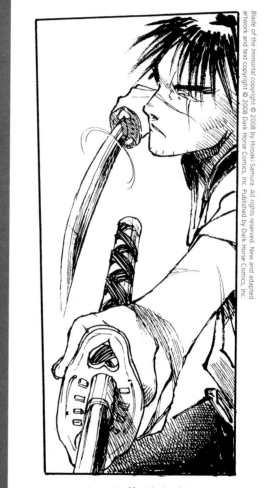

In comics like *Blade of the Immortal,* **Hiroaki Samura** creates a sense of elegant, violent motion with his inking by combining loose, confident contour lines with virtuosic, high-energy cross-hatching that seems to blend in with the motion lines and other emanata.

8.2
Making corrections

BASIC CORRECTIONS

There is no need to devote an entire chapter to corrections, but we all have to make them, so let's take a detour and talk about correcting inked drawings.

You will have probably found some things you want to change on your inked "A month of Sundays" panels after your critique. In some cases you might have smudged some ink before it was dry. In other cases you may decide you want to completely redraw all or part of a panel. Maybe you want to make a smile less broad or maybe a line is too thick and you want to "shave" a bit off. Using your graphic white (or white acrylic or gouache—see Chapter 7) and a brush, paint over ink smudges and make minor adjustments to your drawings where needed.

On the other hand, maybe there is a smile that is too short or a line that is too thin. In this case, get out your ink or an archival marker (this is one time when a pigment marker can be very useful) and use it to draw out a clipped smile or flesh out a meager line.

8 Inking the Deal

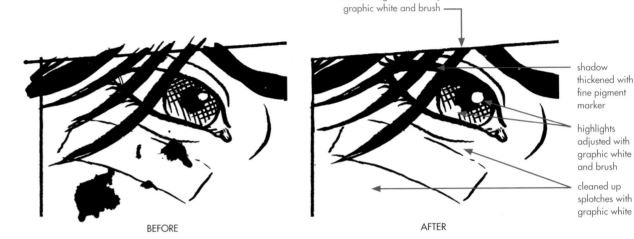

border edges cleaned up with graphic white and brush

shadow thickened with fine pigment marker

highlights adjusted with graphic white and brush

cleaned up splotches with graphic white

BEFORE

AFTER

hair fixed with white

expression fixed with graphic white and fine pigment marker

stubble added with white

BEFORE

AFTER

MAJOR CORRECTIONS: TRACING AND PASTING

Some corrections may be more trouble than they're worth to try to do with graphic white. This is where tracing and pasting come into play.

Tracing

If you find that a panel is beyond salvaging, you may want to start over. However, there are often parts of the original panel that you can reuse, so trace as much of your original drawing as will be useful. Maybe a head shape you originally drew is good but the facial features are a mess. If that's the case, trace the outline of the head and start your new panel from there. Or maybe the drawing itself is OK but the placement of the drawing is off-center. Simply shift your new panel border over until the drawing is where you want it, then trace it. Refer back to Chapter 5 for more on tracing. Below is an example of one of several techniques for making corrections using tracing and pasting.

Problem: You like the head but you want to change the rest of the panel.

Trace the part of the drawing you want to save.

Put registration marks in the corner (or trace the whole border). This will help you match up the new panel with your original page.

Trace onto a new sheet of bristol using a light box or other transfer method.

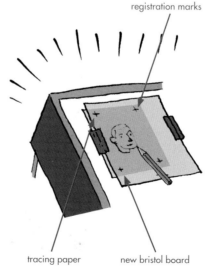

registration marks

tracing paper new bristol board

Pencil and ink your new panel.

Pasting

Pasting in new paper is a great way to correct lettering, too, whether it's a single word or a whole balloon's-worth. The best paper to use is the same one you used for your original page—bristol board with the same surface. Alternately, you can use other drawing paper or even decent sketchbook paper. You can also use blank mailing labels for a quick fix, but keep in mind that they aren't archival and will turn yellow and possibly fall off with time (see the "Making your corrections stick" sidebar).

When you reproduce work that's corrected with pasted-on paper, the reproductions (photocopies or scans) will sometimes show shadows along the edges of the pasteups. Just clean up the shadows on the reproductions by using correction fluid on a photocopy—the one time you want to use correction fluid—or a quick Adobe® Photoshop® correction on a scan.

Carefully cut out your panel.

Paste your new panel over the old one using a glue stick or archival tape.

photocopy

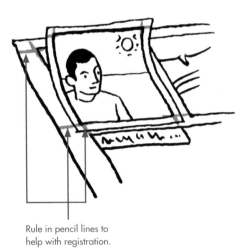

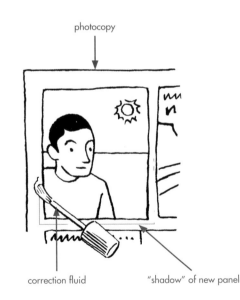

cutting board X-acto knife

Rule in pencil lines to help with registration.

correction fluid "shadow" of new panel

And speaking of Photoshop®, if you are already familiar with that or similar programs, you can of course make all of your changes and corrections on the computer. It might even save you time. Still, many of these corrections are just as easy to do on your originals, and it's always nice to make your hand-drawn pages look like finished works of art that you can frame, give as gifts, trade, and sometimes sell. We will be talking about scanning and Photoshop® touch-ups in Chapter 14, so for now you might just want to stick with the classic techniques. ■

☞ Making your corrections stick

Corrections come at the end of a long process of working on a page. You're probably tired, and you might be tempted to use whatever is at hand to do the job: Scotch tape, rubber cement, mailing labels.... However, if you care at all about the long-term condition of your art, you need to make sure that the adhesives you are using to paste on corrections are not going to turn yellow with age, or dry up and fall off, or both. Materials that are labeled "acid free" will not yellow as other materials will. Rubber cement, for example, while very effective at first, will yellow and fall off within a few years.

Here are some good options to consider:
- Garden-variety glue stick, as long as it's labeled "acid free"
- Archival double-sided tape, often sold in the scrapbook section of art supply stores as "scrapbooking tape"
- Acid-free sticker paper or mailing labels (look for uncut 8.5" x 11" sheets by the box; then you can cut them to the sizes you want)
- Positionable Mounting Adhesive: This is a roll of adhesive that you can transfer onto the back of any kind of paper (like bristol board, for example!). It's kind of expensive but very handy to have around, and a roll of the stuff will last you for years. ■

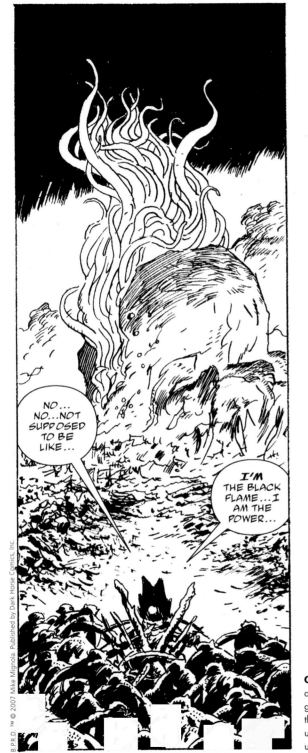

NO...
NO...NOT
SUPPOSED
TO BE
LIKE...

I'M
THE BLACK
FLAME...I
AM THE
POWER...

B.P.R.D. ™ © 2007 Mike Mignola. Published by Dark Horse Comics, Inc.

Guy Davis's inking style is characterized by sketchy lines and a great variation of line weights, from the most delicate to the blackest. He utilizes a variety of marks to build up a deep and believable space.

Homework
"A month of Sundays" inking

Materials
- your penciled "A month of Sundays" strip
- inking supplies
- correction supplies

Instructions
Using what you discovered in the critique of the three versions of the one-panel activity, ink your entire penciled "A month of Sundays" page. After the inking is complete (and completely dry!—wait a good half hour or more to be sure), erase all of your pencils, make any corrections necessary, and photocopy your page so that it fits on an 8.5" x 11" piece of office paper.

Absolutely do **not** use any ink wash, screen tone, or other gray tone: If you feel the need for gray, *simulate* the effects of those methods using hatching or line techniques. This is pure line drawing! ■

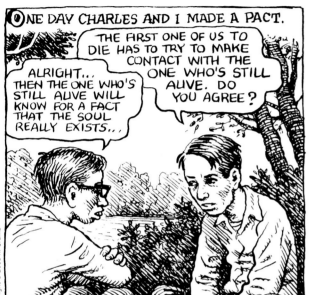

Robert Crumb is the master of whatever tool he touches, but for many fans he is inextricably linked with the scratchy, organic lines and hatching textures he creates with his Hunt 102 nib.

☞ More nib examples in this book

In the past, the nib pen was by far the most common tool used for drawing comics (although in almost all cases, solid black was inked with a brush). In contemporary comics, however, you are more likely to find that cartoonists combine pen and brush, using a brush for heavy foreground lines and sinuous shapes like hair, and a pen for fine detail and hatching. In fact, when looking for examples for this chapter and Chapter 13 (brush inking), we had a difficult time locating examples by artists who use exclusively one tool. We did manage to find a few. In addition to the examples in this chapter, there are others scattered throughout this book that are primarily, but not necessarily exclusively, drawn with a nib. Here is a guide:

In Chapter 3
- *Mutt and Jeff* and *Wash Tubbs* are both drawn using nib pens exclusively. In *Wash Tubbs*, especially, note the sharp, clean lines, and wide variation of line weights—this variation comes from using a flexible nib.

In Chapter 6
- *Krazy Kat* and *Thimble Theatre* (Popeye) are also both drawn with nib pens. Herriman's scratchy, angular linework belies the subtlety of his drawing, his ability to create carefully gradated tones and clear forms.
- Mike Mignola sets the bar high for adventure cartoonists via his extremely minimal and abstract nib drawing style. Depending on fine, dead-weight lines for outlines, innovative patterns for grays (see the trees in the background of panel 1) and bold, angular blacks (probably inked with a brush), no one could mistake his work for anyone else's.
- David B.'s clean, striking linework and heavy blacks are unmistakable. His style is all about control.
- Osamu Tezuka set the standard in Japan with his fluid, cartoony drawing of characters and careful, delicate rendering of space. You can see another example of his work in Chapter 11 (the Buddhist temple).

In Chapter 11
- Julie Doucet (NY apartment) builds pattern, almost to the point of chaos, with a variety of line weights and obsessive attention to the objects of everyday life.

- Kim Dietch (1930s animation studio) refers back to classic pen technique such as you saw in *Thimble Theatre* (Popeye) and *Mutt and Jeff*.
- Lat (small-town Malaysia) puts his semi-grotesque characters in elegant, subtle, pen-hatched settings.
- Kaz (duck on bike) uses bold blacks and whites, and heavy, fairly dead-weight lines to lend an animation look to his grubby *Underworld*.
- Eddie Campbell (London Bridge) pushes the outer limit of scratchiness in his pen rendering, but this technique easily evokes Victorian England in *From Hell*.
- Jacques Tardi (1980s NYC) has an exact, dead-weight line and a precise eye for detail that's well served by pen inking.
- Winsor McCay set the standard for pen inking. His use of carefully calibrated line weights to evoke deep space, and careful placement of spot blacks combine with his elegant, masterful nib lines to create a gorgeous comics world.

In Chapter 12
- Alison Bechdel's obsession with accuracy (she models for every character) is reflected in her careful penwork and precise control of line weight.
- Chester Brown depends on clean lines, clean blacks, and judicious deployment of simple textures to build his minimal panels.
- Jordan Crane demonstrates the difficult technique of white-on-black pen inking in this panel—and manages to make those lines as clean and controlled as his black linework.
- Frank Miller's late pen-inking style (as opposed to in his earlier books, such as *The Dark Knight*) is as much about what he leaves out as what he puts in. A few carefully placed pen lines balance and give solidity to the oceans of black shadows (which, though surely inked with a brush, probably are laid in with pen and filled afterward).

It's also worth noting that the vast majority of our illustrations in this book, of Nate Krusher and Azteka, and Clay and Junko, are in pen. ■

Extra credit
Line for line

Materials

- reproduction of a pen-and-ink drawing you like
- photocopier or scanner
- bristol board
- penciling tools
- inking tools

Instructions

Start off by choosing a drawing that you like, and which, to the best of your knowledge, was inked using nib pens. There are a few ways to figure out how a drawing was inked:

- Make a judgment based on visual clues in the drawing. Do all of the marks look as if they were made with the same tool? Can you spot any metallic-looking scrapes where the nib ran out of ink? Conversely, can you see split hair marks or dry brush effects that would indicate that the drawing—or that part of it at least—was drawn with a brush? Your ability to spot these characteristics will improve as you get more familiar with these tools.
- Find an interview with or article about the artist in which he or she talks about the materials used to draw his or her comics.
- If you have a reproduction from an art book or gallery catalog, look for an index that describes the size and medium of the drawing.

Once you are reasonably sure your chosen drawing was created using a nib pen, you need to find out to the best of your ability what the original size of the drawing was. In addition to using the methods above, you can assume that the original was at least somewhat larger than the reproduced copy. If you are dealing with a panel from a comic book or manga, the original is likely to be about 150 percent larger than the reproduction. That's a good rule of thumb for all reproductions, though the true percentage can vary quite a bit.

Enlarge the drawing using a photocopier or scanner to what you believe to be the original size. If you're not sure about the enlargement percentage, make two or three different copies and judge for yourself which copy looks the most manageable.

Trace the drawing in pencil onto bristol board using a light table or other transfer method (refer back to tracing tips in Chapter 5).

Study the drawing and think about how the artist might have approached inking it. You may be tempted to simply start at the top and copy all the lines you see, but that is certainly not how the artist did it. Try to learn something about the artist's process and visual thinking, in addition to attempting to reproduce the final surface effect. Most artists start by drawing the outlines of the figures. Then they might draw the outlines of the backgrounds, followed by shading. Study the kinds of lines your chosen artist uses. Are they long and sinuous? Are they short and jagged? Does he or she use different kinds of lines for different tasks (figures vs. backgrounds)? Is the cross-hatching deliberate and careful, or is it loose and carefree?

When you've finished inking your copy, wait for it to dry, erase the pencils, correct your mistakes, and photocopy your inked drawing back down to the printed size. You'll be amazed at what your drawing will look like! ■

Joe Sacco's cartoony yet intensely detailed drawings are made with a combination of nibs: a very flexible one, the Gillott 1950, for the main linework on the characters, and a stiff one, the Hunt 104, for his meticulous hatching and detail work.

Structuring Story

Now that you've drawn one whole story based on a script we gave you, it's time to start thinking about how to create your own work from scratch. In this chapter, we'll start that process by introducing you to the most universal type of story structure, the narrative arc.

9.1

The narrative arc

UNCOVERING STORY STRUCTURE: JESSICA'S TALE

I drew my first comic at age 18 on small sheets of office paper, using a tiny .10 mm technical pen. Practically devoid of backgrounds other than the occasional column, my comic told a trippy version of the play *Medea* that flashed back and forth between ancient Greece and the 24th century (or thereabouts). At the end, Medea throws her kids out of the air lock of a spaceship. At a technical level, it was a mess. One thing that first attempt did have, though, was a story—but that's only because I ripped it off from Euripides.

In the ensuing seven years, I drew a lot more comics, and I learned about such technical and artistic considerations as bristol board, perspective, nib pens, figure drawing, india ink, writing dialogue, sable brushes, capturing emotion on a character's face, beveled rulers, and even the Ames Lettering Guide. While it did take me a while to figure that stuff out—I didn't have the benefit of a book like this one—I eventually got it. But I did not learn a single thing about how to give structure to a story. I took a class in screenwriting and another in fiction writing, I majored in English, and I read a million novels. But still no one ever explicitly helped me to understand what makes Jane Austen's novels, to give you just a single well-loved example, tick.

By 1995, I had written a lot of flabby "mood pieces," and even, for better or for worse, published some of them. I occasionally stumbled upon a more compelling structure, by accident. But whatever that magic something was that made one story better than any other remained mysterious to me. I feverishly cast about, trying to figure out how to make my stories pop. I knew I had the interesting characters, their fraught relationships, their individual voices, the unusual settings. But the key to it all was missing. I felt like there was some big *secret* out there that no one was telling me, something that would make everything click into place.

As it turned out, I was right. One summer day, the new issue of the alternative comics anthology *Blab* came out, and there was a book release party for it at a local Chicago bookstore. Cartoonist Terry LaBan was standing there by the keg, and I fell into conversation with him. As it happened, he had recently become obsessed with *Archie* comics. He extolled the virtues of the stories, and in particular, their perfect distillation of traditional story structure. The next morning I ran right out and bought an *Archie Double Digest*, and spent all morning literally charting the characters and their run-ins with one another. I still didn't have the idea down

in words, but I finally understood: characters are challenged by problems that intersect with their particular needs and desires, and these problems send the characters on journeys to resolve them. The characters don't always succeed the way they want to, but the problems are always definitively taken care of one way or another. I felt jubilant: I knew I had started to crack the code.

Of course, it wasn't actually a "secret" at all. There are tons of books about structuring stories, the first one published over 2,000 years ago: Aristotle's *Poetics*. And the story structure I started to sense in *Archie* comics is only the most widely used in the world. Well, I never claimed to be original.

Artist's rendition (you think we'd print the one Jessica drew at 18?!)

THE NARRATIVE ARC

Think about your favorite novel. Now think about a great movie. Almost guaranteed, those works of art have been structured using what we call a "narrative arc." We are confident making this claim because the vast majority of works of fiction throughout the millennia and throughout the world use a narrative arc structure. (Which is not to say there are no other narrative structures—more on that later.) In the earliest known English-language narrative, *Beowulf*, the Danes are going about their business until Grendel shows up, and then Beowulf has to fight him off. In *Journey to the West*, the Monkey King and his companions are just sinners hanging out in China until Buddha decides to send them on a journey to the West to get the Buddhist scriptures from India—a chance to be forgiven their sins. In Euripides's play, Medea is happy with Jason and their two sons until Jason leaves her for another woman, giving her no choice but to do something about it.

As the above examples show, the basic structure of the narrative arc is this: a protagonist is thrown off balance by an event. The event causes the protagonist to want something—the treasure, the girl, to get free, peace and quiet, or some other object of desire—and to work to get it. Obstacles stand in the protagonist's way. He or she must struggle to overcome those obstacles. At the end, the object of desire is either achieved or definitively lost.

Why so traditional?

The traditional narrative arc might sound overly prescriptive for some sensitive literary souls (not to mention those who just want to write some good gross-out humor), but it leads to infinite possibilities. In Franz Kafka's *The Metamorphosis*, Gregor Samsa wakes up as a cockroach. He wants his life back, and this results in an absurdist series of events. In Virginia Woolf's novel, the eponymous character Mrs. Dalloway is having a dinner party, thus must go out and buy flowers, an errand that leads to a complex and beautifully constructed meditation on one person's seemingly simple life. In one episode of *Ren and Stimpy*, Stimpy develops an irrational fear of being nude, which annoys Ren so much that he throws Stimpy out in the street with no clothes. Hilarity ensues. Narrative arc is a hanger that, well-constructed, will support and make engaging your most erudite—or ludicrous—ideas. It's what helps readers care about what you want to say.

The key to working in a literary mode (and this applies also to genre stories that aim to be more than simple adventure yarns) is in the details. If you, the writer, think deeply enough about human instinct and behavior, and if you create characters that have various levels of conflicting motivations, you have a good chance of producing work that has something to say. If you avoid easy answers and reject cliché, you are on the path to writing interestingly and well, whether your protagonist is a Martian bounty hunter with a chip on his shoulder or a 17th century philosopher searching for life's meaning.

Why conflict?

Why do you have to create conflict in order to tell a story? Why can't things just be nice and cute?

Insufficiency is a characteristic of human life. We confront it every day: lack of money, lack of love, lack of time. If you don't have enough money to buy a car you desperately want, you live in conflict. You have to either borrow money, get a higher paying job, or scrimp and save. You may have to try each approach before you find a solution. You may not find a solution (sorry), but then, your life is not structured as a story.

This basic human state, that of having a desire caused by the advent of a new condition, is so familiar to us, and so essentially compelling, that we almost involuntarily care about fictional characters faced with similar circumstances. Have you ever had the experience of someone making you see a stupid movie that you didn't want to see, but as soon as you started watching it, something happened to the protagonist, and you got sucked in? You may still have hated the movie, but you couldn't help being engaged in the story. That's the narrative arc in action.

OTHER NARRATIVE STRUCTURES

The narrative arc structure doesn't describe all existing narratives. For example, many experimental "art" comics dispense with straightforward narrative structure in order to explore visual themes or states of mind. Meanwhile, some people would argue that many manga—some shoujo manga, for instance—do not follow a narrative arc because they are more concerned with conveying mood and emotional truth than telling a traditional story. The episodic form, popular in alternative comics and independent film, downplays overarching conflict in favor of an accumulation of observational sketches. There are narratives that try to be (or to seem) as unstructured as possible: they may be dreamlike, or a survey of a subject, like a tour. Narratives structured like poetry may build meaning and hold interest through use of repetition, rhyme (verbal or visual), allusion, or metaphor.

However, the majority of fictional narratives, especially in popular media like comics, film, and television, observe the narrative arc structure we are explaining in this chapter. Even works that at first seem to be structured nontraditionally reveal an underlying narrative arc structure of some kind when examined closely. This is because the narrative arc is such a reliable and time-tested principle for telling stories. But how do you construct a story using a narrative arc? There are several essential elements to it, which we'll describe next.

Homework critique for Chapter 8 on page 242

9.2

The elements of a narrative arc

THE FIVE ESSENTIAL INGREDIENTS

A narrative arc consists of five essential ingredients: the protagonist, the spark, the escalation, the climax, and the denouement.

1. The protagonist

First of all, you need a vehicle to ride through the story. That vehicle is called a protagonist. What's the difference between a protagonist and a character? A protagonist *is* a character, of course, but he or she (or even it) is a special class of character. The protagonist is the character who has the desire that powers the story. All other characters are secondary to the protagonist (or protagonists—you can have more than one in a single story).

What we do when we create a story is turn one of its characters into the protagonist. How do we do that? By throwing something at this character that pulls him or her off balance, and that gives the character the *will* to put his or her life back in order, one way or another. This magic thing, that changes a character into a protagonist, is what we call the spark, which we'll describe in a moment. Three traits define a protagonist: empathy, motivation, and ability.

Protagonist: the character(s) who experience the spark.

Empathy

The first identifying trait of the protagonist is that he or she is the "hero" of the story. But does the "hero" have to be a good guy? What about the bank robber protagonist? The woman who's trying to off her elderly husband for his money? As long as we care about what happens to the protagonist, as long as we're invested in him or her, it doesn't matter if the protagonist is a good guy. The reader doesn't even have to particularly like the protagonist. In Jessica's book *La Perdida*, the protagonist Carla weaves her own doom with her naïvete, self-involvement, and ignorance. This doesn't mean she's not effective: you still want to find out what happens, and you still care about her, even if you are mad at her at the same time. This concept is called *empathy*.

You must identify with the protagonist's point of view.

Motivation

A second trait of the protagonist is that he or she must want something, and want it enough to do things he or she wouldn't ordinarily do. This is known as *motivation*. The protagonist's motivation can be conscious—"I need to steal that million dollar payroll"—or unconscious—"I need to meet a man who reminds me of my father and resolves the turmoil I was thrown into when he died." It can be both. The motivation doesn't have to be in the protagonist's best interests. You can make a protagonist consciously want something that will actually work against his or her interest and unconsciously want the right thing, or vice versa.

The protagonist must feel the need to act.

Ability

Finally—and this may seem superfluous, but it's extremely important—the protagonist has to be able—possibly—to fulfill his or her desires. If the protagonist of your story is a pot-smoking 20-year-old who finds out a meteor is going to hit Earth unless he stops it, your story had better be a comedy where your protagonist turns out to be Bruce Willis. If that stoner doesn't turn out to have Bruce-Willis-like abilities and instead sinks into a 24-hour *Dr. Who* marathon and waits for meteoric

death, we readers will be pretty bored by hour two. We do not mean to imply that the protagonist always succeeds. By no means is this true. But it has to be *possible*.

The protagonist doesn't have to succeed, but he or she has to have the potential capability to solve the conflict.

2. The spark

Perhaps the most critical ingredient of the narrative arc is the "spark." As mentioned before, the spark is what transforms a character into the protagonist. But what is it exactly? The spark is an unexpected event that directly affects the protagonist, creating an imbalance in the protagonist's life that propels (motivates) him or her to resolve the imbalance.

The spark can be anything—anything, that is, that isn't what normally happens. It can be as mundane as a phone call—as long as the content of the call is not routine. Not "Hey, what's up?" but "You owe me money," or "I'm breaking up with you." It can be an offhand comment from a stranger, as long as the comment leads to imbalance. "You look just like this girl I know—Justine" (which turns out to be the name of the protagonist's long-lost sister).

Importantly, the spark must be something nonroutine *in the context of the protagonist's life*. A Martian bounty hunter who shoots a fugitive might just be doing his job. No story here, move along. A drug addict who makes his living as a mugger has a routine: mug a guy, take the cash, buy drugs, do the drugs, run out, mug another guy. It's ugly, it's spectacular, but it's routine in the context of this protagonist's life. Now, if the mugger accidentally kills a guy in the course of a mugging, only to find out that the dead guy is an undercover cop? *Now* we've got a spark, a problem that needs solving.

Spark: an unexpected event that directly affects the protagonist. The spark sets up an imbalance that the protagonist wants strongly to correct.

3. The escalation

A story isn't much of a story if the protagonist immediately solves the imbalance created by the spark. If, in our previous example, the protagonist thinks again and says to herself, "Oh wait, my long-lost sister was named Julia, not Justine," there's the end of your story, and your reader will be wondering why you bothered to tell it. An effective story must incorporate escalation (sometimes known as complication), a series of unexpected events after the initial spark which make the protagonist's attempt to resolve the imbalance more prolonged, interesting, and suspenseful.

For example, the cable goes out. This is a spark for our protagonist, Roderick, who is waiting for the world synchronized-swimming championship to start. He is motivated to get the cable back on, and he has the potential capability to achieve his desire. He even has a time limit (always helpful to create suspense). What is the first thing Roderick will do? It won't be to kidnap the daughter of the president of the cable company (though that might happen later, after a number of other attempts have failed). Perhaps Roderick will start by calling the cable company. If, as a result of this call, the cable fizzles back on, we have no story. This is normal. This is what happens. We've got a story when Roderick calls the cable company, and they tell him he owes $999. Or that he owes $10,000. Or they have him confused with someone named Rodrigo, who owes $10,000. All of these things are escalations in the story, and

will make Roderick try harder to resolve the imbalance in his life. He still just wants his cable back on, but now he has to track down Rodrigo, and make Rodrigo pay his enormous cable bill.

What happens next? I don't know, but one thing's for sure: if this is to be a good story with a narrative arc, Rodrigo won't just apologize to Roderick, call up the cable company, and pay the bill. What if it turns out Rodrigo is Roderick's long-lost uncle? Or he answers Roderick's knock at the door with a gun? Or "Rodrigo" is an alias for a world-famous synchronized swimmer? Or Roderick opens the door and finds himself in his own house?

Whenever you have your protagonist do something in pursuit of his goal, what happens next is *never* what *usually* happens. Escalating events should push the narrative in new directions, and make the protagonist work harder each time to reach his goal: to resolve whatever has thrown his life out of balance.
Escalation: a series of unexpected turns of events that make the protagonist work ever harder to resolve his or her problem.

4. The climax
Ideally, a story will consist of at least three repetitions of this cycle: A problem leads to an attempt to solve it, which leads to a further escalation of the problem, which in turn leads to a more intense attempt to solve it, and so on.

In this scenario, the third and final episode would be the climax, wherein the protagonist either *definitively* resolves the imbalance created by the spark or doesn't. Readers know when they've hit the climax: they have a sense of "Ah, yes, that's it," not "And what's next??"

You have probably had this experience: You've come to the end of the movie, the music soars, the credits roll, and you're sitting there thinking, "Wait, what, that's it? What about that girl who jumped behind the building? She would have called the cops. And the guy didn't shoot the bad guy, so he's definitely coming back. There's no way!" That means the director left holes, unresolved threads, things the protagonist might have attempted to resolve the conflict, which meant that the climax of the story wasn't definitive. It made you think "what happens next?" and then left you hanging.

The climax must lead to a definitive answer: yes or no. It may leave you with regrets, wishing things had worked out better for the protagonist, but you know the story's at an end. Even ongoing sagas have interior arcs that end definitively. (Harry Potter always defeats some evil soundly, but that doesn't mean Voldemort won't be back next time.)
Climax: the final iteration of the protagonist's attempts to resolve the imbalance, in which it's either resolved, or definitively not resolved.

5. The denouement
The final phase of a narrative arc is the denouement, or that action that occurs after the climax and serves to tie up loose ends and provide a sense of closure. Whether the denouement consists of a simple "and they lived happily ever after" or resolves a few dangling story lines, it should be simple, and it should be short. Some stories skip it altogether.
Denouement: action that comes after the climax and does not tie in directly to solving the protagonist's problem. ■

The narrative arc:
constructing a story worth the telling

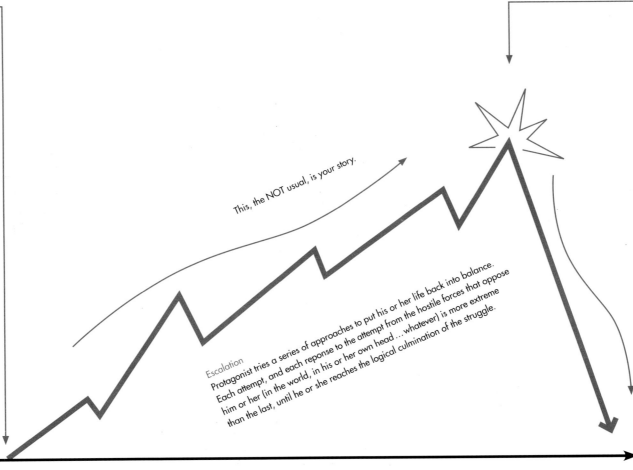

Spark
The event that propels the protagonist into action. This event must create an imbalance in the protagonist's life that he/she then must correct. The spark makes us ask, "What is he or she going to do about that?" The protagonist now has a clear need or desire.

Protagonist
A character
1. who has our **empathy** (i.e., we identify with him or her);
2. who has the **motivation** to pursue needs or desires;
3. and who has the **ability** (hypothetically) to achieve those desires.

Climax
The ultimate event in the cycle of escalations. The protagonist enters into a decisive confrontation with the forces arrayed against him or her. The protagonist either achieves his or her need or desire, or definitively does not.

Denouement
The loose ends of the story are quickly tied up. This does not necessarily mean that a happy ending has been reached, only that the protagonist's life has returned to stability and normalcy (perhaps a different "normal" than before the story).

This, the NOT usual, is your story.

Escalation
Protagonist tries a series of approaches to put his or her life back into balance. Each attempt, and each reponse to the attempt from the hostile forces that oppose him or her (in the world, in his or her own head ...whatever) is more extreme than the last, until he or she reaches the logical culmination of the struggle.

The path of normalcy: Things happen as you might expect them to happen. This is not your story.

THE FIVE INGREDIENTS IN ACTION: CINDERELLA

Let's look at how five ingredients of a narrative arc play out in a story we all know, *Cinderella*. We're probably all more familiar with the Walt Disney filmed version than the more gruesome Brothers Grimm fairytale version, so let's go with Walt.

Protagonist
Cinderella

Spark

Cinderella's father dies, leaving her in the hands of her wicked stepmother. While her heartless stepsisters are treated like princesses, Cinderella is demoted from noblewoman to servant. Her life is clearly out of balance, and she has the motivation to resolve the issue. You could say that her first, rational response to her situation is to get used to it. But that doesn't work, because her situation keeps getting worse.

Escalation

1. Then, the prince must find a wife, so his father throws a ball and invites all the eligible women in the kingdom. Being a princess would certainly solve the injustice problem for Cinderella, so she tries really hard to go to the ball. But, though she's eligible (she's the daughter of a nobleman, unmarried, and the right age), her ugly stepsisters and evil stepmother destroy her dress, making it impossible for her to attend.

2. Her response to this new challenge is to mope. Under normal circumstances, Cinderella would be a completely insufficient protagonist (she lacks enough will to change her circumstances), but this is a fairy tale, so her fairy godmother shows up and magic-wands her into action. She attends the ball in glamorous clothes and with servants in tow, but with a time limit. Her clothes will return to rags at the stroke of midnight.

3. The clock strikes 12 just as she falls in love with the prince, and she flees (leaving her shoe as a clue to her identity, which helps make the transition to the next segment of the story). Though the prince (via his servant the duke) has a plan to find the girl with the most teeny-weeny feet to fit the widdle shoe, he's almost foiled by the wicked stepmother, who locks Cinderella in the attic.

4. Fortunately for Cinderella, she again has help, in the form of her animal friends, and she escapes in time to try on the shoe. . . .

Climax

5. But evil stepmother makes the duke smash the shoe. Now it will be impossible, impossible! for Cinderella to be found. Ah, except she has the other shoe. She puts it on, it fits her dainty foot…

Denouement

…and Cinderella and the prince live happily ever after.

Notice that each consecutive event *escalates* the conflict. At first, Cinderella has no hope of regaining her place, and certainly not of becoming a princess. All she wants to do is attend the party. Seems simple enough, but her family makes it impossible. Impossible becomes possible through magic help, which makes Cinderella even more gorgeous and glamorous than she would have been otherwise. She's more of a contender now. She goes to the ball and the extremely unlikely happens: the prince falls for her, and only her. But she's reduced again to rags when the clock strikes 12. When the prince launches an enormous kingdom wide search, she's held prisoner by her family to prevent his finding her. Again with outside help, she escapes, but then the key to her identity is lost, permanently. In a tragedy, this would be the end. But no, she has the proof, and she wins her freedom (and then some).

The order of escalating events is very important. The prince won't go on a house-to-house manhunt before he's been bewitched by a mysterious, elegant girl. If you were writing the story, and the prince's search for Cinderella is what you thought of first, you'd have to develop a progression of events that led to this event. Remember: the first response a protagonist has to the spark is simple, logical. Cinderella's spark, her father's death, is a cataclysmic event. She loses her status, but she can't get it back by going and introducing herself to the prince. While that would be nice for her, she will have to overcome many setbacks first, in order for the story to be compelling (and believable). Without these setbacks, we wouldn't care about her. You have to lead your protagonist down a trail of carefully calibrated obstacles, or you'll lose your reader. ■

FURTHER READING

Aristotle, *Poetics*

Syd Field, *Screenplay: The Foundations of Screenwriting*

David Mamet, *On Directing Film*

Robert McKee, *Story: Substance, Structure, Style, and the Principles of Screenwriting*

Dennis O'Neil, *The DC Comics Guide to Writing Comics*

9 Structuring Story

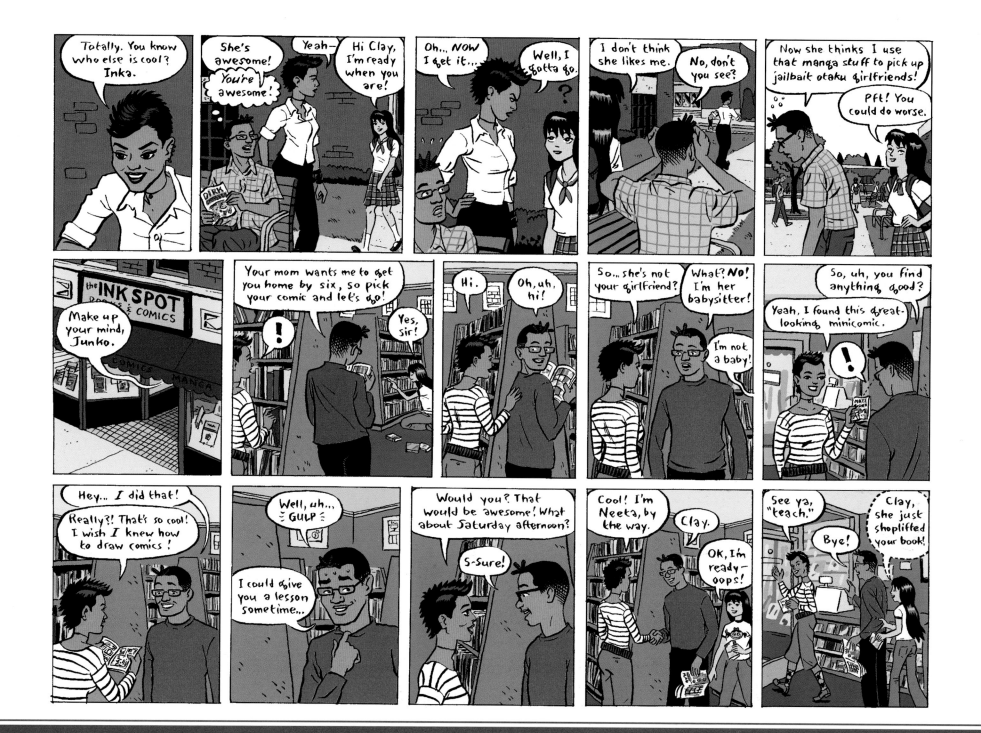

Talking points

Identify the ingredients of the narrative arc of the story:

- Who is the protagonist? (How do you know?)
- What is the spark of the story?
- What does the protagonist want?
- How does the story twist in an unexpected direction after the spark (the first obstacle in the story's escalation)?
- What is the next obstacle? Talk about how it relates to, and builds on, the first.
- What is the third obstacle? How is this one related to the obstacles that have come before?
- Do the obstacles build in difficulty?
- What is the climax of the story?
- How is the story resolved?
- Is there a denouement?

What might happen in this comic if there were no narrative arc? Go back and look at the narrative arc chart. Imagine a "normal" sequence of events and talk about how this story diverges from it.

Discuss the ways that the events of the story are tied together.

What do you learn about the characters from this story? Describe the personalities of Clay, Junko, and Neeta. How did you come to those conclusions?

Can you think of ways to rewrite this story that might improve it? ■

TV writer make-believe

Just as when you were getting acquainted with single-panel comics back in Chapter 2, one of the best ways to get used to the narrative arc is to make up a lot of them. If you're in a group, brainstorming together is an excellent way to do this.

Materials
- Your encyclopedic knowledge of *Simpsons* episodes and your sharp wits

Instructions
With a group of friends (they don't even have to be comics fans), make up five or ten new plots for *The Simpsons*. If you don't like the *The Simpsons*, make up plots for the crew of the *Enterprise*, or for Mulder and Scully from *The X-Files*. Pick a TV show that you are all very familiar with, ideally one without many ongoing plot developments (not a soap opera or drama). You want a show that begins each week with more or less the same pre-exisiting conditions.

Start by picking a lead character for your plot. In the case of *The Simpsons*, if you pick Bart as your protagonist, your spark will probably involve him playing a joke on someone, or breaking something and trying to cover it up. If you pick Homer, your plot might revolve around some harebrained scheme to get beer or donuts.

Alternately, think of a spark first, then think about the character who might be set into motion by it. If you imagine a spelling bee as your spark, Lisa will probably be your protagonist.

Or, start by imagining some scene near the climax, like maybe Lisa's beloved sax is in a pawnshop. How did it get there? Work your way back.

Draw a rough approximation of the narrative arc line, following the chart in this chapter, and write your ideas at the appropriate points on the arc. Take note of where there are gaps in the arc, and fill them in.

Remember to escalate conflicts from minor to major. Keep your eye on the subject of your plot, and don't get too fancy.

Every event you imagine in the "show" should be tightly tied to the spark, and to resolving the conflict.

Keep the spark simple, something it's possible to resolve in the given time. Try to reach resolution of the arc in three or four steps of escalation. Remember, if you're doing *The Simpsons*, you're writing a show that's no more than 20 minutes long.

When you've got it, do a few more. Repetition is key to understanding this form. Try to keep in mind that the idea behind this exercise is to keep the stakes low. You're working with franchise characters you have no personal investment in. Have fun with them and don't spend as much time agonizing over quality control as you might with your own characters.

Ronin
You can easily do this activity alone, though it won't be as much fun. It doesn't require comics pals, so why not try it with some other friends?

You can find various examples of narrative arcs on the website, www.dw-wp.com. ■

Homework
Thumbnails for a six-page story with a narrative arc

Now that you've created at least a few complete story arcs, it's time to get down to the business of writing your own story using the narrative arc. We want you to start from scratch here—we know that many of you will have more or less developed plans for some kind of massive epic spanning generations, but we know from experience that if you dive into that—even to tell just part of the story—it's very easy to get bogged down and creatively frozen. Just set the whole thing aside for now and create a new stand-alone story. Once you complete this story, you will be that much better prepared to attack your magnum opus.

Materials
- office paper
- pencils
- 1 percent inspiration
- 99 percent perspiration

Instructions
Brainstorm

Work up an idea for a six-page comic that you will be seeing through all the way to inks in the next several homework assignments. Create new characters (you'll be thinking about that more fully in the next chapter) and come up with an interesting setting (more on this in Chapter 12). You will also need a story arc: what is the spark of the story, what are some of the conflicts and challenges that the spark presents to the protagonist, and what are some of the ways in which the protagonist can resolve the situation and bring himself or herself back to a state of balance? You may create more incidents than you need, so be ready to cut to fit the length. Or you may not have everything in place yet; don't worry, you'll have a chance to fill it out as you work.

Keep the scale of the story in mind: six pages probably seems like a lot to you, but you can't fit a saga in there. At the same time, a simple gag setup might be too skimpy to fill up a story of this length. Read some six-page comics as well as some that are longer and shorter to get a sense of what your range might be.

Make an outline

Come up with as close an approximation of your story as

possible, to the point where you're ready to discuss and critique it. Present your outline in four parts:

1. Sum up the idea of the story in two or three sentences. Keep the focus on the protagonist, and the spark. What does the protagonist need, and why?
2. Write a short scene-by-scene description of the action, focusing on what the obstacle is that the protagonist must overcome in each scene. Each scene must either move the story forward (contain action) or reveal character. In a story this short, almost all scenes need to move the action forward.
3. Make sketches and overhead maps of any important settings.
4. Decide how much space each scene should take up and write that down.

Begin thumbnails

You won't be ready to finish these thumbnails until you talk to your group, if you've got one, or gotten some feedback from the website, www.dw-wp.com, or a friend, but in the meantime, get started.

Once you've planned the approximate length of each scene, take six sheets of office paper, number them, then write briefly on the top what should happen on each page. Then begin writing the story in thumbnails. Try to get at least halfway through the thumbs. As always, keep the drawing simple and the lettering legible. Don't forget to leave space for your title, even if you haven't decided on one yet.

If you're more comfortable creating a written script separately, feel free, but along with your outline, the work you present to the group should be in thumbnail form. Working in thumbnails will cause you to think in terms of *visual* storytelling.

Remember to consider where you place dramatic moments, and to think about visual ways to convey information that you may have originally thought of in words. For example, how can you show "Helen hates Steve" in pictures, without saying anything about it?

You will finish your thumbs next chapter, and then have a chance to revise them later. ■

Extra credit
Thumbnail a three-page *Chip and the Cookie Jar* comic

Remember your Sunday page from Chapters 6, 7, and 8? Now you're going to use the same family of characters to write and thumbnail a three-page comic with a complete narrative arc. You can add a character if necessary, but the story should center on Chip trying to get a cookie. To review: Chip is about five or six, naughty, a trickster, and obsessed with cookies. Father is a bit absent-minded and indulgent. Mother is strict and sharp-eyed.

The narrative arc is hard to fit into short stories. It has several distinct stages, so it's hard to jam everything into a few pages. With *very* short stories, you don't have room for multiple iterations of the cycle. But even gag structure has some sort of narrative arc to it. In three pages, aim to create three escalations ending with the climax, and followed by denouement, if necessary.

Materials
- office paper
- pencil
- eraser

Instructions
Plan and thumbnail a three-page comic as described above. Include all of the ingredients of a complete narrative arc. ■

Getting into Character

To write a story with a narrative arc, you need a few basic ingredients. One of these ingredients is the protagonist. Now let's spend some more time on not just the central character, but also on the other characters in a story.

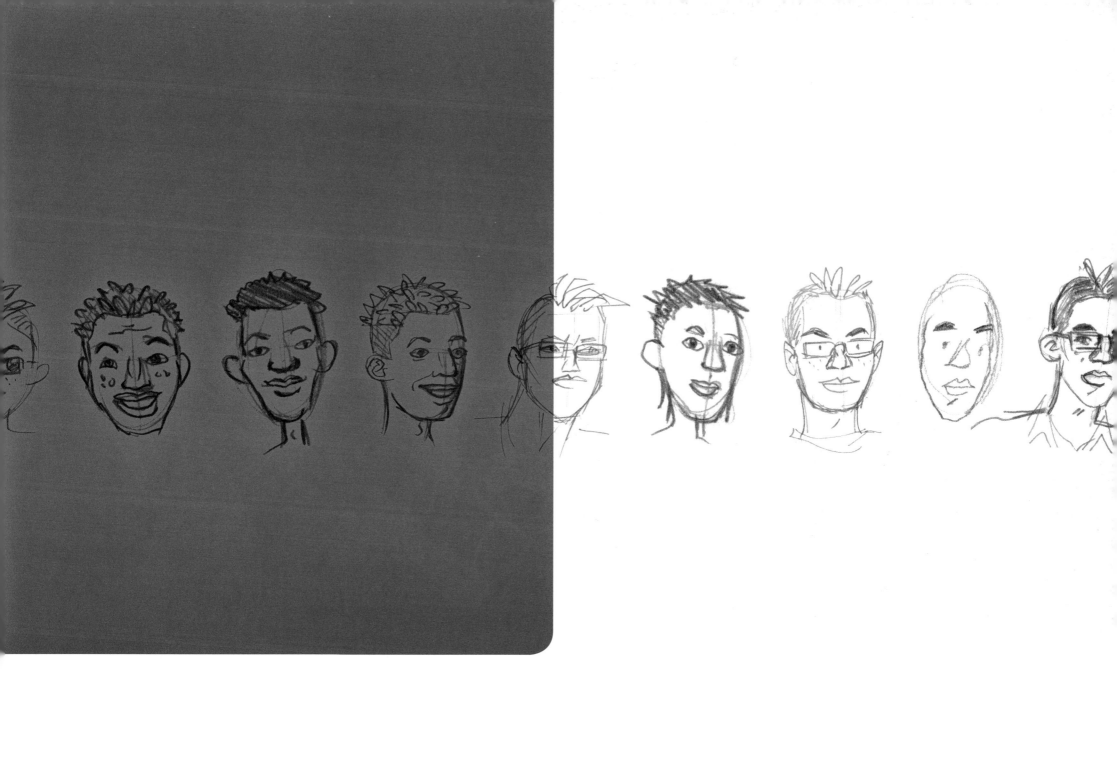

10.1
Developing your character

Homework critique for Chapter 9 on pages 242 and 243

WHICH COMES FIRST—THE CHARACTER OR THE STORY?

Within the narrative arc, there are two major approaches to creating story. One is to come up with a spark, a conflict, and build characters to fit that spark. The other is to start with an idea for a character and build the story around that character with his or her particular characteristics acting as an engine for the spark and the story.

The story starts when a protagonist reacts to the spark with action of some kind, and the consequences of that action—always surprising, never the thing that usually happens—create an escalation of events that leads to the climax of the story.

You may be wondering why we didn't discuss characters in depth before talking about story: after all, you need characters to have a story, right? True, but you also need a story to have characters. Without a story, characters are just paper cutouts.

Character and story are inextricably intertwined: you use character to determine the way the story plays out, and you use story to show us who the characters are. It's a chicken-and-egg situation, and you've got to start somewhere. In this chapter, we get to the egg. Or is it the chicken?

WHAT IS A CHARACTER?

A character is a fictional person with identifiable attributes that plays a more or less active role in a story. What we know about that character, as readers, is made up of the sum of what that character does and says in the context of a given story.

Trish Trash, roller derby star
- cheerful
- spiked collar
- X-games

Fred Xed, Martian tour guide
- worrier
- wears a skirt
- tour guide

CHARACTER TYPES

Now that we have a general working definition of character, let's dig a little deeper. Characters essentially fall into three categories: archetypical characters, naturalistic characters, and what we call intermediate characters.

Archetypical characters

First of all, let's just say it right out: not all characters need a complicated psychological makeup. We don't care what childhood trauma made Elmer Fudd want to hunt wabbits, do we? Bugs Bunny and Elmer are what we call archetypical characters.

So is Chip, of cookie jar fame. Chip is a kid, bratty and clever, who likes cookies. That's about it. The humor in Chip comics comes from giving this archetypical character a spark that triggers his desire, perpetual and profound, for cookies. For example: Chip uses Tinkertoys to build a ladder to the top of the fridge, where the cookie jar is kept. Chip learns hypnosis to try to trick his mother into giving him cookies. Chip goes to chef school to learn to bake cookies. Chip tricks his babysitter into handing over the whole box of cookies. And so on.

Archetypical characters have only a very few dominant characteristics, and those characteristics don't change as a result of things that happen in the story line. Wile E. Coyote will always be inept and hungry for Roadrunner. Archie will always jilt Betty for Veronica. Homer Simpson will always be a sucker for a donut and a nap.

We don't learn a whole lot about human nature from them, but the beauty of archetypical characters is that you can use them over and over again, and their reactions will be based on the same simple characteristics. This is one reason why comedy, especially in sitcoms and humorous newspaper comics, commonly relies on archetypal characters. Once you see one story line with Homer Simpson in it, you basically "get" him and will always be able to understand his motivations.

With these characters, surprise in the story—the laughs or thrills or intense engagement—doesn't come from discovering new layers to their personalities; it comes from unexpected story twists.

The downside of archetypes is that they can turn into stereotypes—the rapacious businessman, the grandma who stuffs you full of food, the

dumb blonde—and while they can be funny, these stereotypical clichés can also be boring and occasionally insulting (e.g., the drunken Irishman or the snooty Frenchman). Another downside is that you can't build upon these characters. Even if they "learn something" at the end of one story, they will be back to square one in the next story.

That said, archetypes can be great fun, and many of our favorite characters fall into this category. When you create one, don't over-think him or her. Just stick with the basics.

Naturalistic characters

Naturalistic characters represent the other end of the spectrum. Their main defining characteristic is that they change; that is, they learn from the events of the story. If the story covers a long period of time, they will visually age. This doesn't mean naturalistic characters are necessarily realistic. A naturalistic character might be a talking goat or an alien.

But you do need to know the details of your naturalistic character's history—the events that have shaped the character before the current narrative. This is known as backstory.

If you're writing a very short story, you don't need to know many historical details about a character, but you do need to understand something about the character's personality and point of view. The longer and more involved the narrative is, the more clear you'll need to be about a character's backstory.

It's likely that most of the backstory won't ever get mentioned in the story, but it will have informed the character's personality, and his or her outlook on the world. But sometimes backstory is an essential part of the narrative. On *The X-Files*, the defining event of Mulder's life was his sister's abduction by aliens when he was a kid—he was there and couldn't do anything to help her. The guilt and heartache caused by this incident are what make him such a driven—even obsessive—investigator into the paranormal.

When you're thinking about backstory, you don't have to write giant biographies of your characters, and you certainly don't have to write the entire backstory all at once, before you start your story. A few key details, like the one above about Mulder, may be enough.

You may find that as you move past the initial spark of the story into more serious obstacles your protagonist must overcome, you are not sure what your character would do in a given situation. You may feel a bit blank, as if your character isn't revealing to you what you need to know. That's when you should take a little time out to work further on the backstory.

For example: You create a character who is an orphan raised by his Puerto Rican immigrant grandparents, and who becomes an Eagle Scout. He is now a camp counselor for troubled rich kids, and he's

leading them on a hike up a mountain. The spark that motivates him into action occurs when one of the kids runs off. Even with what little you know about his past, you have all kinds of ideas about what kind of man your protagonist is. You know that he is a Latino from a modest, hardworking background. He's a skillful camper and woodsman. And he believes in the principles of the Scouts. He's a "good boy." So he will definitely feel responsible for this situation, and he'll have some idea of what to do. You can probably figure out what his first, logical reaction to the situation will be. Let's guess it's something like establishing a base camp and getting all the kids to stay put while he searches for the missing kid. He finds a broken path in the woods and stumbles upon a marijuana patch. But at this turn of events, you may find you simply don't know enough about the character to go further. Does he have experience with drugs? With drug runners? How does he feel about the drug trade? How does he feel about his campers? Are they spoiled white rich kids to him, or does he really care about them? What was it in his life that made him think that way? Now it's time to flesh out the backstory.

Intermediate characters
Somewhere between naturalistic and archetypical characters are most adventure and romance characters, including the majority of manga characters and superheroes. Let's call them intermediate characters. These characters don't age; they often have very simplistic motivations (fight evil, get the girl) and little backstory, if any. In these ways, they are a lot like archetypical characters.

Intermediate characters are, in some ways, creatures of comics: serialization of stories requires that characters be recognizable and stay pretty much the same from episode to episode. However, in order to keep the story interesting long-term (both to readers and to writers), the characters do accumulate experience, and some sort of attenuated backstory.

In the world of superheroes, this is called continuity. Superheroes don't change much, but the world they live in accumulates history, which their writers must then respect. As a result, these characters need to be a little more fleshed out than archetypical characters. Let's look at Peter Parker, aka Spiderman, to take one example. Unlike Elmer Fudd (who has remained the same every time he has appeared since 1937), over the last half-century, Peter Parker aged (a little), got married,

and experienced several major reversals of fortune and crises of faith. Nonetheless, his basic motivations and personality remain very much the same as when he was created in 1962.

Manga are a slightly different case, because their series do end eventually, even if they run for years. Within the short narrative arcs of 20 or so pages that appear in weekly magazines, manga characters can take on the appearance of archetypical characters, seemingly staying very much the same from week to week. But there is often a very long narrative arc with a fairly definitive ending that the artist is working toward. Some incremental change in the characters, much less than would be expected with naturalistic characters, can come about in an episode, but it may be very little. In *Dragonball/Dragonball Z*, Son Goku fights his way through numerous story arcs and bad guys, usually staying very much himself. Eventually, though, over many volumes, he does grow up, and he even dies.

CHARACTER MOTIVATION
As discussed in Chapter 9, the progression of the story depends on the actions and reactions of the protagonist.

To review, the protagonist is the character who experiences the spark of the story, and his or her reaction to the spark is to act, not to sit there and see what happens. It is crucial that your protagonist (or protagonists) has a strong need to regain balance in his or her life.

Conflict
You learn about your protagonist (and other characters) by putting them under stress. Give them crises to deal with. Why? Because if you don't put pressure on your characters, your readers won't really know anything about them.

You may tell us your hero is strong, but you can't just show him or her flying around in a superplane and expect us to believe that your character is worthy of our admiration. We won't really believe it unless we see him or her faced with an incredibly powerful adversary, so powerful—this is important—that your hero is almost defeated, and wins in the end only through great effort and maybe some luck or friendly help.

Using drawing to help develop characters

Our first idea of Clay was that he'd be a morose, geeky, white hipster.

Then we decided we wanted him to be black. We played with the idea of a skinny, elongated design, with and without glasses. And he started to get more cheerful.

Matt liked more hair, Jessica liked less, but after a while, Clay started to take on his final form.

We also played with different drawing styles.

The same goes for love stories. If boy meets girl, they like each other, they go on a few dates, and then they fall in love, the end, we are *a*) bored, and *b*) uninvolved. We need to see the boy overcome major obstacles to get the girl, or we don't believe it's true love.

In the real world, of course, it isn't precisely true that you need conflict to learn about people. But think about this as an analogy: you meet a new friend and spend all your time with her. She's awesome, so much fun. She calls you all the time to go out. But then you get really sick and have to go to the hospital. It's not fun, it's not a good time, but you're going to need help. Is your new friend going to be there for you? Difficult circumstances can teach you a lot about a person's character in real life too.

The antagonist
One surefire way to introduce conflict into your story is to balance out your protagonist's actions with those of an adversary, or antagonist.

Antagonists must have motivation and strength equal to protagonists. If you have the Roadrunner, an absolutely simple character with only one need—to mock the efforts of the Wile E. Coyote—then the Wile E. Coyote must be equally simple. All he wants to do is catch the Roadrunner. Do not give him Freudian motives.

If, however, you have a complex protagonist like FBI agent Clarice Starling in *The Silence of the Lambs*, you need an equally complex antagonist like Hannibal Lecter on the other side. If Clarice's antagonist were Wile E. Coyote, you wouldn't have much of a story. Even if you gave her Marvel Comics supervillain Dr. Doom, you wouldn't have that much of a story; Dr. Doom is so much stronger physically, and so much less complex psychologically, that Clarice would be dead, flattened in the first scene. The protagonist and antagonist are locked in conflict, and if they're not evenly matched, the outcome will be predictable, and, thus, boring.

This is not to say that the antagonist has to be a person. In many stories, there is no human antagonist. There is either just an internal battle within the protagonist, or the impersonal events of the story working against him or her. But the forces arrayed against the protagonist need to be *almost* exactly equal to the forces in favor of the protagonist. If not, your story will be lopsided.

SHOW, DON'T TELL
One last important point regarding character: show, don't tell. That old catchphrase has been laid on you so many times, you probably don't even think about what it means anymore. But it's an important idea, so here's a new translation:

Whenever you want to give your readers information, whether about a character, a relationship, or an event, you need to find a way to dramatize that information. "Dramatize" doesn't mean "make melodramatic"; it means that you need to find a way to show your readers the information through action. Don't just say about a character, "She was really charismatic." Write scenes in which she acts charismatic, and other characters react to her charisma. Don't say, "They got along great." Show them getting along. Don't say, "He cut through the ceiling and stole the diamonds." Design a beautiful heist scene and draw it for us, providing all the fascinating, new—visual—twists you can come up with.

The word "dramatic" is problematic. Hear it and the image of a freaking-out diva may pop into your head. But it's a very useful concept. Information should be conveyed to the reader through actions and dialogue, not handed over on a platter (or in a narration box). That's what we mean by dramatic action. ■

 Play your cards right

Before you plunge into designing your own characters, let's see how the process of developing characters and stories works with some rather silly raw materials.

Materials
- character cards (see Appendix C)
- spark cards (see Appendix C)
- office paper
- pens and pencils for sketching and note-taking

Instructions
Part one
After you create your sets of cards as instructed in the appendix, shuffle each set separately. Make three piles of character cards, one for physical traits, one for personality traits, and one for occupations. Set the spark cards aside until part three of this activity.

Get out some office paper and a pen, and then pick one card from each character card pile. No givebacks! Take whichever cards you get. Immediately start writing down whatever your three cards bring to mind. After a few minutes, you should be starting to get an idea of a character. Make a few sketches of what he or she might look like.

Trish Trash and Fred Xed, at the top of this chapter, are examples of the kinds of characters you might create, given a certain set of cards.

Part two
After about five minutes of general note-taking and thinking, fill out the questionnaire below on a separate sheet of paper. You don't have to answer every question; some of them won't even make sense for a given character. Just use them to get you going.

Questions for characters

Physical description
- *Name?*
- *Age?*
- *Sex?*
- *Race/ethnicity?*
- *Features and mannerisms?*
- *Species?*

Personal/professional history
- *Education?* Describe an incident each from grammar school, high school, and higher education or training.
- *Occupation?* Describe his/her workplace, boss, coworkers. Tell a story from work.
- *Parents?* What is the character's relationship with his/her parents? Describe an incident that happened with his/her parents when he/she was 10.
- *Love relationships?* Whom does he/she love? Is he/she married? For how long? Is it a happy marriage? Is he/she single? Dating? Describe an ex and his/her current relationship with that person. Describe an incident in his/her current relationship.
- *Friends?* Who is his/her best friend? What is their relationship like? Describe an incident with that person.
- *Beliefs?* God? Allah? Science? Astrology? Aliens?

A few more questions
- *What does he/she do when alone?*
- *Any pets? Hobbies?*
- *How is his/her bedroom decorated?*
- *Describe a time when the character achieved something major.*
- *Describe a time when the character failed.*
- *What's his/her dirty secret?*
- *Who was his/her first love?*
- *What's his/her favorite music and/or art?*
- *Describe an incident that created a scar, either physical or mental.*

OK, now sum up this character in a sentence or two. Include a sketchy physical description, mention qualities that work for and against him/her, and mention his/her main motivations. Make quick drawings of the character.

Part three

Next, team up with a colleague and describe your characters to each other. If your characters are not obviously of the same fictional reality (for example, our roller derby star and seven-legged Martian), come up with a scenario in which they could reasonably exist together and know each other (for example, Mars has been colonized, and the number-one colonial sport is roller derby).

Pick a spark card (one spark for the two of you). Using your two characters and the spark, brainstorm a way that your two characters will be brought together in a story. At least one of your characters needs to be the protagonist, and the other can be a secondary character, another protagonist, or an antagonist. You may need to adapt the spark card somewhat to your situation, but its main role must be to start a story. For example, if our roller girl and Martian draw a spark card that says "a suitcase full of money," the money could be U.S. dollars or Martian ducats, but it must appear on the scene in a way that gets a story going: Maybe someone's trying to bribe the roller derby team via their Martian manager, or maybe the roller girl accidentally picks up the Martian's bag of Venutian latinum instead of her roller gear, just before he's supposed to deliver the money to a crime overlord.

Refer to the narrative arc chart in the last chapter for help, and come up with at least three obstacles of increasing difficulty that the protagonist must overcome to bring his or her life back into balance.

When you're done with your story scenerio, read it through again and tighten it up. Try to keep your description to the bare minimum, just dramatized actions: obstacle, attempt, unexpected result that leads to the next obstacle.

Part four

Finally, pitch your story to the group. Pretend the group is a comics publisher's editorial board, or a group of movie producers. *Take no more than five minutes to explain the story.*

Talking points

The group should then vote on whether or not they want to make this comic, and, of course, explain why or why not! Try to focus on the various parts of the narrative arc: Does the action build logically? Do you believe these characters would do what they're doing? Try to pinpoint weak spots and brainstorm better solutions.

Ronin

You can do this activity on your own, up to the pitch part. Simply pick two sets of character cards and create both characters yourself. Create a full story outline, and try to figure out how you would pitch it. You can even repeat the exercise a few times, to get comfortable with how story arcs work.

Since there's very little drawing involved, this may be an exercise you can get some film-buff or TV-fanatic friends interested in, as well. ■

Homework
Character pin-ups for your short story

Now that you've started your thumbnails for your six-page story, it's time to work on your characters more specifically. Remember, you should be creating all-new characters here.

Instructions

Work on at least two characters, but not more than three or four. If you are devoid of ideas, try picking some character cards (you can do givebacks this time if you want). Or you can read the newspaper and see if anything catches your eye (a striking face, an unusual occupation, etc.), then base a fictional character on what you found.

When you have a vague idea of your character, develop it by using the "Questions for characters" from this chapter's activity. Write at least two pages of backstory for each character, then sum them up in a sentence or two.

Finally, draw three full-body designs for each character. These designs should be significantly different from one another: different hair, different body types (more different than in the examples to the right), different clothes, different postures. The idea behind the three designs is that actually drawing the characters and making yourself think about them visually in three different ways will help you broaden your understanding of who the character really is to you. ■

Here are three designs for a young, progressive schoolteacher Jessica developed for a book for the American Library Association. Although the description initially called for dreadlocks, once the character ideas were actually on paper, everyone felt that number two was the best expression of the character.

In the case of this character, a finicky, middle-aged special collections librarian, the qualities that interested the group were in several sketches that were then recombined to create the final design.

Thanks to the ALA and designfarm for their collaboration on these character designs.

Homework
Finish your short story thumbs

Finish the second half of your thumbnails from last chapter's homework. Make sure you have good notes on your group critique of the story, and any critique you might have done yourself on the first half. Apply the things you learned to your work. ■

Extra credit
Character mash-up

Comics is a visual language in which personality is expressed by the way a character is drawn as much as by that character's actions. A round head suggests innocence more than a square one, which suggests strength. We're not suggesting that these shapes have hard and fast meanings, but there are conventions associated with certain shapes and styles, which you can use to your advantage. An important source of these meaningful associations is the wide world of existing comics characters: We may associate a round head with innocence because it reminds us of a baby's head, but we may also be thinking of all the young and/or innocent characters drawn with round heads, such as Mickey Mouse, Tintin, Charlie Brown, or Bone.

Now, what if you were to take Tintin, and put Dick Tracy's nose and jaw on him? ⟶

Or what if you were to give Dick Tracy the mouth and beard of Robert Crumb's Mr. Natural? Suddenly you have a new and rather disturbing character. ⟶

Now try a combination of all three characters. You may well end up with a character who is his own being, but who retains strange echoes of these other characters. ⟶

You could even add a fourth character to the mix. How about Zippy the Pinhead? ⟶

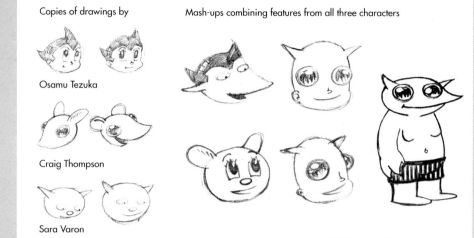

Copies of drawings by — Osamu Tezuka — Craig Thompson — Sara Varon

Mash-ups combining features from all three characters

Copyright © Jon Sperry. http://www.jonsperry.com

Few artists actually go about creating characters this way, but all of us draw to some degree on the iconography of the past. If you pay attention to character design as you look at comics, you are sure to spot features and shapes that have been appropriated, whether consciously or not, from other artists' creations. Inventing a character by consciously combining traits of different characters is an illuminating—and fun—exercise that will make you think about how characters are created visually.

Materials
- lots of comics of different styles (a good library is your best bet)
- sketchbook
- drawing tools

Instructions
Flip through the comics and find three characters that appeal to you but that are quite different in style and proportion. First, draw at least two faithful copies of each character in your sketchbook. Note the characters' names as well as the names of the artists who drew them. Now, draw at least three new mash-up characters by copying and combining different features from each of your three characters. For instance, you may use the face shape of character A, the eyes of character B, and the hair and mouth of character C. Your goal is to come up with three new characters that have a look and personality of their own. ∎

Setting the Stage

Chapter 11

In this two-part chapter we'll take a look at some of the many ways you can approach composing effective and attractive comics panels, and then we'll show you how to think up and lay out snazzy titles for your comics.

11.1

Panel design

BUILDING A BETTER PANEL

It's always important to keep in mind the overall composition and feel of a page, as we discussed in Chapter 6. That said, however, the basic unit of the comic is not the page but the panel, and a significant portion of your work as a cartoonist consists of planning how to make each panel as legible, efficient, and expressive as possible.

As we have seen in earlier chapters, comics tell stories via a sequence of panels. However, this is not to suggest that an individual panel has no importance or meaning when considered on its own.

There are tons of ways to approach any individual beat of a comic. 1960s comics star Wally Wood drew a series of tried and true ideas for panel layouts to refer to when he wanted to save time, and one of his assistants later collated those ideas into the now-famous cheat sheet, "22 Panels That Always Work" (we have a link to it on our website, www.dw-wp.com). Of course, referring to a collection of ready-to-swipe panel compositions will not make you an instant cartoonist. However, it's worth considering that, while there are limitless approaches available to you each time you embark on a new panel, there are a variety of common compositional solutions that are tried and true. There will also be a number of solutions that you personally are drawn to (no pun intended) and return to again and again. It's not a bad idea to make a mental checklist of these "panels that always/often/sometimes work." Even basic distinctions of close-up versus long shot or detailed versus zero background can help get you going.

Each of the choices you make about panel composition needs to be driven not by a desire to simply "change things up" but by a series of questions having to do with what's going on in the story, the relationships between the characters and their attitudes about the matter at hand, the readability of an image, and the overall aesthetics of the page, among other possible issues (such as theme, motif, or stylistic choices). You shouldn't simply say, "I feel like sticking a silhouetted, overhead long shot here." You need to ask yourself if that particular panel composition supports your story both narratively and visually.

Thinking through your design choices on all of these levels sounds hard, but the truth is, many of your choices will happen subconsciously. However, because the process often goes on a bit automatically, most of us rely a little too much on the same kinds of panels over and over again without thinking about it (hello, close-up!). So try to build some level of conscious choice into your process. When you've drawn your thumbs more or less automatically, it's valuable to dive back into them and reassess some of your panel choices.

✍ Homework critiques for Chapter 10 on pages 243 and 244

PANEL PROBLEM-SOLVING: FOUR BASIC CONSIDERATIONS

Now let's take a look at panel problem-solving in action. Clay has been working on a scene where Nate Krusher and Azteka discuss her next dangerous mission, one from which she might not come back. Also, Clay has decided that Nate and Azteka are falling for each other, but they're both reluctant to act on their feelings—it's hard enough as it is working together under such stress.

The scene just isn't working yet. It's looking incredibly boring, with midshot after close-up after midshot, lots of gritted teeth and furrowed brows. It looks too much like every other scene. And Clay's not happy. This scene is supposed to be pivotal, especially the panel in which Nate offers Azteka the data pad containing the mission files, and she accepts it.

Let's run through some of the possible decisions Clay will need to make to get from here . . .

. . . to a revised, satisfying thumbnail of this panel.

There are four considerations Clay will need to ponder when designing his panels (in no particular order): framing, blocking, acting, and mise-en-scène. These are not the only issues comics artists need to think about, but they are the basic ones that they need to figure out the answers to, consciously or unconsciously, for every panel. The more conscious and intentional they are about these things, the more control they will have over their work. Note, by the way, that these terms are borrowed from film (see this chapter's "Film terminology and comics" sidebar for more on the similarities between the two media).

Again, these decisions don't need to happen in the order we are presenting them in; knowing the answer to any one of these questions could be the seed of the final panel. You might know the panel shape before you decide on framing, for example. This is just one way to look at a few of the myriad choices available for that one final panel.

Framing

Framing makes you consider the relationship between your readers and the action of the panel. How close to the action are we? Where are we relative to the characters in the panel? From what angle are we seeing the action?

Blocking

Blocking asks you to consider where the characters are relative to each other, and where they are moving. Blocking influences readability and clarity of action, but it also tells your readers about the relationships between the characters.

Acting

Closely related to blocking, acting makes you further consider the relationships between characters: What are the characters' expressions? How do they "say" their lines? Are the gestures and facial expressions exaggerated and theatrical, or understated, even nonexistent? Acting also affects how we understand the information being conveyed: Is it important? Funny? Insulting?

Mise-en-scène

The French phrase mise-en-scène (pronounced "meeze on sen," more or less), literally means "putting on the stage." In comics, as in theater and film, it refers to both the size and shape of the "stage" (the panel) itself and to the arrangement of elements within the panel, such as props, background elements, and lighting. Unlike in theater and film, mise-en-scène in comics also refers to the arrangement of elements that don't exist in those media, such as black spotting (whether related to lighting or not), word balloons, and emanata. In addition, it refers to decisions about drawing style: simple vs. complex; cartoony vs. realistic; etc. Note that mise-en-scène also involves the arrangement and movement of characters, so in that sense, mise-en-scène incorporates both blocking and framing. Mise-en-scène choices can contribute to or impede readability and clarity of a panel, but they can also make an aesthetic statement, establish mood and atmosphere, and contribute to your reader's understanding of the unspoken meaning of the scene or story.

60 PANELS THAT JUST MIGHT WORK

Here are 60 panels illustrating framing, blocking, acting, and mise-en-scène options that Clay might choose from to improve his scene between Nate Krusher and Azteka. These are examples of choices you might consider *in your head*. We're not suggesting you actually create 60 options for every panel you draw.

Framing: Let's start with four basic "camera" setups: a medium shot, a close-up, a long shot, and a tilted shot.

Blocking: Then we'll try varying the placement of the characters in the scene.

Acting: We can also introduce varying examples of "acting."

Mise-en-scène: Here we play with formal elements like lighting, black spotting, drawing style, panel shape, and background.

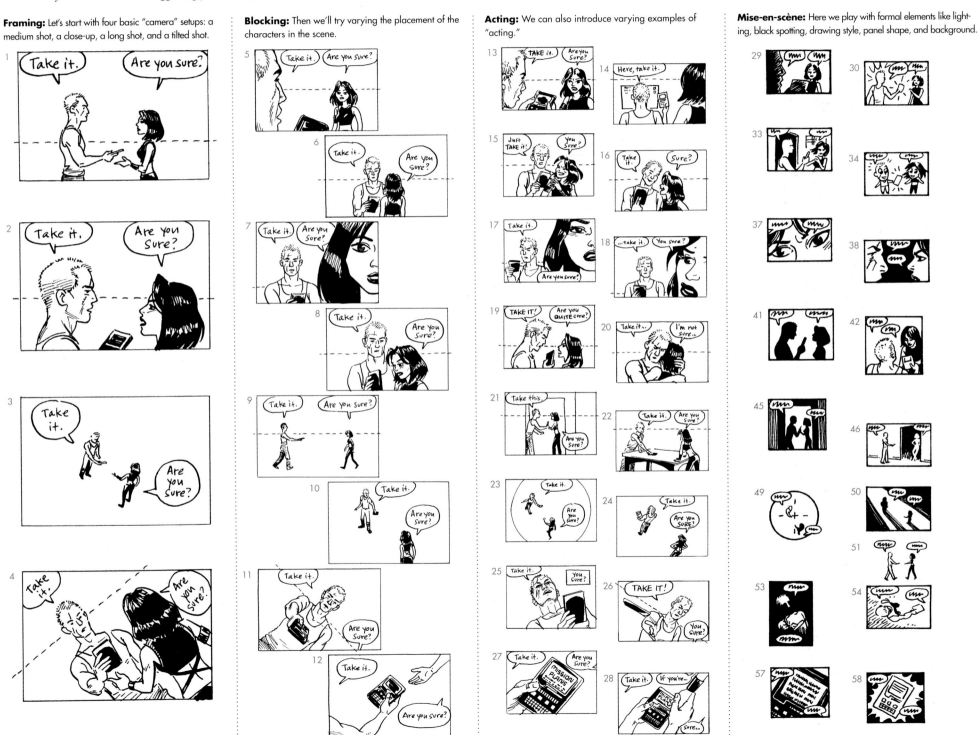

A few notes on the panels

As you can see from this admittedly extreme demonstration, there are limitless ways to approach the design of a single panel. So when you get the first version of your thumbnail done, don't brush off your hands and say, "Done!" Look at it again, and see where you might make a more effective choice.

1 a basic two-shot in profile; does the trick but it's a little dull—too symmetrical, for one thing. This was Clay's first idea.

2 a close-up heightens tension and intimacy.

3 a long shot from above suggests that the characters are being watched.

4 a canted angle adds drama by creating a sense of vertigo.

5, 13, and 14 are all variations on a classic over-the-shoulder shot; the emphasis on the first two is on Azteka, while in 14 it is on Krusher even though his back is to us.

6, 15, and 16 suggest the variations that come from acting. 6 plays it straight, 15 suggests a playful, competitive feeling, and 16 a friendly—maybe too friendly—comfort level.

7 is a little unusual in contrasting a medium shot with a close-up. The cropping of half of Azteka's face and the fact that she's looking out blankly at the reader add a sense of tension and uncertainty.

17 and 18 alter the positioning of the characters and give them more definite expressions.

11, a subjective canted angle, is a little weird because it makes it look like Azteka is leaning over.

21 and 22 start to suggest what can be done with props and framing using elements of the setting. 45 through 48 carry that idea further, adding abstract black spotting as an organizing principle.

27 focuses on the tablet that Krusher is handing to Azteka, and their voices are "heard" from off-panel. Zooming in closer, as in 57, you could even spell out details of the mission.

31 a view of some element of the room leads the reader to expect mood-setting aspect-to-aspect transitions, or that something important is up there in the corner.

32 and 35: changing the shape and ratio of the panel has a significant impact on the composition: In 32, the horizontal space crops and separates the characters, creating a sense of distance and alienation (helped by the chiaroscuro lighting), while in 35 the characters are much more intimate, intertwined, and almost pressed together by the sides of the panel.

34 this probably isn't the moment for super-deformed cuteness, but this nonobjective technique does come in handy at times.

36 the data pad is emphasized by placing it in front of a black doorway.

41 silhouettes are an easy way to create a sense of mystery—a bit too easy, many artists decide.

44 is an abstract composition in the sense that Azteka and Krusher are probably not standing this close, but the emphasis on their mouths makes the moment intimate, almost sexy, and also focuses on the dialogue.

49 the panel shape has taken on narrative meaning: it's now a gun sight.

50 the strong light coming from the upper left corner creates an asymmetrical geometric composition, the long shadows create a sense of menace and secrecy.

51 is a vignette: That is, it has no border. Combined with a long shot, it creates a sense of extended time, slowing down the crucial moment of the scene.

53 concentrates on Krusher and plunges him into near-total darkness. The unease is accentuated by a slightly canted angle.

60 takes place after the scene in question. The dialogue is in quotes within narrative boxes while we see Azteka running off with the mission files. (It also utilizes manga-style subjective motion.) Sometimes the most effective way to draw a scene is to not draw it at all.

Make a choice

In the end, Clay will choose between panels 7, 19, 50, 53, and 60. The choice will come down to what he wants to emphasize: the seriousness of the moment in Azteka's mind (7), or perhaps a battle of wills between the two big egos in the room (19), the secret nature of the mission (50), the responsibility Nate Krusher feels (53), or the fact that this mission simply has to be done, and they both understand that (60). ■

Film terminology and comics

The world of film has generated a large number of terms to describe different kinds of camera setups, compositions, and editing techniques, and some of these terms can be very usefully borrowed by us cartoonists, even if the meanings don't always line up 100 percent.

Film and comics share quite a few features—they are both relatively young media that tell stories using a combination of words and images, and they both rely on technology to varying degrees.

Of course, they are also crucially different in a number of ways: one is photographed and the other drawn (usually, at least: photo comics and animation blur that particular distinction); and film is time-based and continuous, while in comics, still images appear in a sequence and the reader sets the pace of the story. In comics you also have the storytelling possibilities offered by panel size and shape, as well as page and spread design.

Setting aside for the moment fruitful debates about the relationship between comics and film, let's take a look at some film terms for camera placement (shots) and camera angles, many of which you will already be using whether or not you know they come from that other medium.

Camera placement (shots)

Establishing shot

A shot, usually at the beginning of a scene, that shows us the setting where the action will take place. The establishing shot could be of a cityscape, a deep-space vista, or a suburban interior. In comics, this is often a splash panel or page.

Close-up (CU)

Usually a torso or head shot, when dealing with characters. But it can also be a close-up of an object.

Extreme close-up

This might be a shot of just the eyes or mouth when focused on a character.

Medium shot

A shot showing part of the body of one or more characters.

Long shot (LS)

Usually a full-figure shot, emphasizing the background and the blocking of the characters. A long shot can be further qualified as a medium long shot or extreme long shot.

Over-the-shoulder (OTS) shot

A shot incorporating the shoulder and rear three-quarters profile of the character whose point of view we are closest to. Often a series of contrasting OTS shots will be used to show a conversation.

Point-of-view (POV) shot

A shot seen through the eyes of a character.

Camera angles/techniques

Canted angle, or dutch tilt

The camera is tilted to one side so that the horizon line is no longer parallel to the edge of the screen.

Focus

Film and photography can use shallow focus, where only one plane (foreground, or, less commonly, background) is seen clearly, or deep focus, where the foreground and background are both in focus. This is a useful tool for guiding the viewers' attention, and it can be simulated in comics in any number of ways.

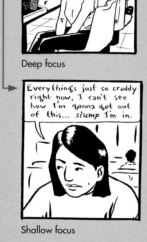

Deep focus

Shallow focus

High-angle/low-angle shot

The camera looks up or down at the action.

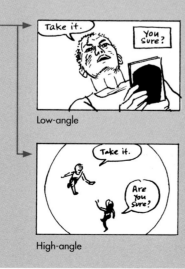

Low-angle

High-angle

Iris

An early camera effect from the silent era, in which a circular area closes in on a detail or opens to introduce a scene. The iris effect was common in early animation (think "Th-th-th-that's all, folks!"), and its effect can still be seen in the use of circular panels in comics.

Split screen

A post-production effect in which two or more pieces of film are shown simultaneously, divided by a hairline or blur effect. It's occasionally imitated in comics, often for a telephone conversation.

Wide screen

A film projected as a wide, horizontal image. ■

Sin City copyright © 2008 Frank Miller, Inc. All rights reserved. Sin City and the Sin City logo are registered trademarks of Frank Miller, Inc. Published by Dark Horse Comics, Inc.

This panel from **Frank Miller**'s *Sin City* exhibits a geometric use of blacks, and dramatic contrast between the diagonals and the standing figure, who is off-center, somewhere around the 1/3 mark, both in the panel and in the internal frame created by the light on the floor. There is a strong reading path guiding the eye through the two narration boxes via the standing figure, then out of the panel along the wisp of smoke, which hangs oppressively over the figure's distorted shadow.

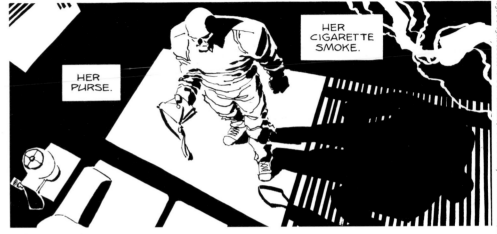

PANEL COMPOSITION

Panel composition, you ask? Weren't we just talking about composition in the last section? Short answer: Yes. Long answer: In this chapter, we're approaching the challenge of panel design from two different (but overlapping) directions. At the beginning of the chapter, we discussed panel design from the point of view of storytelling, using some of the tools of film and theater. In this section, we shift focus and apply the principles of purely pictorial problem-solving.

So what is *composition*? You've probably heard of the word in the context of an article on a photo or painting, or in art history class. But it's a hard idea to put your finger on, and it can be an intimidating concept to try to understand. Don't let the word scare you. In fact, you've already done a lot of thinking about composition.

To attempt to define the idea succinctly in comics terms, composition is the harmonious wholeness of a panel, the way in which the whole panel functions as a single effective and attractive unit in terms of tone, texture, balance, line, shape, and other visual elements.

Panel composition has a lot to do with traditional pictorial composition, so if you've ever learned anything about that, you can apply your knowledge here. If not, don't worry. Composition is a largely unconscious set of design decisions. There are no "right" solutions, just more effective ones that you will get better at as you practice.

Many of the concepts we will discuss in this section also apply to the page design ideas we talked about in Chapter 6, so it would be a good idea to review that section at this point.

There are many approaches to solving compositional problems. You don't need to absorb the following concepts all at once or to apply them all to each panel you draw. This is simply a tool kit for you to delve into when faced with a blank page or tricky scene. We've also included some wonderful examples of professional cartoonists' use of these concepts.

Asymmetry

If you attempt to create a sense of balance by placing a character smack in the center of the panel, especially standing four-square facing the reader, you usually end up creating a static and unengaging panel. The panel doesn't "move," doesn't feel active. In order to array your elements in the panel in a way that *feels* balanced but also has a sense of flow, you need to *offset* the center of focus. The "visual center" of an image is not the literal center but an area near the center that can be determined a number of ways.

One method is to divide the panel into thirds or fifths and place key visual elements on the intersections of the lines.

Another technique is to draw a diagonal connecting two corners of the panel, and then to extend lines from the other corners perpendicular to the diagonal. Where those lines cross may also be a visual center. This doesn't mean you have to have everything in the panel on those crosshairs, but that the arrangement of elements centers on that area.

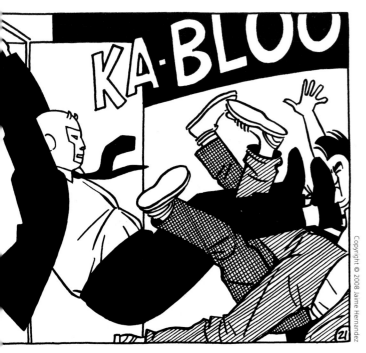

Jaime Hernandez strips visual information down to a minimum to emphasize the almost abstract quality of his panels. He composes with solid black and negative space, occasionally using cross-hatching and patterns to vary the composition and increase clarity. In this panel the eye is firmly guided by the blacks along the path of the kick, ending in the comical jumble of flailing legs (and a face that seems to be smooshed against the panel border). The spotlight shadow on the rear wall reinforces the movement of the action as well as creating a backdrop for the cartoony sound effect, which, like the receivers of the kick, is cropped to suggest the force of the blow. Notice too that the dynamic use of blacks, contrasting diagonals, and the grouping of forms makes the use of motion lines unnecessary: This is creating a sense of action through composition.

Tonal balance

The distribution of values—gray tones as well as black and white—is a powerful tool in pictorial design. Value is a technical term describing the lightness or darkness of a tone or color. The easiest way to think about it is in terms of percentages of gray: For example, a medium gray would be 50 percent. You want whatever tones you are using to help guide the reader through the image as well as create a pleasing and varied composition. Try to keep the whole page in mind, in addition to the panel at hand. Both variation and balance are important: If you distribute black and gray over the page equally, you can end up with a monotonous sense of pattern that exists on a separate level from the art, like wallpaper.

Diagonals

Diagonals are useful in pulling readers into a page or panel and guiding them where you want them to look. Too often, artists will choose to set picture elements absolutely parallel to the frame, and that can work against a sense of movement. Diagonals are inviting because they are inherently dramatic, while rigidly parallel and perpendicular compositions tend to be static.

Reading path

You always need to help readers navigate your panels: Readers should be able to easily follow the order of actions, dialogue, narration, and background detail.

As we said in Chapter 1, the most basic Western reading order is the same for words and images: left to right, then top to bottom. This is not to say that there should be only one possible way to read a panel (nor that you can prevent readers from approaching a panel any way they please), just that you need to design each panel with the reading path in mind.

The way the eye moves through a panel can suggest physical movement—think of a thrust-out fist in a fight scene—but it also helps determine the passage of time. A clear, straight path through a panel will create a "quicker" panel than a complicated, winding path. Just make sure the reading path isn't confusing, or difficult to navigate.

This panel from **Chester Brown**'s *Louis Riel* is elegantly composed using diagonals in contrast with the upright forms of the trees, a rich tonal and textural variety, and the use of negative space to highlight the small figure dwarfed by the natural world. A subtle sequence of blacks delineates the figure's upward path. Although the figure draws our gaze right away, he is not in the actual center of the image, rather in one of the asymmetrical but balanced visual centers. Note too that by making the figure climb against the normal reading path, Brown subtly augments the sense of struggle.

This panel from **Jordan Crane**'s *Uptight* shows an unexpected but very effective way of framing a car crash. Our eye is first drawn in by the "CLUNK" sound effect and on into the flurry of dust clouds at the bottom of the panel. It is only in following the upward diagonal of the sound effect and then the path of dust clouds up and counterclockwise that our eyes focus on the overturned car suspended amid the jumble of debris in the inky black void beyond the fence. The absence of motion lines creates a snapshot effect and suggests the moment of terrible quiet just before the car hits the ground below.

The visual center of this panel from **Gilbert Hernandez** is the figure in bed. Even though he is dwarfed by all the other elements of the page, those elements also serve to lead our attention to him: the frame of the window and the subframe created by the body of the boy in the window; the gaze of the boy in the window; the shading on the wall, which keeps us focused on the lower half of the room; even secondary elements like the white diagonal lines on the outside wall and the arms of the character himself.

Highlighting
Sometimes you need the reader to really notice something or someone in particular within a busy or crowded panel. Use compositional elements like converging diagonals, silhouettes, and shading to "point" to an object or character subtly but clearly.

Internal framing
Similar to highlighting, another excellent tool for creating emphasis and guiding the reader's eye is to use a framing device. Note that we're talking about *internal* framing here and not the "camera placement" type of framing discussed earlier. Figures, trees, or architectural elements (like doors, windows, and archways) can work with and draw attention to the main focus of an image, surrounding and/or pointing to that element. Be careful not to let your framing device get too symmetrical, though. The same principles of asymmetry apply to framing as to other picture elements: Keep the internal frame in harmonious balance with the larger panel border.

Visual rhythm
Repeated patterns and shapes create visual rhythm in a panel or across multiple panels to provide a compositionally unifying "backbeat." You can vary and punctuate this rhythm in lots of ways that will enhance your story. If there isn't enough variation in the rhythm, you risk ending up with a lifeless wallpaper pattern.

Anders Nilsen works without a panel border here, creating a sense of spatial and temporal openness: The same figure appears at progressive points in space and time. The diagonal path he follows guides us clearly into the forest, helped along by the shrinking word balloons and music note-like blacks. The trees generate a visual rhythm through repetition and variation: They create an irregular beat as we move from left to right while, at the same time, the variations in line weight and size create a sense of trees receding into the distance.

Negative space

One of your strongest compositional tools is what you don't draw. Pay attention to the negative space (that is, undrawn space) in the image, and how it works with and balances the drawing.

Silhouetting

Silhouetting (or filling characters with black) is a powerful compositional tool that combines black spotting and framing devices. It's also useful to check how powerful your character positions are: If you black them out, do they read clearly? Can you tell from their outlines who they are, and what they are doing? Be careful not to overdo it with silhouettes—they are dramatically effective but can also feel like a shortcut.

Depth of field

Another way to control focus and draw a reader in is to manipulate depth of field, which, in film and photography, refers to the amount (from foreground to background) of an image that is in focus. You can draw focus to the foreground by making the background less specific, or you can do just the opposite—focus on the background. You can create multiple depths of field within the same panel, a rich possibility for storytelling. ■

This panel from **Hiroaki Samura**'s *Blade of the Immortal* shows a number of ways to highlight a figure: the crouching girl is framed on either side by the almost-silhouetted trees in the foreground; she risks getting lost in all that cross-hatching, but she is surrounded by a slight halo and is in a clearing that is surrounded by darker shadows. Lighter areas at the top left and bottom right of the panel help make this center spotlight more subtle and also create complicated diagonal bands that contrast with the trees.

This panel from **Alison Bechdel**'s *Fun Home* shows how depth of field can be used dramatically—in this case to illustrate a family's alienation. We read the narration above the panel and are then interrupted as we move into the panel by a word balloon whose tail leads us back to silhouettes of the parents, framed and silhouetted two doorways back. The narration box then brings us into the front room, where the narrator's childhood self is absorbed in reading while her siblings—in white against the ink wash of the middle room—watch TV. (Note that the placement of the word balloon, right in the line of sight of the two siblings, puts the lie to their studied indifference to their parents' fighting.)

Nick Abadzis expresses a character's alienation in a number of simple but effective ways here: The small door at the bottom of the thin, vertical panel suggests great distance, and the lack of background leaves a void between the figure in the door and the silhouetted figure, cropped uncomfortably in the foreground, her arm raised hesitantly. The long tail on the word balloon reinforces the sense of distance and emphasizes the weight of the negative space that dominates the panel.

THE EXPLANATION OF REPRESSED HOSTILITY MADE NO SENSE TO ME. I CONTINUED READING, SEARCHING FOR SOMETHING MORE CONCRETE.

Rethinking composition

Sometimes it's really hard to make yourself think in a fresh way about thumbs you've been slaving over. Here's one way to break out of the rut.

Materials
- thumbs for your six-page story
- paper
- pencil
- eraser

Instructions
1. Pick out a panel in your thumbs that you're particularly unhappy with, find boring, or have otherwise struggled with. Mark it with colored pencil or a Post-it note and trade it with someone else in the group for their problematic panel.
2. Read your partner's comic in order to understand the context of their panel better.
3. Use your own imagination as well as ideas from the "60 panels" section in this chapter to make fairly tight sketches of five proposed alternate takes on the panel. Be serious: Think of five approaches that would work within the context of the story, not just five wacky, unusable possibilities. Make sure all the necessary elements are in place: the characters that need to be there, the dialogue, etc. But feel free not to use elements that you think aren't important.
4. If there's time, show your versions to other members of your group. See which ones they think work best.

Ronin

This is obviously tough to do by yourself, but you can try to apply each of the compositional devices described in this chapter to a given panel, and then see which works best. There are more ideas on the website, www.dw-wp.com. ■

11.2 TITLES

THE IMPORTANCE OF TITLE DESIGN

As we've said from the beginning, comics are about communication. You, the artist, have something to say, and you want to use comics to make that something understandable to someone else. OK, fine. But you also want to make sure others bother to read your comic in the first place. How are you going to grab your reader's attention? A good title and an effective title design for your comic—whether it's book-length or a one-pager—will be the first thing to catch your reader's eye.

Titles are important. They telegraph information about the work to a reader, and if they're inappropriate, they may put an unwanted spin on the work or even discourage a reader's interest. There are no hard and fast rules for developing titles, but there are some principles you can follow. A title can be descriptive, like *A Portrait of the Artist as a Young Man*, or it can evoke the mood or theme of the work, such as *The Dark Knight*. A title may be taken from a quote from the work (such as Jason's *"Hey, Wait…"*) or from another source (for example, Ernest Hemingway's novel *For Whom the Bell Tolls* takes its name from a poem by John Donne).

PLANNING YOUR TITLE DESIGN

Once you have selected a title, you can start thinking about how its type treatment reflects the content of the piece, sets the mood, provides ironic counterpoint, or just looks awesome.

There are a lot of intricacies to "display lettering" (carefully designed titles and logos), but at a basic level, you have three challenges: make it eye-catching, make your design appropriate to the comic in question, and make it readable.

Here are some ways you might develop your ideas for title design:

1. Collect samples of type that appeal to you. There's a long history of wonderful display lettering. Be inspired by old advertising or editorial design, or look at comics from the past like Will Eisner's *The Spirit* or George Herriman's *Krazy Kat* (see Chapter 6 for an example of that). Look also at contemporary lettering design in magazines, on CD covers, and on websites.
2. Try to connect the content of the story to the title design. A cowboy story might be titled with log lettering, a sea-going story with a swooping wave-form title, a chrome-looking title for a story about cars, and so on. If you've drawn a story about space travel, you probably don't want to use type that looks Victorian, unless maybe you're doing a retro sci-fi story about steam-powered space ships. Title design is an aesthetic choice that you need to ponder. Of course, avoid clichéd styles, unless you're being funny, or are paying tribute to something.
3. You might want to quote other comics styles, like the 3-D title style associated with superheroes, if your story has something to do with a specific tradition.
4. Think about the mood suggested by different kinds of lettering. This can be pretty subjective, but consider for example the difference in feel of a title lettered in a wispy script font as opposed to jagged glass-like forms. ——

Rope lettering may not be the best choice for a science fiction epic.

We used ironically heroic lettering for our instructional comic.

LAYING OUT AND INKING YOUR TITLE DESIGN

There are a number of ways to go about getting your nifty title on paper, so let's now turn to the topic of title layout.

Sketch

Once you have come up with a title that is short and snappy, something that will spark a potential reader's curiosity, sketch out some lettering ideas in your sketchbook or on scrap paper.

Placement and composition

Now think about where you're going to place your title on the page and how much real estate you want to devote to it. One option is to have a separate title page with a big splash image to go along with it, but when you are working on relatively short comics (like your six-pager), you're better off putting the title on page one of your comic and devoting one or two panels' worth of space to it. You could also have it running across the top of the page, making the letters two or three inches tall. As always, keep in mind that your page is ultimately going to be reduced during photocopying/scanning, so don't make the title too small.

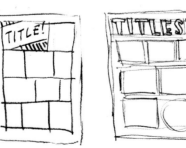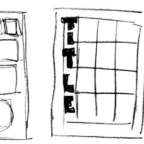

Letter measurement and drawing guidelines

Once you've decided on a design, placement, and composition, it's time to lay out your title on your bristol board. Rough in the lettering in pencil to give yourself an idea of how the title is going to fit on the page. As with moving from thumbnails to pencils, you can also trace or transfer a blown-up copy of your original sketch to serve as a rough guideline. That's what we did in the following demo. Then refine your measurements, making sure that letter width and spacing are consistent and well-balanced.

In our example, the letter forms have tapered stems (the vertical portions of the letters) and thin crossbars (the horizontal portions of the letters). Using the "T" as the standard, we figured out the relative sizes of all of the letters. Our stems are ten units wide and the crossbars are five units tall. The spacing between the letters is five units. Because these letters are all square in shape (except for the "S"), we were able to give them a consistent look.

Pencil in the guidelines for your lettering using a ruler (the Ames guide may also be helpful here) or freehand if your title has a more organic or irregular shape.

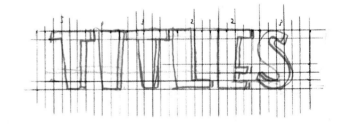

Penciling

Now pencil in your title, lightly at first and then more tightly. Ignore your first, unrefined roughed-in lettering or lightly erase it if necessary. You may find at this stage that some of your ruled measurements need adjustment. For instance, we ended up making the height of the crossbars a little bit shorter than the five units we had ruled out for them. We just liked how it increased the contrast in the shapes of the letters. Use a ruler where appropriate. Pencil curved shapes like "S" and "O" by hand and try to get them as tight as you can. Emulate the style of the squared letters as much as possible.

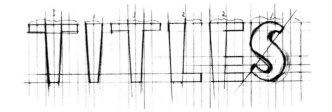

Double-checking

Before you commit your title to ink, make sure it reads clearly, has regular spacing, and is well-balanced. Put your penciled title on a wall and stand back, looking at it from a distance to better evaluate the title's balance and consistency. Squint and consider its balance as an abstract form.

You may see that your title looks funny, as if you measured the spacing wrong. Well, that's always possible. More likely, you measured right, but need to adjust your kerning (the spacing between letters; see "Type terminology" sidebar, below). Kerning is an art, not a science. Evenly spaced letters often look wonky and gappy, or too tight. You need to adjust the kerning so that it looks right to you visually, not mathematically. Here are a few methods that will help you to pinpoint problems with kerning as well as other design flaws.

Turn the title upside down to see it as an abstract design—the goal at this point is to judge your title for its shape and balance, not for its legibility.

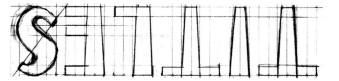

To check kerning letter-by-letter, mask the title so that you can see only three letters (and two spaces) at a time. It should become apparent to you where the kerning is off. You can also combine the two methods discussed so far: Mask all but three letters while the title is upside-down.

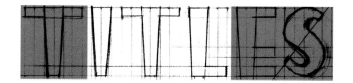

Another way to check kerning and overall balance is to give yourself new perspective by laying tracing paper over your title and blacking in the negative space between the letters.

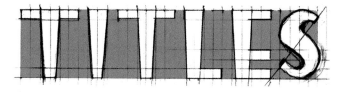

Make any necessary adjustments. You might need to erase a letter or two and pencil them again. Sometimes it helps to do the title design on office paper or tracing vellum so you can cut it up and adjust before tracing down on your final page. You may even need to redo the whole title. Resist the temptation to let problems slide—readers will notice if the title lettering is off-kilter.

Inking straight letters

You can ink straight title lettering any number of ways depending on the style and look you are after. Speedball nibs are often used for classic comics titles, but you can also use a brush, other types of nibs, pigment pens, or a ruling pen. In our case, we chose a technical pen (a #2 Rapidograph) because we wanted clean, tight lines, and since we are planning to fill in the letters with black, the title doesn't need to have any "expressive" quality to it. In this example we have inked the straight letters using a T-square and a triangle.

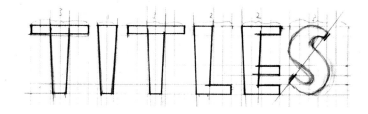

But what to do about the S…

Inking curved letters

Cleanly inking a curved letter can be an exasperating experience, and it takes a bit of patience and some trial and error. The basic principle—which is the same for inking circles and curves in general—is that you should pencil curved letters as best you can in freehand, then, to ink, use any ruling tools you might have handy, and look for the best fit. We have already talked about circle and ellipse templates in Chapter 7. French curves and flexible rulers are also a big help for neatly inking irregular shapes.

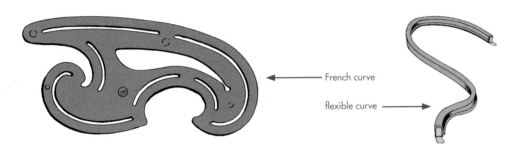

French curve

flexible curve

There is no way you can ink a curved letter like an "S" in one go, so just ink one curve at a time. Rotate, pivot, and slide your French curve around until it lines up with all or part of each letter curve you want to ink. Then, making sure the beveled edge of your French curve is facing down (if there's no beveled edge, tape some pennies to the underside), ink that section of the letter. Technical or pigment pens are the easiest-to-use inking tools, but you can also use a dip pen or ruling pen if you are careful. If you ink beyond the area you wanted, don't worry, you can clean it up later. Work your way around the whole letter this way.

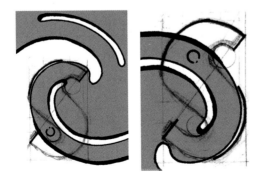

Flexible rulers work much the same way, but of course, they're flexible, so you can bend them to match your curves more exactly.

Here is our title, fully inked, before corrections.

Touch-ups and corrections

When you're done inking, make corrections using graphic white and a fine technical or pigment pen.

Don't bother cleaning up inside the letters if they will be filled with black.

Use graphic white and a fine pen to clean up and smooth curves.

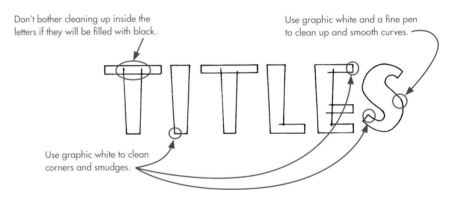

Use graphic white to clean corners and smudges.

With a thicker line, this title could work as an outline, but we decided to fill the letters with solid black (using a brush) for greater boldness. ■

☞ Type terminology

The world of type design is a vast one, with a huge store of history and its own terminology. You don't need to know everything about type terminology, but the more you know, the easier using type in your comics will be. To start, here are a few basic terms that you'll need to know more or less right away.

Typeface or "face"
This is the full set of letterforms, symbols, and punctuation created to work together, with the same stylistic attributes. It often includes **bold**, *italic*, and ***bold italic*** versions, and may also have **black** (extra bold), narrow, and other styles.

Font
Originally, a font was just one particular style or size of a typeface (such as Times New Roman 12-point). Now, the word's pretty much interchangeable with typeface.

Serif/sans serif
Serifs are the little pointy parts of some letters.

The purpose of serifs is to make typefaces more readable. The points help to draw the letters together and form words into blocks of type and negative (white) space. This is an extension of what we talked about in Chapter 7 with reference to using upper- and lower-case letters. Typefaces without serifs (such as Helvetica) are called sans-serif fonts, or sometimes just "sans." "Sans" means "without" in French.

Kerning
The space between letters. You can have w i d e k e r n i n g or tight kerning. But kerning is an art. If you're titling a comic with block letters, and you leave even amounts of space between each, you'll start to understand why kerning matters. Good kerning is attentive to how a word *looks*, not to mathematical precision in letter spacing.

Leading
Leading is pronounced like the metal "lead," not the verb "to lead," and refers to the space between lines of text. Unlike kerning, leading is mechanical. You want to have your lines of text all equidistant from one another, far enough apart so as not to be muddy and hard to decipher, but not so far as to make it hard to connect one line to the next. In hand lettering, this is what the Ames Lettering Guide helps us achieve! ■

✍ Plan, lay out, and ink a title design for your six-page comic

Materials
- thumbs for your six-page story
- a sheet of 14" x 17" bristol board laid out with a 10" x 15" or 12" x 16" live area (which will be the first page of your pencils)
- office paper
- penciling tools
- bristol board
- T-square
- triangle
- Ames Lettering Guide
- templates and curves
- inking tools

Instructions
Following the guidelines in this chapter, plan, lay out, and ink the title for your comic.
1. Devise a title that will grab readers' attention and that is appropriate for your comic.
2. Design your title in a way that connects to the content of your story and evokes its mood.
3. Consider carefully the placement and composition of your title.
4. Measure your letters and pencil in lettering guidelines in your title panel(s).
5. Pencil in your title and then double-check and adjust as needed.
6. Ink your title, using a T-square or triangle for squared letters and a French curve for curved letters.
7. Finally, touch up and correct your title as needed. ■

Homework
Revise your six-page story thumbs and start penciling

Materials
- thumbs for your six-page story
- office paper
- two sheets of 14" x 17" bristol board, including the one on which you've created your title
- penciling tools
- ruler
- Ames Lettering Guide
- mechanical pencil
- T-square

Instructions

Use the information you gathered from the critique of your thumbnails to thoroughly revise them. If you find yourself just giving them a quick pass, put on the brakes. Remember, this is your last chance to really revise the way your story reads and how it looks, on a global level. Once you start penciling, it's going to be awfully hard for you to go back and revise again. So, with that in mind, here are some specific things to do with your thumbs:

Revise your drawing:
- Revise the layout of two full pages (refer back to Chapter 6).
- Revise the compositions of at least ten panels, using some of the ideas in this chapter.
- In at least one scene, cut out a close-up or three, and add a large establishing-shot panel.

Revise your writing:
- Read the whole comic out loud, ideally in front of an audience (a sympathetic one, such as a significant other, is OK). Listen to yourself as you read, and ask your audience to take notes about where it works well, and where it falls flat.
- Rewrite at least ten word balloons.
- Rethink the motivation of a character in at least one scene, and let that guide your dialogue rewrites.
- If you're using more than a few narrative boxes, cut at least three out completely, and reduce two more in length.
- Have a friend (who is good at it) check your spelling and grammar!
- If a page just isn't working or you want to change the layout, either redraw it completely or cut and paste the salvageable

elements onto a new piece of office paper. Remember that thumbs are fast and dirty diagrams of your comic—don't worry if your drawings look crappy, just make sure your thumbnails are legible enough for your colleagues to be able to decipher and respond to them.

Begin pencils:

Lay out the second of your two sheets of bristol board according to page two of your thumbnails, using the same live area as you used on page one (either 10" x 15" or 12" x 16"). Fully pencil pages one and two, using your thumbs as a guide.

Remember the order of activity from Chapter 5:
- Lay out the panels.
- Very roughly pencil in the drawings.
- Lay out the lettering (get the lettering right at this stage).
- Tighten up your pencils.
- If you need a refresher, see Chapter 5 for penciling, Chapter 6 for layout, and Chapter 7 for lettering. ∎

Extra credit
Draw a folk tale

Use the following script to draw a three-page thumbnail. Make sure to fit in *all* of the actions described.

The words in bold type represent dialogue. We've made it as dull as possible, so you can go back in and spice it up. Make the characters' speech patterns distinct from one another. Originally, these stories were written down in a southern African American voice, but we've seen them done in hip-hop, cockney, French, and all kinds of other modes. The characters are tough and can bear up under your most creative inventions.

Don't forget to start by going through the script and breaking it down into chunks that correspond to pages. Since you don't have to think at all about what happens in the story, this is a perfect opportunity to think about *how* it happens. Rework your layouts, rethink your compositions. Don't use your first thumb, or even your third. You might even try setting yourself assignments, like using a certain number of panels defined by film terminology, or addressing the four considerations for panel design discussed in this chapter explicitly and consciously.

About Br'er Rabbit

Br'er Rabbit is a traditional African American folktale character. The "br'er" is a dialect rendering of the word "brother" (actually pronounced more like "bruh"), and refers to the tradition among African American slaves of calling one another "brother." ("Coon," by the way, is short for "raccoon.") There are many theories linking Br'er Rabbit to African folk traditions of the trickster, the character who uses his wits to outsmart a physically more powerful foe or oppressor. You can see how this kind of character might appeal to African American slaves. Despite some controversy about racially insensitive use of the stories in the past, Br'er Rabbit is a great character and belongs to a proud tradition.

Br'er Rabbit, Br'er Coon, and the Frogs

Br'er Rabbit and Br'er Coon were both good fishers. Br'er Rabbit liked to go for fish, but Br'er Coon preferred frogs.

One summer, though, Br'er Rabbit was having all the luck. He pulled in lots of fish every day, while Br'er Coon couldn't catch a frog no matter what he did. Br'er Coon was puzzled and **wanted to know why Br'er Rabbit was having luck and he had none.**

Br'er Rabbit answered that **he'd forgotten about catching King Frog.**

Br'er Coon **remembered the good meal.**

Br'er Rabbit said that **he may have been good, but now all the frogs shout warnings when Br'er Coon comes to fish and then they disappear.**

Br'er Coon asked **how, then, could he catch them?**

Br'er Rabbit smiled and said that, **since Br'er Coon was a pal, and had never done him wrong, he thought he could help him.**

Br'er Rabbit told Br'er Coon to **get on a sandbar out between the creek and the river and stagger around as if he was sick, then whirl around and fall down as if he was dead, then lie completely still. He must not blink his eyes or twitch his tail, even if a fly landed on his nose.** Br'er Rabbit told Br'er Coon to **just lie there until he told him to move.**

Br'er Coon did just as Br'er Rabbit said. After Br'er Coon had been lying there for a while, Br'er Rabbit called out that **Br'er Coon was dead.** Frogs popped up from everywhere and eyed Br'er Coon's body warily. Br'er Rabbit sat on the bank pretending to ignore the frogs.

The frogs decided to investigate and hopped over to Br'er Coon. He certainly looked dead. There was a fly crawling on his nose and he didn't even twitch.

Br'er Rabbit called out to Cousin Frogs that **they'd wanted to get rid of Br'er Coon, so now all they had to do was bury him deep in the sand.**

Big Frog asked **how they could do that.**

Br'er Rabbit told them to **dig the sand out from under him and let him down into the hole.**

Hundreds of frogs started to dig a hole around Br'er Coon. He didn't twitch. The frogs kept digging until Br'er Coon was in a nice hole.

Big Frog wanted to know **if it was deep enough.**

Br'er Rabbit asked **if he could jump out.**

Big Frog said **he could.**

Then it isn't deep enough, said Br'er Rabbit.

The frogs dug some more and asked **if it was deep enough.**

Br'er Rabbit asked **if they could jump out.**

Big Frog said **he could.**

Br'er Rabbit said he needed to **dig it deeper.**

The frogs dug and dug and dug. Then they asked **if it was deep enough.**

Br'er Rabbit asked **if they could jump out.**

They answered that **they couldn't, and asked for help to get out.**

Br'er Rabbit laughed and yelled to Br'er Coon to **get up and get his food!** ■

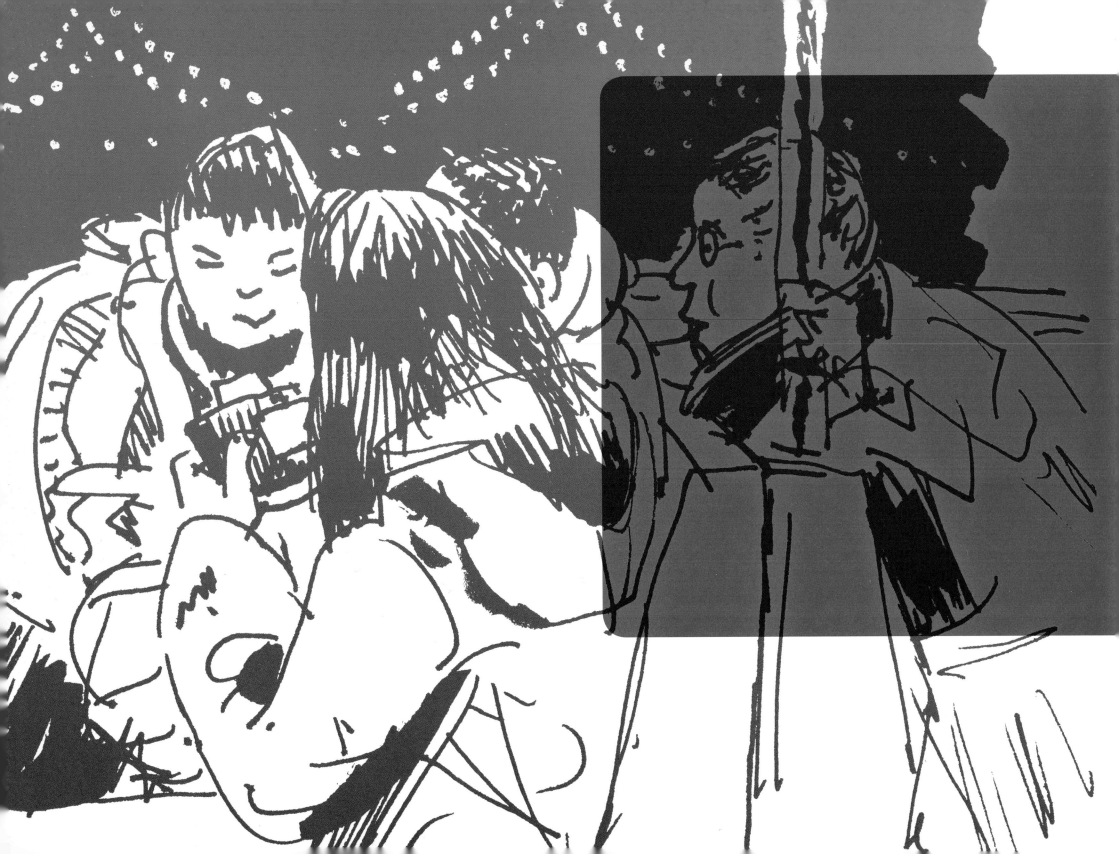

Constructing a World

Chapter 12

In this chapter we'll focus on creating a sense of place. We'll also take a side trip, as we did in Chapter 5, to talk more about drawing figures.

12.1

Creating a sense of place

Homework critique for Chapter 11 on page 244

THE IMPORTANCE OF BACKGROUNDS

If there's one thing that consistently challenges new comics artists, it's backgrounds. Or rather, it's coming around to the understanding that you have to draw them! Most of us learned to love drawing by sketching page after page of heads, faces, eyes, and character and costume designs. But how many of you can look through your old sketchbooks and find fully-imagined worlds? Houses? Trees? Landscapes? Or even an interior? In fact, your *Chip and the Cookie Jar* strip may be the first time you ever had to grapple with drawing places.

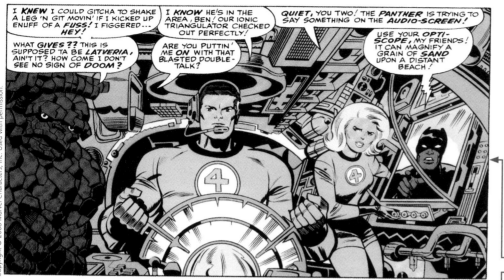

Now think of your favorite comics. Depending on what you are into, what springs to mind might be just about anything: fascinatingly complex vehicles or futuristic buildings, an animation studio circa 1933, a New York apartment in the 90s, or a small-town Malaysian kitchen in 1951. Regardless of what your taste is, though, one of the central elements of memorable comics is a deeply imagined sense of place. The characters you love so much inhabit a world, and that world reflects and enhances what the characters are like and what they do.

Even if your comics are completely cartoony, you still are going to have to occasionally put your characters on a bike, or in a car, (or, as one student of ours recently realized, on the set of *The Price is Right*), and you'll need to figure out how big a car is relative to your characters, and how does a steering wheel attach, anyway?

In the last chapter, you started penciling your six-page story. It's crucial that you make your comics world real to your readers. So it's time to bite the bullet.

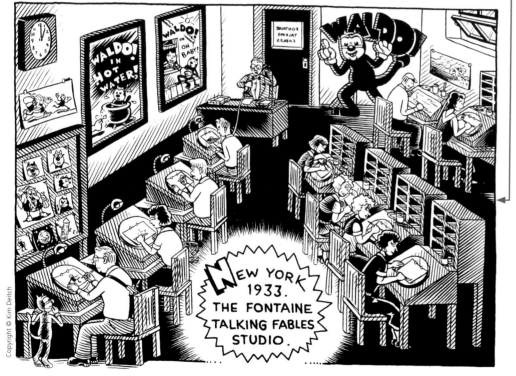

Kampung Boy copyright © 1979 by Lat. Used with permission of First Second Books.

APPROACHES TO WORLD-BUILDING

There are a number of approaches to world-building: drawing from life, using photo reference, researching the real world, researching the imaginary, learning perspective, and simply using your imagination.

Drawing from life

One way to create an evocative sense of place is to use drawings of real locations for the setting for your comic, like a convenience store in Mexico City. This is how it works: Bring a sketchbook (preferably one with a spiral binding so you can flip the cover back and hold it more comfortably), and a pencil and/or pens. Find a good vantage point where you won't be in the way of other people, and draw what you see.

Matt drew the comics panel on the right with the help of the drawing on the left, from his sketchbook.

While this may sound simple, drawing from life is a skill that takes a lot of practice. So don't worry if your drawings don't look perfect. Anyway, when you're sketching locations from life, you're not there to make a finished drawing, you're mainly taking visual notes. When you get home and start your comic, you'll have a fresh memory of the places you sketched, a detailed set of notes, and, most importantly, you'll have looked more closely at the locations than you probably ever have before. Drawing something is a really good way to learn about it.

 ## Drawing specifics

Fine-tuning as you draw

Keepin' it real

We will mention the dreaded *cliché* several times in this chapter for a reason. Cliché is a direct result of laziness. When your story is seeming kind of samey and overly familiar, either in the way the characters look or act, in the construction of plot, or in the world you've created, that is because you have not thought hard enough about those elements, and more specifically, because you have relied entirely on the limited contents of your own memory to design them. The answer to cliché is always to go outside your own brain and look at the world around you. This is harder than it sounds: Can you do a drawing off the top of your head of a garbage truck? Of the street where you live? Of three different kinds of trees in your neighborhood? One way to train yourself to pay close attention to the world around you is to keep an "I notice" diary for a week, a month, or a year. Every day, make it a point to notice, and make written and/or pictorial notes on, at least five things. These things could be anything, from the way your roommate stacks the dishes in the drainer to the mechanism of the doors on newspaper boxes on the corner. Just make a point of really paying attention and then noting what you observe, and your stock of material will grow exponentially.

From Matt's "I notice" sketchbook

The devil's in the details

When you draw from your imagination, especially when you're a novice, you tend to draw schematic, idealized forms. For example, when you draw a "tree" you usually draw the same tree you've drawn for years. It will have a trunk (sometimes wide, sometimes narrow, but usually quite straight and featureless), and a crown of leaves (usually round, and perhaps a bit bumpy). ⟶

Look outside your window. If you've got trees in view, you'll immediately notice that each one, and especially each type, is different. Outside our window are plane trees. They bend and lean toward the street as a result of years of pruning on that side. Their bark is mottled, with patches of light, medium, and darker greenish-beige. Their leaves are pale and cluster in large masses, irregularly. Their branch structure is elegant, visible through the upper canopy. What kinds of trees can you see? A pin oak? A Japanese maple? A black tupelo? Whatever you see, I bet there's not a single "tree."

Part of learning to draw from your imagination—a vital tool for the cartoonist—is stocking your imagination with notations taken from life. When you started drawing people, at the age of two or three, you drew a head, eyes, a mouth. Later, you learned to notice torsos and noses, ears and eyebrows. Gradually, you learned to remember all the parts of the body. Often, though, that is where we stop learning. It's time for you to pick up where you (may have) left off, and to draw from life as a way of stocking your imagination with the endless weirdness that is reality.

Draw what's in front of you

A common habit among cartoonists is to filter everything they see through an established set of drawing conventions—idealized superhero, manga cute, and so on. Have you tried to draw a realistic portrait of your best friend, and then noticed that he or she came out looking distinctly manga-ish when you were done, and not like him- or herself? That's the "face" you had stored in your imagination, not your friend's face. You are "tracing" from a mental template. This is a tendency to be wary of because it can make your art look lifeless: like the copy of a copy.

At the same time, many comics do call for drawing in a particular style (maybe it's the style you love, or maybe it's what an editor asks for), so what you need to learn is how to regularly step outside a given style's conventions to study the way people and things really look, then bring that back into your style. We're not arguing for photographic realism here: You will notice that several of the examples in this sidebar are in fact quite stylized and cartoony, yet they all feature very specific representations of trees and plant life.

Using photo reference

If it's not possible to visit the places or objects you want to use in your comic (like, say it's set in New Zealand, or Paris, or on the moon, or on London Bridge in 1888), or if you need a lot more information than you can easily gather in a day or two of on-location drawing, use photos.

- If you can visit the place, take photos yourself.
- If the place is out of reach, naturally you should check the Internet for photographs—Google image search is a great boon for comics artists. You can find all kinds of stuff there. But sometimes the images are too low-quality to be of much help.
- Go to the library. Large public libraries (as well as some college libraries) often house image banks, and certainly they stock plenty of books full of photos.
- Keep your own image bank. Never throw out a magazine without cutting out good photos you might use for reference in the future—and not just pictures of fighter planes and mountains, but photos of interesting or difficult poses, like holding a phone or shaking hands. Organize your clippings by subject and keep them in a file cabinet or scrapbook.

👉 Things to keep in mind when drawing from photos

Using photos is tricky. When you draw from life, you move, the world moves, and all that change gets translated in one way or another into the drawing. On the other hand, a photo captures only a fraction of a second in time. If you slavishly copy a photo, your drawing can easily turn out very stiff. It will just scream "photo," no matter how well you render it. You need to treat drawing from a photo as you treat drawing from life, as a set of visual notes for creating your drawing, not something to be carbon copied. Here's a trick: If you're drawing from a photo of a building, rotate the building slightly in your drawing. That is, change the point of view a bit, so you'll have to figure out the angles on your own. Don't copy everything, just the dominant details that make the building look like itself, and not like another building across the street. Don't get caught up in the literal. Make the photo work for you.

Tracing or closely copying a photo will result in a panel that does not work in a comics context.

The biggest problem with the direct-copy approach is too much information. In this example, the background is confusing, cluttered, and unhelpful, and the various details like straps and handholds are just hard to understand. Also, the four-square composition, stiff pose, and straight gaze of the character make the panel feel as static as can be.

The key to using this photo properly is not to simply copy all of the details, but to find the *telling* details. The angle has been rotated to avoid a static drawing, and the background and other details have been simplified. The plaid pants and boots tell us this is the 1970s, and the delicately worn wooden horse puts us in a very specific park. Other changes make the panel feel more kinetic and help it integrate with the panels that come before and after it.

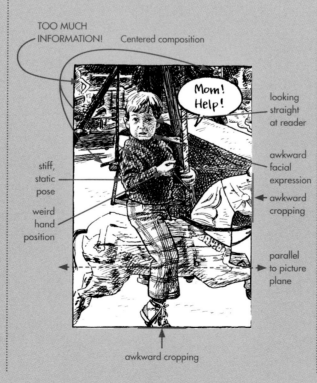

TOO MUCH INFORMATION! Centered composition

looking straight at reader

awkward facial expression

awkward cropping

parallel to picture plane

stiff, static pose

weird hand position

awkward cropping

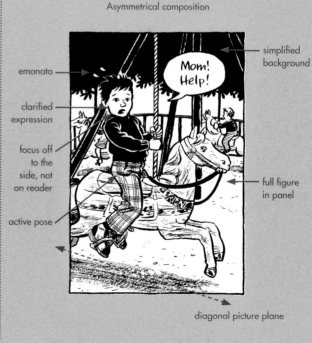

Asymmetrical composition

simplified background

emanata

clarified expression

focus off to the side, not on reader

active pose

full figure in panel

diagonal picture plane

By Osamu Tezuka. Image used with permission from Vertical, Inc. and Tezuka Productions.

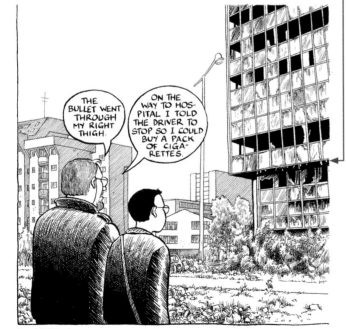

Copyright © Joe Sacco

Researching the real world

Locating photographs to use as reference is a form of research, but it is just one element of the research that can go onto your comic. Any story that takes place in a specific place and time requires further research. Whether you set your comic in New York City in 1982, a temple in ancient India, or in Bosnia in 1995, your story will need backgrounds that show a visual richness that you're not going to be able to just pull off the top of your head. You need to show locations, buildings, clothing, hairstyles, objects and other details that are accurate for the time and place—even the way people moved might have been different. You need to fill sketchbook pages with visual notes, collect reference images and text, and read books about the period in question.

You may be saying to yourself, yeah, whatever, but my story is set in my old high school, I can remember that. Bet you can't. If you don't go there and take pictures, or pull out your yearbooks for image reference, your story will be full of generic "classrooms" and "lockers" and "students," and your readers will feel that the world you've presented to them is shallow and unconvincing. A story without a clear, specific setting feels generic and clichéd. It can ruin all of your hard work on characters and story structure.

American Born Chinese copyright © 2006 by Gene Yang. Used with permission of First Second Books.

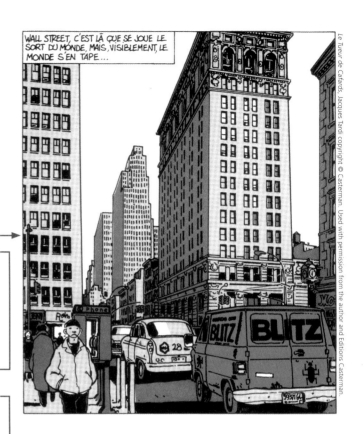

Especially if, for example, your old high school is a fancy private school in Hawaii, as drawn by R. Kikuo Johnson. Check out those light fixtures!

Copyright © 2007 R. Kikuo Johnson

Inventing realities

If you're thinking, "OK, fine, but my story takes place on Mars, do you know what it looks like?" go find out. Even if you want to set your story on an imaginary Mars, with elaborate cities and highways criss-crossing the landscape, what will they look like? If you sit down to draw them with only what you have stored in your brain already, you will end up drawing—you guessed it— "buildings," "highways," and "space vehicles." It will all feel a bit lame. You have a harder research job than that of artists setting stories in the real world, because every aspect of the world you're creating is up to you. You have to make all the rules, set the design standard, and imagine how the history of Martian architecture will be reflected in the Mars of today. But research can be a great help. What about using strange rainforest seedpods as an inspiration for building types? Insects for cars? Beehives or warehouses for spaceships? Or why not interpret Italian fascist architecture for a low-gravity environment? Will your people wear space suits? Evolve new breathing apparatus? Are they even human? If not, how will they walk, talk, cry, fight? How many legs (if any)? Do they live underwater? You will need a lot of sketchbook space to figure it all out, and you need to do that work before starting the story.

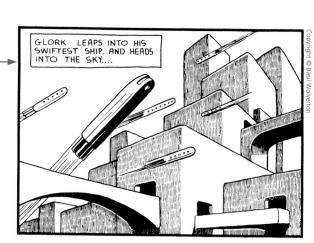

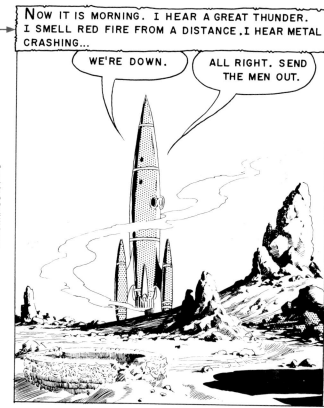

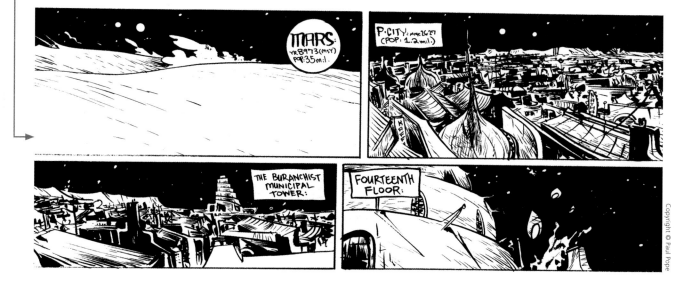

Using your imagination

None of what we've discussed above is meant to imply that you're not imaginatively involved in the process of developing the world of your characters. We've emphasized research over and over again, because you're unlikely to have really *looked* at, and made a mental catalog of, the world around you. If you become the world's greatest racecar comics artist, you probably won't need to closely observe and research racecars after the first year or so. You'll just know all the parts by heart. Same goes for figure drawing. There is always more to learn and more to observe, but once you learn anatomy and how the human body fits together, you won't have to go to the model every time you want to draw another panel. In fact, too much reliance on observation and research can be a real crutch. You never want to get so married to your reference that you can't invent what you need. Try not to get addicted to drawing from photos. Do take all that material you've found, recombine it, alter it, and use it as a jumping-off point. Your imagination is central to this whole enterprise. Just don't let it go hungry. ■

Perspective

Linear perspective is a system of visual conventions used to create the illusion of three-dimensional space or a two-dimensional surface. Although teaching you to use perspective in your comics is beyond the scope of this book, it's a topic that will be absolutely necessary for many of you to study. Even those who work in an entirely cartoony style will find themselves needing to place characters relative to one another and in some kind of deep space at least some of the time. Look for classes on the subject, and study some of the books in the "Further reading" section below.

FURTHER READING

David Chelsea, *Perspective! For Comic Book Artists*

Joseph D'Amelio, *Perspective Drawing Handbook*

Ernest Norling, *Perspective Made Easy*

Ernest W. Watson, *Creative Perspective for Artists and Illustrators*

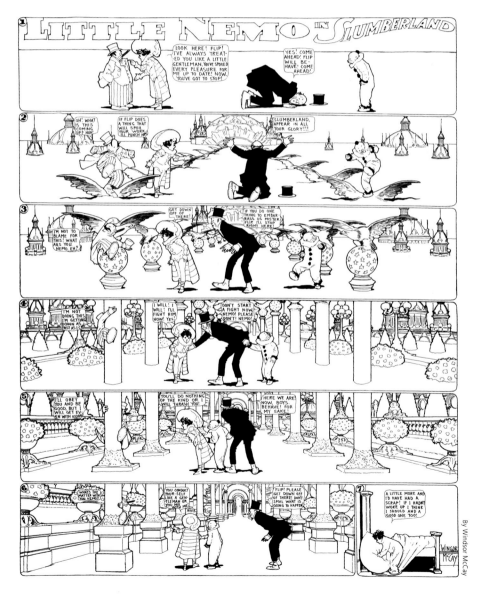

By Windsor McCay

No time like the present

Materials
- sketchbook
- drawing tools of your choice

Instructions
Turn around and make a drawing of a corner of the room you're in right now. Do not leave anything out. Even if it's your most familiar space—your own bedroom—you will find that you don't know it as well as you thought you did.

Talking points
If you're in a group, share your drawing when you're finished. Point out things about the architecture or contents of the room, or interesting juxtapositions of items that you only noticed once you had to draw them. Does a colleague's drawing help you notice things in or about the room that you never saw before?

Ronin
Even if you're doing this by yourself, you can use the exercise to really look at your own environment. Share your drawing with your roommate or significant other, and see if it gets them to see the space in a new way. ■

12.2
Figuring out the figure 2: heads and hands

HEADS AND HANDS

In comics, you write with pictures. Your characters' bodies and faces carry story content, and you've got to get that information across clearly, which means learning how to depict gesture and emotion. Faces and hands are not the only places gesture and emotion reside; a character can have a particular walk or posture that speaks volumes. But the head and hands are the most expressive body parts we've got, and as such, they're pretty crucial to this project. Drawing them can be really frustrating. In this section, we'll provide a few tips. Although many of the examples we show here are drawn in a "realistic" style, you'll find that most of the principles apply to all styles of drawing.

Facial measurements
Although you should keep in mind that everyone's face is different, right down to the distance between their noses and mouths, here are some general guidelines that can help you place facial features where they belong:

Face and eyes
To draw a head from the front view, draw an oval or egg shape with a cross through the middle of it. That center horizontal line is where the eyes go. Though it's completely counterintuitive, people's eyes are just about halfway between the crowns of their heads and their chins. The space between the eyes is about the width of one eye.

Nose and mouth
Divide the lower half of the face into five equal horizontal sections, and mark the center of the nose 2/5 to 1/2 of the way to the chin. Once you've drawn the tip of the nose, draw in the mouth, which goes halfway between the nose and the chin.

Ears
The tops of the ears line up with the eyes, while the earlobes line up with the tip of the nose.

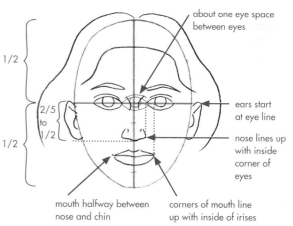

about one eye space between eyes

ears start at eye line

nose lines up with inside corner of eyes

mouth halfway between nose and chin

corners of mouth line up with inside of irises

1/2

2/5 to 1/2

1/2

Side view

From the side, the head shape isn't so simple. It's closer to a rounded triangle than an oval. If you divide the side view of the head into four quadrants, the eye is, again, right in the vertical center. The nose and chin jut out beyond the smooth oval of the basic side-view head shape. Note the front plane of the face. It may angle slightly away from vertical for some people.

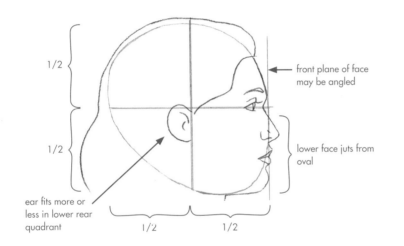

1/2

1/2

← front plane of face may be angled

lower face juts from oval

ear fits more or less in lower rear quadrant

1/2 1/2

Variation

Again, every face is different, so take general facial measurement principles with a grain of salt. Also, it's important to differentiate your characters carefully. One way to do that is to draw characters of different racial and ethnic backgrounds. Despite major differences in the way any one person's features look, the basic measurements above apply to everyone but with variation in an individual's forehead, chin, nose, eyes, and mouth.

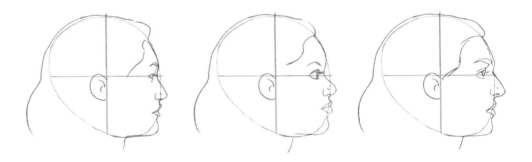

From the principles here you can make all kinds of variations to develop distinct and unique characters: You can play with head shape and facial features for comic, or serious, effect.

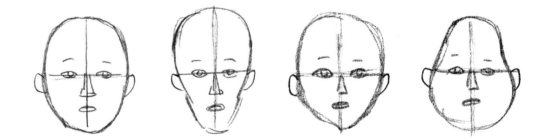

Rotation

When you have to rotate the head away from a face-forward or full side view, things get a bit trickier. Those layout lines that look like crosses from straight on wrap around the head when you rotate it. You should draw the layout lines on the three-quarter view as best as you can to get a good underpinning for the features.

Here's a full horizontal rotation. Notice when the nose starts to overlap the eye on the far side, and when the nose starts to disappear in the rear three-quarter view.

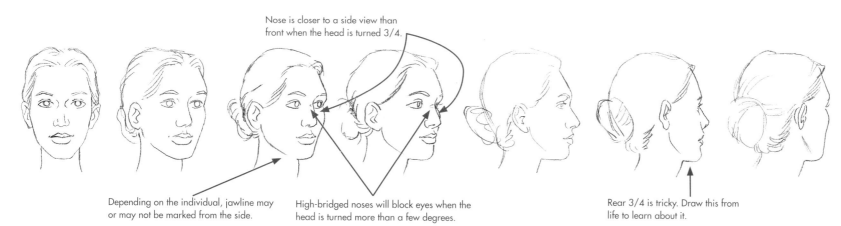

Nose is closer to a side view than front when the head is turned 3/4.

Depending on the individual, jawline may or may not be marked from the side.

High-bridged noses will block eyes when the head is turned more than a few degrees.

Rear 3/4 is tricky. Draw this from life to learn about it.

The layout lines on the head go all the way around vertically, too. Try drawing layout lines and a face on a hard-boiled egg and drawing it from different angles to get an idea of how this works.

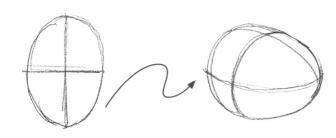

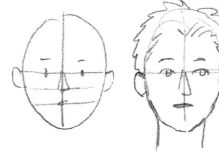

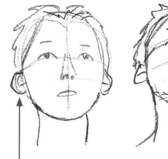

Also, the nose line marks the place where the nose connects to the lip, not the tip of the nose.

The chin stays rounded downward until the head is tipped quite far back.

Note that the ears move down relative to the eyes as the head tips back.

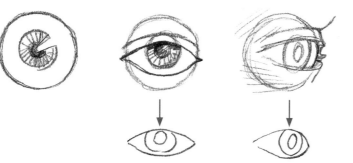

The ears and eyes are both a bit tricky to understand during rotation. The eyeball is spherical. Even though you can see only a little bit of it at a time, remembering that fact can help you draw eyes more accurately. Note that the visible portion of the eye changes shape as you see it from different angles.

Notes on drawing heads and facial expressions

Pay close attention to how the face distorts to show emotions. The eyes and eyebrows, in particular, are telling.

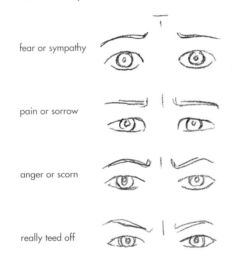

Note how in fury, eyes will squint on the inside corners, while in happiness they will be pushed up by the cheeks on the outside corners.

Four levels of eyebrow distress:

fear or sympathy

pain or sorrow

anger or scorn

really teed off

Simplify for greater readability and graphic impact.

The mouth is less expressive than the eyes, but there are some cool things it can do with its corners.

When the mouth is open, the lower lip retains the same distance relationship to the point of the chin. (The angle of the jaw will change, however.)

Infants' and children's eyes are bigger, and their faces are smaller relative to their heads. We see this as "cute," and apply the same principle to manga characters.

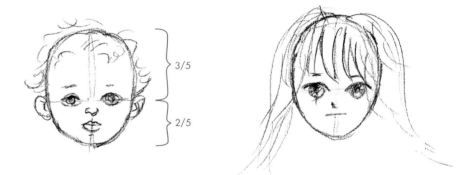

3/5

2/5

Don't make this common mistake: Your focus on the face leads you to make it much bigger than it should be relative to the rest of the head. Check those center lines.

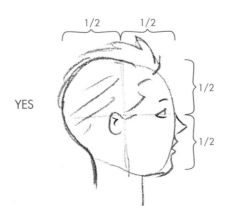

1/2 1/2

1/2

YES

1/2

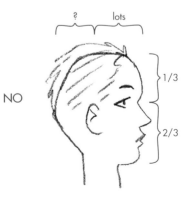

? lots

1/3

NO

2/3

Drawing hands

Unfortunately, there aren't as many great tricks to drawing hands as there are to drawing heads and faces. Mostly, you just have to practice.

Fortunately, you always have ready models hanging at the ends of your arms. Draw them all the time; fill pages with them.

The index finger functions more independently than the others. Note that the second knuckle is prominent from any angle.

Note that knuckles fall on an arc relative to one another.

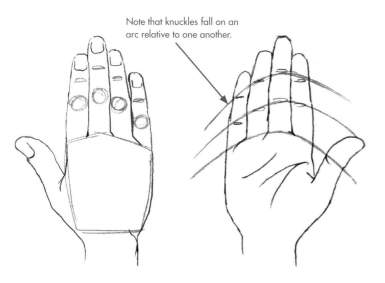

Basic palm shape. Thumb like an add-on.

Draw through to find form.

Second knuckle is always the most prominent.

Don't forget the meaty muscle on the side of the hand. It's bigger on men and people who work with their hands.

The hand folds lengthwise as well as into a fist.

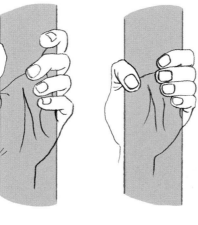

Fingers cluster and curl inward with a tighter grip.

FURTHER READING

Look at "Further reading" in Chapter 5, and if you're interested in learning to draw in a particular mode, like superheroes, or manga, there are tons of books on how to draw in that manner. Just keep in mind that a lot of that stuff is stylistic flourish, and you still need to learn how to draw a head in full rotation and hands in action.

For more specific pointers on learning to see what's around you and to translate it to drawing, Betty Edwards's classic *The New Drawing on the Right Side of the Brain* has a number of very useful exercises.

In *Making Comics*, Scott McCloud has an extensive chapter on facial expressions.

Stephen Rogers Peck, *Atlas of Human Anatomy for the Artist*

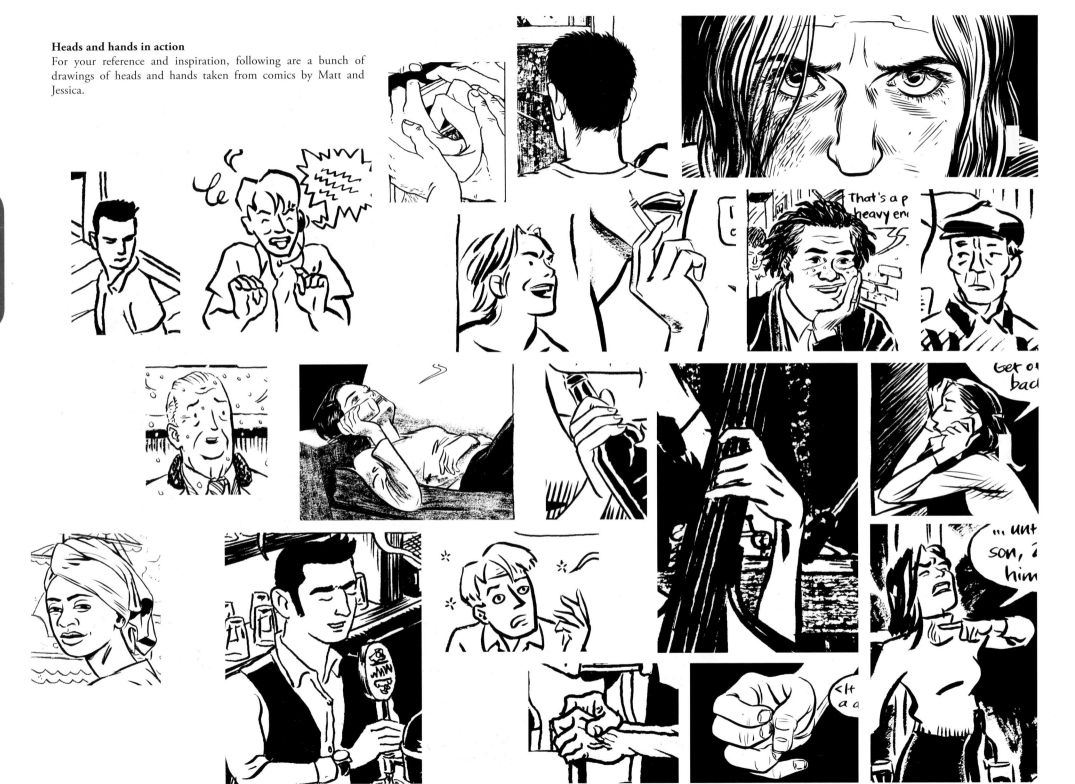

Heads and hands in action

For your reference and inspiration, following are a bunch of drawings of heads and hands taken from comics by Matt and Jessica.

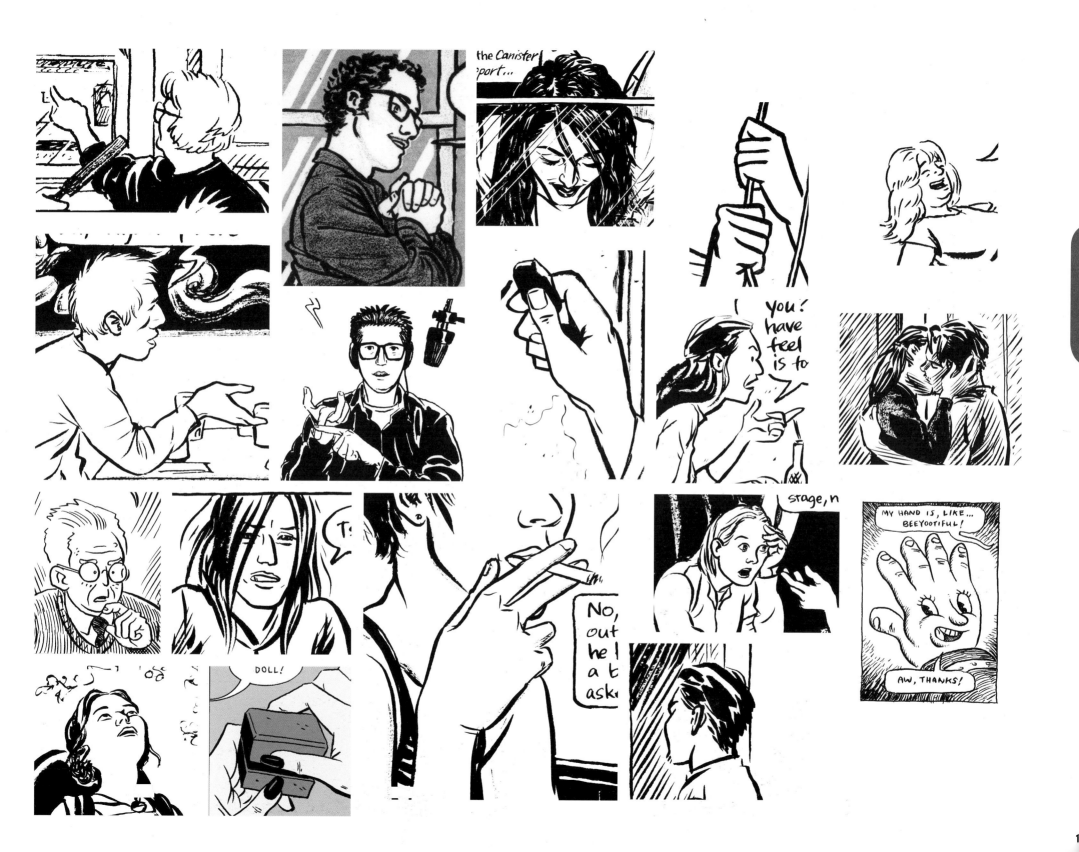

The head's in your hands

Materials
- sketchbook
- drawing tools of your choice

Instructions
1. Fill two sketchbook pages with heads based on the measurements we've given you. Try different types of facial features and all kinds of angles.

2. Draw your comics colleagues from unusual angles: from above, from below, from an extreme rear angle, etc. Draw one page of unusual poses.

3. Ask your colleagues to model tough poses, like holding a cell phone. When you get stuck, try to be very attentive to exactly what you see in front of you. Close one eye to flatten the perspective, if necessary. Start with rough sketches, and tighten them up as you go. Use measurements to help you figure out what you're seeing.

4. Draw two pages of people on the bus or in a café. Draw full figures, not just heads and hands, and go for overall effect, not perfect anatomy and proportion. This is different from "life drawing" (from a model). It's much more informal, more like visual note-taking as we talked about in the first half of this chapter. Pay close attention to the way people carry themselves, and any facial expressions they might have. Also, in the spirit of the first half of this chapter, make careful (visual) notes on what they're wearing, and how they're wearing it. This conveys character as well!

5. Fill at least two sketchbook pages with drawings of your own hands in different positions.

Talking points
Take a look at your drawings as a group and see if you can pinpoint problems. Use tracing paper to demonstrate correct proportion.

Discuss where "real" proportion is important in a given person's work, and where shortcuts or cartoony versions of reality work better.

Ronin
Most of this activity is ideal for a person working alone. For #2 and #3, above, set up a mirror over your desk and draw yourself from as many angles as possible. Get a friend to model some angles, and also some everyday poses, for you. ∎

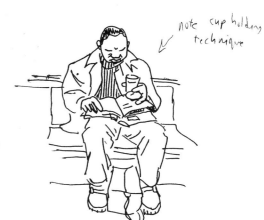

subway drawings from Matt's sketchbook

Homework
Continue penciling your six-page story

Continue penciling. Finish through page five.

In addition

- Do more research on one of your major settings, using photos, if appropriate, and using your sketchbook ideas to come up with new approaches for some items in the story.
- Find out the names and functions of all the parts of some object that appear in your story: a door, a gun, a vehicle, a window, an appliance. Revise your design of that object accordingly. ■

Extra credit
On-location comics

The writing part of this exercise was adapted from an idea in John Gardner's *The Art of Fiction*.

Write a description of a nearby place you have been to, and can easily revisit, as seen through the eyes of a scientist who has just found out that his or her invention has been used for evil purposes. But, in the description, don't mention the invention or what it was used for. Make your description at least a page long, and keep the focus on description, not action.

Once you finish your description, visit the place, and draw a two-page comic of your scientist character there. You must draw your comic, on location, at the location you wrote about. Focus on the character's interaction with the place, and also try to come up with a scene, something that happens. You may add characters, an interaction, but keep the invention and the evil happenings out of the scene (they may be—probably should be—felt as a kind of resonance). If the character has something he or she needs or wants to achieve, that will help!

You can draw this comic entirely in a sketchbook, and in fact that's not a bad idea. You can lay out your panels ahead of time, and then work on them on location. If you have a smallish sketchbook, make the comic longer—four to six pages. ■

Chapter 13
Black Gold

If you take a look at Jeff Smith's *Bone*, Craig Thompson's *Blankets,* or any of the hundreds of comics drawn by Jack Kirby, you will see three very different comics styles at work. Yet they all have something in common that is part of their appeal: the lines pulse with life. They seem to flow like liquid across the page, varying in thickness and effect from delicate to bold. The tool that is used to create most of these effects is the brush. This chapter will focus on inking with a brush.

13.1
The liquid line

INTRODUCTION TO INKING WITH A BRUSH

Inking with a brush is the gold standard for many cartoonists. Everyone from classic superhero and adventure comics artists; to literary comics artists (such as Craig Thompson, Charles Burns, Paul Pope, or the French cartoonist Blutch); to newspaper cartoonists as different from one another as Milt Caniff and Bill Watterson have used a brush to create their unique effects.

Milton Caniff was one of the most influential brush-inkers of the early comics era, this despite the fact that he often used a pen for his basic linework and faces. However, his juicy blacks and gestural drapery (not to mention his highly cinematic compositions) were a crucial influence on everyone from Alex Toth to Hugo Pratt to Jessica Abel. This panel is from *Steve Canyon* in 1951.

Bone, by **Jeff Smith**, is one of the best examples of bringing animation-style drawing into comics. (Smith is also highly influenced by Walt Kelly's *Pogo*, another virtuoso brush performance.) Smith's elegant line is controlled, yet flexible and kinetic. He inks with a #1 Raphael brush.

Dan Clowes uses a brush with surgical precision. His inking is almost penlike, but the fluidity of his lines gives the brush away.

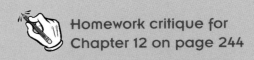

Homework critique for Chapter 12 on page 244

13 Black Gold

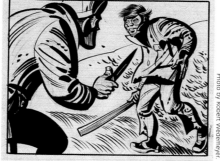

AH, FRESH BREAD!

GAS

SELF-SERVE $1.03

THE END

Harvey Kurtzman is best known as the genius behind *MAD Magazine*'s first, most influential run. His humor comics in that magazine were among the most popular. He mainly wrote humor and adventure stories and assigned them to other artists. However, his highly stylized inking made his serious comics uniquely powerful, as you can see in this panel from *Corpse on the Imjin*.

Bill Watterson is one of the few contemporary newspaper cartoonists to use a brush, to emulate the quality of newspaper comics in the first part of the century. His stylish and accomplished drawing has inspired many a young cartoonist.

Robert Crumb's best-known style is inked with a pen, which is why it's so interesting to see him inking with a brush, as in this panel, written by Harvey Pekar. The brush encourages him to go bolder with lines, and to make the dark areas of the image even darker.

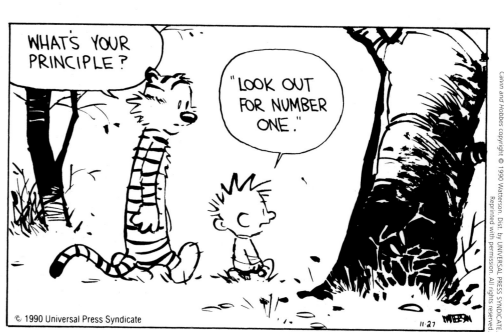

WHAT'S YOUR PRINCIPLE?

"LOOK OUT FOR NUMBER ONE."

© 1990 Universal Press Syndicate

11-27

"And when he got fresh with Mabel Moneyhard, well, there was no helping him."

Brushes are versatile for inking because they are even more flexible and responsive than nibs. They also hold a lot of ink, and apply it thinly, so that it dries quickly, making it possible for an artist to work much faster than with a nib. With practice, brushes can produce beautifully fluid, dynamic-but-controlled lines, but they can also be used in other expressive ways, such as with a carefree, expressionistic approach, with dry brush, or to hatch and cross-hatch. A brush also can be used for filling in areas of black. You should use a brush for this even if your primary inking tool is a pen. Another classic comics brush technique is feathering. This is a way of softening the edge of a line or an area of black with a series of carefully tapered lines that line up to make a sort of zigzag effect that is useful in showing rounded volumes such as spheres, hair, or parts of the body.

BASIC BRUSH HANDLING

To work with a brush you'll need the same basic setup you use to work with nib pens—ink, paper towel or rag, scrap paper—but you will also need a water container. If you didn't buy a brush basin when you started inking, you'll want to do so now. You'll find a brush basin to be an indispensable tool for brush inking. (Look back at Chapter 8 for more about inking setup and supplies.)

Charging your brush

Before you are ready to draw, you need to "charge" your brush with water and ink. First, swish the brush around in clear water to get it soaked through (you will see little air bubbles come out of the brush), then wipe it off on your paper towel or rag. Dip the brush directly into the ink bottle, being careful not to plunge it all the way in. Ideally you only want to dip the bristles one half to two thirds of the way into the ink. Avoid getting ink up into the ferrule (the metal collar of the brush), as this will eventually affect your brush's point and weaken the glue that holds the bristles in. (Yes, you will quickly find that the ink makes its way up into the ferrule anyway, since the brush is built to absorb and hold ink in its bristles, but you don't need to help it along.) Gently wipe the brush off on the rim of the ink bottle. This is called "tipping off" the brush.

Dip the brush again and tip it off again. Doing this a few times will help force ink into the belly of the brush, replacing the water in there with dense ink.

Holding your brush

Now make some marks on your scrap paper with the brush. Hold your brush as you would a pencil and make short lines moving away from your body.

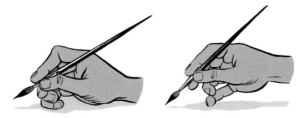

Rest your wrist on the paper and use your wrist as a pivot point, keeping your fingers and the brush steady. Or use your pinkie, braced firmly, as a pivot to allow your hand to move in a larger arc.

You can also try moving your whole arm. Try to make vertical marks by drawing your whole arm toward your body and sliding your hand, resting on your pinkie, along the paper to steady yourself. You will discover as you work that there are a number of different ways to hold the brush. Your goal should be to find the method that works best for you. Try to avoid curling your fingers

under your hand when you draw a line down, as you have limited mobility that way and will end up with shaky lines. But there really is no "wrong" way to draw with the brush other than pushing directly against the point, which will damage it.

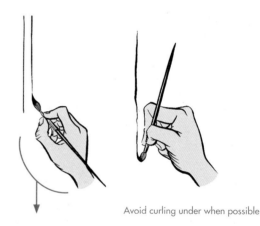

Avoid curling under when possible.

Remember that when doing work on your final pages it's a good idea to wear cut-off gloves to protect your bristol board from moisture and oils on your hand. See the "Troubleshooting" section of Chapter 8 if you don't remember what we're talking about.

Checking your ink

There are two things to look for at this stage. First, is there enough ink and water in the brush? If your marks are gray, you may have too much water in your brush (or you may be using bad ink!); if your marks are fully black but are dry (the ink doesn't fully connect with the paper) you may need either more ink or a bit more water to help the ink flow more easily.

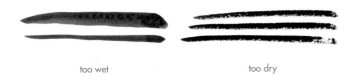

too wet too dry

Checking your brush quality

The second thing to check for is the quality of the brush, and especially its point. When the brush is well-loaded, you should be able to make a decent number of marks before you need to dip for more ink. To check the point, draw a few careful lines by keeping the brush hovering above the paper so that it just touches, and look at the line the brush makes on the paper. Is it sharp and clean? Then you're using a good brush. Does it have split hairs? Or is it dull and rounded? Then you are using a damaged or old brush. If the point of your brush is not perfect, try twirling the brush slightly in your hand as you draw; that will often help even beat-up old brushes make a passable point.

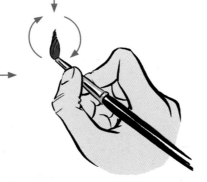

nicely pointed tip raggedy split brush

Mike Allred uses a fat, juicy brush line and classic-style feathering that evokes the work of Kirby and other classic superhero artists, but cleans it up to go more pop. Allred is especially good at using a variation of line weight to create a sense of roundness and depth to his forms.

Practicing your technique

Once you have a good point and the brush is loaded with ink, practice making different kinds of lines in a sketchbook or on a sheet of bristol board.

Draw vertical and horizontal lines, diagonal lines, straight and curved lines; draw lines that are of even weight and ones that vary in thickness; draw lines that go from thin to thick and vice versa. Experiment with different ways of holding the brush. The technique for changing the thickness of the line is to hold the brush so it barely contacts the paper for thin lines, and press the brush closer to make thicker lines.

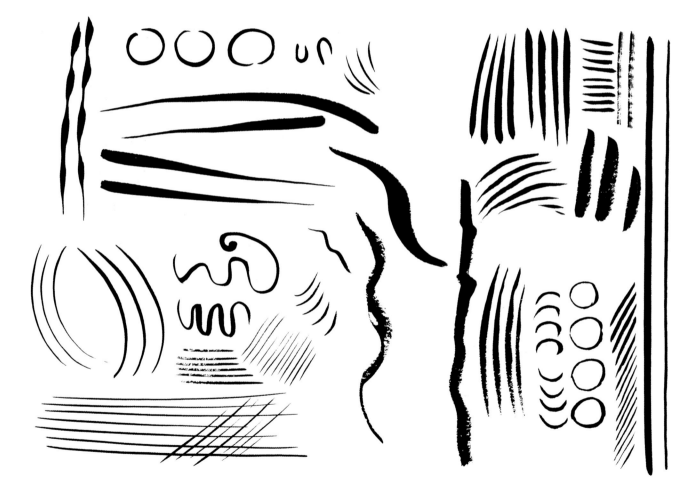

Drawing thin lines is a good time to balance on your pinky!

Press down harder when drawing thick lines.

DON'T "PENCIL" WITH INK

One of the most difficult things for a new cartoonist to grapple with is the dissimilarity between drawing in pencil, which produces nice soft grays, and working with the sharp black and white contrasts that come with inking. But remember back in Chapter 8, when we talked about why it's important to ink? Well, here's another reason inking is important: Printing by either photocopying or offset printing can reproduce only black and white. Not gray.

Take a magnifying glass and look at a photo in the newspaper. You'll see that the gray areas only *appear* to be gray. In fact, the gray areas are actually made up of solid black dots, varying in size and distance from each other. That's called a halftone.

You'll notice immediately when you're inking with a brush that brushes can be used for laying down gray washes (of ink diluted with water). You may be tempted to use this technique in your comics right away, but we really recommend that you avoid it for the time being. Gray washes are devilishly hard to reproduce well—and don't forget, good reproduction of your artwork should always guide your drawing choices. Making a really good halftone (which is what you'd need to do to reproduce a wash drawing), one that faithfully reproduces your tonal choices, is incredibly hard. And then getting your blacks to reproduce black in the same image—practically impossible. The same goes for applied screentones (adhesive plastic film printed with halftone dots) when you don't know what you're doing. So, although we know that you will want to use washes or screentones (particularly if you're into manga, which features a lot of tone), avoid them for now. It's crucial that you develop a full range of marks and tones without using those shortcuts. Later, you can add wash and screentone techniques if it's right for your work. Until then, we will investigate some more easily reproducible ways of softening black areas.

The bottom line is: *Inking is not penciling*. You need to think about inking as a separate technique, not simply as penciling with a more permanent substance, and develop techniques for your drawings that work in ink as ink, instead of trying to recapture your pencil-sketch look. ■

Dupuy & Berberian are an inseparable pair of writer-artists who have channeled influences from illustration in the 1950s and 60s into a stylish and stylized approach to comics.

FURTHER READING

See "Further reading" in Chapter 8.

 Know your brushes

The kolinsky sable round watercolor brush
The classic comics brush is a #2 kolinsky sable round watercolor brush pictured below. All the parts of this description are important.

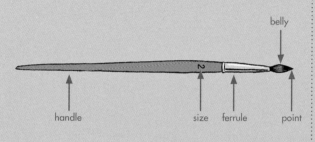

- "Round" means that the opening in the ferrule is round. But the brush tip doesn't look round, it looks sharply pointed (or it should!).

- "Watercolor" describes the type of brush—it's built to hold lots of fluid. It also refers to the handle, which will be short, not more than about 8" long. Acrylic or oil-painting brushes are longer.

- "#2" denotes the size. Note that there are English and continental versions of brush sizes. Therefore, #2 might be a reasonable size, or it might be really small, so use your common sense. When we say #2, we're referring to the English size. A continental #2 will be smaller than an English #2.

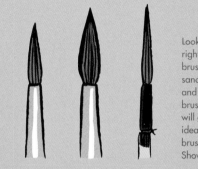

Looking from left to right at three "#4" brushes—a Renaissance, a Raphael, and an Isabey quill brush—side by side will give you an idea of how widely brush sizes can vary. Shown actual size.

You may prefer to use other brush sizes—in our case, we almost always use #4s (English sizing). Just because you're nervous about using a brush is not a good reason to get a tiny one. All good brushes should have good points. You can get as fine a line—with a little practice—with a #10 as a #00. You may be tempted to use a very small brush for seeming ease of use, but a larger brush will give you exponentially more flexibility in how you want to ink. A #2 should be the minimum size if you're only going to have one or two.

- "Kolinsky sable" means the bristles are made with the tail hairs of a type of weasel native to Siberia (called a kolinsky sable, as you might guess). These brushes are assembled by hand, hold plenty of ink, and have sharp and resilient points.

There are also regular sable brushes, made from the hairs of less fancy weasels, and acrylic brushes, which are often just fine for a beginner. Remember, though, that a brush is one tool for which the investment you put in is directly proportional to the quality you get. A fine kolinsky sable brush will pay dividends in ease of use and delicacy of point. Just make sure you take good care of it (see the sidebar, "Buying, protecting, and cleaning a brush," following). A good kolinsky sable #2 should run you about 20 to 25 dollars. ■

When you do take the plunge and buy a fine brush, or any brush for that matter, it's important that you take good care of it. Caring for a brush is not that hard to do right, and if you don't, it's easy to destroy it.

Buying

When buying a brush, know that the most important part of any brush is the tip. Is it sharp? Will it stay pointed while you draw? You obviously can't test a brush with ink before you buy it, but any decent art supply store will let you use water to test a brush you're interested in. First, dip the brush in water, and swish it around a bit. Don't rub the brush against the sides or bottom of the cup, just swish it. This should wash out the sizing (the glue used to protect the brush while shipping). When you pull the brush out and tip it or shake it off, if the tip doesn't come immediately to a sharp point, that's a bad sign. Give the handle a sharp tap against your hand to see if the point snaps together.

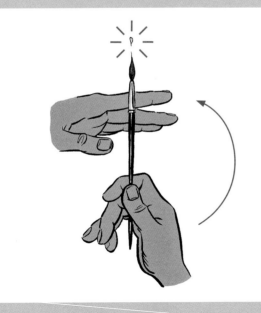

If it doesn't, move on.

If the tip does snap to a sharp point, try out the brush on a piece of brush-up paper, which the store should have available.

Brush-up paper is light blue paper that, when wet, gets very dark. It absorbs water cleanly, without bleeding, so you can draw on it with just water to see how the line looks and the handling feels. See how fine a line you can get. With a brand-new brush (particularly an expensive one) even a #6 or #10 size brush should give you a very fine line if you wield it with enough delicacy.

Protecting

Once you find the brush you want to buy, get a cover from the store.

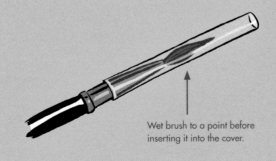

Wet brush to a point before inserting it into the cover.

A brush cover is like a short piece of a drinking straw that you can push over the bristles and lodge on the ferrule. If your art supply store does not have a brush cover that fits, roll the brush in a stiff sheet of paper.

The idea is that you don't want anything to be able to touch or bend the bristles while you are carrying your brush around. Hold on to that cover, or plan to always wrap the brush in paper. You can also buy a bamboo mat (originally designed for rolling sushi) that you can roll your brushes in to keep them safe.

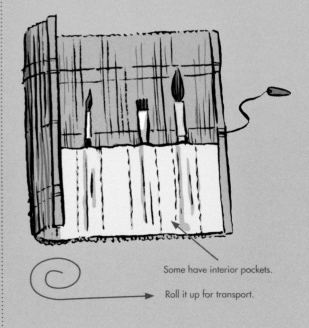

Some have interior pockets.

Roll it up for transport.

Cleaning

Before we get to the specifics of how to clean your brushes, here are a few brush-care "don'ts":

- Never leave an inky brush sitting out to dry. When you go to clean it, it won't clean well, and the ink left in the brush will deteriorate your bristles over time.
- Never leave a brush standing on its tip in water. It will get mashed.
- Don't leave your brush overnight in your brush basin. Eventually, all that soaking will loosen the glue that holds the bristles together.

To avoid these problems, always clean your brushes when you're done inking for the day.

Here's how:

- Buy a tin of brush soap from an art supply store, or just use a mild hand soap. Get the brush wet, drag it across the surface of the soap a few times, and then brush it back and forth on a paper towel or your palm to loosen the ink. (India ink is nontoxic, so it's OK to wash your brush out using your bare hands. Don't try this technique with paint, though!)
- Rinse the brush and repeat until it's clean. How clean is clean? Well, you probably won't get all of the ink out of the ferrule. But get as much of the ink out of the bristles as you can. The surface of the soap should look pretty clean by the time you're done.
- When you're done, you can leave a tiny bit of soap on the brush, form a point by tapping the handle on your hand or the edge of the sink, and let the brush dry. The little bit of soap will act like sizing and help protect the brush until the next time you use it. ■

13.2

Softening the black

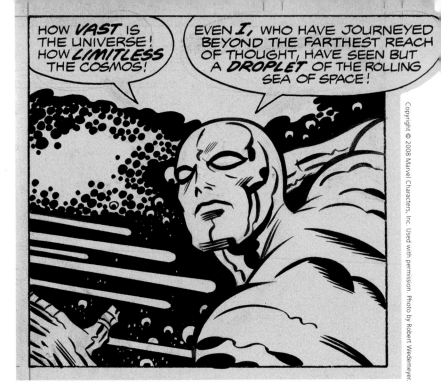

Jack Kirby was generally a penciler, not an inker, but his muscular style guided his inkers clearly, and his basic approach to line and feathering is at the root of classic superhero inking. This panel of the Silver Surfer penciled by Kirby and inked by Joe Sinnott is from *Fantastic Four #49* (1966).

TECHNIQUES FOR SOFTENING BLACKS

OK, so you're going to follow our advice and avoid washes and screentones for now. Still, when you want to simulate gray tones, you've got lots of choices. We've already looked at hatching and other textures in Chapter 8. Now let's look at two more techniques you can add to your repertoire when you're using a brush: feathering and using dry brush.

Feathering

Brushes are great for filling in areas of black. They encourage you to be bold and ink your panels with strong black design in mind. One potential problem, though, is that the areas you fill in are solid black. If you are putting a shadow on the side of a flat-sided shape like a cube or pyramid, that's not a problem. Solid black looks all right.

But if you are trying to create a shadow on the side of a rounded shape such as a sphere or a column, you end up with a shadow edge that looks too sharp and flattens the illusion of roundness.

For a more three-dimensional look, you'll want the shadow to fade into the light a bit. One brush-inking solution to this problem is known as feathering. Feathering involves softening the edge of a black area by breaking it up with a series of brush lines that blend into each other, creating a zigzag shape. Look how the light now seems to wrap around our sphere and column:

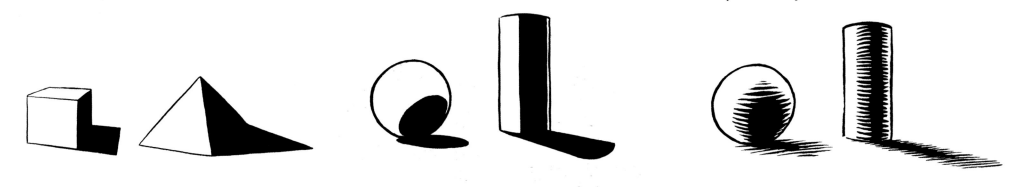

13 Black Gold

Feathering is not as hard as it looks. Using your new-found skills controlling line width with your brush, practice making a series of close-set lines that blend together. For a classic feathering effect, it's best to work from thin to thick with your brush: Start with a thin point and then draw the brush into the black area, gradually increasing the pressure on your brush until the line blends with the previous one you drew.

For a looser, more dynamic feathering effect, one that you might use for blast or motion lines, work from thick to thin: Line up your brush parallel to the direction you want your feathering line to go and put the point to the paper, applying as much pressure as you need to get the right starting thickness. Then flick your brush in the "thin" direction, lifting your brush at the same time. Flick from your wrist or your elbow, not from your fingers.

controlled flick

note corrections in white

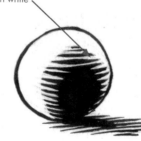

Two pointers to keep in mind:
- You can always go back and touch up your feathered lines with ink or graphic white.
- It's a good idea to pencil in the general shape of the area you are going to feather as a guideline. It's not cheating: Even experienced pros like Charles Burns plan their feathering this way!

The uses of feathering are limited only by your imagination. Here are some classic uses of feathering to get you started. Try to copy them and come up with your own ideas:

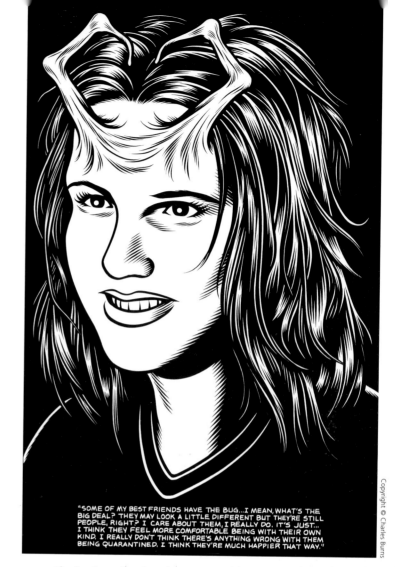

"SOME OF MY BEST FRIENDS HAVE THE BUG...I MEAN, WHAT'S THE BIG DEAL? THEY MAY LOOK A LITTLE DIFFERENT BUT THEY'RE STILL PEOPLE, RIGHT? I CARE ABOUT THEM, I REALLY DO. IT'S JUST... I THINK THEY FEEL MORE COMFORTABLE BEING WITH THEIR OWN KIND. I REALLY DON'T THINK THERE'S ANYTHING WRONG WITH THEM BEING QUARANTINED. I THINK THEY'RE MUCH HAPPIER THAT WAY."

Charles Burns is perhaps the most exquisitely controlled brush-inker. He plans his drawings down to the last pointed feather, and inks with a beautiful, crisp line. He has taken the classic comics and magazine illustration brush styles of the mid-20th century and turned them against their original bland purposes to produce haunting images like this one. (Look back at Chapter 5 for a step-by-step look at how Burns builds up his panels.)

Using dry brush

Another great technique for softening the black is dry brush. As the name implies, this technique involves letting the ink dry out on your brush slightly so that it skips over the paper, creating an almost charcoal-like effect (the more textured your paper is, the better—try this with rougher-surfaced vellum or "cold press" bristol board). In addition to producing expressive lines and tones, dry brush is great because it can reproduce well even on a photocopier or scanner. It doesn't actually make a solid tone, just the illusion created by fine black marks on white paper (like a more naturalistic halftone).

Dry brush is a pretty rough technique, so consider using a cheap brush. To get started, dip your brush in the ink. Make sure the brush is fully charged, that there is no wateriness in there. If the ink is watery at all, you'll end up creating extremely hard-to-reproduce hybrid wash/dry brush tones. Ideally, you want the ink to be a bit thick, even sticky. Some artists use a tube of "lampblack" watercolor paint rather than india ink, because the thickness of the paint is easier to control and adjust (plus the paint produces beautifully rich blacks).

When your brush is charged, wipe it thoroughly on a paper towel or rag. You may want to drag your brush lightly toward you over a piece of scrap paper, in a zigzag motion, in order to spread the bristles out. Make different kinds of dry-brush marks on rough-surfaced paper and you will learn through experimentation that there are limitless expressive effects you can create. In general, though, dry brush is usually used for two classes of marks: lines and tones.

To make dry-brush lines, practice controlling the dryness of your brush to create broken, charcoal-like lines or heavier lines with soft edges:

If you make a line using a sideways stroke with the brush at an angle to the paper, the line will have a sharp outer edge (where the point is) but the inner edge will be rougher and less controllable. This is true even with a fully-charged brush, but with a slightly dry brush the effect can be dramatic.

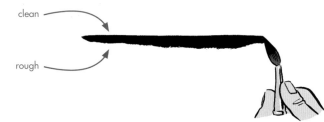

clean

rough

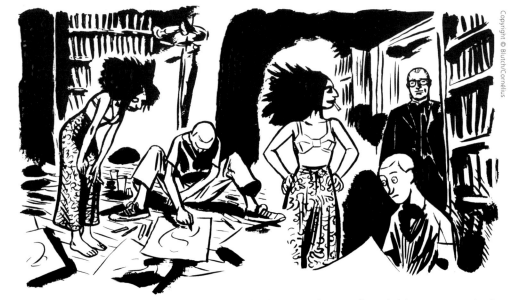

Blutch is among the most influential of the contemporary brush-inkers (although he often uses pen as well). In this case, he's used all brush. This panel, from *Mitchum*, will resonate particularly with readers of Craig Thompson and Paul Pope (and, ahem, Jessica).

There are many ways to create tones using dry brush. By simply brushing back and forth and varying the pressure you can create a smooth gray tone. Practice filling swatches of a few inches square with dry brush tone, and try to keep the value the same.

Another way to create tone is to fan out the hairs of your brush by squeezing them between your fingers.

Yes, you will get your fingers inky with this maneuver.

The splayed-out hairs create subtly striated marks. You can also control different values (lighter and darker tones) this way, but look how different the visual effect is from the technique you just tried:

The striations delineate shape, as in this flag. White was used to draw the white stripes.

When it's scanned or photo-copied, it will look like this. ■

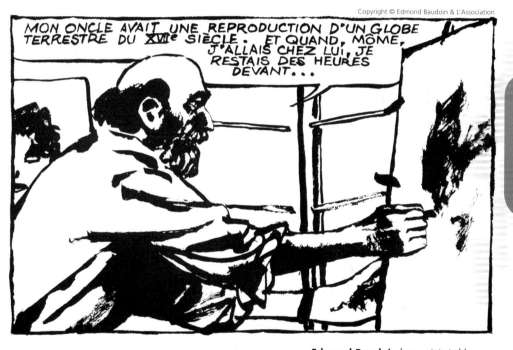

Edmond Baudoin has an inimitable way with chiaroscuro (that is, shadow and light), and sensitive, delicate dry-brush lines. He's an influence on a whole generation of cartoonists, especially in France, including Blutch and Joann Sfar (not to mention American cartoonists like Matt).

INKING A PANEL FROM START TO FINISH

Clay is inking the page he penciled in Chapter 5, and has decided to use various brush techniques on the Nate Krusher close-up.

Pencil
This pencil is traced and tightened up—yet again.

Linework
The next job is to ink in the major linework for the panel. Clay will do this for the whole page before he moves on to details.

Finish inking
Clay has used many brush techniques to get this panel done.

Corrections
He's still not done, though. He overshot a few lines, and Nate's expression looks more like he's grossed out by something than fightin' mad. Time for corrections.

Clay hasn't bothered to pencil in the black areas, they're simply marked with an X.

He hasn't drawn all of Nate's hair, either. He's just marked in the area, since it's an overall pattern.

Black spotting—fill in after outlining an area.

Quick thick-to-thin hatching/feathering.

Fix highlights on glasses.

Clean up edges.

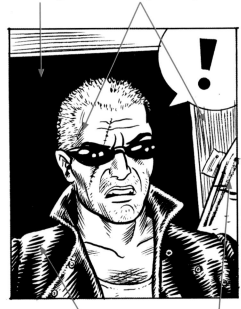

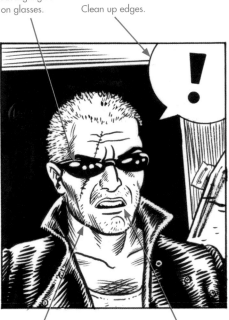

Clay has carefully planned where he will do feathering.

Careful thin-to-thick feathering.

Dry brush.

Add stubble by breaking jawline with white.

Fix expression by adjusting corners of mouth.

13 Black Gold

Scanning

After he scans the page, Clay has one last chance to make corrections. We'll teach you how to scan in Chapter 14.

The nasolabial crease (yes, that is the name!) on the left side of Nate's face was too far from his mouth, so Clay just selected it and scootched it in a tad.

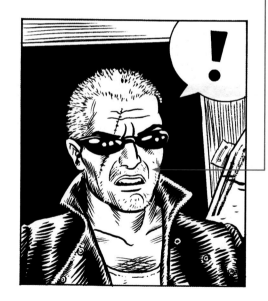

13.3

Notes on using a brush

LINES, SPOTTING BLACKS, AND OTHER TECHNIQUES

As we've already said, one advantage to inking with a brush is that you can work quite quickly, especially when you're inking linework and filling in, or "spotting," blacks.

- When you're inking linework with a brush, think about what kind of line you want to draw and how that will affect your art and story. For instance, what are the different "meanings" of thick dead-weight lines (that is, lines that don't vary in thickness); of sinuous, fluid lines; of brittle dry-brush lines?

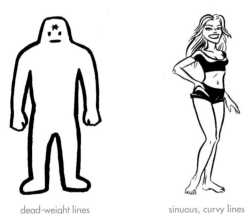

dead-weight lines sinuous, curvy lines delicate, soft lines

- When you spot blacks, it's a good idea to first outline the area you are filling in using brush or pen. However, if you are working against a solid black background, sometimes it helps to fill in the background first, and then work your way up to the edges of the foreground figures and objects.

- After a little practice almost all of the same techniques you have learned to do with a nib pen can also be done with a brush: hatching, cross-hatching, stippling, even scribbling.

stippling with a brush

We're not saying you have to use a brush for everything in a given drawing; it's fine—even a good idea—to switch tools according to what works best for a given technique:

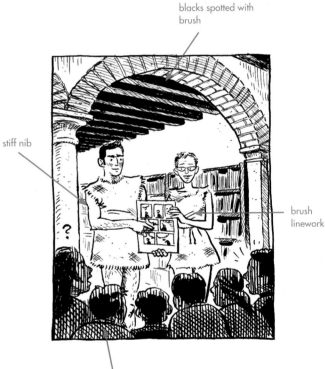

blacks spotted with brush

stiff nib

brush linework

flexible nib

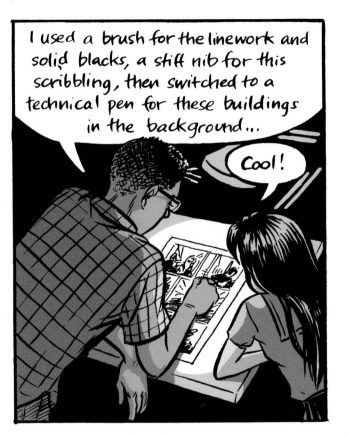

One of the best ways to learn about using brushes is to study other artists who use them regularly. Study the examples in this chapter and throughout the book, and try the extra credit project in this chapter, "Line for line II." ∎

More examples of brush inking

Despite some early exceptions (especially among single-panel cartoonists), brush inking has been less commonly used than pen inking in the history of comics art. Brush inking really only came into common use in the 1950s, during the golden age of comic books. One of the reasons brush eventually became (and remains) popular, is that, despite a steeper learning curve, once you master the brush, it's quite a bit faster than pen inking. A brush holds more ink, dries faster, and is less restrictive in terms of drawing direction.

There are many more examples of brush inking throughout this book.

In Chapter 2
- Wallace Morgan has a loose and energetic brush-inking style that is quite unusual for his time, and presages the work of cartoonists Craig Thompson and Jessica. His linework almost looks like it will dissolve on the page, yet his forms rise out of the hatching clearly and elegantly.
- Seth's brush inking (here working under the name Kalo) is heavily influenced by panel cartoonists of the classic era, like Peter Arno. In this example, he has created a style belonging to a fictional cartoonist named Kalo that evokes a clean and swoopy style popular in the mid-century.

In Chapter 6
- Craig Thompson's lovely, sinuous line, and his careful use of dry brush and brush hatching have inspired a new generation of brush-inkers, just when it looked like brush was going out.
- Paul Pope is one of the true brush virtuosos of the younger generation of comics artists. He incorporates influences as diverse as Guido Crepax, Tatsuya Egawa, and Carl Barks into his frenetic, beautifully designed pages. You can see another example of his work in Chapter 11 (one of the Mars illustrations).

In Chapter 11
- Gilbert Hernandez uses a combination of pen and brush, but in contrast to the work of his brother Jaime, the dominant effect is of heavy, juicy, black brush lines. The texture on the walls here is more likely achieved with pen.

In Chapter 12
- David Mazzucchelli (the Paris scene) started as a relatively conventional mainstream artist and over the years developed an increasingly expressive and idiosyncratic style, often featuring loose and inky brushwork.
- James Kochalka (the moon) uses a thick line and bold blacks. He works fast, and keeps the images clear and clean.
- R. Kikuo Johnson (the high school) is another artist who shows the mark of Milt Caniff (via Alex Toth and David Mazzucchelli). His mastery of black spotting is notable, but he softens his approach with a delicate touch for faces and figures.

The technique illustrations in this chapter are also almost exclusively done in brush. ∎

Ink a panel in brush

Materials
- your pencils
- fresh bristol board
- light box and/or tracing vellum
- pencil and eraser
- round watercolor brush
- india ink

Instructions
Choose a panel from the six-page story you've been working on that has at least two planes of action (foreground and background, maybe some middle ground too) and transfer it three times to a new sheet of bristol board using either a light box or the vellum transfer technique. (Refer back to Chapters 5 and 8 for tips on tracing.) Now ink two of your copies using some of the different brush techniques we have been exploring in this chapter. Think about what you want to emphasize in each panel—what is the narrative content? What kind of mood are you going for?—and let that guide your inking decisions. Look at artists you like and try to adapt their brush-inking approaches to your own work.

After you've inked two of your panels, cut out the third penciled panel and trade it with someone in your group. Ink your colleague's panel with a brush. You will find a new challenge in trying to interpret someone else's pencil drawing in ink, and you may be surprised to see what another artist does with your own panel.

Talking points
- Does one version of your panel really stand out? Why?
- If you used different techniques in one drawing, do they work well together?
- What kind of mood does each of the three versions of your panel evoke? Does the inking enhance the drama and narrative information of the panel?

Ronin
After copying and inking your own panel, go to the website, www.dw-wp.com, and you will find a number of student-penciled panels to print out and ink. If you can print the pencils onto bristol board cut to 8.5" x 11", you will have less trouble with bleeding and buckling. ■

Homework
Finish pencils of your six-page story and begin inking

Materials
- bristol board
- penciling tools
- T-square
- triangle
- ruler
- Ames Lettering Guide
- inking tools

Instructions

Finish penciling your short story. As you refine your drawings in anticipation of inking them, remember to use tracing and photocopying to save time; to work out composition, perspective, and other drawing problems; and to check your progress. At this point you should have your Ames guidelines laid down and tight pencils of your lettering in place.

Ink your lettering with a nib pen or technical pen, then ink your panel borders, word balloons, and narration boxes. Remember to adjust the margins of your word balloons and narration boxes to fit the inked lettering *before* you ink them!

Begin inking the art, using either brush or nib pens, whichever you prefer, starting with your major linework, as demonstrated with the Nate Krusher panel in this chapter. Then move to the backgrounds. Only after all of the major linework is done should you start adding tone (using techniques demonstrated in Chapter 8 and this chapter such as feathering, dry brush, hatching, etc., not wash and screentones) and spotting blacks.

You can start with panel one and work your way through to the end, or you can skip around to keep yourself interested and to ensure a consistent style throughout the story. Skipping from page to page also gives you time to let the ink dry on one panel before moving on to another panel on the same page. This is especially true if you are inking with a nib, which makes lines that take longer to dry than those made by a brush. Get approximately two pages of your comic inked. ■

Extra credit
Line for line II

Here are a few more assignments that will help you explore the expressive possibilities of inking with a brush:

- Draw two or three self-portraits in brush, altering your approach each time.
- Repeat the Chapter 8 extra credit, "Line for line," but make sure the original you're copying this time was inked with a brush instead of a pen. (Make your best guess.) Practice brush control. Place a sheet of vellum over a black-and-white photo. Using a T-square, cover the area of the photo with closely spaced, parallel pencil lines. Load your brush with ink, get a nice point, and, starting at the top of the photo, run the brush carefully along each pencil line, increasing your pressure slightly where the photo is dark and easing up where it is light. Now you're a human inkjet printer! ■

Chapter 14

In Chapter 8, when we introduced inking, we addressed the question: Why ink? The answer: Comics is an art form that's experienced primarily, perhaps exclusively, as reproduction, rather than as original art. The originals are more like a manuscript in relation to the artwork: the printed book. This fact is so important to comics that it earns a fighting chance to be considered part of the definition of the art form (look back at Chapter 1 for more on that). So. Reproduction. Mass quantities. How do you get from your smudgy, bumpy, ink-stained and tear-stained art to a nice clean comic book?

Comics in the Age of Mechanical Reproduction

14.1

Producing reproductions

SCANNING YOUR ART

Although reproducing your artwork is not as deep a topic as thinking about panel transitions or as glamorous as inking, knowing how to get really good reproductions of your work is just as important. There are many methods of reproducing your art that you can choose from, including photography and silkscreen, but the most common methods of reproducing comics are to photocopy them, to offset print them (like the newspaper or a magazine or almost anything in the world you see printed), or to put them online. If you're photocopying, you can work straight from the art, but for offset or online publishing, you need to scan your work first.

In this section we are going to show you how to scan black-and-white line art. The purpose of scanning with this process is to get a very clean, high-resolution image of your line art that will be suitable for printing as is or that can be colored or manipulated on the computer. Keeping a set of very high-resolution scans of your work is a good archival practice as well. If your art involves ink washes, or hand-colored pages, this scanning method won't work. We won't cover coloring in this book, but we will get to it in a future volume.

You can read through this section straight, but the particulars won't stick until you go through the scanning process step by step in front of a computer equipped with Adobe® Photoshop® and a scanner, and scan some of your own artwork. When you're in front of the computer, you'll need to have a fully inked, pencils-erased, corrected page of comics to work on.

NB, there are certainly image manipulation programs other than Photoshop® that will work, and you're welcome to use them. Photoshop® is, however, the industry standard, so that's what we've used as our model.

Step 1: Plan ahead

If you're scanning a whole comics page, which will usually be on paper that's at least 11" x 16", and you have only an 8.5" x 11" (letter-size) scanner, you will have to scan your art in bits and put it together on the computer afterward. Figure out how much of your page you can comfortably fit on the scanner at once, and plan to scan the page in as few segments as possible. For example, if you have a 10" x 15" page with three tiers on it, you might scan the top two tiers as one segment and the bottom tier as another. You want to avoid scanning an individual panel in two parts because it's quite hard to stitch it back together seamlessly; however, sometimes it's unavoidable (in a giant splash page, for example).

top segment

bottom segment

Step 2: Scan

Start off strong: Line up your art as neatly as you can on the scanner bed. Use the edges of your paper and the edges of the scanner to help you—that is, unless your art isn't parallel to the edges of the paper. Weigh down the top of the scanner with a couple of big books to make sure the art lies flat.

Open Photoshop®, and find your scanner driver under the File > Import menu. Different brands of scanners come with their own drivers, and so they all have different names (the driver is the software that runs your scanner). Find the menu item in that list that looks like "Scanmaster" or "Scan Driver" or "ScanTastic"—you're looking for the name that corresponds to the driver that came with your scanner.

When you first open your scan driver, a new window will open. Usually, the interface will look very simple with just a few buttons. This is not the interface you want. Look for a way to click the "Advanced," or "Complex," or "Professional" option. The interface should go from a cute little set of buttons to a technical-looking thing with way too many options.

In the Color or Color Mode window, choose Grayscale.

In the Resolution or Output Resolution window, choose 600 dpi.

In the Scale window, choose 100%. This is the best choice for an archival scan, because it will be higher resolution. If you are preparing work according to specifications given to you, you can use the percentage that will give you the final print size (see below for instructions on how to size art using the proportion wheel). You can also scan at 100% for your own files and resize the artwork later.

If your scanner driver doesn't automatically preview, click Preview, and make sure the area you want is selected.

Click Scan.

Scan all of the segments of your page like this. Make sure you've scanned everything.

Close the scan driver.

Step 3: Save
It's a good idea to save all your scanned segments right away, especially if your computer is prone to crashing. In the Save dialogue box, make sure you select TIFF. A TIFF is a type of file format that is "non-lossy." That means all of the information in the file is saved, even though the file is smaller when closed than when open. JPEG file format, though popular, throws away information crucial for printing. It is generally best suited for posting files online. Even if you're planning to post your art online, though, you should still make TIFFs of your artwork for your archives before knocking down the resolution and saving as a JPEG for online use.

preview select area to scan

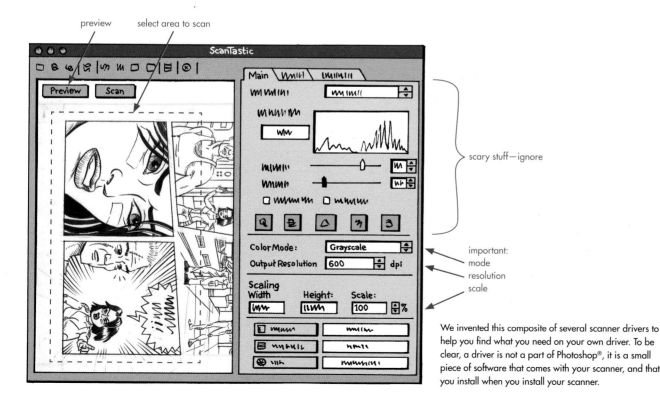

scary stuff—ignore

important:
mode
resolution
scale

We invented this composite of several scanner drivers to help you find what you need on your own driver. To be clear, a driver is not a part of Photoshop®, it is a small piece of software that comes with your scanner, and that you install when you install your scanner.

name your document

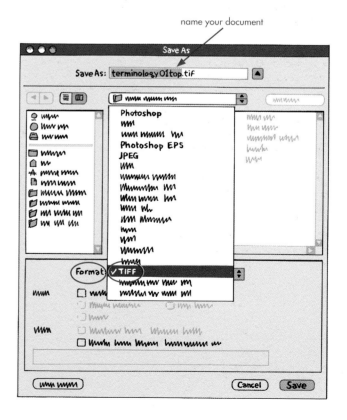

14. Reproduction

You can name your file whatever makes sense to you. It's a good idea to include in the file name the title of the piece, the page number, and the section number if you've divided up the page. For example, you might name a page that you scan in two parts "title01scanA.tif" and "title01scanB.tif." But don't leave it as "untitled." Before very long you'll have a million "untitled"s, and you'll never be able to find the one you want again.

Make sure you select the LZW button in the Image Compression box of the TIFF Options window that will pop up when you click Save. This will reduce the file size considerably without compromising image quality.

Step 4: Combine segments

Before moving on, make sure that the Options toolbar is checked under the View menu, so that you can see that toolbar at the top of the screen. You'll need to have Options open to check the settings on your tools from here on in.

To paste the segments of your pages together, open your first segment, and go into Image > Canvas Size. Change the canvas size to the dimensions of your original page or a bit larger. Use the little Anchor schematic on the Canvas Size window to position the segment you have open in more or less the right spot within the new larger canvas.

Open the next segment. Click on Select All and then copy and paste the segment into your master document (the one for which you just changed canvas size).

For simplicity, we will continue these instructions as if you've only got two segments, which will usually be the case. If you have more, paste them all into your master document now, and extrapolate our instructions below for each separate segment.

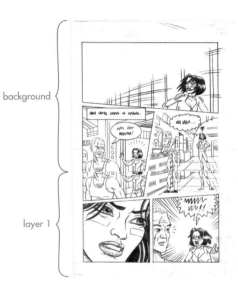

Here's more or less what your screen should look like now.

Go into the Layers menu, make sure your new layer is active (the master segment will be listed as Background here, and your new segment will be called Layer 1 by default). Change the Mode, found on the pull-down menu that defaults to Normal, to Multiply.

If your segments don't fit together well, you might have scanned one of them at a bit of an angle. To fix the problem go to Edit > Free Transform. Move the cursor to just outside one of the corners of the selected segment (you may need to widen your document window by pulling the bottom right corner to get the cursor where you need it). When the curved line with arrows on either end appears, click the segment and drag the cursor, causing the segment to rotate. You can also type in numerical degree amounts in the Set Rotation window at the top of the screen. Align the segment as best you can, dragging the transformed segment into place, then hit Return or double-click inside the segment to accept the rotation.

Use the Marquee or Polygonal Lasso tool to select the overlapping portion of the segment. Ideally, you want the edge of your selection to be in the gutter between panels or tiers. That way you don't have to worry about leaving visual hiccups within panels where the lines don't quite match up. Hit the Delete button on your keyboard to trim off the overlapping portions. Turn your layer and background off and on (click the eyeball next to each on the Layers menu) to make sure you deleted the right part. If there is no obvious place to trim a segment—say you're scanning a full-page splash—be extra careful when lining up the segments and use the Polygonal Lasso tool when trimming so that the fewest lines possible will overlap.

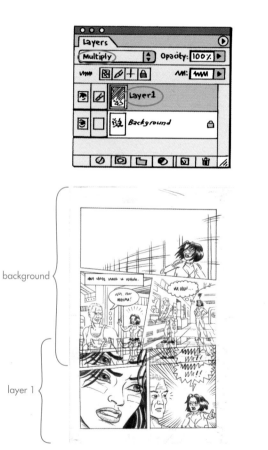

background

layer 1

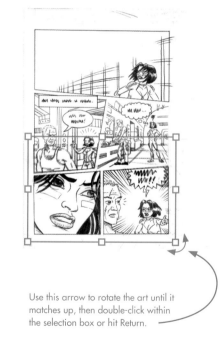

Use this arrow to rotate the art until it matches up, then double-click within the selection box or hit Return.

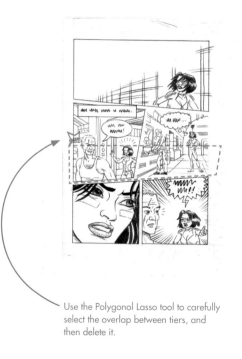

Use the Polygonol Lasso tool to carefully select the overlap between tiers, and then delete it.

You'll notice that wherever the page contains overlapping segments, you can now see both. Use the Move tool to shift the new segment around until it's lined up with the old one. You can drag the movable layer with the cursor, or you can use the arrow keys for minor adjustments.

14 Reproduction

215

After you've deleted the overlap, change the Mode on the new layer back to Normal. Then select Flatten Image, an option on the Layers menu. Repeat this entire procedure to remove overlap between all segments of your page.

Go to File > Save As to save and rename your pasted-together page and call your document "title01scan.tif" or something similar. You don't necessarily need to keep the separate segments that you stitched into one. Once your have your page pasted together, you can throw away the segments.

Step 5: Size image

Go to Image > Image Size, and under Resolution, at the bottom, enter 1200 dpi. Then click on OK to perform the change. This may seem pointless, but it's actually very important; making this conversion here will lead to you eventually having a very finely detailed, but still crisp, bitmap image. You *must* make this conversion *before* you threshold (Step 6).

Save.

Step 6: Adjust the threshold level

This is the artistic bit. Chances are you will see lots of gray, muddy pencils and other junk on the scan at this point. We're going to clean it up as best we can by adjusting the threshold level before making final Photoshop® corrections.

Go to Image > Adjustments > Threshold and the following dialogue window will open:

Slide the little arrow to where your art looks nice and clean. You will see that the higher the number, the darker your art looks. Generally, setting the arrow around 100 to 115 works well for clean black-and-white work. However, if you have used dry brush or inked lightly, or your inking has grayed out a lot from erasing pencils, you may need to use a higher threshold level. If you have very dark, dense art, or lots of grubbiness from over-penciling or using your art as a coaster, you may need to use a lower number. Once you have your threshold level just right, click OK to accept it. Experiment with this on your work, zooming in on dense cross-hatching and other problem areas as testing spots.

Here's what Threshold looks like when applied to a real scan.

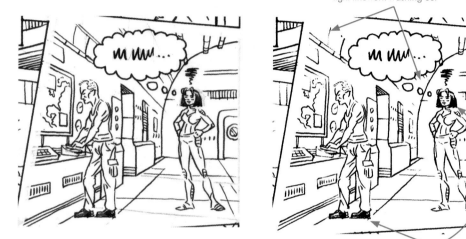

light linework washing out

specks, crap pencil messiness

minimal washout minimal burn in

losing density, detail

corrections burning through

Original

Threshold too low: about 90

Threshold too high: about 220

Threshold just right: about 120

Adjusting the threshold level, by the way, is essentially what a photocopier or printer does. A photocopier chooses whether each pixel is closer to clear white (level 0), or solid black (level 256), and then converts the pixel to either white or black accordingly. The starting point of division is right at 50% (i.e., level 128). Anything 50% gray or darker will go black. We usually like to go a bit low on the threshold level so more gray will go white, since the black we use is nice and solid. So lowering the number from 128 will make more of your grubby unerased pencils go white (but you may lose some pale inking in the process).

Save.

Step 7: Make Photoshop® corrections

Although you will have already corrected your artwork prior to scanning, Photoshop® enables you to make further corrections, such as cleaning up unwanted marks and redrawing lines that may not have scanned well.

Use the Magnifying Glass tool to zoom in on your art pretty close, but don't go bananas and zoom to the point where you can't tell what you're looking at. Use an orderly pattern to check the art closely for smudges, dots, and schmutz. Once you've located areas to be corrected, use the Pencil tool, never the Brush tool (it has anti-aliasing built in. See the sidebar, "What is anti-aliasing?"). If you use the Eraser tool, make sure it is set to Pencil in its options and the Anti-Alias box is unchecked. Alternately, you can use the Pencil tool only, hitting the X key to toggle the pencil color between white and black as needed to make the corrections.

Tip: Make sure the Pencil and Eraser are at the same or similar Brush size on the Options. Or you might find it useful to set the Eraser at a slightly smaller size than the Pencil, since erasing is generally a more delicate operation.

Save frequently.

Make the Options menu for the Pencil tool look something like this. You can adjust the size in the Brush box.

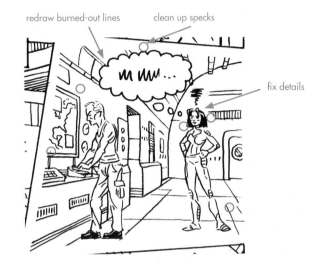

redraw burned-out lines clean up specks

fix details

What is anti-aliasing?

On some tools such as the Eraser, the Lasso tool, and the Marquee, among others, you have a check box on the Options menu for that tool labeled Anti-Alias. When you use these tools, make sure this box is *unchecked*. When you zoom way in, anti-aliased lines look fuzzy at the edges, whereas aliased lines look stair-stepped. At print size, your aliased lines will appear crisper. You'll also avoid other problems later when you color or otherwise manipulate your scan. Even if it seems contradictory to you now, trust us, you want stair-stepped, nonsmooth, *aliased* lines for your final, black, high-resolution linework. We've had you make your art so high-resolution that at naked-eye scale, you'll never see the steps, and the lines will look so much crisper. ■

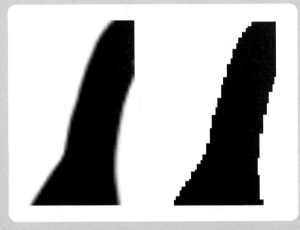

This super-sized line—magnified approximately 20x print size—is anti-aliased (looks fuzzy).

This line is aliased. This is what you want.

If you think we're being extreme about correcting your pages, take a look at the close attention your art will get from a good editor like Diana Schutz of Dark Horse, here descending on pages from *De:Tales* by Fábio Moon and Gabriel Bá. We should note here that Diana's frustration is not directed at the art of the Brazilian twins, but at the quality of the scans provided.

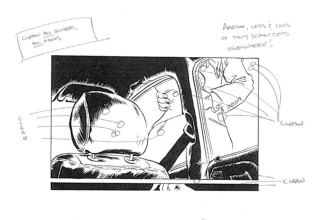

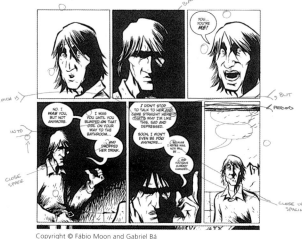

Step 8: Convert to bitmap

The final step in scanning and manipulating your artwork prior to saving it one last time is to change the Mode to Bitmap. This is the best format from which to print line art.

Zoom out and get a look at your artwork. Once you're completely satisfied with the scan, go into Image > Mode, and convert the art to Bitmap. Make sure that the Method in this window says 50% Threshold (meaning it's set to 128, automatically). Since you've already carefully thresholded the artwork, don't worry. This won't readjust your threshold level.

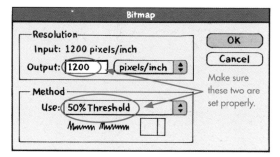

Save again, and you're done.

Remember to back up your computer regularly, using whatever system or software you normally use—and if you don't have a system, get one! We can't even begin to list the number of students and friends who have lost months, and even years, of work due to catastrophic computer meltdowns—with no backups. You can also periodically burn backup copies of your files onto CDs or DVDs for a second level of protection. ■

FURTHER READING

Ron Regé Jr., Dave Choe, Brian Ralph, and Jordan Crane, *Re: A Guide to Reproduction*. Available as a free download on http://reddingk.com/reproguide.pdf. Scroll down to the bottom of the page. This little booklet is a fantastic guide to photocopying, screen-printing, and offset printing in a very DIY mode.

14 Reproduction

Print history:
film and "non-photo blue"

You may be aware that these devices called "computers" didn't always exist. In fact, the use of computers for almost all aspects of printing is a fairly recent development, dating from around the late 90s. And computers played almost no role in printing until about 1990.

Film

Up until that point, line art (black and white art) was "shot" onto "film." Film was (and sometimes still is) an essential mid-point between original art and printed pages. A process camera wasn't a little handheld point-and-shoot, however. It was more like a large walk-in closet. The original art was mounted on a movable stand, and the film was mounted on the other end of the camera, inside a small room, which was also home to darkroom equipment. The film was exposed and developed right there, inside the camera/room. Some print shops still have this technology available, so that, if you like, you can have film shot straight from your art without scanning.

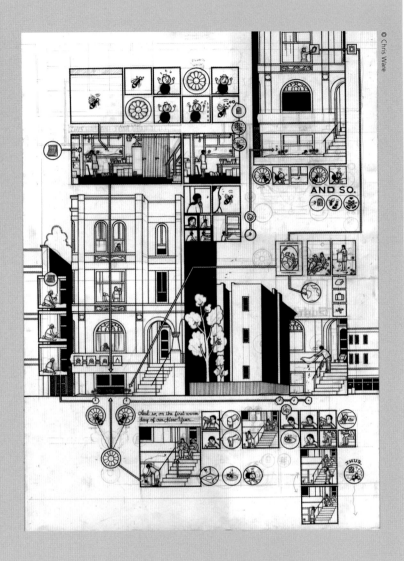

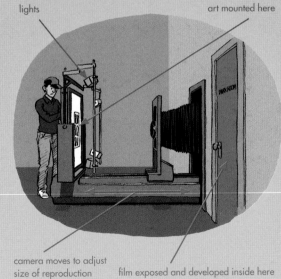

lights

art mounted here

camera moves to adjust size of reproduction

film exposed and developed inside here

Non-photo blue

The photographic reproduction process is the source of the term "non-photo blue." The blue in blue-line "comics" paper and non-photo blue colored pencils is a color that the camera couldn't "see," and therefore would be invisible on the final, reproduced art. Many artists still use blue pencils and blue-line paper, but you should be aware that scanners and photocopiers can sometimes pick up non-photo blue, although it will be faint. So be careful; if you get too heavy with your blue penciling, you'll still have issues with getting clean scans.

If you get a chance to look at an original Chris Ware page, you'll notice that he uses non-photo blue for his pencils and doesn't bother erasing (in the image on this page, we've printed the blue pencils in red, so you can get a sense of what his original pages look like). Of course, when his work is printed, you can't see any of this underdrawing. You just see beautiful, crisp, black linework (and the jewel-like colors he later applies to the scanned art using Photoshop®). When Ware began drawing comics, his work was always reproduced photographically, so he got used to using the non-photo blue pencil method, where he would build up his drawings in blue, then ink, but skip the step of erasing the underlying pencils. When Chris began scanning his pages, he found that he could set the scanner so that the pencil would disappear just as well as with a photographic process. He calls his approach "essentially just a nostalgic left-over from the days of camera photography." ∎

14.2

Olde-styley tools again

USING THE PROPORTION WHEEL

You've been photocopying your art since Chapter 7, and we hope you've started to see how that can be useful. Whether you're exclusively using photocopying to reproduce your artwork, or mixing it up with your scanner and printer, there's one other classic tool you will want to have handy for sizing up and sizing down your artwork: the proportion wheel. (It's sold as a "proportional scale," but in practice most people call it a proportion wheel.) Get yours out and follow along as you read this section. You'll never understand all of this without trying it yourself.

The main thing you'll do on a regular basis with the photocopier is make reductions of your originals to share with friends, to make into minicomics, to check your work, or to test inking ideas.

The tool you need to use to figure out how much to reduce your oversized page to fit on an 8.5" x 11" sheet of paper is the proportion wheel. The proportion wheel was developed so that you never have to use algebra again. So, as much as this tool is a pain in the butt, remember that algebra is worse! Unless you like algebra. In which case, be our guest.

$$\frac{10.5}{16} = \frac{x}{100}$$

Also, think about the "Line for line" exercises (chapters 8 and 13). When you sized up those drawings to copy them, you made an educated guess. But sometimes you actually can find out how big the originals were. How can you determine the exact proportion to use to size up your originals? You know the answer by now.

SIZING DOWN AND SIZING UP

There are three important parts of the proportion wheel. The inner wheel is labeled "size of original," the outer wheel is labeled "reproduction size," and the window—this is the most crucial part—has an arrow pointing to one spot that says "percentage of original size." You can ignore the other arrow, labeled "number of times of reduction."

There are two ways to use the proportion wheel. You can size your artwork down, or you can size it up.

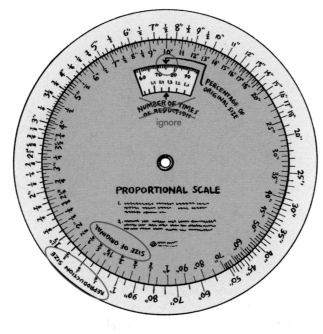

Sizing down

Let's start with sizing your artwork down, since this is what you will need to do to copy your originals on a single sheet of office paper.

There are three variables in play here: the size of your original, the size of the final, and the reduction percentage. In order to use the proportion wheel, you must know two of these variables. In this case, you know what size your art is, and you know what you want your final print size to be, but you don't know the reduction percentage. Solve for X. Just kidding.

$$\frac{\text{size of final}}{\text{size of original}} = \frac{x}{100}$$

Let's say the live area of your original art is 10" x 15", which a lot of your art will, in fact, be. The art needs to fit on an 8.5" x 11" sheet of paper. However, photocopiers don't print all the way to the edge, so give yourself a 0.5" margin all around.

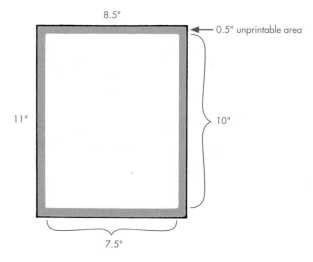

(By the way, this illustration of a sheet of 8.5" x 11" paper was drawn to scale using … the proportion wheel!)

That means that you will need to find the percentage required to reduce a 10" x 15" image so that it will fit in a final print size of 7.5" x 10".

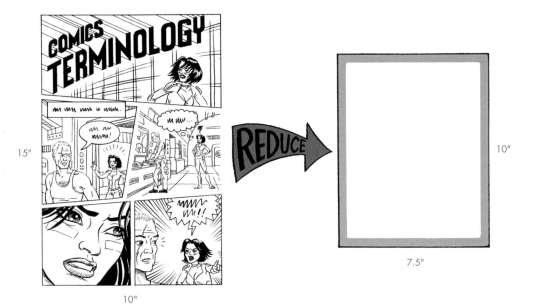

15"

REDUCE

10"

10"

7.5"

Now you need to find the comparative proportion between either the length or the width of each size. Let's take the width. You are reducing 10" (the width of the original live area) to 7.5" (the width of the print area of the reproduction). So find 7.5" on the outer wheel, and line it up with 10" on the inner wheel.

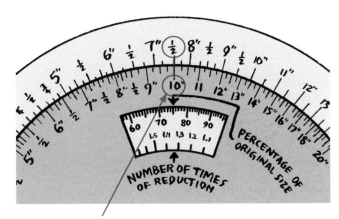

Find 7.5" on the outer wheel and line it up with 10" on the inner wheel.

Look at the window to see what percentage is at the pointer. It is, of course, 75%. You probably could have guessed this one off the top of your head.

75%

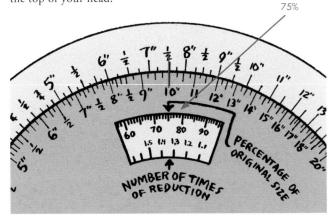

Now, do the same procedure again, but using the *length* of the original, and the *length* of the print size (10" on the outer wheel needs to line up with 15" on the inner wheel). What do you come up with?

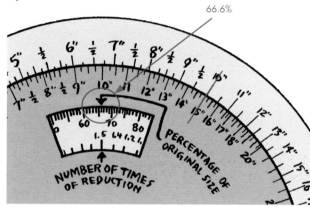
66.6%

66.6%. You may be asking yourself, why do this twice? Well, you came up with two different percentages. If the original art and the page on which it is to be reproduced do not have the exact same height-width ratio (and they rarely do) you will get different percentages for reducing the height and the width. So which percentage do you choose? You choose the smaller of the two. Why is that? If you use the bigger percentage, your reproduction will turn out bigger, and it will run off the edges of the page when printed. So that means that, for this exercise, you should reduce your art at 67% (rounding up the 66.6% slightly).

reduced at 75%—still too tall to fit on the page

reduced at 67%—a perfect fit, vertically speaking.

Sizing up

The situations in which you would size up your artwork are when you know the exact size of the book in which your comic's being printed, or you know the size at which an editor or art director wants to print your artwork. You are starting from scratch, so you can make your art fit the space exactly. In this case, you have a different set of variables: You know the reproduction size and the proportion, but not the size you want your original page to be.

When sizing up you need to treat the inner wheel—the "size of original" wheel—as the reproduction size. That's the "original" for the calculation. Don't worry if you can't remember this, however. What's important is that you use your logical brain. If you're sizing up, you know the number in the window should be over 100%. If it's under 100%, you've got the inner and outer wheels backward. Realign, and check again. The opposite goes for sizing down. Your proportion (in the window) must be under 100%, or your final result will be larger than what you started with!

Let's say you know your work will be printed at 6" x 9" (this is close to the print size of artwork live area in a standard American comic book). Find in the window the percentage of enlargement you'd like to use—let's say 150%—and line it up under the pointer that says "percentage of original size." Hold the proportion wheel so it doesn't shift, and find one of the final dimensions on the inner ring. Let's start with 9". Find the number that matches up with it on the outer ring.

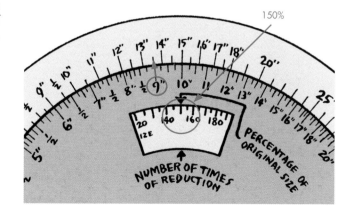
150%

It's 13.5". So that's one of the dimensions.

Now, without moving the rings (because both dimensions are being sized up 150%), find the other dimension on the inner ring (6") and then match it up with the outer ring. You'll find it lines up with 9". That's your second dimension.

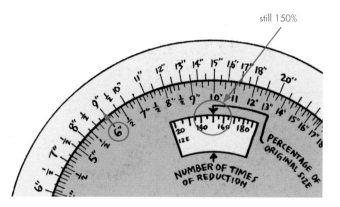
still 150%

So the live area of the original art will need to be 9" x 13.5", in order to be exactly 150% of reproduction size. Notice that the proportions of the standard American comics page are in a 2:3 ratio (which can also size up to 10" x 15", as we've been doing), but that at exactly 150% of print size, your original will be slightly smaller. Just for fun, why don't you figure out what percentage you'd need to use to size up 6" x 9" reproduction size to 10" x 15" original size? Not actual fun, of course, but you know what we mean. ■

Try the proportion wheel

Before you forget everything we just did, test your skill with the proportion wheel a few different ways. Remember to use your logical brain. If you're getting confused, think: Is the number I'm looking for supposed to be larger or smaller than the number I'm starting with? Is the proportion I'm finding logical? Will it produce the result I want?

1. Find the proportion needed to reduce a 12" x 16" page to fit on 8.5" x 11" office paper.
2. Find the percentage to fit 10" x 15" original art on a photocopied page that's 5.5" x 8.5" (minicomics size). Don't forget to leave a border clear so the copy doesn't get cut off.
3. Find the percentage needed to reduce 12" x 16" original art to fit on a photocopied page that's 7" x 8.5" (legal-paper minicomics size).
4. Size up a reproduction size of 6" x 9" at 150%, and at 200%.
5. Size up a reproduction size of 2.75" x 4.5" at 150%, and at 200%.
6. Size up a reproduction size of 7.5" x 10" at 150%, and at 200%.
7. You have a comic that will be reproduced at 6" x 9" and you want to draw it as big as possible on a 14" x 17" sheet of bristol board. What's the largest live area you can work at with a minimum of a 1/4" margin left around the edge of your bristol board?

Answers on the website, www.dw-wp.com! ■

Homework
Finish inking, make corrections, and reproduce your six-page comic

Instructions

As you ink your six-page comic you should periodically make reduced photocopies of your pages-in-progress. Make sure your lettering is legible and that your linework isn't too fine or too strong. Use your photocopies to check your choices. Also use the photocopies to test out ideas for spotting blacks, using different kinds of hatching or stippling tones, and so on.

If you feel you've botched something or you spill some ink, don't panic. Just keep working: You may well find that you decide to black in a whole area where you smudged a line, and in other places mistakes that seemed glaring may seem less so as the page fleshes out.

Keep in mind that your page is going to be reduced and copied. Don't get caught up in too much minute detail.

Don't do any corrections with graphic white until the very end. Thoroughly erase your pencils, carefully make your corrections. You may want to paste in corrections as well. This is the time for that.

When you've finished making corrections, you're still not quite finished! Make reduced photocopies of your original artwork to fit on office paper, or try your new scanning prowess and print the scanned pages out at office-paper size. ■

Extra credit
"It was an accident"

Create a two- to three-page finished comic about an accident. It should be an actual accident, one that happened to you or someone you know personally. It can be a happy accident, like running into an old friend, or a serious accident, like a fall or a car crash. You can play it for laughs or tears. It's up to you.

Importantly, although this will be a story that's closely connected to a true event, don't be a slave to reality. Select only the events of the story that are relevant to the accident and the fallout from it. If your main character bought an ice cream cone, called his mom, and then got in his car and had a car accident, your job is to cut out the ice cream and the call (unless he got in the accident because he dropped the ice cream cone or argued with his mom!).

Materials
- office paper
- pencil
- eraser
- inking tools

Instructions
Write and draw a three-page thumbnail on office paper. Revise, then continue with the story, penciling, inking, and correcting the pages. Here are the important elements of a successful accident story to keep in mind (refer back to Chapter 9 for more on story structure).

Setup
This should be brief, but it should give your readers enough information to understand what happens. Plant clues about the factors that caused the accident: Was the character in a hurry, and not paying attention? Was he or she angry? Was he or she being a space cadet? Show us the crucial elements before heading in.

The accident
What, when, where, and why? You must break down the action into understandable bits. If you're drawing an accident in which a car cuts in front of a truck, then the truck jackknifes and three other cars crash into it ... that's complex. You need to think very carefully how you're going to break this complicated scenario into bits so your readers know what's going on, who was responsible, and who was hurt. Using different points of view might help. Drawing an overhead map of the scene (see Chapter 5 to review) is essential to getting the action clear in your own mind.

The aftermath
What happened to the main character as a result of the accident? How did he or she resolve the problem or react to the situation?

Wrapping it up
There isn't always an easy way to do this, but is there a point at which you feel a sense of closure? That's the end. Use it. ■

Chapter 15

24-Hour comic

We've reached the end of the book. Let's take one last creative challenge...

15.1
Marathon cartooning

Homework critique for Chapter 14 on page 245

THE 24-HOUR COMIC

In the summer of 1990, Scott McCloud was convinced that (as he put it) he was the second-slowest artist in comics—second only to his friend Steve Bissette. He found this idea depressing, and he wanted to rediscover the joy of creating comics that got him started in the first place. When Bissette came to town in August for a book signing and ripped through a pile of sketches in minutes flat, McCloud had a brainstorm: Why not challenge Bissette—and himself—to each draw a 24-page comic in 24 hours, from start to finish? (And to do it within the month of August.) Scott went on to make the first 24-hour comic on August 31, 1990. (Bissette made the second on "August 36th.")

The rules for the 24-hour comic, as delineated by McCloud (see "the Dare," under "inventions" at www.scottmccloud.com) state that in one 24-hour period you have to come up with the idea, thumbnail the comic, pencil and ink it, make corrections, and even paste it up and photocopy an edition of the story as a minicomic. In practice, most people just aim to finish inking the comic and some people consider it allowable to cheat and finish up the last adjustments and corrections after the initial 24-hour period, as long as the majority of work is already done.

Scott's idea caught on and remains a popular activity on the comics scene, and it has even inspired similar events in other media, such as the 24-hour play and the 24-hour film.

The 24-hour comic is more than just a perverse endurance challenge, although it certainly is that. It's also an activity that forces you to set aside a lot of the regular hang-ups you might have—procrastination, perfectionism, lack of motivation—and go all-out in the name of fun and of competition with yourself. If you don't think you can create 24 pages in 24 hours, you are *just* the kind of person who should try to do so. An additional benefit comes when you do a 24-hour comic with a group of fellow cartoonists. It's enlightening and encouraging to spend this marathon with a group of like-minded artists egging you on, discussing their creative approaches, and talking about comics, art, and life.

In today's modern, high-speed world, not everyone can devote a whole day to creating a comic. Plus, some of you are using this book in a classroom or workshop situation. So, for you on-the-go, time-is-money types, we propose the shorter-but-still-challenging "three-hour comic": three pages of comics, from start to finish, in three hours. ∎

The cover of the first 24-hour comic, *A Day's Work* by Scott McCloud

Copyright © Scott McCloud

FURTHER READING

http://www.scottmccloud.com/inventions/24hr/24hr.html

Various, *24-Hour Comics, 24-Hour Comics All-Stars*, and others (a series of collections of 24-hour comics)

24-hour comic (or 3-hour comic)

Materials
- penciling and/or inking tools
- office paper
- bristol board
- 24 (or 3) consecutive hours of free time

Instructions

Your objective is to write, pencil, and ink a 24-page comic in 24 hours. Your comic should tell a complete story, not be a series of random gags or aimless, inconclusive events. There are many ways you can approach this activity, but the important thing is to time yourself carefully. Most people spend the first chunk of time coming up with a story and sketching thumbnails, then spend the largest chunk of time penciling on bristol board, then usually rush through the inking frantically to get the comic done on time. That's fine: Your goal is not to create a polished, flawless work of art. Instead, you are challenging yourself to do the best you can under a harsh deadline. If it's impossible for you to set aside 24 hours for this, or you're just a scaredy-cat, you can do the three-hour version.

When buying snacks for your all-nighter, remember: Pretzels make the perfect cartoonists' treat. No greasy fingers!

Some hints to get you started

The most challenging and rewarding way to tackle this thing is to begin with a completely blank slate—no story ideas, no characters in mind, just all of those empty pages to fill. Some people are good at seemingly conjuring stories and characters out of thin air. Depending on your mood and energy on a given day, you might be one of them. Most of us, though, are intimidated, if not reduced to a frozen panic, by the blank page. But there are many ways to jump-start the story process: strategies to give you some threads with which to start weaving.

Here are a few:
- Before you start, gather some (preferably random) photos, for example, a page or two from a magazine or newspaper. Look at the pictures, read the captions, and think about what kinds of stories and situations the photographs suggest. (McCloud's first 24-hour comic was partially inspired by a pile of art books he'd checked out of the library.)
- Think of the ending of a story, maybe even a last panel with a few unlikely elements in it. This last panel could depict something moody (a woman in a wedding dress, standing alone in the rain) or absurd (a bear carrying a briefcase sitting in a rowboat in the middle of the ocean). Work your way backward to figure out what could have happened to lead up to this ending.
- Give yourself a random formal constraint. For example: Every panel has to make reference to a color, can't show any people, or must show only eyes (or hands).
- Make a quick list of personality traits, physical characteristics, and jobs. Pick one of each at random, and you have the makings of a character. Repeat as necessary. (This is essentially your set of character and spark cards, introduced in Chapter 10.)
- It may occur to you in desperation to create a comic about how you have to draw a 24-hour comic and you don't know what to write about. Please don't.

Ronin

You can do this one alone, but it makes a big difference if you do it with a group. If you don't know any cartoonists to join you in this activity, try putting up a flyer at a local comics or bookstore, or post an online message on a comics-related message board. ■

15.2

Onward and upward

THE END (BUT ALSO THE BEGINNING)

Congratulations! You've made it to the end of this book. Although our time together has been short, we've already made a tour of all of the major aspects of making comics: storytelling within the image and between panels, narrative arcs and character design, penciling and inking, lettering, page design, and more. By now you should be able to produce a pretty coherent comic of any length on your own, from thumbs to reproduction.

Not only that, but you've got at least 11 pages of comics done (an imageless comic, the *Chip* page, your six-pager, and the three-hour comic). If you did the extra credit assignments, you've got even more. That means you have got enough material to self-publish your own minicomic. Making a self-published comic is an essential step in understanding how your work functions in the world: you're looking at it in reproduction, and bound into spreads. More importantly, *so are other people*. You can (and should) give your minicomic to friends and parents who have been wondering what you're up to. You can send it to editors as a portfolio. You can give it to artists for feedback or just because you like them. And you can sell it to total strangers, which puts you in spitting distance of the big leagues. All of these people will give you feedback of one kind or another, and that's what you need to keep progressing.

You can find a concise tutorial on making your own minicomic in Appendix E.

We plan to return in the near future with a second volume of this book, where we will delve a little deeper into a lot of the topics we've discussed so far, from inking to story structure to generating ideas. We'll also talk a lot more about becoming a comics professional. Until then, keep working on comics! Visit us at our website, www.dw-wp.com, to get ideas and keep yourself motivated. ■

FURTHER READING

Esther Pearl Watson and Mark Todd, *Whatcha Mean, What's a Zine?*

Appendix A

Supplies

We cover supplies in more detail in the chapters in which we first discuss them. However, for your shopping convenience, we've compiled the cartoonists' basic tool kit, with a few almost-essential add-ons.

ESSENTIALS

Paper

- 8.5" x 11" office paper —————————

- 14" x 17" pad of student-grade bristol board, regular or plate surface. We recommend Strathmore brand.

- A pad of heavyweight tracing paper (also called vellum)

Pencils

- An assortment of graphite pencils—you'll mainly want HB pencils, but a few softer (say 2B and 6B) and harder (4H or 6H) pencils will come in handy. —————————

- A mechanical pencil in 0.5 mm or 0.7 mm size with HB graphite

- Erasers: kneaded and white plastic types —————————

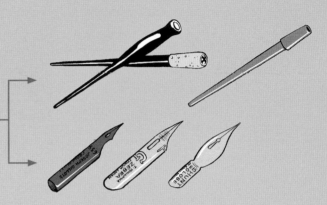

Inking tools

- Nib pens: a few pen nibs and holders
 Here are some starter sets:
 › Rexel Drawing Pens Set: includes eight Gillott nibs
 › Speedball (Hunt) Sketching Pen Set (more versatile than the "artist's" or "cartooning" sets)
 › Deleter Trial Pen Set: assortment of nibs used in Japan

- Brushes: (round watercolor, sizes 2 through 4) acrylic or cheap natural hair for starters, or up to kolinsky sable. We recommend the Raphaël sable brush; it has an orange handle end. If you shell out for kolinsky sable, definitely get the brush basin (*see below*).

- India ink: Winsor & Newton, Dr. Ph. Martin's, Koh-I-Noor Universal 3080-4, or other brand of waterproof india ink (if you get the Koh-I-Noor, you will need a small ink jar with a tight seal as well). Higgins brand inks are pretty watery but useful for nib pens. Don't get "fountain pen" ink, because it is not waterproof.

- Graphic white (white ink for correction). We recommend Deleter brand "White 2."

- Small/stubby brush to apply white with

- Brush basin

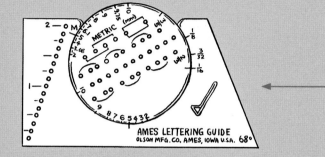

Drafting tools
You can find all these in the drafting section of your art supply store or website.

- 18-inch clear plastic grid-style ruler with an inking bevel.

- 18- or 24-inch T-square. We recommend the wood kind with clear plastic edges on either side, but the metal ones are also acceptable.

- Ames Lettering Guide

- proportion wheel. This is sold as a "Proportional Scale," although in practice most people refer to it as a proportion wheel.

- drafting tape

- X-acto knife

- double-sided archival ("scrapbooking") tape

- archival glue stick

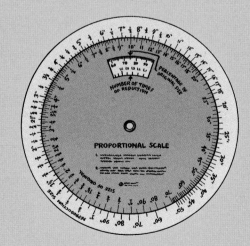

OPTIONAL BUT RECOMMENDED

You can find all these in the drafting section of your art supply store or website.

- technical pens ——————————————————————→
- pigment markers ——————————————————————→
- ruling pen ————————————————————————————————→
- Speedball "B" and "C" nibs ——————————————→
- erasable colored pencils, such as Sanford Col-Erase brand, in various colors, particularly "light blue." (Avoid nonerasable colored pencils) ————————————————→
- circle and ellipse templates
- set of French and/or "S" curves ——————————
- a compass with ruling pen attachment
- 30° – 60° – 90° triangle
- ink palette dish
- a computer with a scanner and a copy of Adobe® Photoshop®

Appendix B
Homework critiques

GETTING STARTED

When you start out reading and critiquing other people's comics, it can be difficult to figure out what to say, how to say it, and even what you think. Here are a few ideas for how to get started.

POINTERS ON CRITIQUING

- ***Don't try to argue someone else into sharing your perceptions.*** Let differences of perception exist. Find it interesting that people see things so differently. Critiquing is about giving true feedback to your peers, not making a case.

- ***Don't let the big talkers hog the floor.*** You'll quickly get bored, even resentful that you can't get a word in edgewise. And the critique will suffer from limited perspective. Learn to take your space.

- ***Don't succumb to "groupthink."*** Hold on to your own impressions and ideas and believe in them. If you're really convinced by others' opinions, fine, but even if everyone but you loves something, and you hate it, own that, and say so.

- ***Don't suppress your reactions to genre.*** Do you hate manga? Fine. Say that, but talk about what annoyed you about the manga being critiqued. Then talk about what worked. Do you hate superhero comics? OK, same thing. But don't get hung up on theory: "American comics *represent* blah blah blah." Keep your comments specific to the work at hand. Anything—any structure, any art style, any artistic decision—can work if it works, but anything can also suck if it sucks. There are no hard-and-fast rules.

POINTERS ON BEING CRITIQUED

- ***Take notes on your critique.*** Don't let this valuable feedback get lost!

- ***Don't introduce the work.*** If you have to tell the readers anything about your work, the work does not stand on its own. Avoid introducing your own work defensively: I hate this, or it sucks, or I hate the assignment. Simply put your work up and see what happens.

- ***Listen first.*** It's tempting to jump in the minute someone says anything you don't agree with about your work. But it's important to let the critiquer have his or her say fully, so you can get a complete set of impressions. If you interrupt, you'll miss out on some of their fresh reactions. If a critiquer asks you a question, wait until the end of the critique to answer. Learn to just listen (and take some notes), and then let everything you've heard simmer for a while. And know that critiquers are not always right. You'll find that critiquers and other readers will often have completely contradictory reactions to your work. That's a good sign that there is an issue with the work, but you won't necessarily know what that issue is.

- ***Respect your critiquers' points of view.*** You may not agree with what people say about your work. That's OK. You are always right about what the work means to you, but remember this: Your critiquers and readers are *also* right. They get only what they get from the work. And if they're missing something crucial that you think is totally clear, it obviously isn't clear enough. Consider making it clearer.

A NOTE FOR EVERYONE

Your job is communication. You are trying to get *your* idea into *someone else's* head. Summarize each scene for yourself—what is the point? What were you trying to do? Are you shouting into the wilderness, or making it happen? Ask yourself: Does your least-involved colleague, to whom your approach is most alien, get what you're trying to do?

BASIC CRITIQUE TECHNIQUES

"I notice…"

This is a sort of game in which each person in the group takes a turn verbalizing something they see in the comic. The verbalization could be something as simple as "I notice there's a lot of black in the middle of the page," or as complex as "I notice the main character has some serious issues with her father." Here's the trick to this technique: Avoid value judgments. In other words, don't say, "I notice that I hate this drawing," or " I notice that this is really well told." The point is to take the time to look at and read the comic, letting the details soak in. The "I notice" technique is a great way to start a critique.

Retelling the story

Another way to get a critique started is to retell the story being critiqued. There are several ways to do this.

- Summarize the story—tell the group a compressed version of what you read. This tells the group (and more importantly, the author) what you see and what you're missing.
- Read the story and retell it without looking at the work—what do you remember about it best? What don't you remember clearly?
- While pointing to the relevant parts of the story, tell the group what you felt and thought as you read it.
- Retell the group the story as you would have done it.
- Retell the story while following the action within each panel with your finger, taking as long pointing as you felt when you read it. How long here, how long there? What is your eye drawn to next? Even if you skip to a new panel before you were meant to and then come back, show us that. This is especially useful in examining how well the artist handles reading order.
- If you find yourself confused by the story, retell it, pointing out where you were confused. Perhaps you can puzzle it out if you give yourself enough time, but think about this: Will the average reader bother? Is that really the best use of our time? If the story isn't totally clear from one panel to the next, say so.

DEEPER CRITIQUE TECHNIQUES

Talk about the story

(These ideas are explained in Chapter 9.)

- Is there a strong narrative arc?
- Who is the protagonist and what is his/her motivating desire or need? How is that need addressed?
- What's the spark?
- How is the story resolved?
- Do you think that the author has made the story compelling? How?
- Did you find the story satisfying? Why or why not?

Talk about the timing

- Did the story fit the length? (i.e., did the story feel cramped or overlong?)
- Where should the story be compressed or lengthened?
- Was closure used in an interesting way at any particular point?

Talk about the art

- How appropriate was the art to the story?
- What panel(s) did you like the best? Why?
- Choose a panel that needs work. What would you suggest to fix it?
- How is the lettering? Is it clear? Attractive? Point out problem areas.
- What do you think about the author's inking choices?
- How well integrated are the drawings and the words? Can they exist apart, or are they interdependent? Look for a place where drawing takes the place of words.

Talk about the writing

- Is the dialogue well written?
- Do the characters have individual, distinctive voices?
- Are descriptions well chosen? Do they repeat what is visible in the drawing? Could you get rid of some of the narrative by making the content visible? ■

1

Drawing in action

Post your homework on a wall and look at it as a group.

Talking points

Discuss the ways in which the panels work (or don't).
- Is the sequence of events in each panel clear?
- Follow the path of the action in each panel with your fingers. Is it easy to figure out the correct way to read each panel? Do the panels read left-to-right, and top-down? If not, do the panels still make sense?
- Does the composition need to be adjusted in order to make more sense?
- Are the characters clearly defined, and are their expressions and gestures understandable?
- How are the images framed? How might you choose to frame, crop, and design any image differently? Think of at least three alternately framed versions of each panel. Sketch them quickly on a piece of paper or on a blackboard.
- Is the full space of each panel used efficiently? Or, if any panels are off-balance, is that quality used to good narrative effect?

Ronin

Start by posting your own work on a wall and standing back from it. Particularly if your work is a few days old, you'll start to get a new perspective on it when you look at it in this manner. Ask yourself the same questions we pose above. To check the reading order, draw a mental line through the actions in the panel to check that they follow the left-to-right, top-to-bottom reading order. Also, look at the website, www.dw-wp.com. You will find examples of and commentary on other students' work there, along with more specific guidelines for looking at your own work. ■

2

Gag me

Post your homework on a wall and look at it as a group. You should be laughing out loud at your compañeros' gag comics!

Talking points

The discussion for this homework assignment will be not unlike last week's discussion. You'll want to start out with the same questions.
- Is the sequence of events in each panel clear?
- Follow the path of the action in each panel with your fingers. Is it easy to figure out the correct way to read each panel? Do the panels read left-to-right, and top-down? If not, do the panels still make sense?
- Does the composition need to be adjusted in order to make more sense?
- Are the characters clearly defined, and are their expressions and gestures understandable?
- How are the images framed? How might you choose to frame, crop, and design any image differently? Think of at least three alternately framed versions of each panel. Sketch them quickly on a piece of paper or on a blackboard.
- Is the full space of each panel used efficiently? Or, if any panels are off-balance, is that quality used to good narrative effect?

And then think about a few more questions
- Are the panels funny? Why or why not?
- How would you define the humor in each panel (ironic juxtaposition, wacky gross-out, surprise twist…?)
- How could you make the cartoons funnier or the writing tighter?
- How does the drawing contribute to the humor of each panel? Look at the way characters are drawn, the way the scenes are framed, and the style of the linework.
- Think about the "voice" of the cartoons (or characters). Is the voice in each panel interesting and individual? Try to assess how meaning arises from the combination of word and image, and whether meaning exists in word and in image separately.
- The assignment included writing multiple captions for the drawing. Discuss the various choices and decide if the artist chose the best one.

Also, start to pay attention to the presentation of the work
- What drawing tools did the artist choose for this project? How well did they work?
- Are the panels the required size? It's important to learn early to follow these kinds of instructions.

This is a lot to cover. You don't need to answer every one of these questions for each cartoon you look at; just use these questions as a guide to what's important to look for.

Ronin

As always, start by posting your own work on a wall and standing back in order to gain some new perspective on it. It's better not to post your work immediately. Wait a couple of days so that you're not so close to it.

Ask yourself the same questions we pose above. Also, look at the website, www.dw-wp.com. You will find examples of other students' work there, with commentary. ■

3

Strip it down

Post your homework on a wall and look at it as a group. Before you begin your critique, take a few moments to read all of the strips carefully. Remember that you are not critiquing the quality of the drawings at this point, just the storytelling. Thumbnails are rough drafts, sometimes very rough indeed.

Talking points

- Are the characters clearly identified in the opening panels? How did the artist handle that job? (For example, it is OK if they are labeled with text like "boss" and "employee"?)
- Is there a new condition, a problem, that is introduced in the first or second panel of each strip?
- Reading the whole strips, can you clearly follow the action and dialogue? If you are uncertain about anything in anyone's strip, point it out. Be honest; you may be able to figure out the intention of the author, but is it really the best use of your time to have to figure it out? Will ordinary readers bother?
- Do the punch lines work? That is, beyond whether you find them funny or not, do they have satisfying or logical (or satisfyingly illogical) conclusions to the situations that have been set up?
- How does the visual rhythm of each strip feel? Try lightly tracing a pencil line through the characters, word balloons, and any props or motion lines that play a part in each strip.
- How is the writing in each strip? Correct spelling errors and make suggestions for better timing and rhythm or for more effective phrasing.

Ronin

Start by posting your work on a wall and standing back from it in order to gain some new perspective. As always, it's better not to do this immediately. Wait a couple of days so that you forget some of the details.

Ask yourself the same questions we pose above. Also look at the website, www.dw-wp.com. You will find examples of other students' work, with commentary, there. ■

4

Closure comics

Post your homework on a wall and look at it as a group. Take some time to look at each of the thumbnails and read through them before discussing.

Talking points

Remember that the goal with the Jack and Jill story was to tell it clearly while using all seven types of panel transitions we discussed in the last lesson.

- Can you identify all seven types of transitions in each comic? Point them each out one by one.
- Are there panel transitions in any of the comics that could be identified as more than one type of transition?
- Are the different transitions used effectively to tell the story? That is, do they add or reinforce meaning or drama, or do they feel randomly stuffed in to meet the requirements of the assignment?
- Compare and contrast the different comics, thinking about pacing, mood, and how clearly and/or interestingly each comic depicts the events of the story.

Ronin

Start by posting your own work on a wall and standing back from it. Ask yourself the same questions we pose above. Also, look at the website, www.dw-wp.com. You will find examples of other students' work, with commentary, there. ■

Revisions and notes

Now that you've heard what others have to say about your work, remind yourself of this: Your thumbnail is a working document. It is, essentially, the manuscript for your comic, a rough draft. Take notes either during or immediately after the critique on what gets said, and then take a good hard look at your thumb yourself, keeping those comments in mind. You don't have to take every suggestion to heart, not by a long shot, but it's important to truly utilize the valuable feedback you got.

Once you've thought about your feedback, it's time to revise. Erase, redraw, tape down new panels, even cut up your thumb and rearrange it. This is why we told you to keep it simple!

We won't harp on this each and every time there's a critique, but you should make a habit of revising all of your thumbs before penciling. ■

Penciling

Post your homework on a wall and look at it as a group.

Talking points

1. Start by taking the overall images in. For each panel tell the story of the action depicted, talk about the emotions projected by the characters, and discuss the visual design of the panel.
2. Identify, as far as you can, the penciling techniques used to draw the panels.
3. Try to point out areas that need work: Could one or more penciling technique help solve problems in the particular panel?
4. Check that the panels follow the directions. In each panel are there three planes (foreground, midground, and background)? Identify them. Are there at least two characters interacting? Measure the panel borders: Are they at least six inches high and eight inches wide?

Ronin

Start by posting your own work on a wall and standing back from it. Ask yourself the same questions we pose above. Also, look at the website, www.dw-wp.com. You will find examples of other students' work, with commentary, there. ■

"A month of Sundays" thumbnails

If you are in a big group, you may want to do this critique in smaller subgroups of four or five people. Post your thumbs up on the wall. Take a few minutes to read all of the comics and take mental notes on them.

Talking points

1. Start with the basics. Is the action understandable in each comic? Is each story complete?
2. Concentrate on composition. How effective are the choices the artists have made? Are the panels dynamic and interesting to look at? Can you think of other ways to arrange the elements in the panels? Does the composition of the individual panels add up to something greater in the whole page?
3. How does the dialogue read? Try reading some of it out loud. Does the dialogue have a good ring to it? Do the characters' voices sound individual and unique? Are the jokes funny?
4. Are there spelling or grammatical errors in any of the comics? Correct them now.

Now, using the feedback you got in the critique, rework your thumbnails to make them stronger and funnier. If you don't have time to revise immediately, don't forget to take clear and extensive notes on your critique.

Ronin

Start by leaving the work aside for a few hours or days and then posting it on a wall and standing back to get a new perspective on it. Then, check the website, www.dw-wp.com, for samples of other students' thumbnails with critiques. Compare your solutions with theirs, and work out at least three alternate panel compositions that improve your work. ■

A comic with no pictures

We know this was an activity, but since you finished it for homework, here are some critique guidelines. Post your original pages on a wall next to your photocopied reductions.

Talking points

- Are the photocopies clean and professional looking? Are there unerased pencil marks? Smudges that weren't cleaned up?
- Look at the lettering. Is it neat? Are the spelling and grammar correct? How does the lettering size work on the photocopies: Is it too small to read? Is it too big?
- Examine the layouts: Are the image areas perfectly rectangular? Are the panel borders inked neatly? With what tools were the borders inked? What do you think of the gutter width, both between panels and between tiers of each comic? Are panels too close together or too widely spaced?
- How are the stories? Can you figure out what's going on? Does the artist use the lack of images in an interesting or creative way? If there is dialogue in a comic, how can you tell which character is talking? What does the lettering style and size tell you about the personality or mood of the characters?
- If there are emanata or sound effects in the comics, are they intelligible and neatly inked?

Ronin

The website, www.dw-wp.com, will have a variety of examples of "image-less" comics by students that you can compare with your own.

✳ Turn the page for critique guidelines for your "A month of Sundays" pencils.

A brief look at penciled "A month of Sundays"

If you are in a big group, you may want to do this critique in smaller subgroups of four or five people. Post your pencils up on the wall. Take a few minutes to read all of the comics and take mental notes on them.

Talking points

1. Have any significant problems from the thumbnails been addressed and fixed? If not, what still needs to be done to fix the problems?
2. Consider all aspects of the drawing and point to areas that need improvement or that are working well in each comic. Look at composition, perspective, anatomy, proportion, and backgrounds.
3. Have some tracing paper handy and if you want to suggest a change to a certain drawing, you can place the tracing paper over the drawing and show everyone what you mean.

Now, either get to work making corrections and revisions to your pencils or make sure you have good notes on what you want to change later. It's a good idea to make notes directly on the page in pencil or on Post-it notes.

Ronin

Start by leaving the work aside for a few hours or days and then posting it on a wall and standing back to get a new perspective on it. You may also want to check the website, www.dw-wp.com, for samples of other students' pencils with critiques. ■

8

"A month of Sundays" inking

Put your inked Sunday pages on the wall. Spend a bit of time thinking about the different solutions people came up with to ink their panels.

Talking points

- Did they use a lot of lines?
- How did they use solid black?
- Are their compositions legible and interesting?
- Is there a visual rhythm and balance to the pages?
- Try to describe the effect of some of the choices other people made.

Stand back at least ten feet from the pages. Now squint your eyes a little to look at the pages out of focus. This technique will give you a better sense of the overall design of the page without regard to the content.

- Do the pages have a pleasing, well-balanced design, or do they look disorganized?
- Is your eye led clearly through each panel and into the next?

Don't be concerned with deciding whether these comics are great or not. Go easy on yourselves: This is probably *someone's* first comic ever, if not yours, right? Talk to your colleagues about what was difficult and what was fun about doing this comic and what areas you think you need to improve on for your next assignment.

Ronin

Use the same techniques described above to look at your own page. Check the website, www.dw-wp.com, for other examples of the Sunday page to compare to yours. ■

9

Thumbnails for a six-page story with a narrative arc

Tell the group your story, and be attentive to your audience. Watch your colleagues' reactions. Do they laugh at the right moments? Do they look surprised at your story twists? Are they zoning out? If so, when? Notice all of these things and take notes.

As you listen to each story, try to grasp who the protagonist is, what he or she needs, and why. Then try to understand how he or she goes about getting it. You'd be surprised how often these basic elements are missing in a story pitch. See if you can understand the story well enough to pitch it back to the author. "Let me get this straight. You say you've got a farmer with failing crops, and a fertilizer salesman comes by...." Take notes on moments you like, and parts you think need work, but reserve your comments until the author is finished speaking.

Talking points

- Sum up the story in one sentence.
- Identify the spark.
- Identify the protagonist.
- What does the protagonist want?
- Does the protagonist get it?
- How does the protagonist go about putting his or her life back in balance?
- Title the scenes in the story ("The Salesman Returns").
- Does each scene have a purpose? Name the purpose of each scene.
- Is there enough material to fit into six pages? Is there too much? How can the story be scaled back or expanded to fit better? If the story won't fit, talk about whether or not the author needs to start fresh.
- When you look at the sketches and maps the author drew, is the visual world convincing? Complete? Interesting? What other preparatory materials does the author need to draw?

Take a quick look at the thumbs-in-progress, but don't get too heavily into them, since the thumbs still need to be finished. You'll look at them more attentively in the next chapter. If you have any specific questions or problems with your thumbs, bring them up with the group.

Ronin

You can of course do this alone; writers do all the time. But if you possibly can, get feedback, no matter who from. Ask your critiquer to take notes on what they like and don't like about your story, but to reserve comment until you've finished talking. While you talk

10

Finish your short story thumbs

about your story, are your critiquer's eyes glazing over? If so, notice the moments when this starts to happen. Does your critiquer get your story? Can your critiquer repeat back to you your basic idea once he or she has heard the whole pitch? ■

Post your thumbs on a wall and look at them as a group. If you are in a large group, you may want to subdivide into smaller groups of four or five.

Talking points

First discuss your colleagues' work:

- Does the pacing of the stories make sense? Is the action all bunched together in one section in any of the stories, or does the tension build steadily?
- Are there too many things (or not enough) happening in any of the pages?
- What is the ratio of scenes/incidents to the six-page limit in the stories? Do any of the stories feel padded or overstuffed?
- Consider the structure of the finished stories. Were suggestions incorporated from the critique of the pitch and of the first half of the thumbs? Can you identify the protagonist, the spark, the crisis, and the resolution in the stories? What are the obstacles that stand in the protagonist's way? What does she do to overcome them? Can the action be made clearer? More engaging?
- Is there a resolution to the stories, and are these resolutions convincingly final? This can be the toughest part of the assignment, so spend some time on it.
- Be on the lookout for cliché. If you see a tired phrase, pose, or idea in someone's story, discuss how it can be altered or replaced with something fresh. Discuss what kinds of research the authors should do. Think of at least two routes to follow with research, even for the least reality-based stories.

Now examine your own work more closely:

- Have someone (who doesn't already know the story) read your thumbs and then tell you what happens. Listen closely for when they hesitate or miss stuff. Don't correct your reader! The important thing is to learn where you aren't being clear.
- Make a literal narrative arc chart, and put the plot points on it, looking for holes in the structure.
- Read your dialogue out loud, at full volume, in front of the group. If you're getting laughs when it's supposed to be serious or stone faces when it's supposed to be funny, you need to rewrite.
- Consider your page compositions. Is there a regular grid, or is each page different? Should the page layouts be more similar, say, following the same nine-panel grid? Or do the pages need more variety in their layouts? Are there ways in which the

page compositions can be adjusted or rethought to tell the story more effectively?

- Look at the composition of individual panels and think about how to strengthen the legibility or drama of a given panel. Are there places where the panel borders should be in a different style or be removed? For instance, are there panels that might work well with circular borders?
- Cut at least four panels.

When you're done with your critique, take notes on all of the suggestions. Remember that the whole point of thumbnails is that they're easy to rework, so don't hesitate to throw out a page or two based on the critique—you'll thank yourself in the long run.

Ronin

The toughest thing about doing this by yourself is getting distance from your own work and making yourself dive back in. Focus especially on the last four points above to get yourself going. If you can find someone to read your story and summarize it back to you, do that.

✳ Turn the page for critique guidelines for your character pin-ups.

Character pin-ups for your short story

Post your character designs (three designs for each character) on a wall, along with the two-to-three-sentence summation that you wrote after developing their backstory. Read each description/summation, and then look carefully at the three proposed designs for that character.

Talking points

- For each character, look at how each design differs from the others. How do details of dress, posture, facial features, and expression affect how the character "reads"? Describe your reaction to these characteristics.
- Which aspects of the proposed designs seem to fit best with the description? Which aspects might enrich the description by being unexpected? Try to verbalize what certain details evoke for you.
- Would you recombine various aspects of different designs to make a stronger final design?
- Would you add or modify characteristics to improve the final design?
- Discuss how developing a character's backstory helped you make decisions about the designs you came up with.
- Watch out for cliché: If a character design fits too perfectly with the description, that can be a problem too.

Using the feedback from the critique, recombine and modify your character designs into a final design for each character. Post these designs above your desk to refer to as you work on your story.

Ronin

Ask yourselves the same questions as above. You might also share these designs with a friend and ask for feedback. There's nothing particularly comics-centric about these ideas. Examples of other students' work, with commentary, are on the website, www.dw-wp.com. ■

11

Revise your six-page story thumbs and start penciling

You've just fully revised your thumbs based on an intensive critique. Run your revisions by the group, especially if you still have questions about certain sections. Then give your thumbs one more complete read-through and start laying out your pages. If there's anything you're struggling with, ask for help.

Take a few minutes to look at your colleagues' penciled pages. Consider page and panel compositions, clarity, originality of images, and accuracy of drawing. Highlight areas that you think need more work, and praise parts that are going particularly well.

Also, look at the preparatory sketches and photo reference for each story. Are they useful? Do they need more work?

Ronin

Post your pencils on the wall as you finish them, and take time to stand back and get a fresh look at them. Try squinting, or turning the pages upside-down to get a different perspective. If you're having trouble with your pencils, look back to Chapter 5, and try some of the tips there to overcome your difficulties. ■

12

Continue penciling your six-page story

Post your pencils on the wall and take a good look at them as a group. Since you've already looked at your group's thumbs pretty thoroughly, this is the time to really look at the drawing: Is it effective? Is it clear?

Talking points

- Identify two establishing shots in each comic, and look for where close-ups were cut.
- Look at your colleagues' revised compositions, and see whether you think they have improved. Make some new suggestions for other changes and improvements.
- Identify where research and photo reference were used. Can you tell without being told?
- Share with the group the names and functions of the parts of an object you researched for your story.
- Consider the overall style and visual approach of your colleagues' art—is it realistic? Cartoony? Expressionistic? With the style in mind, make suggestions for improvement in areas like anatomy, perspective, exaggeration, and distortion.

Ronin

Review your pages with the above points in mind. In particular, take another look at your research materials and see if you can flesh them out. Also, try to assess your new compositions critically. Did you go far enough? ■

13

Finish your pencils of your six-page story and begin inking

Post the rest of your pencils on the wall, and go over them as a group with the same things in mind as you did last week. Look especially for clarity, and good use of reference materials.

Now, take a look at the inking-in-progress. Everyone should have lettering and panel borders inked, and at least some of the linework. Take a critical look at the lettering of the comics. Does any of it need cleanup? Mark places that need to be redone. If you find misspellings, mark those also (wait to actually do the corrections until you've finished inking). Are the word balloons well-formed? Is there enough space between balloon edges and the words? How about the linework? Is it bold enough? Will it reproduce well? Point out any problems to your colleagues.

Everyone should make a few photocopy reductions of their inks-in-progress to test lettering size and line weight. You can also use these copies to test out black spotting and other inking ideas before committing to them on the real art.

Ronin
You, especially, should try out the photocopies. You'll learn a lot from copying your work at this stage. Also, be sure to have someone read your work for spelling and grammar. ■

14

Finish inking, make corrections, and reproduce your six-page comic

Congratulations! Finishing a six-page story is a real achievement.

Post your reduced photocopies or printouts of scans, not the original pages, on the wall. As a group, stand back from the reproductions and admire your handiwork. Now step about ten feet away, and squint a bit. Compare the abstract appearances of different art styles, and how they carry the information over a longer distance. See what you like about your colleagues' work from that perspective, and what might need improvement.

Now move closer. Try to define what you see in these comics: Talk about the textures, shapes, lines, etc. Look at compositions of individual panels and pay attention to how the blacks and grays affect the reading of the panel.

Look for elements that still need correction and cleanup, and point these things out to your colleagues.

Ronin
Do the same process with your own work. We've also posted complete comics on the website, www.dw-wp.com, for you to compare and contrast with your own work. ■

Appendix C

Story cards

Materials

index cards in four colors and a marker

Instructions

Use a different color index card for each category below (i.e., vocations: pink; personality traits: purple; etc.).

Write one item from the list on each card. You can also make up your own items. Keep the cards in four separate piles.

OCCUPATIONS

- artist
- gardener
- building superintendent
- tugboat captain
- spy
- scientist
- secretary
- union organizer
- toll booth employee
- construction worker
- architect
- tailor
- mortician
- actor
- hippy
- hairdresser
- chef
- police officer
- accountant
- pharmacist
- parent
- priest
- mafia boss
- marketer
- prime minister
- mime
- bum
- time traveler
- magician
- fast-food restaurant worker
- mathematician
- exterminator
- bookstore employee
- fashion designer
- soldier
- bartender
- businessperson
- teacher
- newspaper publisher
- taxi driver

- used car dealer
- fishmonger
- opera singer
- wrestler
- brewer
- cowboy/-girl
- salesperson
- street vendor
- flamenco dancer
- student
- candy manufacturer
- lawyer
- philosopher
- bus driver
- doctor
- clown
- farmer
- writer
- punk
- jazz trumpeter
- orchestra conductor

PERSONALITY TRAITS

- loner
- charismatic
- crybaby
- braggart
- uptight
- short-tempered
- weepy
- serious
- vulnerable
- sarcastic
- giddy
- tough
- flirtatious
- deceitful
- caregiver
- overbearing
- confused
- dorky
- highly intelligent
- savvy
- shy
- stupid
- flaky
- funny
- sad
- humble
- suck-up
- cautious
- irritable
- impatient
- logical
- angry
- sly
- snobbish
- troubled
- bossy
- busy
- distracted
- crazy
- emotional

- dour
- witty
- wimpy
- sympathetic
- obnoxious
- honest
- cheesy
- happy
- arrogant
- depressed

PHYSICAL TRAITS

- very ugly
- very tall
- eyepatch
- missing two fingers
- backwards baseball cap
- beautiful/handsome
- bad skin
- very short
- wears wig/toupee
- underweight
- very old
- wears platform shoes
- big ears
- large teeth
- really big smile
- has a limp
- wears glasses
- extremely blonde
- very young
- unusual voice
- wart on chin
- carries a briefcase
- sickly
- slouches
- overweight
- dreadlocks
- wears "traditional dress"
- expressive eyebrows
- long legs
- dirty
- big eyes
- long, delicate fingers
- wears monocle
- wears sunglasses
- in uniform
- well-groomed
- different hair every day
- bald
- long nose
- pipe

- pierced eyebrow
- unusual hat
- scar on face
- tattooed face
- colored contacts

STORY SPARKS

- suitcase full of money
- a surprise visitor
- a lottery ticket
- a contest
- a death in the family
- a phone call
- an abandoned pet
- rent is due
- a misunderstanding
- an illness
- something or someone missing
- a summons
- an accident
- an inheritance
- a funny smell
- a new pet
- an exam
- a birth
- a shocking discovery
- a gun
- a mysterious box
- a purse
- someone asks a favor
- being followed by someone
- visit from a previously unknown relative
- a sudden change in behavior
- an abandoned baby in a basket
- a piece of dangerous information
- a drunk rich guy
- a magic lantern
- an escaped prisoner
- a new job
- a stolen car
- a practical joke

- a secret admirer
- getting lost
- a visit to hometown
- a toy gun
- a free trip
- a diamond ring

Appendix D

Comic book book report

One of the things that will help you grow quickly as a comics artist is to become an attentive comics *reader*. Here are some ideas as to how to go about learning that skill.

Pick out a work to read closely. You might choose a one-page strip, a short comic, or a whole graphic novel. Pick a work simply because it appeals to you, or pick one that seems complicated or challenging. A work might also display some quality you want to learn more about, like a writing style or compositional approach.

OVERALL APPROACH

Read the work. Read it once through normally, then read it again with paper and pencil handy. Anytime something jumps out at you—a word, an image, even the quality of a line—write a note to yourself about it. Later, you will need to choose a section to look at even more closely, so get a head start by taking notes.

THE STORY

Ask some questions about the story. Start by writing down a one-sentence summary of the plot. Then go into more detail by asking yourself the following questions:

Who is the main character or protagonist? Is there more than one? How can you tell that a certain character is the protagonist? What does that character want? Does he or she undergo any change in the story? What?

How much time passes in the whole story? Is time evenly paced, or are there big temporal gaps? What techniques does the author use to control pacing? Identify a slow-feeling section and one that moves very quickly.

Is there a narrator? What is the tone or emotional tenor of the narration? Can you tell who the narrator is? Is the narrator reliable? In other words, is the narrator always telling you the truth about what's happening?

Choose one scene and describe it carefully: What does the protagonist want when he or she enters the scene? What does the protagonist do? What happens? Does the protagonist achieve the goal of the scene? Is this scene related to the larger goal or desire that drives the story forward? Describe the pace of the scene. Identify the panel transitions used in a sequence and think about how those transitions contribute to the pace and feeling of the scene.

THE ART

Get a few sheets of tracing paper. Lay one sheet over a page of the work you like, and trace the path your eye wants to follow. On another sheet, trace the abstract visual shapes that jump out at you. Trace and fill in areas of solid black on a third sheet. Another overlay could show placement of text, to try to understand how text affects the flow and reading order of the story.

Copy one or more panels in pencil. Try inking it as much like the original as possible. You could also try to create your own different version of the same panel.

Describe the quality of the linework. Is it scratchy or fluid? Busy or clean? Try to guess which inking tool the artist has used where, and how large the original artwork might be.

Describe the "camera angles" the artist used, and how far from the action he or she has placed us. Is there a sense of deep space, or is the space very flat? (Look at the sidebar, "Film terminology and comics" in Chapter 11 for more film terms.)

Does the visual style ever change in the story?

Describe the lettering. Was it done by hand, or is it a mechanical font? Is it well-integrated with the art? Are there different lettering styles for different characters, or for dialogue and narration? If there are different lettering styles, what kinds of meaning do those styles add to the work as a whole?

Reread Chapter 6, "Elements of page design" and Chapter 11, "Panel composition," and apply those concepts to one or more pages of the work you're analyzing. In particular, you might look for and talk about:

- black spotting
- panel size as a pacing technique
- picture elements pointing to and/or framing important items
- guiding the reading path with picture elements
- canted angles
- use of the formal aspects of the page for storytelling (e.g., characters interacting with panel borders and so on)
- negative space
- placement and use of sound effects
- placement and use of word balloons and narrative boxes
- weight and texture of panel borders and/or gutters
- asymmetrical composition
- angled panels, vignettes, and other unusual panel shapes
- bleeds
- emanata (including action lines)
- gray tones and balance with black and white
- color
- visual rhythm

FINALLY …

Write up a page-long essay on the comic. Describe the page layout, the story, the dialogue and the drawing style, and give your own response to the comic as a whole.

If you do this activity with a group, take turns presenting your reports to the others. Illustrate your presentation with your tracing-paper diagrams and drawings and with pages from the work you're talking about.

Appendix E

Making minicomics

WHAT EXACTLY IS A MINICOMIC?

The word "minicomic" does not mean "small comic." The "mini" is a reference to a relatively small print run, and to the fact that minis are produced by an individual, not by a professional printer. A professionally printed comic with a print run of 3,000 that is 4" x 5" is not a minicomic. A photocopied comic with a hand-printed cover that's been folded and stapled by the artist even if it's 8.5" x 11" is a minicomic.

WHY MAKE MINICOMICS?

A comic is really not a comic until it is reproduced. Everything you do on your original art needs to be done with reproduction in mind. In this way, comics are similar to etchings or silkscreens, where the original is the print, not the plate or screen you print it from. So in order to start to understand how your comics look and read to someone else, you must gain distance from the work, and you must see it in its intended form, reproduced via printing.

Another reason to make a minicomic is to see how the pages look juxtaposed to each other, and feel how the story works when you turn your pages.

The first time you see your printed minicomics, you'll be shocked, amazed, and proud. It's a great thing to do.

Furthermore, when you create a minicomic, you'll have your work in a neat package that you can give to editors as a portfolio (they will always want to see how you handle storytelling over multiple pages); to artists you admire for possible feedback (sometimes they'll write you back) or just to let them know you like their work; and to friends, family, and fellow cartoonists. You can also sell your minicomics to people you know or, sometimes, through your local comics or record store, to total strangers. It's essential as a cartoonist to get people to be aware of you and your work. That's how you eventually get published by someone other than yourself.

WHAT SHOULD YOU INCLUDE IN YOUR MINICOMICS?

This part is very much up to you. You can put a short story or several in there, drawings and pin-ups, or a serialized part of a longer story. You can even put prose stories, essays, or pictures of yourself in there. Whatever you like. However, it bears remembering that most people who read your comic may only ever see one issue. That's just how it often works out. So if you put a serialized part of your magnum opus in there, your readers may have no idea what's going on, and thus not be interested in it. Just keep that in mind. Also, anthology editors who see a short story they like in the mini you give them might just offer to reprint it in their book. You never know—it could happen!

You should start by including the stories you completed for this course in your minicomic. Then you can add more material, if you want.

MINICOMICS FORMATS

Minicomics can be any size, shape, number of pages, or format you want, taking into consideration a few limiting factors: money, paper size, time, paper shape, and more money.

Let's get to basics first. Any piece of paper, any size and shape, obviously, has two sides.

Grab a sheet of scrap paper and try this: If you fold it in half, it will have...

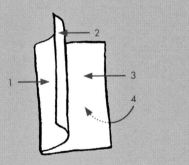

... four sides. If you start by folding standard office paper (which, in the USA, is 8.5" x 11") in half the long way, you get a 5.5" x 8.5" booklet. This is the most common and cheapest format for a minicomic, and it's called "digest size" (it's the cheapest because the paper is cheap and photocopies on it are usually the cheapest available at any copy shop).

And if we fold that four-sided paper a second time, it will have...

... eight sides. This eight-sided paper is 5.5" x 4.25", and is possibly the second-most common format used for minicomics. It's called "minicomic size." Take note that you will have to trim the folded edges in order for the comic to be read. Since you can fit more pages on one sheet of paper, you may find this format even cheaper than digest size, but the drawback is that this format entails the extra work of folding and trimming.

You can even fold the paper a third time, though this is pretty much the limit. Three folds will create...

... 16 sides.

You can already see how the folded paper looks something like a booklet. You can also see how the shape and size of the paper you originally folded will be reflected in the final shape and size of your booklet-to-be.

Without getting too monotonous about it, remember that beginning with a different size sheet of paper will create different size minicomics. If your original paper size was "legal size" (which is 8.5" x 14"), the folded-once-the-long-way version would be 8.5" x 7", and the folded-once-the-long-way version of "tabloid size" paper, which is 11" x 17", would be 8.5" x 11". And so on.

Format doesn't stop there. The possibilities are limited only by your imagination. Whether your minicomic is folded up like an accordion or a road map, it's still a minicomic.

Here are some examples of minicomics that make use of non-standard folding. You can experiment as much as you like and come up with your favorite shape and size.

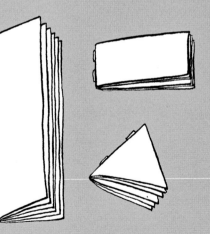

DECIDE ON FORMAT

Keeping in mind the possibilities discussed above, the first thing you have to do when you are considering making a minicomic is to decide what size and shape it will be. You can do this one of two ways.

If you already have a bunch of finished comics (like the ones you finished for this book), simply decide what size and shape of minicomic they will fit best once they're reduced in size. Probably you'll use digest size for your first mini, though if you've been working in a 3:4 ratio, you may want to use legal-size paper folded in half for slightly wider pages.

Alternately, you can decide in advance on the shape and size of your mini and draw new work to fit. To do this, figure out the page size of your mini by making a mock-up blank book (see below for more on mock-ups), measure the pages, and then use your proportion wheel to size those measurements up 125 to 200 percent. Draw new comics at that size.

DECIDE ON CONTENT

OK, so you know what shape and size your mini will be. Now you need to decide which work you'll put in there.

If you are using the digest format, or any size of paper folded once, you will have to fill pages in multiples of four, since each sheet of paper folded in half has four pages. If you are using the minicomic format, you will have to fill pages in multiples of eight.

Make a list of what you want to put in your minicomic, and make sure you have the right number of pages. Make sure to count contents pages, empty pages, title pages, ads, or anything else you decide to include. Add and subtract pages until it comes out to a number that will work. Factor a front cover (FC), back cover (BC), inside front cover (IFC), and inside back cover (IBC) into your page count.

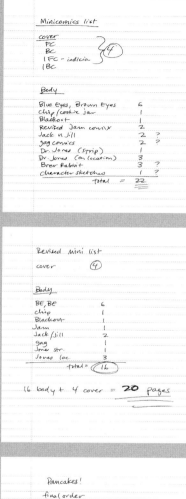

These pages come out to a total of 22, which isn't a multiple of four, so this list will have to be added to or cut down. The artist has marked a few possible cuts.

After careful revision, the page count for the body is down to 16 pages. Those plus the FC, BC, IFC, and IBC come to 20—a multiple of 4.

After the artist knows what to include, he or she needs to figure out in what order everything will fall.

Indicia

In addition to your stories, make sure you make room for indicia of some kind. Indicia are the basic legal and personal information you want to have in your minicomic. At the minimum, you should include your e-mail address and a copyright notice of some kind. (Copyright is a complicated subject, but for now just be aware that including that C in a circle is an important step in asserting your ownership of your work.) You might also want to add your street address, information about your stories, thank yous, whatever. This information is commonly found on the inside front cover or back cover.

The most basic indicia would look something like this:

All contents © 2008 Joe Schmoe
shmoe @ joeschmoe.com

DECIDE ON ORDER

Now look at your list and think about the order in which everything will fall. Remember some basics about the reading experience: In the Western tradition, people expect new stories to start on the right-hand page (also known as the "recto"), which is always odd-numbered, and end on the left hand page ("verso"), which are always even-numbered. If you can respect that tradition, your readers will thank you.

Note that page one of your comic is NOT the front cover, it is the first recto of the booklet. Many artists use the inside covers and even the back cover for more comics, but you can also use that space for your copyright notice or other kinds of text, or you can leave them blank.

Using photocopies of your stories, try out different page orders and think hard about how the book will flow best. It will probably take several tries to settle on an order.

COVER DESIGN

Now that you've made the big decisions about shape, size, content, and order, it's time to think about presentation. It goes without saying (but it's not a bad idea to say it anyway) that the cover is the part of your minicomic that people will see first. If your cover does not attract their attention, your art on the inside will not have a chance to do so. . . . Your potential reader will be long gone.

There are an incredible number of options available to you to make your mini stand out from the crowd. In fact, they are limited only by your imagination, budget, and time available. But these are not idle concerns. If you design a cover that takes you 20 minutes to prepare for each mini, you are going to get very tired, very fast. As a result, you may end up making only a few copies of your mini, when you might have intended to make a huge pile. Similarly, if you design a cover that involves expensive materials, you may not be able to afford to make many of them, you may need to charge too much for your minis (making them hard to sell), or you may find it difficult to make yourself give them away. You have to strike a balance among these factors.

Here are just a few easily repeatable ideas you can use to get started on your cover design:

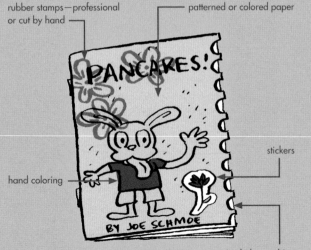

rubber stamps—professional or cut by hand

patterned or colored paper

hand coloring

stickers

creative hole punching

MAKING A MOCK-UP (NOT A SCREWUP)

What's a mock-up? It's a simple working plan of your minicomic that will help you paste up your master copy in the correct order and orientation. Making a mock-up will help you catch planning mistakes you've made before you make lots of photocopies and have to pay for them all.

We cannot emphasize this enough: Making a mock-up is a *vital* step. You *must* make a mock-up of your minicomic if you don't want to make an expensive screwup.

Mock-up for a mini

Materials
- scrap paper, enough for all the pages of your book
- a fat marker
- your list of what goes in your comic

Instructions

A mock-up is a deceptively simple thing. Start with your list. Let's say that you've decided to make a 20-page digest-sized minicomic, including 16 pages of comics, a FC, a BC, a blank IFC, and the indicia on the IBC.

Twenty pages in a digest-sized mini … how many sheets is that? There are four sides to each folded sheet, so that makes five sheets.

Take five sheets of scrap paper, fold them in half, and you've got the basis of your mock-up.

Label each page with your marker: FC, IFC, page 1 through page 16, IBC, BC.

Next, refer to your master list and label in a bold, visible way what will go on each of the pages. If you are planning to include a multiple-page story, make sure you note which page of that story goes on which page of the mini (i.e., page 12 of your mini may have page 4 of your six-page story from this course). In other words, the mock-up page should say both "page 12" and "Six-pager, pg. 4" on it. If you don't use the full titles of your stories, make sure your notation system for the titles is something you'll understand after you put this away and come back to it.

That's it!

To use your mock-up, first unfold it and lay it flat. Pick up the top sheet of paper, the one in the center of the mini. Notice that pages 8 and 9 are written on top, but if you flip the top sheet over, pages 10 and 7 are next to each other.

It's very confusing, really almost impossible in all but the simplest minis, to try to figure out these juxtapositions without the help of a mock-up, particularly if you're making a comic that requires more than one fold per sheet of paper. Here's what an 8-page minisized mock-up looks like.

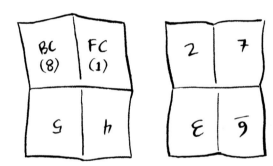

You can see from this that the pages aren't even all facing the same direction. ∎

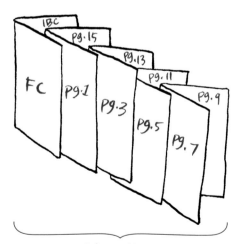

5 sheets = 20 pages

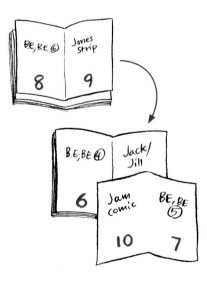

When we reach "Making a master copy" (on the following page), you will see just how useful your mock-up is.

PHOTOCOPYING YOUR WORK TO FINAL SIZE

NB: *If you're scanning your art and pasting it up on a computer, you can ignore the following three paragraphs.*

If you've never actually used your proportion wheel since we taught you about it, now's your chance (refer back to Chapter 14 if you've forgotten how the little monster works). You know the size of your art, and you know the size of your minicomic. Don't forget to subtract borders where the copier won't print. You can mark your reduction percentages on the back of your original pages as you figure them out. When you actually get to the photocopier, you may find out that you can't photocopy your artwork down as small as you need to in one go. You might have to do it twice. Better bring your proportion wheel to figure out your reduction percentages again! Once you have the art the size you *think* you need, check it against the physical page (that is, your mock-up).

Remember that all photocopiers are not created equal. Move around the copy store, try the different machines, and use the best one, even if you have to wait for it. Self-serve machines are the cheapest, but they are also the most messed up, so you're sure to find some really bad ones. If you need help, ask one of the nice workers to teach you how to make double-sided copies. Ask them to demonstrate if you are still confused. Bring more money than you think you need because you will screw up somehow. We all do.

You can pay the people behind the counter to do your copies for you, but remember that you're paying a surcharge for that, and that they may not understand what you want them to do, and so you may have to fight with them about it if they screw up the job (happens more than you'd think). Mostly, at this stage you will want to make the copies yourself, so you have control over how the masters come out. But when it comes to reproducing the whole minicomic, paying someone to run the copies for you is the easiest and most relaxing way to make comics, if you can afford it.

Finally, read Ron Regé's great essay on this subject in *Re: A Guide to Reproduction* as listed in Chapter 14, "Further reading."

MAKING A MASTER COPY

You've got your artwork scaled properly and photocopied to the final size of your book (and you've cleaned up the photocopies with correction fluid (it's fine to use on photocopies)—don't fail to do this step, or you'll leave grubbiness and shadow lines on your master!—and you've got a mock-up of your minicomic. The next stage is creating a master copy of the whole minicomic that you will use for all of your reproductions. Another word for "master copy" is "pasteup," for reasons that will soon become obvious.

You can create your master copy/pasteup either using olde-styley scissors, tape, paste, and correction fluid or doing it on your computer. Let's talk about both methods.

Traditional pasteup

To do an old-fashioned pasteup, here's what you'll need:

- your mock-up
- your photocopied-to-size artwork
- as many clean sheets of paper as you planned for your minicomic (and, of course, the same size as you planned)
- a black pen or marker
- correction fluid
- scissors
- tape or paste (see Chapter 8 sidebar, "Making corrections stick")
- a ruler wouldn't hurt, either

First of all, set your mock-up out in front of you, open it to the center, and get a clean sheet of paper to start your master. Following the numbering on the mock-up, carefully trim and neatly paste or tape down the corresponding pages of your photocopied-to-size artwork on the master page.

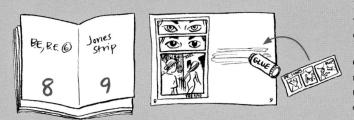

Then, flip the master and the mock-up pages over, and paste or tape the pages of your art that correspond to the back side of your mock-up page onto the back of your master page. Use a ruler, keep it neat.

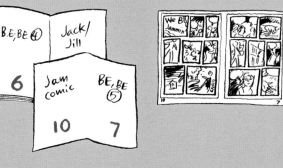

Proceed thus through your entire mock-up and master so that when you finish, you have a stack of pasted-up master copies that correspond exactly to the order you figured out with the mock-up.

Gently fold the master sheets (without creasing them) and page through the "book" double- and triple-checking that everything is in the right order. *This is one of the stages where mistakes most commonly occur. Check three times!*

Now, go through the master copy, clean up blobs and marks with correction fluid, and blacken in grayish bits. Remember that everything that is on these pages will be on your final mini. Be picky about it.

"Pasteup" on the computer

If you know how to use QuarkXpress, InDesign, or Photoshop® and have access to a good scanner and printer, you can "paste up" your master copy on the computer (in this case, you won't need to make reduced photocopies of your pages beforehand). Basically it's the exact same process; you still need a paper mock-up in front of you. You just don't need to cut and paste physically.

Note: Make sure your scans are good enough for print. Follow our instructions in Chapter 14 to make sure your scans make the cut. If you want to use graytones, try to stick to three values at the most (i.e., 30 percent, 50 percent, and 70 percent), since a photocopier will exaggerate them just like hand-applied gray tones, making darks darker and lights lighter.

You are not immune from triple-checking just because you are using a computer. Just the opposite, probably. Print your master out using high-res settings (you want the best possible printing at this stage: you might want to have your master output at a photocopy shop, using a color printer on a black-and-white setting), stack it like the mock-up, and gently fold it into "book" shape, without creasing the pages. Flip through your master and make sure it all looks just right. If you like, you can use paper clips to remind you which sides should be back to back.

PRINTING FROM THE MASTER

Whether you paste up by hand or in the computer, you'll have to decide whether you want to print your mini directly from the master copy or create an easier-to-use double-sided master. The advantage of the first choice is that your final mini will be one generation closer to your original art. The disadvantage is that your master will be more delicate, which means you can't use the automatic paper feeder on the photocopier when making your minis (which means more opportunity for messing up the copy order and orientation). The advantage of the second method is that you can run the master through the automatic paper feeder, do double-sided pages, and collate the pages. If you use the second method, be sure to check for shadows or dark lines on the second-generation copies from the edges of the pasted-up pages, and cover them up with correction fluid.

Computer pasteup people have the same option as the Olde Fashioned pasteup people, above. Either make copies directly from the prints you made, or make one set of double-sided photocopies, and use those as the master.

Whichever method you use, this is your last chance to check your master before you spend the big money!!

PRINTING, COLLATING, FOLDING, AND BINDING

Photocopying

The biggest problem you will run into at this stage is copying the wrong pages onto each other, or in the wrong orientation (i.e., one page may end up upside down). Now is not the time to quit checking your work! Check and triple-check that you have the right pages backed with the right pages, the right way around. Check the copies against your mock-up.

Collating

When you finish copying your pages, often they will be in separate stacks of all the same pages, instead of collated sets. Here is a method for collating in an organized manner:

1. Clear off a large table or make a clean spot on the floor. Arrange the pages into piles that form an assembly line as illustrated above. Your center page should be on the left, center spread facing up, then the next page out, and so on.
2. Place the stack of covers, covers facing down, on the right.
3. Pick up a center page, lay it on the next page, and pick one of those up, and then the next, until you pick up a cover on the bottom of your little pile.
4. Stack the complete pile horizontally and then stack the next one vertically to keep the piles separated and make picking up the piles for folding and binding easier, as illustrated.

Folding

OK, OK, you all know how to fold paper. But there are better and worse ways to do it, and if you want a professional-looking publication, it's wise to use good folding technique. For best results, use a bone folder (find it in an art supply store in the book-binding section—it's real bone, although you can also get a plastic version) to get a crisp fold for each booklet.

You can also use any similar straight and hard object, like a pen, though the bone folder makes the job a lot easier. Jog up your book so that the corners match up perfectly, then create a crease with your bone folder from the middle of the spine out to the edges.

Crease from center outward.

Binding

The easiest way to bind a comic is to staple it. There's not a lot to explain about that, except for the fact that most minicomics (digest-sized and up) are too wide to fit into a standard stapler, so you have to use a specialized one. There are two types. One is a long-neck stapler, which is quite cheap, but also hard to use accurately, since it's basically just a regular stapler with an extension on the back and an adjustable stop. Better, but also more expensive, is a "saddle stapler," which has a shaped base to put your folded booklets on. You can often use the long-neck or saddle stapler for free at the photocopy shop where you've copied your pages.

long-neck stapler

saddle stapler

Two stapling tips: Make sure the fold of the spine is centered directly under the spot where the staple points come out, and make sure to use at least two staples, even on small minicomics, since one staple will not give you sufficient stability. Finally, remember that the teeth of the staple should be on the inside of the comic.

Stapling isn't your only option; there are endless possibilities for binding. The more creative you are, the more your book is going to stand out in the crowd. Some simple ideas come immediately to mind:
- Run your comics through a sewing machine.
- Use a hole punch and yarn.
- Use manufactured binding systems like sliding metal straps, brass buttons, and other connector things that you can get at office supply stores.

TIME TO CELEBRATE

Make enough comics for everyone in your group, and at least a few extras to give away or sell.

What you have in your hands today may very well be your first publication. This is a real accomplishment, and the first step on the road to creating many more comics! Even if you don't feel that you want to become a professional, making minicomics can be a satisfying creative endeavor that you can continue doing indefinitely. And if you do want to become a pro, you've just created your first portfolio. This is a great day: You are a published cartoonist.

Things to do with your mini
1. Trade comics with all of your colleagues who accompanied you through the work in this book. Start your minicomics collection with work by the cartoonists you know best!
2. Donate your minicomic along with a set of the whole group's books to your school library (if you are in school), or local public library for their "rare books" collection. Help your library start a minicomics collection, and think about leading groups of people who want to learn how to do it themselves.
3. Send your minis to professional editors of your favorite comics. Look up their addresses in the books or on the Internet.
4. Send copies to your favorite artists. They may not respond, but they will see your work. You can always send mail to artists care of their publishers, if you don't have a more specific address. Publishers do forward the mail artists receive.
5. Sell copies to your local comics or record store, or leave them on consignment (which means you leave them there—get a receipt—and when they sell them, you can come back to collect the money).
6. Go to a comics convention and sell, give away, and trade your minis.
7. Sell your minis on your website. You have to set up a website for this to work, obviously. Which is always a good idea. ■

Bibliography

CHAPTER 1

Eisner, Will. *Comics and Sequential Art*. Tamarac, FL: Poorhouse Press, 1985.
ISBN: 0961472812

———. *Graphic Storytelling and Visual Narrative*. Tamarac, FL: Poorhouse Press, 1996.
ISBN: 0961472820

Feazell, Matt. *ERT! Not Available Comics*. Livonia, MI: Caliber Press, 1995.

Keavney, Martha. *Badly Drawn Comics #7*. Jersey City, NJ: Martha Keavney, 2000.

Kunzle, David. *History of the Comic Strip. Vol. 1, The Early Comic Strip: Narrative Strips and Picture Stories in the European Broadsheet from c.1450 to 1825*. Berkeley, CA: University of California Press, 1973.
ISBN: 0520018656

———. *History of the Comic Strip. Vol. 2, The Nineteenth Century*. Berkeley, CA: The University of California Press, 1990. (out of print)
ISBN: 0520057759

McCloud, Scott. *Making Comics: Storytelling Secrets of Comics, Manga, and Graphic Novels*. New York, NY: HarperCollins, 2006.
ISBN: 006078940

———. *Understanding Comics: The Invisible Art*. New York, NY: HarperCollins Inc., 1993.
ISBN: 006097625X

Porcellino, John. *Perfect Example*. Cambridge, MA: Highwater Books, 2000.
ISBN: 1896597750

Rees, David. *My New Fighting Technique is Unstoppable*. Chapel Hill, NC: ERP-13 Press, 2002.
ISBN: 0615120229

Simmons, Shane. *Longshot Comics Book 2: The Failed Promise of Bradley Gethers*. San Jose, CA: Slave Labor Graphics, 1997.

Walker, Mort. *The Lexicon of Comicana*. Port Chester, NY: Museum of Cartoon Art, 1980. Reprint. Backinprint.com, 2000.
ISBN: 059508902X

CHAPTER 2

Addams, Charles. *Chas. Addams Happily Ever After: A Collection of Cartoons to Chill the Heart of Your Loved One*. New York, NY: Simon & Schuster, 2006.
ISBN: 074326777X

Arno, Peter. *Peter Arno*. Reprint ed. New York, NY: HarperCollins, 1990.
ISBN: 0060972971

Henderson, Sam. *Humor Can Be Funny!*. Aurora, CO: Dodecaphonic, 1996.
ISBN: 0964932903

Kliban, B. *Never Eat Anything Bigger Than Your Head & Other Drawings*. New York, NY: Workman Publishing Company, 1976.
ISBN: 0911104674

Larson, Gary. *The Complete Far Side*. 2 vols. Kansas City, MO: Andrews McMeel Publishing, 2003.
ISBN: 0740721135

Mazzucchelli, David. (Untitled strip), *Snake Eyes: Post Popeye Picto-Fiction*. No. 1. Seattle, WA: Fantagraphics Books, 1990.
ISBN: 1560970588

Morgan, Wallace. (Untitled strip), *Cartoons of the Roaring Twenties*. Vol. 1, pg 54. Seattle, WA: Fantagraphics Books, 1991.
ISBN: 1560970510

Seth. *It's a Good Life if You Don't Weaken*. Montreal, Quebec: Drawn & Quarterly, 1996.
ISBN: 1896597076

Smith, Joel. *Steinberg at the New Yorker*. New York, NY: Harry N. Abrams, 2005.
ISBN: 0810959011

Storr, Robert. *Raymond Pettibon*. London: Phaidon Press, 2001.
ISBN: 0714839191

CHAPTER 3

Biggs, Brian. *Dear Julia,*. Marietta, GA: Top Shelf Productions, 2000.
ISBN: 1891830120

Blackbeard, Bill, ed. *Smithsonian Collection of Newspaper Comics*. Washington, D.C.: Smithsonian Institution Press, 1984.
ISBN: 0874741726

Bushmiller, Ernie. *Nancy Eats Food*. Northampton, MA: Kitchen Sink Press, 1989. (Part of a series of Ernie Bushmiller's *Nancy*.)
ISBN: 0878160604

Hart, Tom. *The Collected Hutch Owen*. Marietta, GA: Top Shelf Productions, 2000.
ISBN: 1891830171

Harvey, Robert C. *The Art of the Funnies: An Aesthetic History (Studies in Popular Culture)*. Jackson, MS: University Press of Mississippi, 1994.
ISBN: 0878056742

———. *Children of the Yellow Kid: The Evolution of the American Comic Strip*. Seattle, WA: U. of Washington Press/Frye Art Museum, 1998.
ISBN: 0295977787

Karasik, Paul, and Mark Newgarden. "How To Read *Nancy*." http://www.laffpix.com/howtoreadnancy.pdf.

Millionaire, Tony. *Maakies*. 2d ed. Seattle, WA: Fantagraphics Books, 2000.
ISBN: 1560973919

Robinson, Jerry. *The Comics: An Illustrated History of Comic Strip Art*. Milwaukie, OR: Dark Horse Comics, 2007. ISBN: 1593075626

Walker, Brian. *The Best of Ernie Bushmiller's* Nancy. Wilton, CT: Comicana Books, 1988. ISBN: 0805009256

CHAPTER 4

Bushmiller, Ernie. *See listing in Chapter 3.*

CHAPTER 5

Hamm, Jack. *Drawing the Head and Figure*. New York, NY: Berkley Publishing Group, 1963. ISBN: 0399507914

Muybridge, Eadweard. *Muybridge's "Complete Human and Animal Locomotion": New Volume 1*. New ed. Mineola, NY: Dover Publications, 1979. ISBN: 0486237923

CHAPTER 6

B., David. *Epileptic*. New York, NY: Pantheon Books, 2005. ISBN: 0375423184

Herriman, George. *Krazy and Ignatz*. Vols. 1–8 (ongoing series). Seattle, WA: Fantagraphics Books, 2002–2007.

Mignola, Mike. "The Nature of the Beast," *Hellboy: The Right Hand of Doom*. 2d ed. Milwaukie, OR: Dark Horse, 2003. ISBN: 1593070934

Nadel, Dan. *Art Out of Time: Unknown Comics Visionaries 1900–1969*. New York, NY: Harry N. Abrams, 2006. ISBN: 0810958384

Pope, Paul. *Giant THB 1.V.2*. Bowling Green, OH: Horse Press, 2003.

Segar, E.C. *Popeye*. Seattle, WA: Fantagraphics Books, 2006. ISBN: 1560977795

Tezuka, Osamu. *Ode to Kirihito*. Translated by Camellia Nieh. New York, NY: Vertical Inc., 2006. ISBN: 1932234640

Thompson, Craig. *Blankets*. Marietta, GA: Top Shelf Productions, 2003. ISBN: 1891830430

Walker, Brian. *The Comics before 1945*. New York, NY: Harry N. Abrams, 2004. ISBN: 0810949709

CHAPTER 7

Biggs, Brian. *See listing in Chapter 3.*

Chiarello, Mark, and Todd Klein. *The DC Comics Guide to Coloring and Lettering Comics*. New York, NY: Watson-Guptill Publications, 2004. ISBN: 0823010309

Fink, J. C., Maura Cooper, Janet Hoffberg, and Judy Kastin. *Speedball Textbook for Pen and Brush Lettering*. Ed. 23. Statesville, NC: Speedball Art Products Company, 1991. ISBN: 096315320X

George, Ross F. *Elementary Alphabets*. 6th ed. Statesville, NC: Speedball Art Products Company, 1940.

Gray, Bill, and Paul Shaw. *Lettering Tips: For Artists, Graphic Designers, and Calligraphers*. Rev. ed. New York, NY: W. W. Norton & Company, 1996. ISBN: 039373005

Kelly, Walt. *Pogo: The Complete Daily & Sunday Comic Strips Vol. 1: "Into the Wild Blue Wonder."* Seattle, WA: Fantagraphics Books, 2007. (Other volumes of this series forthcoming.) ISBN: 1560978694

Sim, Dave. *Cerebus Vol. 1*. Kitchener, Ontario: Aardvark-Vanaheim, 1991. (There are a number of volumes in this series.) ISBN: 0919359086

Sutherland, Martha. *Lettering for Architects and Designers*. New York, NY: Van Nostrand Reinhol, 1989. ISBN: 0442282141

CHAPTER 8

Claremont, Chris, John Romita Jr., and Barry Windsor-Smith. *Essential X-Men Vol. 5*. New York, NY: Marvel Comics, 2004. ISBN: 0785113665

Crumb, Robert. "Walkin' the Streets," *Zap Comix* 15. San Francisco, CA: Last Gasp, 2005.

Gloeckner, Phobe. *A Child's Life and Other Stories*. Berkeley, CA: Frog Ltd., 1998. ISBN: 1883319714

Guptill, Arthur. *Rendering in Pen and Ink*. 60th anniversary ed. New York, NY: Watson-Guptill Publications, 1997. ISBN: 0823045307

Hernandez, Jaime. *Locas*. Seattle, WA: Fantagraphics Books, 2004. ISBN: 156097611X

Janson, Klaus. *The DC Comics Guide to Inking Comics*. New York, NY: Watson-Guptill Publications, 2003. ISBN: 0823010295

Martin, Gary. *The Art Of Comic-Book Inking*. 2d ed. Milwaukie, OR: Dark Horse Comics, 2005.
ISBN: 1593074050

Mattichio, Franco. *Sans sens*. Paris: Seuil, 1998.
ISBN: 2020332868

Mattotti, Lorenzo, and Claudio Piersanti. *Stigmates*. Paris: Seuil, 1998.
ISBN: 2020343495

Mignola, Mike, John Arcudi, and Guy Davis. *B.P.R.D.: The Black Flame*. Milwaukie, OR: Dark Horse Comics, 2006.
ISBN: 1593075502

Sacco, Joe. *War's End: Profiles From Bosnia 1995–1996*. Montreal, Quebec: Drawn & Quarterly, 2005.
ISBN: 1896597920

Samura, Hiroaki. *Blade of the Immortal Vol. 12: Cry of the Worm*. Milwaukie, OR: Dark Horse, 1998.
ISBN: 1569713006

Smith, Joseph A. *Pen & Ink Book: Materials and Techniques for Today's Artist*. New ed. New York, NY: Watson-Guptill Publications, 1999.
ISBN: 0823039862

CHAPTER 9

Aristotle. *Poetics*. Translated by Malcolm Heath. New ed. New York, NY: Penguin Classics, 1997.
ISBN: 0809005271

Field, Syd. *Screenplay: The Foundations of Screenwriting*. Surrey, England: Delta, 2005.
ISBN: 0385339038

Mamet, David. *On Directing Film*. Reprint ed. New York, NY: Penguin, 1992.
ISBN: 0140127224

McKee, Robert. *Story: Substance, Structure, Style and the Principles of Screenwriting*. New York, NY: Regan Books, 1997.
ISBN: 0060391685

O'Neil, Dennis. *The DC Comics Guide to Writing Comics*. New York, NY: Watson-Guptill Publications, 2001.
ISBN: 0823010279

CHAPTER 10

Sperry, Jon. http://www.jonsperry.com

CHAPTER 11

Abadzis, Nick. *Laika*. New York, NY: First Second Books, 2007.
ISBN: 1596431016

Bechdel, Alison. *Fun Home*. New York, NY: Houghton Mifflin, 2006.
ISBN: 0618477942

Brown, Chester. *Louis Riel: A Comic-Strip Biography*. Montreal, Quebec: Drawn & Quarterly, 2004.
ISBN: 1896597637

Crane, Jordan. *Uptight No. 1*. Seattle, WA: Fantagraphics Books, 2006.

Hernandez, Gilbert. *Palomar: The Heartbreak Soup Stories*. Seattle, WA: Fantagraphics Books, 2003.
ISBN: 1560975393

Hernandez, Jaime. *See listing in Chapter 8.*

Miller, Frank. *Sin City Vol. 2: A Dame To Kill For*. 2d ed. Milwaukie, OR: Dark Horse, 2005.
ISBN: 1593072945

Nilsen, Anders Brekhus. *Big Questions #8: Theory and Practice*. Montreal, Quebec: Drawn & Quarterly, 2005.

Samura, Hiroaki. *Blade of the Immortal Vol. 13: Mirror of the Soul*. Milwaukie, OR: Dark Horse, 2004.
ISBN: 159307218X

CHAPTER 12

Bradbury, Ray, and Al Williamson. "The One Who Waits," *Weird Science No. 19*. West Plains, MO: Russ Cochran, 1980. (New edition forthcoming from Gemstone Publishing.)

Canemaker, John. *Winsor McCay: His Life and Art*. Rev. exp. ed. New York, NY: Harry N. Abrams, 2005.
ISBN: 0810959410

Chelsea, David. *Perspective! For Comic Book Artists*. New York, NY: Watson-Guptill Publications, 1997.
ISBN: 0823005674

D'Amelio, Joseph. *Perspective Drawing Handbook*. New ed. Mineola, NY: Dover Publications, 2004.
ISBN: 0486432084

Deitch, Kim. *The Boulevard of Broken Dreams*. New York, NY: Pantheon Books, 2002.
ISBN: 0375421912

Doucet, Julie. *My New York Diary*. 2d ed. Montreal: Drawn & Quarterly, 2004.
ISBN: 1896597831

DuPuy, Philippe, and Charles Berberian. *Get a Life*. Montreal, QC: Drawn and Quarterly, 2006.
ISBN: 1896597793

Edwards, Betty. *The New Drawing on the Right Side of the Brain*. 2d rev. ed. New York, NY: Jeremy P. Tarcher/Putnam, 1999.
ISBN: 0874774241

Gardner, John. *The Art of Fiction: Notes on Craft for Young Writers*. Reissue ed. New York, NY: Knopf, 1991.
ISBN: 0679734031

Horrocks, Dylan. *Hicksville*. Montreal, Quebec: Black Eye Books, 1998.
ISBN: 0969887469

Johnson, R. Kikuo. *Night Fisher*. Seattle, WA: Fantagraphics Books, 2005.
ISBN: 1560977191

Kaz. *Underworld: Cruel and Unusual Comics*. Seattle, WA: Fantagraphics Books, 1995.
ISBN: 1560970693

Kirby, Jack, and Stan Lee. *Masterworks: Fantastic Four Nos. 51 – 60 & Annual No. 4*. New York, NY: Marvel, 2000.
ISBN: 0785107525

Kochalka, James. *The Cute Manifesto*. Gainesville, FL: Alternative Comics, 2005.
ISBN: 1891867733

Lat. *Kampung Boy*. 1st American ed. New York, NY: First Second, 2006.
ISBN: 1596431210

Mazzucchelli, David. "Rates of Exchange," *Drawn & Quarterly Vol. 2 #2*. Montreal, Quebec: Drawn & Quarterly, 1994.

Moore, Alan, and Eddie Campbell, *From Hell*. Marietta, GA: Top Shelf Productions, 2000.
ISBN: 095878346

Myrick, Leland. *Missouri Boy*. New York, NY: First Second Books, 2006.
ISBN: 1596431105

Norling, Ernest. *Perspective Made Easy*. Mineola, NY: Dover Publications, 1999.
ISBN: 0486404730

Peck, Steven Rogers. *Atlas of Human Anatomy for the Artist*. New York, NY: Oxford University Press, 1982.
ISBN: 0195030958

Pope, Paul. *See listing in Chapter 6*.

Sacco, Joe. *The Fixer: A Story from Sarajevo*. Montreal, Quebec: Drawn & Quarterly, 2003.
ISBN: 1896597602

Tardi. *Tueur de Cafards*. Paris: Casterman, 1984.
ISBN: 2203338032

Tezuka, Osamu. *Buddha Vol. 2 The Four Encounters*. New York, NY: Vertical Inc., 2006.
ISBN: 1932234578

Watson, Ernest W. *Creative Perspective for Artists and Illustrators*. New ed. Mineola, NY: Dover Publications, 1993.
ISBN: 0486273377

Wolverton, Basil. *Basil Wolverton in Space*. Suzanne Taylor, ed. Milwaukie, OR: Dark Horse Comics, 1997.
ISBN: 156971238

Yang, Gene. *American Born Chinese*. New York, NY: First Second Books, 2006.
ISBN: 1596431520

CHAPTER 13

Allred, Mike. *The Complete Madman Comics Vol. 3: The Exit of Dr. Boiffard*. Milwaukie, OR: Dark Horse, 2000.
ISBN: 1569714703

Baudoin. *Le Portrait*. Paris, France: L'Association, 1997.
ISBN: 2909020851

Blutch. *Mitchum*. Paris, France: Cornelius, 2005.
ISBN: 2915492115

Burns, Charles. *Black Hole*. New York, NY: Pantheon, 2005.
ISBN: 037542380X

Caniff, Milton. *Steve Canyon 1951*. West Carrollton, OH: Checker Book Publishing, 2005.
(This panel reprinted from *Masters of American Comics,* which reproduced the art from the original page.)
ISBN: 1933160101

Carlin, John, Paul Karasik, and Brian Walker, ed. *Masters of American Comics*. New Haven, CT: Yale University Press, 2005.
ISBN: 030011317X

Clowes, Daniel. "Caricature," *Caricature*. Seattle, WA: Fantagraphics Books, 2002.
ISBN: 1560974583

Dupuy, Charles Phillipe Berberian. *La Théorie des gens seuls*. Paris, France: Les Humanoides Associes, 2000.
ISBN: 2731613548

Kirby, Jack, and Stan Lee. *Masterworks: Fantastic Four*. Vol. 5. 2d. ed. New York, NY: Marvel, 2004.
(This panel reprinted from *Masters of American Comics,* which reproduced the art from the original page.)
ISBN: 0785111840

Kurtzman, Harvey. "Corpse on the Imjin," *Two-Fisted Tales* No. 25. New York, NY: EC Comics, 1951.
(Reprint volume forthcoming from Gemstone Publishing. This panel reprinted from *Masters of American Comics,* which reproduced the art from the original page.)

Pekar, Harvey, and Robert Crumb. *Bob and Harv's Comics*. New York, NY: Four Walls Eight Windows, 1996.
ISBN: 1568581017

Smith, Jeff. *Bone: The Complete Cartoon Epic in One Volume*. Columbus, OH: Cartoon Books, 2004.
ISBN: 188896314X

Watterson, Bill. *The Calvin and Hobbes 10th Anniversary Book*. Kansas City, MO: Andrews McMeel Publishing, 1995.
ISBN: 0836204387

CHAPTER 14

Bá, Gabriel, and Fábio Moon. *De: Tales—Stories from Urban Brazil*. Milwaukie, OR: Dark Horse Comics, 2006. ISBN: 1593074859

Regé Jr., Ron, Dave Choe, Brian Ralph, and Jordan Crane. "Re: A Guide To Reproduction: a Primer on Xerography, Silkscreening, and Offset Printing," Redding and Highwater Books. http://www.reddingk.com/img/reproguide.pdf

Ware, Chris. *The Acme Novelty Library*. New York, NY: Pantheon, 2005. ISBN: 0375422951

CHAPTER 15

McCloud, Scott, ed. *24 Hour Comics*. Thousand Oaks, CA: About Comics, 2004. ISBN: 0971633843

———. *24 Hour Comics All-Stars*. Thousand Oaks, CA: About Comics, 2005. ISBN: 097539584X

McCloud, Scott. "The 24-Hour Comics," subsection of Inventions. Scott McCloud, http://www.scottmccloud.com/inventions/24hr/24hr.html

Watson, Esther Pearl, and Mark Todd. *Whatcha Mean, What's a Zine?* New York, NY: Graphia, 2006. ISBN: 0618563156

BY THE AUTHORS:

Jessica Abel

www.jessicaabel.com

Abel, Jessica. *La Perdida*. New York, NY: Pantheon, 2006. ISBN: 0375423656

———. *Mirror, Window*. Seattle, WA: Fantagraphics Books, 2000. ISBN: 1560973846

———. *Soundtrack: Short Stories 1989–1996*. Seattle, WA: Fantagraphics Books, 2001. ISBN: 1560974303

Abel, Jessica, and Ira Glass. *Radio: An Illustrated Guide*. Chicago, IL: WBEZ Alliance, Artbabe Army Publishing, and Public Radio International, 1999. ISBN: 0967967104

Abel, Jessica, and Gabe Soria (authors), and Warren Pleece (illustrator). *Life Sucks*. New York, NY: First Second Books, 2008. ISBN: 1596431075

Matt Madden

www.mattmadden.com

Madden, Matt. *Black Candy*. Montreal, Quebec: Black Eye Books, 1998. ISBN: 0969887469

———. *99 Ways to Tell a Story: Exercises in Style*. New York, NY: Chamberlain Bros. (Penguin), 2005. ISBN: 1596090782

———. *Odds Off*. Somerville, MA: Highwater Books, 2000. ISBN: 0966536398

Index

Notes & Sketches

Notes & Sketches